Whores and Other Feminists

Whores and Other Feminists

edited by

Jill Nagle

ROUTLEDGE
New York and London

Published in 1997 by

Routledge
29 West 35th Street
New York, NY 10001

Published in Great Britain in 1997 by

Routledge
11 New Fetter Lane
London EC4P 4EE

Printed in the United States of America
Design: Jack Donner

"Confessions of a Fat Sex Worker" by Drew Campbell originally appeared in *FaT GiRL* #4.

A previous version of Liz Highleyman's essay, "Professional Dominance: Power, Money, and Identity," entitled "My Life As A Dom," appears in the anthology *Second Coming* (Pat Califia and Robin Sweeney, eds., Alyson, in press 1996). That essay focuses on professional dominants within the SM community, whereas this piece focuses on pro doms within the sex work milieu.

Veronica Monét's essay "No Girls Allowed at the Mustang Ranch" is reprinted with permission of the Bay Area Bisexual Network, from *Anything That Moves*, issue #9.

Jessica Patton's "500 Words on Acculturation" was originally titled 'stripping and the second coming (out)' and was written and performed as a character monologue in *Death on Heels: Femme Dykes of the 90's*, first staged at 848 Divisadero Community Space in San Francisco in October, 1993.

Previous versions of Marcy Sheiner's "Odyssey of a Feminist Pornographer" appeared in *Spectator* magazine and *Forum*.

Library of Congress Cataloging-in-Publication Data

Whores and other feminists / Jill Nagle, editor.
 p. cm.
 Includes bibliographical references and index.
 ISBN 0–415–91821–9 (cl). — ISBN 0–415–91822–7 (pb)
 1. Prostitution—United States. 2. Feminism—United States.
I. Nagle, Jill 1964–
HQ144.W544 1996
306.74'2—dc20 96–36045
 CIP

For Nancy

Contents

Preface

AS INSTIGATOR AND EDITOR OF THIS VOLUME, I find myself compelled by many forces. Especially salient are anger, curiosity, and gratitude. It is surely not a new thing for an author-editor to be motivated by righteous rage at discourses, systems, or movements that inflict silence, pain, or injustice. Nor is it uncommon to create a work to quench one's own intellectual thirst—curiosity is a canny catalyst. However, I want to emphasize the personal gratitude I feel toward each of the contributors herein. In my ongoing quest (and it is not over) to illuminate (not resolve) the paradoxical nature of feminist whoring, it is these thinkers, writers, activists, and sex workers who have paved the way by modeling lives of integrity, consciousness, and passion: speaking out, organizing, performing, writing, fighting, and fucking their way to broader conceptual horizons.

Because of them, my world of possibilities is larger and richer. Without having witnessed their lives, I would not have had the tools to craft the person I am today. I undertook this project, then, not only to channel my rage and quell my curiosity, but also to demonstrate my gratitude. I am honored to collect and showcase the works of these very important thinkers, that their words and lives might further inspire and educate.

Acknowledgments

I AM BLESSED TO HAVE HAD THE INVALUABLE SUPPORT AND HELP OF MANY with this project. The material generosity of Rhoda Granat, Nancy Nagle, and Woody Cartwright provided a necessary foundation for periods of concentrated work. Kerwin Brook's multifaceted support and skills buoyed me through the final stretch of this challenging project. Deepest gratitude, as well, goes to Ray Schnitzler for his help during the early and middle phases.

Brad Bunnin imparted sound legal advice and warm, steady faith throughout. Jennifer Finlay provided impeccable research assistance, sound advice and lots of pep talks, all greatly appreciated. Veronica Monét, the first "out" feminist sex worker I ever met, lent support and editorial assistance—my very special thanks; Stacy Reed emerged early and often with editorial and all-around help. Patrick Graham and Tom Geller cheerfully and dependably conferred emergency computer expertise on short notice. My most religious thanks.

Rebecca Kaplan and Naomi Tucker appeared along the way with logistical and any other help I requested. Alison Luterman came through with last-minute editing assistance. Liz Highleyman's strong, skilled, firm, confident editing hand is most palpable in these pages. My deepest thanks, Liz, for your generosity, support, brilliance, and expertise. Not to mention your unfailing good nature. People too numerous to list helped proofread, offered ideas, gave feedback, procured potential contributors, ran errands, or just listened to me kvetch and kvell. I thank you all from the bottom of my heart!

To Zoë, who endured all manner of unconsciousness, especially around deadlines, and also managed to review whatever I put in front of her, I offer my most humble thanks. A bow (or curtsy) to Kate Bornstein, who set me on the right track to Routledge. I thank Eric Zinner for seeing the same light I did and following it to a contract. I also offer most sincere thanks to Jennifer Hammer for her early persistence—it gave me an unexpected confidence. Anders Corr offered unflagging enthusiasm and celebratory appreciation. Cleo Manago, teacher, brother, friend: your love, brilliance, support, and stellar politics buoy and inspire. Your intellectual influence is reflected here, as is that of Kerwin Brook, David Chapman, Liz Highleyman, Rebecca Kaplan, Richard Shapiro, Carol Stuart, and others.

I credit my myriad communities. The goddesses and warriors of San Francisco COYOTE stoked and tended my political fires. Queer Minyan saturated my often thirsty spirit. The Sacred Horses massage exchange rejuvenated my weary body and nurtured my faerie soul. The Radical Writers group gave feedback, confidence, and reduced my sense of isolation. My Internet queer and sex work communities kept my vision broad and my information base rich. San Francisco's Barefoot Boogie gave me a space to dance through my physical tensions, and plenty of playful partners. Spectator's monthly salon welcomed me among the "sexual intellectuals." And the gang: Alina, Alison, Ann, Aurora, Bayla, Beth, Eva, Holly, Judith, Neon, Rebecca, and Susie. You are the strong Jewish women who mirror, feed, and sustain me. The skin of my body contains parts of you, for we spring from common roots. You, too, are here.

Phyllis Nagle Washington, my aunt: your commitments to social justice, radical living pedagogy, and truth-telling continue to inspire me beyond your untimely passing. I dedicate this book to you. Rhoda Granat, my mother: your fascination with intellectual quagmires runs through my blood, and your warning—that only those who feel irresistibly compelled should write—keeps me vigilant. I also dedicate this book to you. And finally, my dear sister Nancy: your chutzpah, humor, perspective, and intelligence—and sisterhood—ground and color my world. I most especially dedicate this book to you.

Introduction

"FEMINISTS? IN THE SEX INDUSTRY? How can a sex worker be a feminist?" I fielded and engaged such queries numerous times during this book's development. The connections between feminism and commercial sex are deep, complex, and transformative. Defined broadly, sex worker feminists are nothing novel. What *is* new is the number and variety of openly identified sex workers speaking *as feminists about feminism*. The essays that follow elaborate perspectives on feminism from those within and in a few cases, closely alongside the sex industry. For this purpose, "sex industry" refers to a range of practices involving the exchange of sex and/or sexually related goods or services for money. Most of the contributors are current or former strippers, prostitutes, porn actors, writers, producers, professional dominatrixes, and phone sex workers in the United States. They reflect a particular historical moment in U.S. culture and particular conditions, largely white and/or middle-class, that afford the opportunity to forge feminisms directly from sex worker experience.

Questioning and expanding the meaning of feminism is by no means the exclusive domain of sex workers. In recent years, women from within many marginalized groups have begun to contribute their perspectives to the dynamic, contradictory body of thought, action, and narrative called feminism. In response, the face of public feminism has shifted to incorporate analyses of other forms of oppression such as race, class, and sexual orientation. However, mainstream feminism has yet to make major moves beyond analyzing how sex work oppresses women, to theorizing how feminism reproduces oppression of sex workers, and how incorporating sex worker feminisms results in richer analyses of gender oppression.

I made no special effort (though was not in principle opposed) to include perspectives of those who advocate abolition of all commercial sexual exchange, as I see such arguments well-represented elsewhere (Barry, 1979; Dworkin, 1981; Wynter, 1987; Russell, 1993) By contrast, the voices of feminist sex workers themselves have been glaringly absent in such discussions. For example, the January-February 1994 issue of *Ms.* magazine featured a cover story entitled "Roundtable on Pornography" that failed to include any women involved with

either producing pornography, or with any other aspect of commercial sex. One participant mentioned having had sex for money, an experience that left her feeling victimized and exploited. Though I feel deeply for any woman who is left feeling victimized and exploited, and though I advocate support, assistance, and the opportunity to voice that experience, a "roundtable" on as controversial a topic as pornography whose conclusions are practically foregone by the hegemonical views of the participants could not but fail to deliver the radical potential it promised.

When that article appeared, I had recently moved to the San Francisco Bay Area, and found pockets of sex-radical communities in which women, men, and transgendered people of all political stripes openly engaged in a range of commercial sex practices. I, too, began exploring various aspects of the sex industry, both as consumer and provider, and was surprised to find many of my own prejudices overturned.

Like many of the contributors to this volume, my racial and economic privilege afforded me the opportunity to choose participation in the sex industry from among many other options. This is not true for perhaps the vast majority of sex workers worldwide, especially those who exchange sex to survive on the streets, who support an addiction, or who are forced into it by others. Yet most public discussions about sex work fail to distinguish between voluntary and coerced sexual exchange, a distinction every bit as salient (and problematic)[1] as that between consensual sex and rape.

Sex worker activists around the globe have been laboring for more than two decades to improve conditions for those who choose the profession, and to oppose all forms of coercion, in the process calling attention to the larger economic context that severely circumscribes the range of options for all women (and most men). A small group of such activists recently helped ensure that the Platform for Action that emerged out of the United Nations' Beijing Women's Conference in October 1995 clearly differentiated between forced and voluntary prostitution, condemning only the forced variety.

Feminism too often has failed to incorporate and theorize this distinction. When it does, the theorizing is usually done by non-prostitutes (see, for example, Pateman, 1988). To momentarily don Marxist headgear, one could argue that the production of feminist discourse around prostitution by non-prostitutes alienates the laborer herself from the process of her own representation. While this is not to automatically discredit non-sex worker feminist arguments against sex work, it is to say it is high time to stop excluding the perspectives of sex worker feminists, time to stop assuming that traditional feminist analysis of sexual oppression alone exhausts all possible interpretations of commercial sex, and time to stop reproducing the whore stigma common to the larger culture. These practices dilute much of feminism's radical potential. This needn't happen. Mainstream feminism can and must take up the mantle to include sex worker feminisms—and feminists—in the larger picture.

Because of *Ms.*'s position as a primary, if not definitive, voice of mainstream

feminism, I objected loudly and vehemently to the political underpinnings of that roundtable discussion. In a letter to the magazine (which went unpublished), I raged, "Would *Ms.* sponsor a roundtable on lesbianism with a panel of famous heterosexual married ladies, one of whom had had a regretted past relationship with a woman?" Whores, I went on to argue, are the dykes of the nineties, the lavender menace whom it's still considered okay to ostracize.

This hasn't been uniformly true throughout feminism's history. As early as 1970 in the U.S., prostitute and non-prostitute feminists gathered in public, argued, formed friendships and alliances, and appeared in print side-by-side (Strong, 1970; Morgan, 1970; Fulbright, 1971; Reisig, 1971, 1972; Kearon, 1972). Though relations between openly identified sex worker feminists and non-sex-worker feminists were hardly seamless (nor was the line dividing these groups), sex workers (from closeted to openly identified, from part- or one-time to professional) figured prominently in many feminist discussions of that decade. After that time, public arguments among feminists became increasingly polarized over prostitution and pornography, culminating in the "sex wars" of the 80s.[2]

In 1985, at the height of the sex wars, sex worker and non-sex worker feminists collaborated to produce a Canadian conference entitled Challenging Our Images: The Politics of Pornography and Prostitution. Out of the proceedings came the book *Good Girls/Bad Girls: Feminists and Sex Trade Workers Face to Face* (Bell, 1987). The title notwithstanding, the book's contents problematize the very distinction between the two ostensibly separate groups. There are not just two party lines, two sets of experiences, two agendas. Yet the sex workers who speak in that volume express feeling pressure to conform to a "good girl" definition of feminism that unifies itself by excluding sex workers. However, as Laurie Bell states in the introduction, the sex workers

> ... maintain that it is the definition of feminism that must change in order to include both good girls and bad girls, not they who must conform to a good-girl image so as to be considered feminist. Sex trade workers claim, in effect, to be feminists in exile; excluded from a rightful place in the feminist movement, they demand to be recognized as members of the women's community. As one prostitute remarked, "Feminism is incomplete without us." (p. 17)

That volume furthered discussion between the two separated groups. *Sex Work* (1987), broke further ground with sex workers speaking for themselves, without traditional feminists mediating or legitimizing, and *A Vindication of the Rights of Whores* (1989) represented a more global and historical perspective on prostitute activism and demands for justice. This collection continues the spirit of those works by further cultivating explicitly feminist U.S. perspectives from within the sex industry. This time, in the pages that follow, sex worker feminists speak not as guests, nor as disgruntled exiles, *but as insiders to feminism.*

According to hegemonical feminist logic of the 1970s, excluding sex workers from feminist discussions seemed reasonable. After all, female sex workers who serve male clients offer a service arguably central to the very set of power relations traditional feminists seek to challenge and overturn. Sexual access fuels the rapist mentality (Brownmiller, 1975). Pornography is the theory, rape is the practice (Morgan, 1978). Prostitution requires self denigration (Millett, 1973). Pornography is inherently degrading to women (Dworkin, 1979). Thus, feminists and sex workers would appear to constitute two groups with mutually exclusive loyalties. Fortunately, the reality is more complex.

Many well-known feminists such as Andrea Dworkin[3] and Susan Brownmiller[4] have exchanged sex for money. Many others have participated in implicit sexual-monetary exchange, such as legal marriages or long-term cohabitation. When looking at actual *behavior*, sex-worker-identified and non-sex-worker-identified feminists form more of a range, or continuum than two discrete groups.[5] As with sexual orientation, those who publicly wear the label become de facto spokespeople for the rest, who can remain comfortably invisible. This "closetedness" allows the general public to believe that there really are two kinds of women, and that those in the sex industry are only ever powerless victims.

In the Meanings section of this volume, Carol Queen asks, "What separates those sex workers who experience their lives negatively from those who do not?" The protocol of feminist discourse has so far overwhelmingly dictated that those with sex industry experience characterize it only as negative/in the past/coerced/victimizing. Feminist activism and discourse has done an excellent (though unfinished) job of clearing space, creating support for, and theorizing women's stories of victimization around commercial sex. In the process, it has silenced feminist whores. Now it is time to clear space, create support for, and theorize other stories. As Adrienne Rich (1979) reminded us,

> If we conceive of feminism as more than a frivolous label, if we conceive of it as an ethics, a methodology, a more complex way of thinking about, thus more responsibly acting upon, the conditions of human life, we need a self-knowledge which can only develop through a steady, passionate attention to *all* female experience. (italics in original).[6]

There is room in feminism for whores, virgins, and everything in between. The advent of postmodernism and queer theory presents both more possibilities and more challenges for feminism. In forging more whore feminisms, we might well begin by looking at what purposes are served by using *any* sexual categories to describe women.

Compulsory Virtue and Harlot Existence: Constructing Binaries of Female Identity

Female identity in this culture takes shape in relation to a variety of binaries. A constructing binary of identity (in this case, of female identity) is a set of two

categories, one marked by relative privilege, the other by relative stigma. The examples I discuss here, in relation to one another, are lesbian/heterosexual, and good girl/bad girl. Other examples include white/nonwhite, reproductive/nonreproductive, and all of these categories interrelate in myriad and complex ways.

It would be difficult to overemphasize the overdeterminacy of white supremacy. To the important sets of questions concerned white feminists ask of themselves, one another and their groups, like "how is this racist, and how can we stop," all feminists must add, "How does white supremacy inform the very terms of this debate?" In this case, though a full treatment of the topic would necessitate another book, one point must be made: *Most of the constructing binaries of female identity signify a particular female's relationship to reproducing offspring of European descent, also known as "white" people.*[7]

These binaries construct identity by forcing females to choose, or at least negotiate between them. Their strength and power is evidenced by the paucity of such "between" space, and what happens to those who dare to inhabit it, or otherwise challenge the binary. Much feminism has done a good job of challenging, or deconstructing some of these binaries. For example, Adrienne Rich's "Compulsory Heterosexuality and Lesbian Existence" (1986), to whose arguments I draw thinly veiled analogies herein, points out how the lesbian/heterosexual binary informs and constructs all women's choices, not just the lesbian-identified, since it forces even heterosexual women to be forever vigilant lest their membership in the "good" category be challenged, as in, "I could never wear/say/do that; someone might think I'm a dyke!"

Similarly, since all our desires and actions still grow up under white supremacist capitalist heteropatriarchy, we need to problematize not only choices *to* participate in the sex industry, but also choices *not* to. Whores, too, are something that women are not only supposed to not *be*, but also, not be *mistaken* for. This division translates into a mandate to not only *be* virtuous, but also to *appear* virtuous, to again demonstrate our affiliation with the privileged half of the good girl/bad girl binary.

Compulsory virtue, then, is also something that informs and constricts women's every move, i.e., "I could never wear/say/do that, someone might think I'm a whore!" Beyond the internal constrictions women experience lie external risks, as well. As with other pariah categories, one does not have to actually *be* a whore to suffer a whore's punishment or stigma. Getting mistaken for a whore can land one in jail, as Priscilla Alexander and Norma Jean Almodovar point out. Recent laws, such as one passed in January, 1996 in San Francisco, give police officers the power to arrest someone for *appearing to intend* to exchange sex for money. As with most laws governing sex work, women are disproportionately targeted and arrested, although the total number of men who participate in prostitution is far larger than the number of women.[8] Good girls, then, stay out of the fray by eschewing any display of sexual intent or autonomy, lest it be used to relabel them bad.

Heterosexual privilege generally functions as a subset of "good girl" privilege,

while lesbianism and prostitution are subsets of " bad girl" categories. One of the reasons female bisexuality has been stigmatized, ostracized, or reduced to mere titillation for straight men, is that it confounds the lesbian/heterosexual constructing binary of female identity.[9] Feminist whores function in a similar way with respect to the good girl/bad girl trope.

To illustrate this, try juxtaposing the statement "No woman with other options could possibly choose sex work" with "No woman with other options could possibly choose lesbianism." Elements of these arguments sound nearly identical: Why risk the stigma, give up privileges, take on pariah status, to do something many believe is aesthetically if not morally offensive? Liberal answers have framed lesbianism as genetic (or the result of bad rearing), and whoring as always and only forced (or fatalistically resulting from poor self-esteem), precluding a consideration of choice in either matter. Bisexual women confound both the conservative and liberal constructions of lesbianism, just as feminist, part-time and unashamed sex workers confound both conservative and liberal notions of whoring. As Rebecca Kaplan said about bisexual women, "Perhaps the ultimate threat to the heteropatriarchy is a woman who has had a 'good fuck' and still isn't 'cured'" (Kaplan, 1992).

The woman who claims to go back and forth—to inhabit heterosexual relationship with all its vicissitudes, to reserve the right to abandon heterosexual relationship and embrace lesbian relationship, and then reserve the right to change her mind once again—(or perhaps embrace both) inspires vitriol from all camps. How many rights, after all, are women allowed to reserve? Like the bisexual woman, the proud harlot, the lesbian feminist stripper, and the part-time whore working her way through grad school all suggest that women can *choose* the less socially sanctioned of the good girl/bad girl boxes, and can do so out of liberation rather than compulsion, or can refuse the dichotomy entirely. The contributors in the pages that follow renegotiate one set of rigid binaries upon which female identity is constructed.

Embodiment

A central problem for feminists of all stripes, including feminist whores, is opposing the nonconsensual treatment of women as *only* sexual bodies while simultaneously challenging the cultural hierarchies that devalue and stigmatize sexual bodies.[10] To come at it from the other side, how do we value our sexuality when 'to be valued for our sexuality' is a primary instrument of our oppression? Karate and aikido are useful metaphors here. Karate is a what I call a "stop" martial art in which students are trained to defend not only themselves, but also every other potential victim of their assailant by disabling the attacker so that they will not be able to inflict harm on anyone else. Karate aims to meet, destroy, and overpower oncoming energy with greater, more effective energy, for the safety of all.

Based in an ostensibly opposite philosophy, aikido teaches escape from harm with as little damage as possible to the attacker. Students are trained to treat the attacker with great care, as though he or she were "the last eagle's egg." To

achieve this, aikido technique involves first going with, rather than against the energy of the attack, and then using the attack's own energy to deflect the attack and escape. For example, in response to a direct blow, the aikido defender would first move her own body in the direction of the blow and then out of the way so that the attacker's own momentum would continue to carry their body forward, leaving time for the unharmed attackee to escape. Conversely, the karate defender would instantly meet and disable that same blow with a comparable force.

Resistance takes many forms. To the untrained western eye, an aikido response to sexist oppression might appear complicit with the violence. But part of aikido's lesson is the paradox that sometimes, to get beyond something, one must first enter it with benign intention. In the successful aikido defense, the attacker, too, is transformed. Aikido's subtle magic also includes more direct defense techniques for last-resort situations.

While taking an aikido-based self-defense course for women, I grappled with these two philosophies as they applied to my own life. Karate appealed to my intense anger at the circumscription of my freedom and safety as a woman. Aikido appealed to my spirituality and utopian ideals.

Like many of the other young, white, middle-class women on my college campus, my feminist activism began karate style, with angry, reactive stances to men's sexual domination of women. I protested lenient date rape policies and sexist fraternity posters, though I stayed home when my comrades went to rally against porn flicks in the student union. "No means no," a catchphrase of the 80s, captured the essence of my peer group's "karate," or "stop" feminism.

Battered women's shelters, rape crisis centers, and increased consciousness around sexual violence sprang directly from this brand of feminism. Unless and until male violence against women ceases, "stop" feminism will be women's 911, a number I always want access to. But "stop" feminism has a limited domain. As a vehicle for sexual growth, awareness, and empowerment, "stop" feminism is to women's sexuality as an ambulance is to human health: a necessary measure, absolutely appropriate in many circumstances, but not suitable for daily care. Like the system of values it opposes, "stop" feminism fails to theorize a positive, autonomous view of female sexuality, instead reproducing much of society's deeply held ambivalence about female sexual agency. It also reflects an awareness of the minefield of sexual oppression within which the struggle to define our sexuality takes place. Without any clues, room to explore, or signs of imminent safety, a defensive posture is, indeed, a rational stance.

From an aikido perspective, the minefield of commercial sex looks different. The sex worker feminisms herein offer clues, create ideological space for divergent experiences, and call for greater safety measures for all women. Many of the sex workers in this volume use the opportunities for dialogue with clients in their work environments to educate men about women's bodies, women's desires, and issues of boundaries and consent. I know one feminist prostitute, Shaun, who regularly demonstrates proper condom usage,[11] relevant female anatomy and biology, and safer sex. She sees this component of her work as

inherently political, both because it challenges any stereotype of ignorance clients might have of her as a sex worker, and because it helps ensure that her many clients learn to treat women's bodies with the knowledge, respect and skill most women desire, and many still cannot articulate. In this way, feminist prostitutes can and do act uniquely as invisible allies of their non-sex worker sisters—a position made possible only by entering the domain of sex work itself.

In the San Francisco queer and sex-radical circles in which I and many of the other contributors have contextualized ourselves, I see a clear and present feminism organically woven into the culture. I watch sexual disrespect get nipped in the bud very quickly, with special attention paid to sexism and women's well being in mixed gender queer sex spaces.[12] I see room being created for men, too, to name, claim, get enraged about and grieve over sexual hurts. Getting my 'no' heard is no longer my primary concern. It isn't even getting my 'yes' heard; rather, I feel invited to articulate my own sexual desires in an increasingly diverse and welcoming context. I am not living in utopia by any stretch—just in a different culture from before, and one that embraces and rewrites, rather than circumvents and silences, myriad forms of female—and male—sexual agency.

I realize that my economic, educational, and racial privileges (to name a few) construct this stance. I also realize that occupying a small counterculture that supports safety and individual freedom for a few doesn't erase the material realities that keep in place systemic sexual and other violence against women, nor does it appear to dramatically touch the lives of masses of women across the globe, or even in this country, who are sexually coerced on a daily basis. However, it does reframe and expand the feminism I knew, which in turn informs how I and other feminists approach such global issues. For example, Priscilla Alexander's essay demonstrates how the same sex-positive grounding that supports small alternative communities of privilege also ideologically supports reconceptualizing human rights for sex workers internationally. Incorporating and expanding beyond the heuristic dualism of "karate" and "aikido" feminisms, Alexander's reframing of human rights issues for sex workers provides much sounder argumentative and political grounding for sex worker's human rights advocacy and activism than traditional feminist ideology. She also clearly identifies the stop elements and the sex-positive aspects as completely interwined in her experience of being a woman in this society:

> I believe that as long as women are arrested for the crime of being sexually assertive, for standing on the street without a socially acceptable purpose or a male chaperone, I am not free. As a woman and a feminist, I believe we will never have rights, opportunities, choices, work options, or an income equivalent to men's *unless we can stop being afraid of being either raped or called "whore."* As women, we must watch where and how we walk, talk, and dress, lest someone mistake (or claim to have mistaken) our intent. (Italics mine; p. 84, this volume)

Traditional feminism can no longer in good conscience advocate rape crisis centers while simultaneously refusing to talk to whores. Similarly, in its rebellious fervor, which I understand and share, sex-positive feminism mustn't make the mistake of disavowing stop feminism. Once a student becomes advanced in either karate or aikido, she begins to see their fundamental similarities. Each is premised on the belief that *the attacks ought not to occur in the first place.*[13] Similarly, as responses to many forms of sexist oppression, karate and aikido approaches to feminism often work different ends of the same rope, appearances to the contrary notwithstanding. When addressing the complexities of international sex worker issues, these categories may need to break down and give way to more dynamic, interparadigmatic[14] approaches.

Polarization, whether in a relationship or in a political movement, often develops a life independent of the issues to which it attaches; the energy used to construct and maintain such polarities can exceed the argumentative content. This is not to trivialize real disagreements among feminists, but rather to raise questions about and differentiate between the dynamics and the actual substance of our debates. To put it another way, I am interested in engaging and deconstructing the dialectic, and uncovering hidden areas of agreement.

This has already begun to happen to the extreme polarization that characterized the sex wars of the 80s. Thankfully, chinks abound in the armor of the two most well-represented sides of the debate, revealing conduits for connection. Note, for example, the similarity of these two passages, both of which describe feminist reactions to mainstream heterosexual pornography:

> Behind the static object which the obscene vision calls woman is a sacred image of the goddess, the sacred image of the cow, the emblematic touch of divinity in the ecstasy of the sexual act, and behind all these the knowledge that within matter and not outside the material is a knowledge of the meaning of the universe. (Griffin 1981, 71)

> When I look at pornography, it reminds me of the hundreds of figurines of nude women that turn up in the prehistoric strata of some archeological digs... The woman in pornography is a triumphant goddess. She is the mysterious source of all pleasure... (Califia 1995, 4)

A feminist known for her oppositional critique of pornography wrote the first passage in 1981; another feminist known (and frequently targeted) for her sadomasochistic fiction, incisive critiques of sexual censure, and political defense of all forms of sexual expression, wrote the other in 1995. Their points of political departure bear no repetition here. I am interested in their areas of accord and in asking questions similar to Carol Queen's above, i.e., what separates those who wish to engage, or at least allow pornographic expressions from those who

would abolish all their incarnations? Many of the contributors herein, myself included, speak from personal experience of having traversed both territories and abandoned neither, but rather embraced the paradox and allowed new syntheses to emerge.

The results speak for themselves. I invite the skeptics to seek out those moments of ambiguity, the points just before an ally threatens to become an ideological enemy and ask, what, exactly, is happening here? Many of the essays that follow chart such pivotal moments within individual lives, shedding light on the complexities that give rise to sex worker feminisms.

On the Inside

We begin, as ever, where we find ourselves. In Section 1, six current or former sex workers grapple candidly with integrating their feminist views with their sex work practices. "Contradiction" says bell hooks, "is the stuff of revolutionary struggle. The point is not to deny the reality of contradiction, but to utilize the space of contradiction to come to a greater understanding." (hooks, 1996) It is from within these contradictory spaces, from the material realities of their lives, that these contributors write.

Vicky Funari explores what separates her, the paid peepshow performer, from the paying customers on the other side of the glass, and in turn, what separates her customers from the men she knows and loves. In the process, she unearths fictions that construct the peepshow experience, male and female roles, and ultimately her own body. Marcy Sheiner traces her development from a teenaged wife furtively perusing her husband's girlie magazines to feminist activist to prolific author for some of those same magazines. Ultimately, neither her fertile pornographic imagination nor her feminist convictions suffers as a result of the other.

Using years of goddess mythology study as a springboard, Cosi Fabian embarks at age forty-two on a journey to embody the holy whore archetype. She at last brings her life into alignment with her beliefs, realizes spiritual fulfillment, and improves her physical health. Ann Renée emerges from years of a complex web of abuse, desire, teenage prostitution, ecstasy, and spiritual searching with a passionate call for justice, shift of authority, and an end to repression. Rather than being "cleaned up," she argues, the sex industry needs to be "made even more shamelessly dirty."

Nina Hartley is a registered nurse and porn star famous not only for her "wholesome" sexiness and upbeat attitude, but also for her politics, talent, activism, and mentoring of new actresses. She chronicles her emergence into the adult film world and the range of issues she confronted, both internally and externally. As her sexual experience and confidence shifted, so did her feminist analysis. Finally, Annie Sprinkle expands her usual role as sex-positive guru to address some of the more taxing aspects of erotic labor. She enjoins sex workers to care for themselves in specific, tangible ways to avoid Sex Worker Burnout Syndrome (SWBS). Through their sex industry experience, many of this section's

contributors expand their understanding of the machinations of sexist oppression, both strengthening and problematizing their feminist analyses.

In many ways the theoretical "meat" of the book, Section 2 takes up the project of such analysis in greater depth. Eva Pendleton situates sex worker feminism in the lens of queer theory, examining constructions of sex worker identity in the popular and lesbian/gay press. Both sex workers and lesbians, she argues, "destabilize heteronormativity," thus placing sex worker feminists in some very queer positions, indeed. Priscilla Alexander uses the human rights rubric to analyze the politics on either of the two main sides of feminist controversy around prostitution. She takes a long view globally and historically, effecting a paradigm shift that calls for the prevention of systemic human rights violations of sex workers worldwide, rather than unilaterally framing sex work as always and inherently a human rights violation in the first place. Tawnya Dudash lifts the curtain on feminist speech in a peepshow environment. The peepshow affords unique opportunities to explore body image, sexuality, attitudes toward age and ethnicity, same-sex interaction and other elements, which Dudash chronicles in a series of interviews as a participant/observer.

Across the U.S., many stigmatized sexual practices are quietly winked at in exchange for silence and pretense of their nonexistence. Tracy Quan shines the light on Barbie as the trope for the lucrative hypocrisy that characterizes the "average American call girl," exposing Barbie's sordid past as Lilli, a German whore cartoon character-cum-doll. The rules governing sexual contracts, it turns out, are no further away than middle America's toyboxes.

Delving directly into the post-sex-war wreckage, Carol Queen carefully unpacks the tenuous relationship between feminism and sex radicalism, deconstructing whore stigma, and offering reconstructive information, directions, and issues for traditional feminism to consider. Finally, Jessica Patton provides a graphic juxtaposition of lesbian sex in two women's spaces: an upscale San Francisco strip joint and an East Coast Seven Sisters college, illustrating some surprising contrasts of sexual and feminist richness and poverty.

Since the commercial sex arrangement that serves as the model for most traditional feminist critique is women providing compliant sexual services to men, Section 3 contains a number of "reversed" perspectives on this common theme, each elucidating a different aspect of the constructedness of this original model. Julian Marlowe, a male prostitute, contrasts the meaning of prostitution in predominantly white gay male culture with that of female prostitution in mainstream North American heterosexual culture. The areas where the arguments against prostitution break down for males reveal how many arguments against female prostitution reify the very cultural notions of femaleness they often purport to challenge. Liz Highleyman analyzes many aspects of the professional dominant's position, a sex industry job usually ignored by traditional feminism, since, in Highleyman's words, "Abolitionists find it difficult to make the case that pro doms are exploited victims with no control over their situations." Highleyman advocates solidarity among all sex workers, regardless

of the hierarchies of stigmatization that often privilege pro doms as somehow less objectionable or oppressed than other sex workers.

Most analyses of and arguments against porn are made against the majority of porn, which is by, for, and about male desire with women represented primarily as props in the service of that desire. The specific terms of sexual representation, then, become conflated with sexual representation itself, so that 'pornography' comes to mean 'that which uses women in the service of men's exploitive (or otherwise "bad") desire.' Leaving aside this time the issue of gay male pornography, what happens to this equation when women begin making sex videos for other women, with the intent to turn this dynamic around? Candida Royalle and Debi Sundahl, two longtime friends and peers recount the struggles and triumphs leading to their pioneering success, and discuss ways their work has helped transform the way women regard and express desire. Veronica Monét gains a special appreciation for professional sexual service (and a bad taste of heterosexism) when her husband treats her to a trip to the Mustang Ranch, a famous Nevada brothel. Finally, Les von Zoticus, in an effort to equalize the skewed arrangements placing femmes always at the service of butch desire, offers herself for hire by women as a "refined butch escort."

Section 4 illuminates areas clouded in silence, stigma, and/or myths. Stacy Reed's three years in Texas's renowned "gentlemen's clubs" divested her of more than just her street clothes. She debunks what she now considers mythical beliefs about stripping, which are based in both lack of information and an old-school feminist analysis. Working in the privacy of one's own home, with the anonymity of the telephone raises different issues. Drew Campbell's "Confessions of a Fat Sex Worker" recounts Drew's coming face-to-face with virulent fat prejudice from a phone sex client's wife.

If fatness puts one in an out group among out groups, so does being a raunchy feminist. Red Jordan Arobateau, whose work was rejected by feminist and lesbian presses for years because of its sexual content, now promulgates a steady stream of chewy filth with a specialty publisher. Because she makes money with her sexually explicit writing, she gets painted with the same derogatory brush as the whores she dated two decades ago. Her spelling of "dike" harks back to that time, and also reflects her working-class sensibility. Though Arobateau occupies a "gray area" vis-à-vis the sex industry per se, her piece illustrates how sex worker stigma leaks onto many forms of sexual representation, particularly when those representations are not white and middle class. As a case in point, Arobateau was recently accused in a lesbian publication of actually being an undercover man, as reviewer Jinx Beers had never heard of stone butches turning tricks with prostitutes, then getting it on with them "in a very masculine manner." Nor could she imagine any "real" lesbians engaging in Arobateau's preferred mode of tribadism (Beers, 1995).

In "Showing Up Fully," Blake Aarens, Hima B., Gina Gold, Jade Irie, Madeleine Lawson, and Gloria Lockett discuss their experiences as women of color in the sex industry, touching on feminism, racism, sexuality, stigma, and the

complexity of their lives. Norma Jean Almodovar reflects in "Working It" on her decision to become a prostitute in order to write *Cop to Call Girl*, an account of her experiences with sexism, violence, and abuse within the Los Angeles Police Department. She highlights the range of abuse and corruption in the LAPD, the ironies of the City's treatment of prostitutes, and the media's changing attitude towards her from the time of her book's publication to the present. Veronica Monét, happily and safely back from the Mustang Ranch, returns to trace her political transformation from traditional to sex worker feminist.

Section 5 is about the interventions and transformations that sex workers and their allies effect in the world. Carol Leigh, aka Scarlot Harlot, who coined the phrase "sex worker," reveals, "When I first looked into that mirror, and said, 'Now, there's a prostitute,' I knew that redefining prostitution from prostitutes' perspectives would be my life's work." Lyndall MacCowan interviews Denise Turner, members of whose lesbian feminist community took jobs at the local massage parlor, then protested and formed a prostitute's education project when working conditions declined. Turner's story, again from a working-class community, strikingly contradicts prevailing middle-class notions of feminists and sex workers as two disparate groups.

Larry Grant, a profeminist man, argues against the Men Against Pornography Statement of Accountability on several grounds, including that its selectivity about the particular kinds of feminists to whom they are accountable is actually anti-feminist. Teri Goodson joins NOW as an openly-identified prostitute, and fights an uphill battle to win allies and educate other members about the political necessity of such alliances. Siobhan Brooks bravely challenges the racism, both subtle and overt, implicitly condoned in the peepshow she performs in, and Joan Kennedy Taylor helps found Feminists for Free Expression in response to censorship efforts from other feminist factions.

Taken as a whole, the essays in all five sections work to close the feminist-sex worker gap. As I have suggested, the artificial separation of feminists from sex workers recapitulates feminist battles over lesbian inclusion, also eagerly exploited by the media to divide women. Then and now, feminism sorely needs exactly what is provided by the group it excludes. As lesbian feminism strengthened mainstream feminism, so will whore feminism. These essays contribute to that strength, not often by offering easy answers, but rather by introducing new questions and reframing old ones.

Postmodern critiques of sex and gender have shown the dangers of subscribing to a monolithic notion of 'woman.' Extending this critique to the notion of sex, the traditional meanings assigned to sexual exchange begin to loosen and admit of greater complexity. The voices in this book ground themselves in the gaps of this complexity, and create wider spaces for debate, for feminist sex work, and for sex worker feminism.

It becomes, then, neither interesting nor valuable to ask whether a sex worker (or any other sort of person) can "be a feminist" but rather, to ask questions like How does feminism inform the lives, choices, and practices of workers in

the sex industry? How does sex industry experience affect the feminism of individual sex workers? How do stigmas limit or define women not in the industry, or on its periphery? And perhaps most centrally, *how do sex worker feminisms change the face of feminism as a whole?*

Notes

1. The notion of consent is problematic in that it is based on abstract equality but is applied to situations of social inequality. For example, what does it mean for a woman who believes it is her duty to have sex with a particular man to give consent? Additionally, the gray areas between consensual sex and rape have often been strategically oversimplified in order to effectively combat date rape. I believe that as negotiation and consent become more standard parts of our sexual vocabulary, that more safety will be created to discuss these gray areas without automatically feeding backlash sentiment that would deny the reality and tragedy of rape.

2. Gayle Rubin has pointed out to me that the term "sex wars" and its attendant image of equally polarized sides reaching toward a conciliatory middle inaccurately frames the sexual outlaws as aggressively promoting particular sexual practices (such as sex work and sadomasochism) rather than defending themselves against attack. In fact, the "middle ground" conclusions represent standard sex radical views from up to two decades ago.

3. See "Roundtable on Pornography," *Ms.*, January/February 1994, p. 39.

4. See Reisig, Robin, *Village Voice*, 1971.

5. Nonetheless, while solidarity demands breaking down the good girl-bad girl binary division, openly-identified sex workers need to be the ones to speak for themselves, rather than obviating their unique perspectives by claiming that "we are all whores," and can therefore speak for one another.

6. "Conditions for Work: The Common World of Women (1976)" in *On Lies, Secrets and Silence: Selected Prose 1966–1978*, p. 213.

7. This means that the stigmas attached to both male and female nonreproductive and counterreproductive sexual behaviors, such as prostitution, homosexuality, bisexuality, abortion, public sex, and nonmonogamy, need to be examined through this lens in addition to any others. The potential results include better informed alliances among progressive antiracist, feminist, sexual liberation, reproductive freedom, and other groups working toward social justice.

8. I include in this number male prostitutes as well as male clients of prostitutes of all genders.

9. Elsewhere I argue that, in addition to sexism, monosexism constructs bisexual identity for both men and women (see Nagle, Jill, "Framing Radical Bisexuality: Toward a Gender Agenda" in *Bisexual Politics: Theories, Queries and Visions*, Haworth Press, 1995).

10. Carol Smart's discussion of the construction of women's bodies in legal dis-

course influenced my thinking here. See "Postscript for the 1990s, or 'Still Angry After All These Years'" in *Law, Crime and Sexuality: Essays in Feminism.*

11. According to Shaun, who has a degree in biology and years of experience as a sex educator, the two major causes of condom breakage are 1) air in the condom and 2) not enough lubricant on the outside.

12. 'Mixed gender queer sex spaces' refers to public or private parties created for the purpose of having, exploring, and watching explicit sexual activity among people of all genders and sexual orientations, making them different from, say, gay men's sex clubs or heterosexual swinger's parties. Safer sex, negotiation, and consensuality are highly stressed in the former.

13. Alex Lewin, personal communication.

14. Aside from conversations on the Internet, I first publicly coined this word in a paper entitled "Interparadigmatics: Toward a Dynamic, Polyvisional Epistemology/Praxis of Queer Liberation" presented at "Queer Frontiers: The Fifth Annual National Lesbian, Gay, and Bisexual Graduate Student Conference," Los Angeles, 1995. It refers to practices that consciously partake of and/or move among multiple frameworks and perspectives, as opposed to those that remain within one.

[one] Integration

The Letter,

The Spirit,

and The Flesh

The answer to the problem between the white race and the colored, between males and females, lies in healing the split that originates in the very foundation of our lives, our culture, our languages, our thoughts. A massive uprooting of dualistic thinking in the individual and collective consciousness is the beginning of a long struggle, but one that could, in our best hopes, bring us to the end of rape, of violence, of war.

—Gloria Anzaldúa,
Borderlands La Frontera

[1] Naked, Naughty, Nasty

Peep Show Reflections

VICKY FUNARI

CUSTOMER SHOW EVALUATION:
December 7, Monday, 7:30 P.M.
Dancer(s) you are evaluating: Clove.
The pink pulsating movement pushed me to the lim-
its of schizophrenic ecxtasy. I'd like to impregnate
triplets in your reverberating womb.
—Octodog

12/2/92

I feel nothing as I spread my labia and move my crotch as close to the window as possible without wiping my own sweat and cunt mucus across it. I want to be sure the man behind the glass gets what he's paying for: a clear, frank gaze at a pussy. Any pussy will do, as long as it's attached to a young female body appropriately undressed in high heels and lacy bits. But our eyes do meet, and this meeting makes us real. If I ever see this man on the street or at a friend's house, it will not be for the first time. He may not recognize me at first, with my buzz cut and my real, unmade-up face, but I will know him. Shall I tell you what he looks like? His race, his age, his apparent socio-economic standing? Shall I tell you how your husband/boyfriend/father/broth-er/son acts in front of a "live" pornographic image? Shall I help you discount the personal dimension of this business transaction or shall I help you face it?

YOU COULD CALL THIS MY FIRST JOB IN THE SEX INDUSTRY. It could also be seen as not too different from jobs I've held in the past. I have waitressed, and been sexually harassed by bosses and customers. I have modeled for art classes, and watched students and teachers fuel their fantasies with my motionless body. I have worked in an office, and been stuck in a cubicle with a coworker who just could not grasp the hard fact that I preferred my woman lover over him. I have worked in the film industry, and felt myself a cog in a multimillion dollar

machine that designs and markets "entertainment" around the sex-value of its stars. These all look like sex industries to me. I wondered: What is the difference between jobs within work systems that hypocritically deny the importance of sex to their smooth operation as opposed to those that exploit it as their very reason for operating? If capitalism was structuring my work experiences, and if sexism was structuring roles within capitalism, what had I to lose by facing overt rather than covert realities? I certainly had a choice of not doing this particular work, but I never had a choice of not dealing with its existence.

1 na•ked \'nā-kəd, 'nek-əd/ *adj* 1 : not covered by clothing : NUDE 2 : devoid of customary or natural covering 3 a : scantily supplied or furnished b : lacking embellishment : UNADORNED 4 : UNARMED, DEFENSELESS *syn* see BARE (PUT YOUR MONEY WHERE YOUR MOUTH IS)

11/14/92
It's a fine Saturday afternoon. I am auditioning for a job at a peepshow. I dress in borrowed leopard-print stockings and garter belt, a bad wig, and heels I bought for $4.50 at the Salvation Army. I pull some see-through tops out of a friend's locker for consideration, but a helpful dancer in the dressing room counsels me against them: "For the audition they like you to wear as little as possible." The manager leads me to the mirrored box euphemistically called a stage, where four other dancers are at work. The room is surrounded on three sides by ten shuttered windows, which look into it from ten narrow black booths. Each customer enters a booth from the hallway outside, feeds quarters into a slot beneath the shuttered window, and the shutter slides up to reveal the dancers. From the booths, the stage at first glance seems vast, the women numberless, the space and its bodies multiplied into infinity by mirrors.

The sign outside advertises "naked, naughty, nasty, live girls" at 25 cents for each half-minute. Some months ago I put a quarter in a slot, visiting a friend who works here. The first time I looked into the stage, I had to laugh. It's an absurd vision: contemporary women, some clearly marked with the tattoos and piercings of radical urban feminism, here moving with indifference through predetermined "sexual" maneuvers. Their shaven heads/purple streaks/crew cuts are hidden by obligatory long hair, Cher/Dolly Parton/Cleopatra-style. Their feet, which outside carry these bodies through art making, law school, mothering, and other hard labors, here balance on spike heels for four-hour to six-hour shifts. Behind heavy makeup their eyes are dull with boredom. It's unmistakable: these lusty ladies punch a time clock.

CUSTOMER SHOW EVALUATION:
December 8, Tuesday, 10:20.
Dancer(s) you are evaluating: Inanna. Loved being bare
with you—would love you to have watched even closer
and tongued—But our cum posture, staring into each
other's lustfully lidded eyes while doggie style—wow!

But now I am inside, looking out, "auditioning." Facing a man in a booth
for the first time is surprisingly easy. His needs seem simple. I am mildly
amazed as, for the first time in my life, I open my cunt lips for someone
who is neither lover nor gynecologist and realize about this stranger, first
of all, "Oh dear. You're a real person," and then, as he smiles nervously
and nods his enjoyment through the glass, "This is all it takes? You get
off on this? You pay for this?" A cunt in motion, an appearance of partic-
ipation in his masturbatory moment. In relief, I tell myself, "Piece of
cake, girlfriend. Show him more." So I do, and this imitation of sex,
which is not sex at all, pleases him, which pleases me. There's nothing I
like better than a job well done. After all, I used to be a Girl Scout.

Another window slides open next to my thigh. The teenager behind the
glass is also anxious and also easily pleased. I watch him break out in a
sweat at the sight of my naked body. A dilemma confronts me: Do I leave
my enthusiastic first customer in mid-jerk-off and concentrate on this
boy? The first guy might feel rejected if I turn away; I wouldn't want to
hurt anybody's feelings. Maybe if I twist my body, like so, I can give them
both a good view and shift my glance back and forth between them to
maintain eye contact. This works. And it's the eye contact that does it:
these men were visibly uncomfortable until my smile and my eyes permit-
ted them to engage. Neat. I interrupt my own moment of satisfaction:
"Get a grip! You quit the Girl Scouts, remember?"

In the next window, a man stares at me impassively. When I smile at him,
not a muscle moves in his face. This hardened stare looks just like hatred,
and yet he continues to watch my body undulate. What name does his
hatred give me that still lets him drink my body's spectacle: "whore?"
"white?" "ugly?" I don't stick around to figure out which of these it
might be, if any; he chills me away to another window.

These first moments are a lesson in the potential internal costs of doing
sex work. I can see that if I want to survive here I'll have to jettison those
praised womanly habits of caretaking and sensitivity and retain only their
physical traces: the open gaze, the welcoming smile. In this work I cannot
mean what I do.

*My mind is so amused by monitoring my own responses and my body is so
absorbed by the music that I don't even notice my audition time is up
until I hear the manager calling my new stage name repeatedly, at the
entrance to the mirrored room.*

After the audition, the manager, who could as easily be a librarian or a store-
owner, sits with me in the office and asks me how it felt. She is friendly and
warm in the way business people are when they look at a person and see cash.
"Fine," I say, telling the truth. She tells me I did well, except that each time I
looked at a customer I rolled my eyes to the ceiling. I smile at my transparency,
"Well, it's kind of weird for me to be dancing naked in front of strangers." "Oh
really? My first time I loved it." She gives me some pointers, tells me to interact
more with the customers, to say, "Hi, how are you? Good afternoon." I remark,
"I can't really hear through the glass." "That's okay," she tells me, "you can't
hear them but they can hear you. You can still carry on a conversation." I want
to laugh out loud at the idea of a "conversation" in which only one person can
hear, but it is a job interview after all.

She is saying, "Just be nice, fulfill their needs." The sign outside calls
customers in with the promise of "naughty, nasty" girls, but I am being told to
"be nice." Men come in to see "naked" girls, but it is a carefully dictated naked-
ness. Each worker must be costumed in high heels, must wear her hair at least
below the ears, and her costume may at no moment cover both her breasts and
her pubic area. Customers and workers receive two different sets of instructions
from management. Exactly what is the fiction being constructed here and why
does it work for those involved?

I wanted a way to look beyond what seem like false polarizations within femi-
nist discussions of sex work: Sex workers accuse antiporn feminists of being
moralistic, puritanical, elitist, and frigid. Antiporn and antiprostitution femi-
nists assume sex workers to be unenlightened slaves of the patriarchy, spreading
sexist behavior by validating men's stereotypes of women as sex objects. I was
tired of hearing and reading these two refrains, fighting words that overlook the
complexities of the choices real women make every day. I talked a line: eschew
dogmatism in favor of curiosity, support women's diverse experiences and deci-
sions. But the reality of myself as a nude dancer was impossible to envision,
alternately provoking hilarity and horror. Still, I thought, if I can say there is
nothing wrong with sex work, I damn well better be able to do it.

CUSTOMER SHOW EVALUATION
Friday, 12/4, 10:15 P.M.
Dancer(s) you are evaluating: PJ.
I say ole girl—Jolly good show! Just because you're so sweet,
kind and fun, you're questioning and exploring are strength-
ened and made clear. Life's invitation keeps pulling
—REEE PEET customer Jimmy Brown loves ya

Monday 11/16, 9 P.M.–2 A.M.

First shift: The shutter goes up and his eyes light up when he sees me. He starts waving at me, saying something I can't hear over the music, nodding enthusiastically as I weave around in front of the window. He pulls out a pen as the shutter slides down, and when it comes back up seconds later he is pressing a napkin to the glass that says, "I love your hair." He points to my belly, my crotch, and my underarms to be sure I understand he means my abundant body hair, not the shiny auburn wig on my head. It's the first human moment in this long evening, and it happened in writing. He proceeds to strip his body of every stitch of cloth-ing, lies back on the bench, and starts jerking merrily away. I'm amazed at his humor, his abandon, and his unusual choice to touch his naked flesh to the cum-spattered surfaces of the booth. I wonder what this joyful man is doing masturbating at a peepshow, but I'm glad he's here. His pleasure in my body hair is a relief; quite a few men have moved around the booths to get away from my bushy body and closer to my pinker, smoother colleagues. While his attraction to body hair is no differ-ent in nature than another man's revulsion, it's undeniably easier to perform for an appreciative audience.

Wednesday, 11/18, 1 P.M.–5 P.M.

Second shift: I start "fitting" my costume. Before this, the wig may as well have been a mop or a book or a vase of flowers perched on my head. Today the borrowed pieces gel into a persona, and I start liking the way I look. My stage name, Capri, begins to have an image that goes with it. For this shift I wear a transparent, black-and-metallic-threaded lace vest, which hangs loosely off my back and swings open around my breasts, alternately covering and exposing them. The sparkling vest gives me something to entertain myself with, since I like the feel and the weight of it. I like shrugging it off my shoulders and looking at my back in the angled mirrors. While the men in front of me amuse themselves with my crotch and swinging breasts, I admire the muscles of my upper back at work, strong muscles shaped by swimming in the icy waters of the San Francisco Bay.

A long period of unemployment and an empty bank account got me into that mirrored room. From among the temporary options visible to me—waitress-ing, office work, and nude dancing—I chose the job with the most comfortable uniform and the best learning opportunities. I put my body where my mouth was, and I made the job tolerable by using it as research. I put my body where the wages were, and my consciousness immediately began changing shape without my permission. I put my body in funny clothes in a mirrored box, and waited for the reflections to show me something.

2 **naugh•ty** \ ʻnȯt-ē, ʻnät-e\ *adj* **1 a** archaic : vicious in moral character : WICKED **b** : guilty of disobedience or mis-behavior **2** : lacking in taste or propriety *syn* see BAD
(YOU'RE SOAKING IN IT)

Friday, 11/20, 11 P.M.–3 A.M.

Booth 26: The mirrored shutter slides open and a small, middle-aged man huddles in his booth. He does not masturbate, instead resting his hands, little mouse paws, on the coin box and staring up at me. He does not return my smile; his face is locked in an expression of frightened solemnity. I kneel in front of the window and handle my nipples for a while. Then I stand, pull open my labia, move my index finger on my clit, sway back and forth a bit. His eyes follow my nipples and then my cunt like a hungry dog watching a biscuit waved in the air. The Girl Scouts strike again: I feel sorry for him.

I lower my face into his eyeline and smile again, but I can't get him to smile back. This is a serious matter for him. It's as if he's never seen a woman's naked body before, as if he's been waiting for this moment of un-abashed looking for years; can this mirthless, desperate, clinical gaze at an alien behind glass be pleasure? Tears are forcing their way out through my shell, tears for him, damn it. I do not want to feel anything for a man who prices my cunt at 25 cents, nor do I have any right to cry for him. This man is Asian. I am ignorant of him, his culture, his family, his life. I can't even know what he sees when he sees me. We are separated more by the abysses of gender and ethnic difference than we could ever be by this pane of glass. I stand, put my face close to the mirrored wall above the window and stare closely into my own unfamiliarly kohl-rimmed eyes to force the tears down.

I locate myself inside the black points of my pupils, but I can't let go of this: in this clown's outfit, I will not be anyone's occasion for solemnity. I sink my face into his field of vision and smile again, holding his eyes until at last he gives in and smiles back. It's an ambiguous triumph. The friend who introduced me to this work had told me she viewed it as a kind of social work, safe sex therapy for the repressed men of the world. She may be right, but I feel poisoned.

CUSTOMER SHOW EVALUATION
12/8, Tuesday, 12:15 P.M.
Dancer(s) you are evaluating: Betty.
Thanks, Betty, really great show.

There is no standard customer. The row of windows is a diverse and constantly shifting spectrum of men. All colors, all ages, all economic brackets, all attitudes.

It's easily the most integrated social environment I've experienced. Except for one little detail: women are on the paid side of the glass, men on the paying side. It's the strongest visual metaphor I've encountered for the feminist argument that sexism crosses all boundaries and encompasses all races, all political, cultural, and economic systems.

I am responsible for the imagery I produce, as a filmmaker and a painter, as a woman in this world, a woman in relationship with other human beings. In the peepshow I'm not controlling the image: I don't make the rules. But I am plugging my body into a predetermined slot, and in doing so I produce my own body as imagery, with all its clear and indecipherable effects. The effects that matter seem impossibly mysterious: How could one trace what effect my nice/naughty Capri has on other women, via these men? It's hard enough to understand how Capri is affecting me. I feed the customers' desires with no illusion that their desires have anything to do with me. But occasionally our desires conflict or coincide, momentarily jarring me back into myself and real time.

Monday, 11/23, 10 A.M.–3 P.M.
Booth 28: I spread my labia and smile at the man on the other side of the glass. I feel nothing, although I think plenty of thoughts, as he points to his dick. He wants me to watch him jack off, he wants to know I will see him ejaculate. I register resistance somewhere inside myself, but I can't think of a reason to resist. Watching his dick will be a blip in the undifferentiated boredom of watching myself, of guiding their eyes always down to my breasts and cunt. He points again. Again, I don't want to watch. I comply, still not wanting to, still not knowing why. A realization pushes its way through my numbness: My own lover, the man I'll go home to when I get off work, likes me to watch him come, to watch his cock empty itself over our bellies. For my lover and so for me, this is a profoundly pleasurable moment. Now some stranger, who leers at me and does not know my name, wants the same thing. I will sell him this moment, via my employers. Via my employers, he has bought this moment. My lover has not. Will I give my lover this pleasure now that it has a price? Will I feel it as a pleasure or as a transaction?

CUSTOMER SHOW EVALUATION:
December 8, 1992, Tuesday, 10:30 A.M.
Dancer(s) you are evaluating: Nikki.
Marriage?

Tuesday, 11/24, 12 P.M.–4 P.M.
Booth 23: He smiles broadly, nods his enjoyment of my swiveling hips, my undulating belly. When I put my cunt to his gaze, an inch from the pane, out comes his tongue and he works it, just an inch from his side of the glass. Funny, I think, that you can tell a good eater of pussy just by

watching him lick air. I am suddenly reminded that there is an outside world, and that it's raining there, because he lifts his curved bamboo umbrella handle to his lips and begins sucking and tonguing it. I laugh, and I silently thank him for having a sense of humor. I am surprised to feel a stirring of actual arousal at the rare sight of a skillful tongue among all these wagging, ineffectual air-lappers, a tongue I can imagine giving pleasure to some woman somewhere in the raining world. I dance for him till he goes away, and it isn't hard to smile at him from my self. I can call that an enjoyable experience.

I keep wondering: Why are men willing to put money down for what is so clearly faked? The only answer that seems to work is that the men aren't interested in the truth of the women's experiences. The porn customer's truth is one of paying for services; that's the only power he can claim in this interaction. But is that what gets him hard? His buying power? Why then are we advertised as seductresses and paid to simulate our own desire? Our performance of female desire is a simple reversal of the truth: the mainstream porn industry, of which this peepshow is one facet, exists to fulfill men's desires, not women's. Why does the heterosexual porn customer need the fiction of female desire to sustain his erection, instead of just naked female bodies? For the man who buys the services of a dominatrix, being "topped" is attractive as long as it's a service. He feels in control of this fictional loss of control because he himself has paid for it. Here again, he trades money for a fiction, not just for a body. Why do the men themselves act so unaware of this economy, when it must be an integral part of their excitement? The show evaluation forms, which the customers fill out and which the managers tape up on the dressing room mirror, strike me as naive, attributing "emotion" and "authenticity" to the performers. I repeat the same moves in front of a few hundred men per shift. The journal in which I scribble my responses afterward seems to document a different universe from the one the customers describe. The friend who compared this job to social work also said, "It's just another fucking McDonald's."

 I am struck again and again by the parallels between the peepshow and the culture in general. The people inside the peepshow—those performing, those observing, and those managing the spectacle—are "normal" people engaged in an activity more explicit but not different in underlying structure from much of the activity of our daily lives. My lover says that the peepshow's function is to allow us to define ourselves and our culture as normal, because we call the peepshow marginal and perverse. From in here, it looks like any clean division between the perverse and the normal is a false one, which allows all kinds of oppressions to go unchallenged. It allows the Christian father who fucks his daughter to say, "I'm not doing anything wrong, look at those perverts over there." It allows politicians to enact wars on drugs, wars on prostitution, wars on aliens while they trade favors with corporate dealers, pimps, and *coyotes* out of their Capitol Hill and City Hall offices. The peepshow does not subvert the culture, it mirrors it.

CUSTOMER SHOW EVALUATION:
Wednesday, 12/9, 2:00 P.M.
Dancer(s) you are evaluating: Archie.
Off the scale! Oh yes! She made me feel good. It was
what every commodified (even personal) sex
experience should be!
—Thank you!

I am beginning to understand just how personal the debate over porn is. I'm still furious that I have to deal with the existence of pornography, that a portion of my energy has to go to thinking about this banal imagery. But my relationship to the men, my "Other" in this context, is changing. Walking along the street after my morning coffee, I smiled at a man washing the windows of a restaurant, and he smiled back. Then I saw in him, as I see in most men now, a possible customer at the Lusty Lady, and my face did not know what expression to take next. It occurred to me that the thing I may be trying to learn from this experience is true acceptance of difference. If I can know that any man I greet could easily be a frequenter of peepshows, and that such a man could still consider himself a lover of women or even a supporter of women's equality, if I can know that and still feel human warmth for him, then I will have accomplished something. Or maybe, if this "warmth" is unilateral, maybe I'll just be a chump.

Wednesday, 12/2, 3 P.M.–9 P.M.
Somewhere in this haze of shutters going up and down, I witness a moment in another dancer's evening. Although we are encouraged to talk to the customers, dancers are not permitted to talk to each other on stage. A surveillance camera sends an incessant image of the inside of the stage to a monitor above the manager's desk downstairs, and if we're caught talking to each other our pay is docked. So there is no verbal communication on stage and very little in the dressing room, where "loitering" is not permitted and dancers run into each other only as we arrive, leave, or rest during staggered ten-minute breaks. Paprika and I have been on a few shifts together. I have never seen her out of costume, so I don't know who she is beneath her '60s' James Bond ice-queen outfit: peroxide blond flip, wide vinyl belt, breasts pushed up and out of a torpedo-tits bra. She's at the next window, and the man behind the glass is grinning, licking air. She lifts one high-heeled foot and sharply kicks the glass in front of his face with the point of her heel. He starts slightly, but decides this is play. A moment later she does it again, harder. "She's on her way out," I think. That purposeful, shocking little "thunk" seems to conceal and reveal all her contained disgust with the job, the men, her own role in this economy. Unless we run into each other in the dressing room, I won't get a chance to ask her if I'm right. My speculation will

remain just that, as will the customer's decision to read her action as an
expression of "naughty" lustfulness.

Friday, 12/4, 9 A.M.–2 P.M.
Booth 25: A couple loudly occupy the booth, the woman shouting nervous
laughter when the shutter opens. Women customers are quite a rarity, and
when they do show up it's usually like this, accompanying a man. This
woman can't believe her eyes. Cherri leans against the wall opposite the
window, twirls her purple feather boa, and grins at the woman, which
produces a fresh burst of shrieking laughter. "You sure are having a good
time in there. What's so funny?" says Cherri, loud voiced, so she can be
heard through the glass. "That's right. You're at a carnival and this is the
pussy tent." She steps across the stage and leans close to the window.
Another squeal of laughter. "Yeah, this is really funny. That's right, honey,
I'm a real naked woman. Don't get too close." At this point another dancer
springs over and spoons up to Cherri's back, thrusting her pelvis against
Cherri's butt a few times and moaning. Hysterical laughter from the booth.
I draw closer, chuckling, and the fourth dancer on the shift comes over and
shoves her face right up next to the glass. The woman screams, a roller-
coaster, haunted house scream. "Woo, scary, huh?" Cherri says. Over the
sound system, Aretha Franklin proclaims, "You make me feel, you make me
feel, you make me feel like a natural woman." It's too much for the couple
in the booth, and they flee as noisily as they arrived.

There is no standard sex worker. Each woman has her own reasons for working, her own responses of boredom, pleasure, power, and/or trauma, her own ideas about the work and her place in it. This work can be oppression or freedom; just another assembly-line job; an artistic act that also pays well; comic relief from street realities; healing social work for an alienated culture. What is at work within each woman that lets her accommodate this situation? Intense denial, infallible sense of humor, codependency, incredible strength, a liquid sense of self? The only safe thing to say is that we're all in it for the money.

For me, each moment is tolerable, as a moment. Sometimes, I can enjoy the workout with other women in a room warm and moist with our sweat. Mostly, though, I focus on the job at hand. Next face, next cock to spill. Like a bad drug experience, time passes differently and identity becomes complicated. I know perfectly well that I exist inside this decorated body, but I also know that I am acting as if I don't exist.

I have no feelings, but I know their absence means they are hiding beneath the shell I must build and then demolish every time I work a shift. It's hard work, maintaining this shell. Upon arrival at work and during the half-hour in the dressing room when I am replacing street clothes with the dressings of a Naked Girl, I enter a state of suspension of Vicky. I construct a being who can see and observe and analyze, but who cannot respond or feel. She is naked, but she is not

exposed. As she approaches a window, she can look at a hostile customer and think, "Okay, you hate me, I hate you, so let's just get down to business and make you come," but she cannot allow that thought to translate into an inappropriate facial expression. Somebody colonizes her body temporarily, and the shell is an attempt to keep that colonization external. But who, after all, is the "somebody" doing the colonizing: the men, the boss, the economy, the culture, herself?

After each shift, she has to reclaim herself to become me again. How does one reclaim one's own body after use—stamp it: Mine? For me, to remove my make-up, to gulp the street breeze on the walk over to my lover's apartment, to spend long moments in silence, to shower, often to cry, to talk with my lover, to fuck him as hard as I can, these things have become some kind of reclamation ritual. I ask myself if this fucking is helpful or if it makes things murkier. I conclude: If "I" am partly defined through my love for him and our lovemaking, then surely to fuck him is to erase the others. But is it my own knowing gut or my good-wife training that draws this conclusion?

Many of the dancers chat with the men, calling through the glass or murmuring incomprehensible, sexy words. I never do, because I fear it would betray my contempt for this interaction. Or worse, it would carry the interaction into the realm of language, which is where I keep privacy, where I make words for the feelings I can't allow myself to have or show at work: "Man, I pity you for your blindness. . . I hate you for inflicting it upon women." Or, as I smile and shake my head at the man waving a hundred dollar bill at me: "Not in a million years, Frogface." Is what I feel towards the customers an outward leaking of something I feel about myself? Or is it the leaking inward of their disavowed hatred for me? It's impossible to tell how these currents flow, so I can neither fight them nor choose to move with them. When I took this job I chose to immerse myself in whatever I would find, and now I am adrift.

3 nas•ty \'nas-tē\ *adj* 1 a : disgustingly filthy b : physically repugnant 2 : INDECENT, OBSCENE 3 : MEAN, TAWDRY 4 a : extremely hazardous or harmful b : sharply unpleasant 5 a : difficult to understand or deal with : VEXATIOUS b : psychologically unsettling: TRYING *syn* see DIRTY

(FIGHTING WORDS)

The "V" Word: Pornography is violence against women. Pornography degrades women. These are the flattening generalizations around which antiporn feminists build their argument. It would be helpful to ask: What pornography? Which women? For example, the antiporn argument ignores this complication of "live" porn: When you smile at each other the guy has an inkling you're human. He may be completely misinterpreting *who* you are, but he usually seems to know *that* you are. Who's to say that his visit to the peepshow won't do as much good as harm? He'll get demonstrations of a variety of methods of clit

stimulation that his wife or girlfriend may not feel empowered to give him—I have made it my personal goal at this job that no man leave my sight without knowing how to find the clitoris and some things to do with it once he's found it. He'll indulge his fantasies without passing on or catching physical illnesses. Will he be more or less likely to treat women as objects, as the Other upon whom he is destined to act?

Mainstream pornography does minimize participants in its economy. It reduces the man to nothing more than his dick and what "it" wants. It collapses the woman to nothing more than her cunt and what it's worth as a commodity. While a single sexual image might be arousing, an industry has been built upon the willingness of men to pay for multiple, standardized looks at women's bodies. Violent porn—like violent TV, violent politicians, and violent words—is part of a complex and pervasive feedback loop of violence. Most mainstream porn is part of a feedback loop of consumerism: boring, repetitive, quantifiable self-hypnosis. The porn industry has more power to deaden our imaginations and our passions than it has to hurt us physically. Like any distraction, porn can be used to the point of abuse. Like any abused substance, it has its pushers, users, and bystanders forced to respond to the situation.

The peepshow and male violence against women exist in the same matrix (patrix?), and they no doubt influence each other; but eliminating the peepshow would still leave us encountering each other on the street, at work, in bed, within the same socioeconomic system. Our only choice as women is to remake the system and pornography itself in our image, to surround our daughters and sons with images we want them to see and, more importantly, with a reality we want them to live.

The "E" Word: There is a standard line among feminist sex workers that sex work is empowering and even healing. I certainly feel powerful in relation to the men in the booths, but I never feel "empowered." What we are doing is so prefabricated, so prescribed and circumscribed that I couldn't imagine somebody feeling empowered by it except in comparison to an overwhelmingly disempowering daily existence. That is frequently our condition as women. But are the relations we live out each day so destructive of our sense of self that a woman can use the power imbalance of the peepshow to feel herself on top, in control? Whether it brings true power to some women is a question I can't answer, but power exercised from any kind of a pedestal is not a power I want.

CUSTOMER SHOW EVALUATION:
November 28, 7:45 P.M.
Dancer(s) you are evaluating: Persia.
Hi! Persia! You've been great! Please get in touch
with me. (415) 555–2285. Call me!
—Steve

Sunday, 12/6, 3 P.M.–9 P.M.

I knew when I started this job that it was a matter of time before the shutter would rise to show me the face of someone I knew. A few blocks from here is the café where I have my morning coffee. On my second shift, a fellow café customer showed up. Although I was standing right in front of him, he did not recognize me. Today a guy who works behind the counter at the café appears, his smirk reflected in the mirror. There's no way of hiding. I am multiply reflected on every wall of the room, and if he goes booth hopping, as many customers do, he could show up right in front of me at any moment. I know the best thing I can do is to catch his eye and say hello, as if we were passing each other on the street. But somehow I just can't. To make things more interesting, his whole group of friends begins popping up in the windows. John, my lover, plays soccer with these guys on Sunday afternoons. They have probably just come from a game with him. One slight difference in life experience or predilection, and John would be with them now. When the next familiar face appears a moment later, I'm already wincing in anticipation: it's another Sunday soccer player who works at the cafe, a gentle man with whom I often chat over the counter. Saïd has a goofy grin on his face and his gaze is darting around excitedly. I concentrate hard on the window I am in front of, pushing my face as close to the glass as I can to minimize my reflections. When I look up a moment later Saïd is gone, and as the shutters go up and down around the stage, no familiar faces are behind any of them.

This job seems to be messing with my sexuality in the worst way it possibly could: I feel distinctly unenthusiastic when I think about having sex with John. We've had sex, and it has been good in the ways I know to check: plenty of passion, plenty of orgasms, and a sense of relief on my part at being brought back from the other world and into possession of my body as mine. But in my regular moments, driving around, working on my film, washing dishes, sex enters my mind as a chore, a pointless effort, a performance. This is so stereotypical an alleged response of sex workers to sex itself that I don't want to strengthen the stereotype by mentioning it. But it is clearly happening to me.

Monday, 12/7, 10:30 A.M.–2:30 P.M.

For a couple of shifts in a row, a guy has come in who looks exactly like John's graduate school friend, Greg. Greg and John and I chat over morning coffee occasionally, and Greg and his wife have spent Thanksgiving with us. When I bought an accordion and began to learn to play, he gave me a tape of accordion music. Funny thing: I kept looking at this guy and thinking, how odd, he looks so much like Greg; yet it didn't really strike me that it might actually be Greg. Today he's here again and as I watch him staring up at a dancer's crotch, giggling and wagging his shoulders and head like an excited little boy, it slowly dawns on me that this is Greg.

I examine his face, the length of his moustache, the color of his eyes, and still, in my Naked Girl dream state, I'm not sure. Finally, I sashay closer to his window and memorize his jacket, army green with a fluorescent orange lining. I want proof, not of his transgression but of my own stunning unwillingness to believe it really is him.

I have come to exist in two distinct modes of physical feeling, defined through my sense of touch, the way my own touch feels to me. At work, what my hands find in touching my body is "product." Away from work, my body has continuity, integrity: my toes are connected to my scalp by means of everything in between. When I run my hand down my body it's not necessarily to produce sexual feelings; it's because it feels good to get from here to there along the path I know best, which is the surface of my body. My hands know each curve, mole, patch of hair, each warm spot. At work, the same skin feels different to the touch. Most of my body's surface becomes a backdrop to the pieces that matter: breasts, cunt, butt, thighs, lips. Floating body parts that my hands display, stroking, spreading, pinching. This "naked" body, framed and cropped by lingerie, is rented out. The fully naked body in bed at home is the one I know as mine. Last night, lying in bed after work, I touched my belly, my breasts. They felt like Capri's, and they refused to switch back. When John kissed me I inadvertently shrunk from his touch. Shocked, we both jerked away and stared at each other. Somehow the glass had dissolved and he had become one of them.

This morning, Greg came into the cafe. His jacket was army green with a fluorescent orange lining. "It was him," I told John, trying to understand why this should bother me. If I'm in there, why shouldn't Greg be? It's just that he looked so dumb, giggling, his tongue lolling out. I look pretty dumb in there too, but I get paid and he pays. I'm undercover and he's for real. That's my fiction. I still don't know what his is.

Friday, 12/4, 9 A.M.–2 P.M.
Booth 24: This man is young, handsome, sweetly goofy in wire-rimmed glasses. I notice him because he likes my body hair, is undone by my body hair. Not since my first shift and the man who wrote the note on the napkin has someone responded so strongly to my hair. This guy stares at my matted, sweaty underarms as if nothing on earth could be sexier. He wants to see them close up, wants me to kneel in front of the window and show him my pits. This makes him come. He leaves, comes back later in the shift, drinking an Evian. He stays a long time. I dance hard and enjoy his surrender. It is like fun, but it is not fun. In the silence between songs, he wants to know: Am I European? What shifts do I work? What is my name? Do I shave my legs? When he departs, he leaves his bottle of pure mountain water behind, perched on the sill, where it spills on the next customer to enter the booth.

CUSTOMER SHOW EVALUATION:
11/21/92, Saturday, 12:30 A.M.
Dancer(s) you are evaluating: Tigger and Taj.
More dialogue and higher heels! These people are
totally existing. The smiles are warm and inviting
and the humor was authentic; tissues for everyone!
—Jack Ruby

To be a woman with abundant body hair is to be both blessed and cursed. The stigma attached to female hairiness needs no elaboration. The blessing is that, like any mark of stigma, it serves to reveal others as well as to shed light on the very structure of stigmatization. Never able to fit into the feminine mold and unwilling to comply with it in any case, I learned to stake my identity, in part, on my deviations from it.

Nude dancing has crystallized this for me. I like seeing the customers' eyes widen and their mouths fall open when I dig through my heavy thatch of pubic hair and spread my labia to reveal my cunt. I don't get a speck of sexual pleasure from it, but I enjoy their surprise, their moment of not knowing how to respond, how their bodies will respond to all that hair. How does each of these men arrive at his own interior list of "female" attributes that produce either erotic effects or disgust? As a teenager, before the full sprouting of my moustache, of my underarm, chin, belly, leg, and crotch hair, I remember being revolted by the sight of a man with a hairy back. As I matured, this revulsion gave way: I became attracted to a person's energy, and whatever physical form that energy takes has come to seem an integral part of a compelling whole. But my own (colonized) sexual fantasies are quite involved with form, as an expression of power: size, numbers, position. And the sight I present at the Lusty Lady is meant as a fantasy for people with the buying power and the self-importance to hire real bodies on which to superimpose their fantasies. Just as I fantasize about fucking a guy with a really big dick or fist-fucking with a strong-armed woman, the body-hair fetishist fantasizes about fucking a woman with a really hairy vulva. The sole difference between us is that my fantasy stays in my head, while he is willing and able to rent human props to facilitate his. Both fantasies may have been shaped in resistance to dominant thinking in each of our worlds: big dicks showed up in my fantasies, unbidden and extremely disturbing to me, only after feminism taught me that size mustn't matter. Perhaps the body-hair fetishist is inadvertently resisting the culture's dominant taboo against hairy women.

Porn promises variety to its customers. It's a variety with limits: you won't find any 300-pound women or postmenopausal women dancing, even at this establishment reputed to have a "feminist" approach to pornography. While the publicity for the Lusty Lady in yuppie and progressive newspapers mentions that it is woman-run and offers a "safe, supportive, clean environment for women to express themselves erotically," one of the first things the manager

told me was: "This is not a feminist enterprise. We're here to provide a service for our customers." But porn does offer a variety of sorts, and when I fit my body into the porn mold I discovered a variety of tastes among men that I had never believed was out there. There are men who love body hair, men who are indifferent to it, men who hate it, and men who fetishize it. Feminist writings tend to lose sight of the specificity of individuals in attempts to get at overarching truths about sexism and patriarchy. Learning to live in my body has included the lesson that "men" would sometimes reject me for the ways in which I did not fit the dominant model of "woman." That has largely proven true, but it isn't the complete truth. Woman lovers can stigmatize body hair. And men can love it. My favorite customers at the Lusty Lady have undeniably been those few who made a point of adoring my body hair, because they counteracted the long-past but still resonating voice of my first male lover, who joked after eating me out that it was like "licking roadkill." Eleven years later, every time John's tongue touches my vulva, I still hear "roadkill" and work to keep from stiffening. Lately, it's getting easier to let him lick me, to enjoy his mouth as much as I have enjoyed women's mouths. Do I owe any thanks to a message scribbled on a napkin on my first night of work: "I love your hair"?

Wednesday, 12/9, 2 P.M.–6 P.M.
My bespectacled Underarm Hair Fetishist returns, as I knew he would. A warning trembles through me: I am glad to see him. Today, as he ejaculates, I look into his eyes. What do I call this moment? The boundaries are feeling dangerously fluid. I am hot and sweaty from dancing, but I am sexually unmoved, completely cunt-dry; and therefore able to stare at him and silently demand that he hold my gaze as he comes. If it isn't "sex" to make someone come and to see through his pupils and into his skull as he comes, what is it? Does it matter that I'm unaroused, that glass separates us, that I would sooner kill any one of these men than have one of them touch my flesh? What is the difference between enabling these men's orgasms and enabling a lover's?

When I came in for my next shift, my first customer evaluation was tacked up beside the dressing room mirror along with all the others, as I knew it would be:

> December 9, Wednesday, 3:00 P.M.
> Dancer(s) you are evaluating: *Capri*
> *Excellent, again!*
> — Don (with glasses)

I read Don (With Glasses)'s little stamp of approval with a mixture of amusement, disgust, and affection. In a few days I would be leaving to visit my family for Christmas. I had a long-term video-editing job lined up starting as soon as I got back. This was my last shift. I emptied out my locker and considered taking

Don (With Glasses)'s evaluation form. But this piece of paper didn't deserve relic status.

I still can't answer the questions I came in with, much less those that the job brought up for me. What stays with me is the question of how to relate to those men who exist both in the world of the peep show and in "my" world. In the café, after their Sunday visit to the peepshow, the guys behind the counter had trouble looking me in the eye. I made the effort, I smiled and forced eye contact, and they began to feel safe. Saïd came in to show off his newborn daughter and managed never to look in my direction. As the weeks passed, I occasionally ran into Greg over morning coffee. I couldn't tell if he felt uncomfortable, if he had even recognized me in my peep show drag, so I smiled and made eye contact. If there is ever a morning when the café is empty enough of ears and neither of us is hurrying off to work, maybe there will be a reason for communication.

I am still waiting to run into Don (With Glasses). I want to destroy his image of Capri, of the industry he's supporting. And more than that, I want to rehabilitate my image of him. I want to give him a chance to be something more than a fool.

What *will* I say to Don (With Glasses) on the day I run into him at a party, at a job? Hey, Don (With Glasses): Are you listening? If you stake your sexuality on what I forbid you, sell you, lose to you, on what you can take from me, buy from me, shape in me, divide in me, name me, then neither of us will be able to give or receive. If I stake my sexuality on reactive strategies, on what I can control, on how I can protect myself, I will always have to fight to hear the rush of my own blood beneath the din. The mystery of my body is not in what I choose to reveal to or conceal from others, but in its workings; its gases; its fluids; the blood that rinses my womb and springs from cuts; the soup of brains that endures sharp blows to the skull and yet reorients to left and right, up and down, pain and pleasure; the tears that swell in my throat when I feel the planet spin magically away from the sun at dusk and toward it again at dawn. Don (With Glasses), Guys behind the Counter, Greg, my lover John, my brother Jonathan, Dad: I never asked to play these games, these war games in which a loser is necessary to the winner. But here we are, having learned them well. Now what?

In his diabolic solitude, only the possibility of love could awaken the libertine to perfect, immaculate terror. It is in this holy terror of love that we find, in both men and women themselves, the source of all opposition to the emancipation of women.
—Angela Carter, *The Sadeian Woman* (p. 150)

[2] Odyssey of a Feminist Pornographer

MARCY SHEINER

SINCE THE MID-EIGHTIES, I've been writing and selling pornographic stories; and since the early nineties, I've worked sporadically as a phone-sex operator. Like many people who work in the sex industry, these are not things I planned or expected to be doing in my life—I've always seen myself as a "serious" writer, with aspirations along the lines of Doris Lessing or Virginia Woolf. Sex work is something I drifted into, and when I learned that I could not only earn money at it but also enjoy it immensely, I continued.

My first intimate contact with pornography occurred when I "caught" my husband masturbating into a *Playboy* centerfold. I was all of eighteen at the time, and my budding sexual ego was seriously bruised by the discovery that he had chosen an air-brushed bunny rather than me on which to spill his precious seed. With not a little guilt, he tried to convince me that, even were he "married to Raquel Welch," he would still feel compelled to participate in this all-American male sport.

Thereafter I tried to ignore what I saw as his perversion, but one day I stumbled upon a collection of girlie magazines in the back of the file cabinet in his study. (Men in early '60s' suburbia, no matter what their profession, always had "studies.") With a sinking heart, I sat down to peruse the images of naked women, expecting to feel degraded and repulsed. But as I turned the pages to view one exquisite female creature after another, a funny thing began to happen: I got excited. Tentatively I touched the perfectly shaped breast on the page before me, letting my fingers wander down to a feathery vulva, imagining what it would feel like in real life. I found myself reading the silly captions with interest: "Lola loves to ride horses and play tennis, but her main ambition is to fulfill her man's every fantasy." "Monique works out every day to keep in shape for her lover." The not-so-subtle theme of these biographical sketches was that the women existed solely to bring men pleasure. As a budding feminist, I was confused by the arousal I felt from such a notion—but that didn't prevent me from lying right down to masturbate. In the ensuing months, whenever the kids took their afternoon nap, I crept into the study, pulled out the secret cache, and reached heights of ecstasy while visually devouring tits and cunts.

One image from those magazines is so burned into my brain that even now, nearly thirty years later, I sometimes utilize it in fantasy: a young Rita Moreno lookalike, crouched on her knees with her huge luscious tits thrust forward, her mouth parted suggestively. In retrospect, it was a rather ordinary picture, tame by postmodern standards; but there was something about the look on the model's face that has come to represent, for me, the essence of pornography's appeal. "Look at me," her eyes seemed to be saying. "Lust after me. Pay me for this privilege."

Again, while I believed that women were more than the sum of their physical parts, the fact that they so wantonly displayed themselves for money made me positively feverish. At the time I had no idea why this excited me, but now I do: power is an aphrodisiac, and in our culture money is the ultimate expression of power. This element was and remains, for me, one of pornography's key turn-ons: its sheer existence. The fact that some people earn money by sexually entertaining those who can afford to pay for it has always been in and of itself exciting to me. That it was usually women entertaining men went unexamined (and was indeed part of the turn-on) until much later, when feminist theory compelled me to view the selling of sex as the foundation of women's oppression. Later still, I did another about face, becoming newly inspired by of actually being the object for sale, of knowing that men pay for the privilege of hearing my voice or reading my stories.

And that's where I am today, without apology. All across the country men masturbate to the memory of my voice on the telephone wire, whispering nasty things in their ear, and their hot cocks throb in their hands. They close their eyes and visualize the woman I've described myself to be (entirely different from who I really am) and they moan with desire. I cannot overemphasize the positive effect this has had upon my psyche: It makes me feel terrifically lush and powerful.

Similarly, somewhere in this world a couple is lying in bed perusing a sex rag. They read from a story I have written:

Jake moved his mouth to my ear. "That's right, honey, grind it," he whispered encouragingly. "Grind it."

And in a moment I began to come—without penetration, after knowing this man half an hour, I was shamelessly writhing and moaning on top of his huge generous body.

"Put your fingers inside me," I begged, and he slipped his hand back into my panties to finger-fuck my palpitating cunt.

After my orgasm subsided I sat up on him, opened his fly and pulled out his gorgeous prick. I stroked it lovingly, wanting it in my mouth but still wrestling with my original intent not to go too far. Jake put his fingers, musky with my juices, into my mouth and thrust them down my throat.

"You're gonna make me suck it, aren't you?" I said.

—(From "Chemistry" published in *Private Lives*)

The man and woman reading my words turn to each other and embrace. She flings her legs around his hips and his cock slides into her. Spurred on by my story, they fuck for hours.

Is this power? It sure feels like it to me. But it did not always. My journey to self-acceptance as a pornographer has been fraught with anxiety. Those masturbatory moments in my husband's study turned out to be only the beginning of a long, confusing journey.

After leaving my six-year marriage, for reasons having nothing to do with pornography—or, for that matter, sex (we fucked like bunnies until the very moment of separation)—I became involved in consciousness-raising groups and the women's liberation movement. Porn was not a hot topic among feminists then; we were too preoccupied with more basic concerns, ranging from legalizing abortion to who did the dishes, and pornography did not command much of my conscious attention. The issue resurfaced when I fell in love with Marco Vassi, one of the most articulate erotic writers of our time.

I met Marco in Woodstock, New York, during the postfestival halcyon days of hippiedom. He and his then-wife (one in a series of four) presided over a weekly event called "Dharma Drama," billed in the local newspaper as a philosophical discussion group, but really a forum for the charismatic Marco to hold forth and attract a following of groupies. There was an electricity about him, an intense alertness; whatever space he inhabited became a vortex of energy that others gravitated toward. I was immediately enchanted.

One of the things that differentiated these gatherings from ordinary get-togethers was that the proceedings were videotaped. Once, when the tape was played back at the end of the night, the camera panned in on my face as I watched Marco; my naked adoration was clear to everyone—including, of course, to Marco himself, who looked at me with sudden sharp interest. (Marco and I were to maintain an on-again, off-again relationship that spanned some twenty years, reaching its greatest intensity during his struggle with and subsequent death from AIDS. But that's another story.)

I sought out Marco's books and masturbated my way through each one, dismayed that I should be turned on by the material, even when—particularly when—it smacked of misogyny. What I learned from reading Marco's work (aside from that I wanted to sleep with him as soon as possible) was that sexual literature could be not only arousing but also witty, intelligent, insightful, even profound.

During this crash course in pornography, I was still traveling in feminist circles, organizing "Take Back the Night" marches, writing tirades for equality in the weekly newspaper. I took pains to keep my relationship with Marco hidden from my feminist friends. When Women Against Pornography (WAP) brought pornography to the forefront of public debate, I became positively schizophrenic, arguing with Marco on the one hand and with feminists on the other.

I saw some validity in the position taken by WAP: it was perfectly obvious that the porn industry was one in which women serviced men. But to Marco,

as to most male pornographers, there was no debate: he regarded the antiporn women as pathetic morons who possessed no aesthetic sensibility whatsoever. With feminists I argued the other side: that the portrayal of sexuality per se wasn't necessarily bad, and that perhaps we as women might even learn something about our sexuality from pornography. To my feminist friends, the case was just as cut and dried as it was to Marco, but their position was that pornography exploited women, period.

I felt that neither side understood the complicated nuances of the issue— the gestalt of the sexual/political dichotomy. I was in a difficult place, a place many women are still in today: I bought the feminist rhetoric that pornography demeaned women, yet I was undeniably aroused by it.

I felt completely isolated in my confusion. I was living in Woodstock, New York, a town that, despite its hip reputation, is pretty phobic about any flavors other than vanilla. Had I been in San Francisco, where sex-positive feminists were forging a new politics and reclaiming pornography, I might have felt less alone, might even have been one of the early pioneers of this movement. As it was, the appearance of *On Our Backs*, the first pornography I'd ever seen created specifically by and for women, only served to deepen my confusion.

It wasn't that I'd had no lesbian experience: one of the hottest relationships of my life had been with a woman. Claudia and I had explored all kinds of role play, dressing up in theatrical costumes, fooling around with what I would now term bondage and light S/M, taking turns topping or bottoming— though we did not possess the language to articulate it as such. During the year we were together I assumed I was a lesbian, but when we broke up I slept with men again. And then another woman. Then a man. Woman. Man. Woman. Who/what was I? Lesbians called me a traitor for "sleeping with the enemy." Male lovers wanted me to take them to dyke bars and choreograph threesomes. Nobody back then thought that being bisexual was natural or even hip. But bisexual was apparently what I was.

And I was more attracted to men than to women—another demerit on my feminist report card. So when *On Our Backs* didn't grab my crotch with the same intensity as *Playboy*, it only increased my sense of shame. My response to pornography seemed to be entwined with the very idea I opposed: women servicing men. I decided that my sexuality was hopelessly "male identified." For it wasn't just my attraction to male pornography that troubled me: it was also my politically incorrect fantasies.

Since childhood I have had an extremely vivid sexual imagination; I can't recall a single orgasm that hasn't been induced in part by movielike images and long involved plots spinning through my brain, no matter who my partner. I've developed an extensive repertoire, and during sex I flip through "the fantasy Rolodex," as Lisa Palac (former editor of *Future Sex* magazine) calls it, until I hit a proven winner. Some of my most cherished scenarios date back to adolescence—like the African motif, which spans an entire lifetime, beginning with me being prepped by the tribal elders for my place in the harem, and end-

ing with me as eldest wife sucking the chief's cock so he can impregnate his newest bride. Then there's the more recent, but almost as detailed, S/M wedding, in which I am publicly pierced and tattooed with my beloved's initials.

For a while I tried to alter my fantasies, to "reprogram" my responses as advised by some feminists. I would masturbate to visions of egalitarian sex in meadows, or try not fantasizing at all. Like the good Christian who fights with the impulse to masturbate, I fought what I saw as weakness, but my weakness won out. Time and again, hovering on the brink of orgasm, I would allow some image of myself as groveling sex slave to carry me blissfully across the abyss. After several months of these reprogramming attempts, I decided that, like my long-gone husband who would masturbate to *Playboy* centerfolds even were Raquel Welch his wife, I would be fantasizing scenarios at odds with my political beliefs for the rest of my natural days. Embracing the inevitable, I turned away from the feminist sex debates. Though I kept my fantasies to myself, I followed R. D. Laing's dictum to allow my mind free rein. I conscientiously examined my fantasies, hoping at least to learn about my psyche from them; sometimes this was productive. Gradually, though, I weaned myself from the puritanical habit of ascribing a beneficial purpose to everything and let my mind become a playground for the enhancement of sexual pleasure.

Today I am no longer ashamed of my fantasies; in fact, I exult in having been blessed with such a rich imagination. It has brought me enormous joy, a joy that increased considerably when I discovered my fantasies could be financially lucrative. The way I began writing porn was wholly accidental: I was lying in bed one night fantasizing about my neighbor, who was driving me nuts by warming up his truck at five o'clock every morning. I imagined confronting him, and the confrontation becoming sexual. As I began to masturbate, it occurred to me that I might put my fingers to better use with a pen, so I got out of bed and simply wrote out the fantasy. I was astonished by the ease with which the words poured forth—though I'd been writing for years, it had always been an agonizing process. Now, though, it seemed as if the freeing up of the sexual realm had also loosened my creativity. The next morning I read my story, called "A Neighborly Compromise," and found that my first erotic story was witty, hot, and nearly perfect in its first draft.

> "Well, now, let's see," he said, slowly rising from his chair. "We actually have a unique opportunity on our hands. I need to get warm in the morning—and believe me, it can be mighty cold in the truck at that hour. You need to relax so you can get back to sleep. We can kill two birds with one stone by use of our imaginations. What do you say?"
>
> His eyes made all too clear his method for getting himself warm and me relaxed, but I feigned ignorance. "How are we gonna do that?" I whispered.
>
> He laughed. "Don't be dense," he said, unbuttoning my flannel shirt and pulling down the cup of my 38–D bra.
>
> "Tell me when you're relaxed," he murmured, taking my whole breast into

his mouth. It occurred to me that, as long as I pretended to be tense, he'd keep working on me, so I stopped making noises and stood rigidly against the wall, trying to show no emotion.

This tactic worked. Soon he was undoing the drawstring of my sweatpants and sliding down to my throbbing mound. With an expert tongue he began licking and kissing my clit until I thought I'd nearly faint with the effort to remain standing. He must have sensed what I was going through, because he looked up with those steely eyes and asked, "Still not relaxed? Come over here." He led me to his bed.

(From "Dirty Diary," published in *Hot Talk*)

Aiming high, I sent "A Neighborly Compromise" off to *Penthouse*. In a few weeks I received an offer of $350 and publication in *Hot Talk*, one of that empire's many magazines. Let me tell you, after years of papering my walls with rejections from *The New Yorker* and *Ms.*, I nearly fell off my chair.

"Writing," said Moliére, "is like prostitution. First we do it for love. Then we do it for a few friends. Then we do it for money." During the course of the next year I sold four stories to *Penthouse Forum* at $1,000 a shot. When the editor I'd been working with left, the gig was up, but by then I'd started to connect with the sex network, and eventually I found other markets for my work.

I became a veritable erotic fountain, every sexual fantasy and life experience finding its way into a plot. Soon I had established a routine—writing a first draft, editing while masturbating (whatever additions were needed to trigger my orgasm got put into the story), and typing a final copy—altogether about a five hour process. By now I've written hundreds of erotic stories, some of which have been translated into Swedish, Danish, and Norwegian.

Of course, I always used a pseudonym and told only a few close friends what I was up to. For a time I worked at a battered women's shelter and secretly felt both amused and confused by my seemingly double life. While I was proud of my stories, I couldn't really show them around; I couldn't get the kind of respect, for instance, that I got when I published an article in *Mother Jones* about my work at the shelter.

Craving recognition, I began showing stories to potential and actual lovers in which they starred as thinly disguised characters. I discovered that this was the surest prelude to a kiss: people were flattered. They assumed I wanted to live the fantasy I'd portrayed and were only too happy to oblige.

As I shyly confessed my extracurricular activities to more and more friends, I found, to my surprise, that they were amused rather than disapproving. I even told my mother, who was actually delighted that I'd finally found a means of earning money through writing. But while friends and family accepted what I was doing, they certainly did not consider it valuable work, nor did they have any notion that I put as much thought and effort into writing porn as I did into poetry, or that I was as proud of one as of the other. In other words, while I didn't encounter disapproval, neither did I gain the kind

of recognition every artist, or person, wants and needs for their work.

This, of course, remains a persistent problem. My mother saves all my boring news stories, but never even sees my witty porn. My friends praise my analytical book reviews but laugh dismissively at the unread erotica. In my pornography I've traveled to Paris, Greece, and Hawaii, but the writing my peers are likely to see is confined to a few square miles. To them, the fact that I write porn is some kind of a lark or a way to support the more "creative" work they imagine I do. To me, porn *is* the creative work.

Since I moved to the San Francisco Bay Area, though, things have improved by leaps and bounds; in fact, it is here that I've been able to move from shame to self-acceptance. (I'm still working on pride.)

The first thing I did when I arrived in San Francisco was to make a beeline for Good Vibrations, a vibrator store "especially, but not exclusively for women," where I picked up a Hitachi wand (a powerful vibrator), a silicone dildo, a G-spot stimulator, and a flyer seeking stories for the first *Herotica* anthology. I sent off four stories and had two of them accepted. Being a "real" book, it seemed to me more respectable than *Penthouse*, so I decided to use my real name. Publication in *Herotica* led me to Joani Blank and Susie Bright, two wonderful supporters and teachers, and eventually to the sex-radical community.

Now I'm using my real name on all the porn I write. I'm the editor of *Herotica 4* and *Herotica 5*. I've finally found like-minded people with whom I can speak without fear of being judged or deemed "inappropriate," something I was called many times in the past (particularly for being a—gasp!—*mother* who doesn't hide her sex work from her grown children). Theories about politics and sexuality, as well as sexual words and images, are the stuff of everyday conversation. I no longer have to guard my language or worry lest I make some outlandish remark about sexual activity, a topic I discuss as casually as others drop recipes for chocolate fudge. That kind of talk goes on all around me now.

And it's the kind of talk on which I thrive. I said that I drifted into sex work, and that's true; but actually this drifting has been a very organic process. I do sex work because it interests me, because I'm good at it, and because I can make money at it; but unlike most sex radicals, I'm not in this as a political cause. I don't really give a shit if Molly in Idaho reads one of my stories and has her first orgasm, though it's fine with me if she does. Sure, if a phone sex customer expresses guilt and shame about masturbating, I give him the sex-positive pep talk. But I don't like debating with the prudish about the ethics of what I do, and I'm not out to convert anyone; I just don't want others telling me I can't do the work I love.

Don't get me wrong; I fully support the folks who are out there on the front lines defending sexual freedom; I've even done a bit of it myself, in the natural course of my work. The sex-negative culture surrounding this little oasis of sanity known as the Bay Area does tend to push those of us who dare seek and promote pleasure into an aggressive stance.

But for me, the discourse among sex radicals—the exchange of informa-

tion and ideas—all feels utterly natural, the way things ought to be. My life is filled with a variety of activities, many of them having to do with sex and many of them absolutely mundane. I don't feel all that unusual, or think of my friends and our talks as extraordinary. I'm apt to forget that mainstream America regards us as perverts, and that I'd do well to clean up my act any time I decide to leave the Bay Area.

Just how extraordinary we really are, and how perverted we appear to the mainstream, was recently brought home when I was interviewed for an article in *Elle* magazine on—what else?—"the new women's erotica."

"So you all sleep with each other?" the reporter asked, convinced that my life was one long orgy.

"It's just amazing," he continued, ignoring my negative reply. "Here you are, a nice Jewish girl, a mother, and you're living this life full of sex!"

That old sense of being an oddball returned full force. What did not accompany it, however, was the feeling of being "inappropriate." In fact, I began to view my inquisitor as the true oddball. Can he really, I wondered, be so ignorant? Can he really still hold these archaic attitudes?"

"None of my friends talk about sex," he told me. "We would never say the things you say."

I actually felt sorry for him.

Meanwhile, the feminist debates continue, aided and abetted by writers for *Elle*. As far as I can see, the level of discussion hasn't evolved much since the early days of WAP. As I said, I try to stay away from the debate. I admire women like Susie Bright who can articulate reasoned arguments in the face of picket lines and red-faced hecklers, but this is something I am unable to do, even one-on-one, even with questioning friends. I grow weary of the oh-so-rational anti-censorship tack. Sexual expression is about more than anticensorship. It's about, well, sexual expression!

Contrary to the opinions of the conservative antisex faction of the women's movement, I no longer doubt that I am a feminist. Ironically, this "F" word has fallen into almost as much disrepute as the original "F" word, but I consider feminism a core part of my identity as well as an honorable philosophy to espouse. To me feminism means a belief in a very basic goal: full equality of women. I don't see pornography or sexual pleasure as undermining that belief or that goal. Like everything else, it can certainly be used destructively—but it isn't an inherently negative force.

Au contraire. Writing and reading pornography has been, for me, fun, exciting, creative, illuminating, empowering, and lucrative. And I feel no qualms or contradiction when I say that I am both a feminist and a pornographer.

[3] The Holy Whore

A Woman's Gateway to Power

COSI FABIAN

I am proud to be called "whore."

When I became a whore, I declared my religious convictions.

When I became a whore, I declared my creativity to be as worthy as motherhood.

When I became a whore, I shouted my defiance of the machine that is our "male-voiced culture."

When I became a whore, I transformed tragedy into strength, loss into freedom.

Having become a whore, I have become a teacher of spiritual and psychological transformation.

Having become a whore, I have been honored as poet and performer.

Having become a whore, I have discovered my true voice. I live by the rhythms of the moon and the wisdom of my body.

Having become a whore, I have been enlightened by the tender and worshipful nature of men's desire for "the Wondrous Vulva."

AT THE AGE OF FORTY-TWO, I BECAME A PROSTITUTE. The immediate impetus was unemployment and disgust at the women's labor market, but my deeper motivation was the continuation of my quest for wholeness and meaning. My inspirations were the *Qadeshet*, the "Sacred Prostitutes" of our ancestors' temples. This seven-year experiment has paid off magnificently. By using prepatriarchal models of female sexuality as a noble, even divine power, I have constructed a life that is extraordinarily sweet, to say nothing of confounding most of this culture's preconceptions around both female and male sexuality. I share my story because I see its relevance to all women.

Seven years before I took the great leap into whoredom, I had staggered through the door of a twelve-step meeting and started my ongoing recovery

from alcoholism (which is, along with a certain flamboyance and good legs, part of the Fabian legacy). Carl Jung wrote of alcoholism, "[it is] the equivalent on a low level of the spiritual thirst of our being for wholeness, expressed in medieval language: the union with God."[1]

Twelve-step programs are unique in that they offer a pragmatic, effective spirituality without a theology. If one does not like the Christian undertones—and this agnostic hated them—one can construct a theology of one's own. And I did. For me, a great gift of this approach to recovery was the practical guidance in taking that vague, alienating, "spiritual thirst" and transmuting it into the ability to negotiate my daily life and its accrued pain with integrity and grace—and without a large brandy. So, I shifted my quest from the bottle to the library, where I began my continuing search for a *mythos* and an attendant morality that would express and inspire me as a woman. To an extent, my spirit resonated with Native American and Asian prayers, but the driving force of my life was still without words, without shape, without story. As a woman whose spiritual force was matched by a sexual joy, I still was without a noble framework.

Then I picked up a copy of *The Politics of Women's Spirituality* and read Carol P. Christ's introduction to her essay, cowritten with Charlene Spretnak:

> Women's stories have not been told. And without stories there is no articulation of experience. Without stories a woman is lost when she comes to make the important decisions of her life. She does not learn to value her struggles, to celebrate her strengths, to comprehend her pain. Without stories she cannot understand herself. Without stories she is alienated from those deeper experiences of self and world that have been called spiritual or religious. She is closed in silence.[2]

This same volume introduced me to feminist historian Merlin Stone and her book *When God Was a Woman*. This, along with Barbara Walker's *The Woman's Encyclopedia of Myths and Secrets,* threw me the lifeline I so desperately needed. For here was a version of the Divine that was not only female but also wondrously, gloriously sexual. It was in these and other histories of the ancient Near East, the cauldron of the contemporary religions that still govern our lives, laws, and souls, that I discovered sex as prayer, dance as worship, and the "Sacred Prostitutes."

The Temple Harlot is as old as writing itself, for it is in humankind's first known writing—cuneiform—that I found the *Qadesha*, the "sacred one," and her Great Goddess Inanna, "queen of heaven and Earth." In translations of Mesopotamian hymns I was introduced to the young goddess:

> Inanna placed the shugurra, the crown of the steppe, on her head.
> She went to the sheepfold, to the shepherd.
> She leaned against the apple tree, her vulva was wondrous to behold.

Rejoicing at her wondrous vulva, the young woman Inanna applauded her-
self.
She said: "I, the Queen of Heaven, shall visit the God of Wisdom ..."
Inanna set out by herself.[3]

Yes! Here were the stories that Carol Christ was talking about. Stories long
silent. Stories that made *virtues*—by elevating to divine status—precisely the
characteristics that had, since early childhood, condemned me as "bad girl":
social initiative, a sense of the profound worthiness of my sexuality, indepen-
dence, and adventurousness. I had come home.

I wanted to know more. The sexual aspects of the great goddesses—Inanna,
Ishtar, Astarte, Isis, Ostera—in their original, prepatriarchal concepts have
been difficult to unveil. Centuries of Greco-Christian values muddy our view
of "The Radiant Star, Lady of the Evening" Inanna (we know her as "Venus").
Her priestesses, who included sex in their religious duties, have been even more
sullied by core Christian values that essentially place the burden of the fall of
man upon the sexual and seductive power of woman.

Religious or not, Christian or not, all women are distorted by this veil of
shame, which hides us from ourselves and each other. But there was a time—in
fact, throughout most of human history—when the Wondrous Vulva was ven-
erated. We see the unmistakable triangle on cave walls. We enter the long bar-
rows of Europe through the vulvic gateway to the sanctuary of the womb
interior. We still see one of the most ancient symbolic representations of the
vulva in the lilies that adorn churches at Easter, originally a springtime orgiastic
festival in honor of the Goddess Eostre, also known as Astarte. Lilies were sacred
to Astarte and Easter is still set by the pagan—lunar—calendar.

Women's bodies were the first calendars; they were "cosmic order" incar-
nate. The word "ritual" carries this connotation: in Sanskrit, *R'Tu* meant both
"menses" and "appointed time for sacrifice." Menstruation, called by the
ancients "the time of dreams and visions," has been demonized along with our
sexuality. Still it is presented to us in terms of "sickness" and "failed pregnancy"
rather than as an "endocrine symphony" that attunes us to the rhythms of our
world. Yet the magical power of "the wise wound," entrained with the moon
and tides, gave humankind—gave *women*—our first "mystification of nature,"
our first rituals and religion. Menstruation and women's attendant, unique,
nonseasonal sexuality were key factors in the development of human con-
sciousness and culture.[4]

Spiral dances carry the memory of the dance of woman and moon, as did
the Sacred Prostitutes of Ptolemaic Egypt, the *horae*, who marked the passage of
time when they danced the sun god Ra safely through the gateways of the
night. They were called *Ladies of the Hour*. The dancing priestesses were banished,
but their rituals and nomenclature survived: in Medieval Europe, nuns and
monks marked the orderly passage of time by reading a "Book of Hours"—spe-
cific prayers for specific times.

The *hora* leads us to the root of the word "whore," and to my pride in that noble title. To quote Barbara Walker, "As Mother of Harlots, Ishtar was called the Great Goddess *Har*. Her high priestess, the *harine*, was spiritual ruler of 'the city of Ishtar.' "Har" was a cognate of the Persian *houri* and the Greek *hora*, also the origin of 'harem,' which used to mean a temple of women, or a sanctuary."[5]

Sacred prostitution was extensive throughout the ancient Near East and Mediterranean civilizations, as well as in Meso-America and much of Asia. "Cultic sexual activity was an essential aspect of religions that venerated a mysterious life-power manifesting itself in a cyclic manner, following the rhythms of nature, which was most often conceived of as feminine. . . . [I]t is likely that the women temple-servants were considered to be living embodiments of the goddess."[6]

The elaborate and formalized costuming of a prostitute, even that of street-walkers, also has its ritual origins. Masked eyes (think "mascara"), red mouths, and moon-shaped jewelry have all been traced back to our foremothers' menstrual/religious body decorations. Adornment was an expression of numinous feminine powers. This symbolic decoration of the female, indicating her divine powers, connects us to the Greek idea of *cosmetikos*—the ordering principle of the world. The ancients remembered what we have now forgotten: that it is woman who brought man from animal consciousness into a sentient, social and moral existence. And the quintessence of woman in her ritual, empowered, cosmic aspects was, and is, the Holy Whore.

Shamhat, the temple harlot featured prominently in the Sumerian Epic of Gilgamesh, teaches conscious, sentient life, as opposed to nonconscious survival. This is her story:

Once upon a time, there was a young king, the strongest man in the land, whose name was Gilgamesh. But there was a problem: the strongest man in the land was totally out of control—enslaving the men and claiming the maidens for his own pleasure. He was abusing the power given him by the gods, had become Tyrant, not Savior. The people were in despair: who could challenge and tame this rogue king? They asked Aruru, Mother of the gods, to create a foil for Gilgamesh to temper his harmful strength. So the goddess "pinched off a piece of clay, cast it out into open country. She created a primitive man, Enkidu the warrior."[7]

But there was still a major problem. Enkidu was wild and primitive. Covered with shaggy hair, he ran and drank with the animals. "He knew neither people nor country; he was dressed as cattle are."[8] If Enkidu was to temper the king, he must first be tamed and civilized, himself. Who could educate the wild brute, prepare him for his role as companion and confidante to Gilgamesh?

Some say it was the goddess herself who placed Shamhat by the oasis water. Some say it was a hunter frustrated by Enkidu. Either way, the next time Enkidu came gamboling down to drink at the water's edge, Shamhat was waiting. Enkidu's life—and consciousness—would never be the same.

"She reveal[ed] to him her many attractions," and Enkidu came running. They lay together for six days and seven nights, after which time the "wild

man" tried to return to his animal companions and his former state of innocence. But the animals now feared him, for Enkidu had been changed:

> He had been diminished, he could not run as before.
> Yet he had acquired judgment, had become wiser,
> He turned back, he sat at the harlot's feet.
> The harlot was looking at his expression,
> And he listened attentively to what the harlot said.[9]

And so Shamhat spoke to him of the glories and delights of Gilgamesh's city, where his fate awaited him as companion to the handsome king. She showed him how to shave and dress himself, then took him by the hand and led him to the gates of the city so in need of his now civilized strength.

The Holy Whore archetype derives from many stories such as this. Sacred prostitute stories reveal an understanding of women as gateways to transformation. In them, women use combinations of sexual ecstasy, formal ritual, and informal teaching, and are seen to embody incarnations of their goddess, a goddess considered to be the source of kingship in prepatrilineal times. In Sumer, in the third millennium B.C.E., at the height of the new year festivities the High Priestess bestowed kingship from her temple bed, to the young man whose sexual gifts proved him most worthy of royalty. Indeed, the *Hieros Gamos*, or "Sacred Marriage," was an important rite in most of the major religions of the western world, surviving even Christianity's pogroms in rural areas of Europe into the last century.

How refreshing to discover guiding religious metaphors (and all religions are metaphors, as Joseph Campbell reminds us) in which female sexuality *saves* rather than *damns* humankind. This is a marked departure from Christianity's representation of Eve and all her "daughters."

To switch to a modern metaphor, Jean Shinoda Bolen's Jungian understanding of the gods and goddesses as archetypes was also crucial in my long struggle for an honorable sense of myself and a fulfilling life. In her now-classic *The Goddesses in Every Woman*, I found a psychological mirroring that did not pathologize my sexuality but rather placed it in the context of Aphrodite, who "inspired poetry and persuasive speech, and symbolized the transformative and creative power of love."[10] Here, I learned of the ancient Greek *hetaira*, the highest class of prostitute or courtesan "who was educated, cultured, and unusually free for a woman of those days. . . . A type of woman whose relationships with men have both erotic and companionship qualities. . . . The Hetaira fertilizes the creative side of a man and helps him in it."[11]

Here, in the company of Aphrodite, Shamhat, and Inanna, I found stories that gave shape to my soul, delineated my interior architecture, and framed my external landscape *as a woman*. These were the stories that taught me "to value [my] struggles, to celebrate [my] strengths, to comprehend [my] pain."[12]

For seven years I undertook what was essentially a religious education. I

immersed myself in myth and history. I explored the New Physics, medieval Catholic mysticism, contemporary French philosophy, and modern American psychology. I kept going to twelve-step meetings. Life was better than I had ever known it; I was of value in my community and at peace with my deities. Yet there was still a sense of loss, a feeling of something within me being betrayed. As my internal life developed, it became increasingly obvious that my external world (I worked in advertising) bore very little relation to anything that was meaningful to me. Despite great efforts, I was sliding into the mire of depression. Stress-related illness was sucking all my energy.

Then I was "downsized." At first I panicked, forgetting I hated my job. However, it gradually dawned on me that to put myself "back down the pit" (the phrase that kept running through my head at the time) would be to abandon myself far more cruelly than anything visited upon me by family and lovers. I had a strong sense that I would die, metaphorically if not literally, and I had fought too long to give up now.

What to do? Like all my friends and colleagues at that time, I watched Joseph Campbell's inspired series *The Power of Myth* on PBS. With Campbell's frequent exhortation, "Follow your bliss," tickling my being, I found the courage to commit to my undeveloped creativity despite my terror at not knowing how I would pay the rent. I so desperately wanted to write—to develop my poetry, to use my varied experience in a joyful way. Maybe I would go to art college, as I had wanted to as an adolescent.

Spurred by my strong sense of prepatriarchal values, as well as Campbell's message about bliss, I saw that sex work was an obvious area to investigate, although I knew very little about contemporary prostitution. I knew no one in the business and had no idea where to find pertinent information—it is a felony for one woman to tell another how she might benefit from her sexual skills at the expense of men. Television and movies told me it was dangerous, but I knew only too well that I could rely on myself in a crisis and that I didn't lack physical courage. Besides, my research had revealed how certain lies had crippled me, and the odds were good that the "dangerous" nature of women's autonomous sexuality was also a fallacy. Prostitution was definitely a path to be explored consciously on behalf of all women, and I was unusually unhampered in that I am without family—no parents, spouse, siblings, nor children, and thus no one to shame by association. What had been a bed of loneliness could be transformed into a flight to freedom.

I did know I possessed a vital and experienced sexuality, but at forty-two I was understandably concerned about my age. Plus I had many typical anxieties of a woman: breasts too small, butt too fat, hair too thin. My experience ultimately proved my mother right who, when I bemoaned my nonclassical face, told me that personality is more important than looks.

What concerned me most was my ominous sense of the *irrevocability* of this move, this "flight beyond the pale." I had always been an iconoclast and an outsider, but to become a prostitute would truly cast me out of mainstream

society, and maybe cost me my friends and future partners. If I became a whore I would, for all intents and purposes, have no protections under the law—criminal or civil—for any investigation of my life could prove disastrous. As an immigrant renter, I stood to lose both home and country. Mothers are even more vulnerable: they risk losing the very children they are working to feed and clothe. Still, the more I mulled over the possibilities, the more compelling was the idea of reclaiming this ancient office. I had to do it. If not me, who else?

There is a key mythic figure—the patron saint of "bad girls" and feminists—whose stories cradled and inspired me in my transition. All women need her; she is our banished shadow sister, she is ourselves. She is everything men fear in women. She is *Lilith*. With her wings and bird feet she harkens back to the prehistoric icons of Old Europe. She stands on two peaceful lions, the horned crown of godship tall on her head. Long earrings hang from under the waves of her hair onto her breasts. She is young and shapely. Guarded by great screech owls, her braceleted hands hold "the rod and ring of Sumerian royal authority, suggesting that she indeed was a figure to be reckoned with."[13]

Captured thus in stone by a Mesopotamian sculptor over four thousand years ago, an ambivalence already existed about her potent combination of sex and power: she appears in ancient hymns as both a sacred prostitute who lured men into the goddess Inanna's temple, and as an uncontrollable demon who fled to the wilderness when Gilgamesh—and patrilineal kingship—colonized both temple and goddess. Always defiant, always wild, always sexual, Lilith has been in exile ever since—glimpsed only as "night hag," "succuba," "witch," "vampire," or "harlot of hell."

Lilith represents raw creative power, instinct, heat, and fire. She is the dark, earthy, desirous side of woman. She "cut[s] to the essential nature of things," as Barbara Black Koltuv writes in *The Book of Lilith*. Koltuv believes Lilith to be an essential, and lost, aspect of women: "A woman, in order to grow and develop psychologically, needs to integrate Lilith's qualities of freedom, movement, and instinctuality. Lilith is that quality in a woman that refuses to be bound in a relationship. She wants not equality and sameness in the sense of identity and merging, but equal freedom to move, change, be herself."[14] Here is how Lilith entered the stream of Judeo-Christian mythology:

> Eve was not the first woman created!
> According to Hebraic tradition, the first woman "made by God" was—Lilith.
> She was created from blood and dust, as was Adam before her, and so felt herself to be his equal.
> So originally it was "Adam and Lilith" in the Garden of Eden!
> Everything was fine between them, until it was time for sex.
> For then Lilith incurred the wrath of God and Adam for an act of great defiance: she refused to lie beneath Adam in the "missionary position" insisted upon by the patriarchs.

Lilith preferred what the historians call the "woman-superior position"—
 and I call the "Isis Squat."
Lilith would not relent.
"Out, out of the Garden!" cried God.
"Out," said Adam.
And so Lilith was banished. She went to live in the caves by the Red Sea,
 where she coupled with demons.
Presumably, in any position she wished.[15]

If Lilith could choose exile over submission to values she opposed, so could I. And I did. It was the best move I ever made. I had found my vocation. As it turned out, my naiveté was a saving grace. For without contemporary practical advice, I had to look to my own research, my own vision, for guidance in the powers and duties of a *Qadesha*.

In my work as a modern day Holy Whore, I always light incense, burn candles, and say a silent prayer. The men, and occasionally women, leave their offerings on the altar. I conduct myself with dignity. I respect my clients, who in return have displayed a great sweetness to me. It's not like the movies.

Contrary to our culture's Judeo-Christian portrayal of the sexual dynamic between men and women as fraught with danger and loathing, my experience over the years has been one of joy and abundance. Rather than inviting rape and murder by being overtly sexual, my anonymity apparently offers men a rare chance to be vulnerable, receptive, grateful—what some might call "feminine." Far from the squalid stereotypes of hooker and john, I participate in honorable interactions between intelligent adults seeking relief from our manic world.

I have concluded, sadly, that many men—perhaps including the readers' husbands and boyfriends—reveal the depth and intensity of their desire only with a woman who is a stranger. For it is too often only here, in my temple room, that their passion is received unconditionally and *without shame*. Indeed, this absence of shame, this sense of the integrity of the Wondrous Vulva, is the most salient "skill" that I bring to my work. Guided by Bolen's idea of the Aphroditic woman as the guardian and inspiration of the poetic soul, I talk to my clients about their dreams, their lost creative pleasures. I encourage them in their talents and receive the depths of their wounds. I surround us both with beauty: rich hangings, icons, art, and opera. I access the soul through the senses, using the mind as a pathway.

My seven years as a Qadesha have infused me with a great tenderness toward the creatures I had once considered "the enemy." I attribute this blessing to my historically inspired transpersonal (as opposed to *im*personal) approach to my work and clients. It seemed only fair that if I were to claim sacred lineage for my desire, then I must grant the same to men: as they worshiped the Wondrous Vulva, I in turn approached each man as the *fascinum*, the "sacred phallus," the "annointed one," the *Christos*. ("In the east, the god's lingam or the erect penis of

his statue was anointed with holy oil—Greek *chrism*—for easier penetration of his bride, the Goddess, impersonated by one of the temple virgins.... Jesus became a Christos when he was *christ*-ened by Mary, the magdalene, or temple maiden.")[16] The rage I had felt for so many years over the theft of my history and soul has transmuted into the delicate gift of compassion. I am no longer afraid of men, their institutions, nor their gods—is there anything more vulnerable than a naked man with a hard-on?

It is important to know that one can do—or not do—anything one wants in this work. One can be—or not be—anyone one wants. I screen clients vigorously—for intelligence, humor, and respect. As a friend remarked, this could well be why I have never been "set up" by the police! I do not, beyond a change of name, in any way dissemble my nature. If anything, I am most alive, most myself, when I am with a client. I have clear boundaries, deflecting infatuation and neediness. I know what are and are not my responsibilities. I am not afraid of conflict and will assert my rules when necessary. And I can change those rules whenever I need to.

There are days when I am distracted or under the weather, when I feel there is no energy with which to dance. No one was more surprised than me to discover that with just a quick and silent prayer ("Help!") in the direction of my altar and its temple memories, I find myself laughing, moving, resonating to some force greater—older—than myself.

As my experience has pervaded my acculturated mind, I have come to more deeply appreciate some of the the honorable—sacred—histories of men's desire for women. Where else, unfortunately, other than pornography, can men find the most ancient image of all—the Wondrous Vulva? I now realize that, as a feminist, I was demonizing male sexuality and character as women had been demonized. It is essential that we stop this cultural cycle of abuse. Mothers must teach their children about Lilith, Inanna, Shamhat, and all our wild and wise foremothers, including those from other cultural traditions throughout the planet. Whether approached as historical precedents, active archetypes, or divine metaphors, the stories themselves have a power independent of their relationship to "truth." I have witnessed that power guiding, shaping, and transforming my life and the lives of many other women.

For five years now I have been teaching in small groups and large halls. Time and time again a woman will approach me, often in tears of gratitude, and say, "I always knew there was something else. I've had dreams ..." In my classes I have watched women expand their minds and spirits, reclaim their strengths, and find their creative talents, all in the name of the Sacred Prostitute and her goddesses. My own creativity, so long frozen, has burst forth in a riot of art and writing. I have found the immutable place within that is untouchable, that is free.

It would appear that my problem, and women's problem in general, with the clichéd "lack of self esteem" (and indeed I felt less than an ant fourteen years

ago) is not so much the "esteem" part of the equation, but the "self." Once I re-discovered and revived a sense of self, the esteem followed automatically.

When I started to impose internal and external order upon my life by "get-ting sober," there were many festering wounds to be cleaned and healed. Some of these wounds I share with many women: rape, alcoholism, denied educa-tion. Some were more particular: the protracted dying of my father, the sui-cide of my mother, the survival—and witnessing—of a ghastly plane disaster, my experiences as a *mescalita* in Chiapas. But the greatest wounding of all was the theft of my spiritual/sexual/creative core by our "male-voiced" culture. Without a sense of my core self in its uncorrupted form, I was without voice, without connection to the culture around me. How telling that I had to become a prostitute, outlawed by our androcentric society, to discover and express my Woman Voice.

This loss of "self" and "voice" is by no means an aberration. Current research reveals that, at puberty, virtually all girls surrender their spirits to the demands of our culture—demands to be *nice*. Carol Gilligan writes that before the mysteries of menstruation and sexuality are visited upon them, "girls' voices [show] clear evidence of strength, courage, and a healthy resistance to losing voice. . . . [They] take difference and disagreement for granted in daily life." Girls then lose this clarity and autonomy in favor of fulfilling more fem-inine roles. In meeting the demands of western, "male-voiced" culture, young women lose "their vitality, their resilience, their immunity to depression, their sense of themselves and their character."[17] In a sense, what young women lose is Lilith: our creative, autonomous, fiery selves.

The eleven-year-old girl that Gilligan illuminates wields an untainted war-rior energy similar to the prepatriarchal goddesses. This helps explain a para-dox of my life as a prostitute: that it is the pre-patriarchal eleven-year-old inside me who has leapt to life as something innocent and "virgin."[18] Ritual, stage, art, astronomy, history, costume, design, writing—these were the delights of my childhood. Thanks to the examples of the Temple Harlots, these delights are now, at last, developing into a creative livelihood.

It is a sweet life, both deepening and expanding. I am proud to have studied for many years with Judy Grahn (*Blood Bread and Roses, Queen of Wands, Another MotherTongue*) and Betty Meador (*Uncursing the Dark*). I have money to buy books and the time to read them. There is beauty in my home and in my life, which no longer feels fragmented but rather like a cohesion of spirit, work, sex, art, and companionship. I am in a position to honor both the sun (heading for the park or beach when the weather demands it) and moon (I have chosen to sacrifice money to honor my menstruation by a deep retreat, invoking the "time of dreams and visions," to recharge my energy). Even my doctor, who was initially horrified at my career move, has been impressed by the extraordi-nary improvement in my trauma-damaged health.

I can truly say: "I am proud—and happy—to be called 'whore.'"

Notes

1. Alcoholics Anonymous World Services, *Pass It On: The Story of Bill Wilson and How the AA Message Reached the World* (New York: 1984), p. 384.

 2. Carol P. Christ and Charlene Spretnak, "Introduction," in Christ, *The Politics of Women's Spirituality*, p. 327.

3. Diane Wolkstein and Samuel Noah Kramer, *Inanna, Queen of Heaven and Earth* (New York: Harper and Row), p. 12.

4. Penelope Shuttle and Peter Redgrove, *The Wise Wound: Myths, Realities, and Meanings of Menstruation* (New York: Bantam, 1978).

5. Barbara Walker, *Woman's Encyclopedia of Myths and Secrets* (San Francisco: Harper and Row, 1983), p. 82.

6. Mircea Eliade, ed., *The Encyclopedia of Religion*, Vol. 6, p. 309.

7. Henrietta McCall, *Mesopotamian Myths: The Legendary Past* (British Museum Publications, 1990), p. 39.

8. Ibid., p. 39.

9. Ibid., p. 39.

10. Jean Shinoda Bolen, *Goddesses in Every Woman: A New Psychology of Women* (New York: Perennial Library, 1985), p. 224.

11. Ibid., p. 230.

12. Christ, *The Politics of Women's Spirituality*.

13. Elinor Gadon, *The Once and Future Goddess*, (San Francisco: Harper and Row, 1989), p. 123.

14. Barbara Black Koltuv, *The Book of Lilith* (York Beach, ME: Nicolas-Hays, 1987), p. 22.

15. Cosi Fabian, *The Sacred Whore* (San Francisco: Staged, 1993 and 1996).

16. Walker, *The Women's* Encyclopedia, p. 167.

17. Carol Gilligan and Lyn Mikel Brown, *Meeting at the Crossroads: Women's Psychology and Girls' Development* (Cambridge: Harvard University Press, 1992), p. 3.

18. I use "virgin" here as Bolen, Harrison, and Briffault do, meaning "one unto herself."

[4] A Sex Protector/Pervert Speaks Out

ANN RENEE

I WANT TO FUCK THE WORLD. I fantasize about everything: birds, trees, hermaph-rodite dancers. Who'll dare contain me? It is my own private sanctuary. The world of dreams and musings holds more coherency and relevancy than the waking word of hypocritical slosh. Even though all the dream folk want to see me dead from time to time. Even though I wake in a stupor sometimes and have only a vague recollection of where I've been, I have always found comfort in the unspoken. Grandpa's fingers move without his head attached. He wants something from me and gets it. The bird spirits pluck me from the most excru-ciating violations. I talk to the trees, the wind in the trees, the wind in the wind. They prove themselves to be the most reliable sources of comfort, the most stable support. Outside of that coherency, the world wrings itself dry time and time again on the daily obsessions with climbing to get a view; being somewhere else, stockpiling party favors. Above ground, at the breakfast table, Gramps performs a perfect pirouette of purity. When Daddy says I'm delicious, I know what he's eating. I know. I am one of "those," and I will always be one. I am one of the down under. I read the signs of sea foam. Witches visit my six-year-old bed with iridescent snakes, snapping at my spine, shocking me awake. I am one of the shocked and shocking ones. Beware. I will not be thwarted in my efforts to be who I am and protect my brethren.

I masturbate ferociously. Nothing escapes my six-year-old lust. I want to get it on. I want to get inside everything and dissolve. My stale surroundings come to life in that underworld of humping. I have something no one else can have. Mine. All mine. I have a universe of connection no one can tamper with. So what great step is it to be the seventeen-year-old prostitute I masturbate about? To fuck another lonely soul is not a crime.

I didn't expect the trees to start singing, I didn't ask the spiders to talk. But their resounding choruses export me from everyday banality, from the insidi-ous fabrications of truth. The mountains will remember with me. They will be my family.

I have always found the world perplexing. I've cloaked myself with an invis-ible river, stuck my hand outside, and seen it shrivel and dry up. Whose world

is it, anyway? It imprisoned me for prostitution and let my batterer go free. It's a world where my bruised body had no refuge. There were no rape crises hotlines, no shelters, no prostitute's union that I knew of in Boston, 1978. But the courts were glutted with women who sold their bodies. There was no attention paid to their well-being. Only to their incrimination as sexual deviants. There was no attention paid to protecting them from the abusive and violent police, johns, boyfriends, husbands, judges, and pimps. Those players in the cultural drama of good and evil were deemed innocent.

I am an advocate for shifting the locus of control. I vehemently protect women's rights to choose how they employ their sexuality. By the blood and bruises of sexual violations that I have suffered, I advocate protection for consensual sexual expressions of all kinds. For all genders. I advocate amnesty for all manifestations of sexual rapture. I willingly offer myself as an instrument for the dissolution of systems of shame. The entire sex industry needs to be overhauled. Not cleaned up, but made even more shamelessly dirty. Released from the cowering titillation of repression. If I ran the circus, the authorities would not get juiced on incriminating their deepest desires. Authority would be internalized. All coercion would cease. We would only need to protect ourselves from our ravenous impulses. We would only need to fear the force of spirit itself jolting us into consciousness.

I wanted to fuck the world. I still want to fuck the world. To get close. To touch. I've been on my own in a world where ecstasy housed itself snugly and discreetly in my body. Who would meet this fury? The whores today are my compatriots. Dancers in the fire of the forbidden. It is a dangerous country. Not because sex is dangerous, but because sex has been relegated to the terrain of theft and murder. A whore steps herself willingly into the arms of someone stealing a fuck. Is her stance in the snake world of the erotic firm enough, or has she fallen prey to the conviction of her unworthiness? In this world of the "tainted act," is she protected from the snares of apology and shame? It is almost an impossible task for the whores of today, in this frigid climate, to remain out of the loop. Can my compatriots keep their souls intact? Stand firm for the glory of ecstasy, union, and holy dissolution?

Oh bury me, bury me way down yonder where the cum runs thick and the women taste divine.

In the Flesh

A Porn Star's Journey

NINA HARTLEY

I'VE BEEN PART OF THE FEMINIST DEBATE ON SEX WORK since I first went public as a sex worker over ten years ago. I came out as both a hard-core[1] stripper and a novice hard-core (triple-X) video performer in order to join the heated debates concerning women, men, and sexuality. At that time, I had just fulfilled my longstanding fantasy of being in a sexually explicit video, and had already had eighteen months' experience as a once-a-week nude dancer/performance artist at the O'Farrell Theater (known locally as the Mitchell Brothers) in San Francisco, which turned out to be a wonderful part-time job for me while I pursued a full-time nursing degree. In 1984, many words had been written *about* sex workers, but few had been written *by* them. I had very definite ideas about sex and my relationship to it, and I wanted to bring my real-life experience to the discussion.

Like many of my sisters in sex work, my decision to enter the field was a very conscious one, arrived at after much deliberation with my two life partners: my husband Dave and my girlfriend Bobby (thirteen years and counting). Dave and Bobby came from Detroit and the radical movements of the 1960s and 1970s: Students for a Democratic Society, free love, the Black Panthers, NAM,[2] and the labor movement. I was raised in Berkeley, California, the bosom of social change and experimentation, by left-liberal parents. The youngest of four kids, I was left to explore whatever piqued my curiosity. The study of sex was one of those interests.

With backgrounds like these, the decision for me to begin a life of public sex was not taken lightly. My partners and I had many long discussions covering a lot of questions. Is the sex industry defensible on any level? Was our collective feminism reconcilable with the idea of sex work, much less its reality? How could I defend my personal desire (and long-held fantasy) to indulge my strong streak of exhibitionism/voyeurism, as well as to have access to other bisexual women? (I reasoned that my odds of finding women receptive to my longings were much higher if I fished in the sex-entertainment pond. I was not disappointed.) Was it wrong to find pleasure in arousing male lust in a controlled environment? Could there be "responsible hedonism"? What were the

gaps of logic in feminist criticisms of objectification and was objectification, ever okay? Could my family and I withstand the loss of privacy? Did we want to deal with the danger inherent every time a woman crosses the "virtue" line that society draws for us all? Could I defend my position with feminist philosophy and arguments?

Having decided that we could live with all of those issues (and there were even more we hadn't bargained for), I went ahead with that first video, *Educating Nina*, in March of 1984. Juliet "Aunt Peg" Anderson was the director, producer, writer, and star of the video. Her early help was invaluable to us. It was only because my husband had met Juliet, an educated, mature woman in the business, that we felt we could do it, since the sleazy characters we had encountered in our explorations up to that point had left me feeling like dancing was going to be the extent of my public sexual expression.

Since that time, I've performed in over 300 videos, appeared on countless talk shows, been interviewed for books, contributed to anthologies like this one, received many awards (for my acting, sexual performances, and political activism), networked with many fascinating, sexy women (some of whom have contributed to this work), and have finally begun producing, writing, and directing my own erotic videos. I was one of the founders of a peer support group, The Pink Ladies, which published a newsletter for two years. While I'm no apologist for some of the more negative aspects of my industry, I do a lot of public speaking and outreach, putting a human face on a highly stigmatized business.

My life is richer and more rewarding for having chosen a sexually oriented occupation. The main rewards have been increased self-awareness and self-confidence, as well as the pleasure I bring to others. When queried about my personal experiences in the business, I highlight first a range of positives: enhanced self-image, sexual variety, creating a platform for my ideas about sex and society, creative erotic expression, exhibitionism, fantasy fulfillment, and economic gain. A level-headed woman can make a decent amount of money in a relatively short time if she's willing to work hard. If she has vision and determination, she can even carve out a career for herself. If someone comes to me wanting in, I stress first the (very real) negatives such as social and familial repercussions of joining a stigmatized segment of the population; the temptation to spend money as fast as it comes in; exposure to the seamier side of life (the entertainment industry is notoriously brutish); and the difficulty in creating or maintaining intimate, romantic relationships. Like any profession, some people's involvement with adult entertainment is more positive than negative. For others, the opposite is true.

Because of my experience, newer actresses entering the business have looked to me as a role model. They've watched me perform, heard me speak, or read my writing and realize that they, too, can enter this line of work and come out ahead. I often act as a sort of mother hen, pulling aside new actresses as I meet them to see how they're adapting, and to inform them of their pro-

fessional rights and responsibilities. In short, I strive to practice the feminist principles of sharing one's experiences with others, promoting empowerment for workers, and building consensus.

In January of 1995, I was elected to the board of directors for the Free Speech Coalition (FSC), an organization dedicated to fighting censorship as well as working toward change within the sex industry. Our activities include maintaining a public database of current and past censorship cases (aka Know Censorship); finding a group health insurance carrier for FSC members (most performers have no health insurance); supporting store owners whenever possible in their local censorship battles; providing partial funding and setting industry guidelines for HIV testing for performers; and conducting outreach to performers regarding mental/physical health, talent/management relations, and counseling (we've set up an 800 number to provide crisis counseling to adult performers).

Despite the depth and breadth of my activism, I have borne the brunt of many preconceived, ill-informed notions of who and what I am. I have experienced contempt, some of which I expected (from the religious Right), and some of which shocked me (from feminists).

My early exposure to feminist discussions revolved strongly around the body and sexuality, especially childbirth and early, theoretical, explorations of pleasure-centered, nonprocreative sex, especially lesbianism. Books such as *Birth Without Violence, Spiritual Midwifery*, and *Our Bodies, Ourselves* stressed the physiology of pregnancy and birth as normal and nonpathological. Indeed, my impetus to go to nursing school (Bachelor of Science, *magna cum laude*) was to become a nurse-midwife so that I could help women to have a more rewarding birth experience. After all, what could express my commitment to feminism more than being a healer/advocate for a woman at possibly her most vulnerable-yet-powerful state? Many if not most women in our culture are ill at ease with their bodies, with their innate "animal-ness." This alienation keeps us off balance, insecure, and easily manipulable.

Birthing and orgasm are both profoundly physical phenomena that can change a woman forever. Is it not in our best interests to become friends with our bodies, fully at home in them? If I or my work can be of assistance to a woman striving to overcome that physical alienation, then I am happy. Books like *Rubyfruit Jungle, Liberating Masturbation, The Joy of Sex*, and *Everything You Always Wanted to Know About Sex But Were Afraid to Ask*, as well as lesbian publications such as *Amazon Quarterly* stressed the possibilities of female sexuality freed from the pleasure-killing fear of unwanted pregnancy, as well as the woman's responsibility to take control of her own orgasm, to actively participate in her pleasure and not wait for her partner to "make everything all right."

I am a direct product of the new thinking around sex of the late 1960s and early 1970s, reflected in that literature. I grew up believing that nudity was beautiful; that home childbirth and breastfeeding were the preferred way, that no sex was "sinful" or "dirty" or "perverse" if it was consensual, and that it was

okay to be a dyke. *Our Bodies, Ourselves* said that consensual exhibitionism and voyeurism were *not* bad, but acceptable sexual variations. So in some ways, it was a natural progression for me to arrive at proud participation in the depiction of fucking and the belief that I had the absolute right to explore that side of myself.

My only problem seems to be that I was born too late: by the time I was of age to act on my long-held fantasies, porn had been transformed from chic and sophisticated entertainment for liberated adults (1972–79) to the whipping boy of both the religious Right and the feminist movement (the 1980s).

Instead of being viewed as a trailblazer, many of my sisters view me as (at best) misguided and brainwashed or (at worst) as a traitor and rapist. Luckily for Eros and Aphrodite (the Greek gods of erotic love and passion), there exists a small but growing parallel universe, occupied by sex-positive feminists and the people who love them. Among this crowd, I have learned that there are many people out there who get what I'm giving in the spirit it's intended: the joy of sex offered by a humble handmaiden of Aphrodite.

My willingness to explore and accept many aspects of my sexuality has led me to wonderful places. It has made me a happier and more loving woman. It has helped increase my capacity for compassion and pleasure, and I'm still learning and growing. My "good girl" side wants to share all the wonderful things I've learned, and my health professional side wants to teach people how to use erotic pleasure as a healing force as well as to demonstrate specific skills. A fulfilling sex life makes all things more bearable.

Over the past twelve years, I've observed that the more uncomfortable a woman is with the state of her sex life, the more outraged and irritated she is by the existence of porn and the women who are proud to make it. The angrier she is at "the patriarchy" and the more she blames men for all the ills of the world (and her own particular problems), the more she wants to punish men for their ability to become easily aroused through visual stimulation. In their efforts to remove the injustices of rampant sexism in the public arena, some women have become overzealous and extended their prohibitionary efforts to the bedroom, exactly where privacy and tolerance should be most extended. Speaking as one to whom a lot of their anger has been directed, it feels like they've cut off their clits to spite their orgasms. These women appear to be acting like the worst of their Victorian sisters, with all of their erotophobic logic: lust is evil, and only romantic love and its chaste expression are civilized and acceptable, and it's up to woman to control men's animalistic side (if she's self-hating enough to sleep with them in the first place). Collaterally, any woman who caters to men's "base" desires or, Goddess forbid, *likes* sex (especially sex with men, or sex outside of a committed, monogamous relationship) is deserving of pity and contempt.

I've come to this opinion slowly, over the past twenty years or so, as I have continued to read and observe the debate over sex and gender roles from my unique vantage point as a member of the "alternative sexuality" community,

and this opinion has only gotten stronger since I've been making a living as an openly identified sex worker.

Interestingly, my sex industry experience has also helped decrease my long-standing fear of men and their sexuality. My views about gender were influenced on the one hand by books like Susan Brownmiller's *Against Our Will: Men, Women and Rape,* and on the other hand by other books (mentioned above) that extolled the naturalness and positive aspects of sex. My early and few fumblings with boys in high school didn't do much to clear up my questions, and there was no place for an underage woman to go for answers. I had a lot of feelings and fantasies (having sex with women, performing sex for an audience, watching others have sex, wanting sex without romantic love) that I knew society looked down upon. I was angry that I couldn't be open about my explorations with other girls, that there was no place for me to gain sexual skills without the cumbersome burden of "relationships" and "love." You could go to school for any other skill, but not sexual skill. It made no sense. Stripping and adult films provided a safe place to practice lots of sex with lots of different people in lots of different situations. I gained competence and confidence, two things I had always wanted.

Most women don't have that many partners or opportunities to learn skillful sex. Many women are plagued by self-doubt, confusion, and insecurity about their worth as sex partners, emotions mined by Madison Avenue for gross profits. Fortunately, the 1990s offer alternatives to such negativity via the increasing open availability of consensual sex in a variety of group environments, particularly in large cities and on the coasts of the United States. These are particularly positive opportunities for curious women, as many of these groups and organizations emphasize safe, consensual, and nonpredatory etiquette.

Through my experiences stripping, I learned many valuable lessons. I learned that my body was attractive to many different men, even though I am many inches and pounds away from any magazine model. I found that the majority of heterosexual men will follow sexually if the woman will only lead, and that men feel victimized around sex just as women do, only in different aspects of the sexual dance. I realized that, as a committed feminist, I had to be open to men's pain and see it as equally valid to women's. I discovered that a woman who is willing to talk about sex honestly and show her body can get men to listen, learn, and be better lovers with their partners. Finally, I learned that to be eternally mad at men's sexual "nature" was as useful as being mad that water is wet. Anger inhibits intimacy and shared pleasure, to the detriment of all involved. I seek in my work to defuse anger so that the pleasure I invoke can work its healing magic.

In the beginning of my career as a sex professional, I was angry a lot. I hated curling my hair, wearing makeup when I wasn't going to be on a set, and having to look sexy when I wasn't in the mood. I had never worn makeup or tried to dress sexily before becoming a dancer. Rather, my uniform was Birkenstock

sandals, overalls, granny glasses, and flannel shirts. My few forays during junior high school into trying to look hip and sexy were met with rejection, so I retreated into my books and didn't come out again until I was twenty-one. I didn't realize it at the time, but I had internalized the idea that it was oppressive to cater to men's visual needs and desires. It felt like an unfair burden to take time to try to get boys to be interested in me. According to what I was reading at the time, I shouldn't have to pay attention to what might please my partner. Sex should just happen, and any "need" for accouterments was a remnant of the patriarchy. This turned out to be a rather self-defeating attitude for someone who wanted sexual attention from men.

It remains a fact of life that appearance affects the way people respond. Because of my fear and indoctrination about "oppressed" women who were "obsessed" with their looks, I resisted teenage experimentation with the subtleties of the boy-girl social dance. So in my early to mid-twenties, I was learning things about appearance that most women start to master at age fourteen or so.

Tears of frustration, resentment, and petulance characterized my efforts at getting "done up." Dave and Bobby would point out that this was what I had chosen, what I said I wanted, and that I was going to have to live with certain realities. I could fight it and be miserable, I could quit and go be a nurse, or I could deal with my choice and grow as a person.

After a year of kicking and screaming, a funny thing happened. I started enjoying myself. I had gotten better and faster at doing my makeup and hair, and it became no big deal to go from frumpy to fabulous in thirty to sixty minutes. Once I understood that the fashion magazines are full of shit, and that men are actually rather easy to seduce and beguile (short, low-cut dresses and high heels worked!) I felt less oppressed deciding what to wear, and it became fun, rather than a burden, to play with being sexual in this way.

It was the same with getting my hands on so many different bodies. I'm so used to it now that it no longer makes me nervous. Consequently, I can better tune into my partner and our pleasure.

I believe that sensual pleasure (self-generated or shared) is a meditation, opening a direct path to the life force, i.e., "God." I do not find it particularly demeaning to make a living with my body, because I don't think sex is intrinsically bad. I don't think vulvas and penises are dirty, and I don't think that lust is horrible or anti-love. Nonconsensuality and self-destructive behavior are the evils.

This culture's sexual mores stem from those of the founding religious fanatics who hanged women who were different; our current sex laws come directly from their warped, religiously based viewpoints on social control and are predicated on the assumption that sensual pleasure tempts one away from godliness. Anti-female, anti-sex, and anti-pleasure proponents (starting with the Puritans), who put such severe restrictions on where, when, and under what circumstances it is permissible or acceptable to express sexual feelings, set the

stage for the sorry state of affairs today. For them, sex was a balance beam: one false step and you're damned forever. For me, sex is like a gated big meadow with a sign that says, "Consenting Adults Welcome." In this place, it's impossible to fall off into damnation. Like some of the sex parties I have attended, one can play in this corner, gambol in that corner, or sit in the middle and just watch. Conversely, the current blue laws impinge on *my* religious freedom and ability to worship or make a living as I see fit.

The antiquated fear of sexuality these laws reflect has curiously colored much of the feminist-generated writings on sex. I say curiously, because feminist theoretical discussions are usually quite logical (if passionate), except when they try to address anything related to sex. Then, outrage, pain, and an inability (or unwillingness) to consider the possible validity of others' experiences too often predominate.

I've come to believe that those individuals who universalize their self-appointed victim status do so at least in part as a way of avoiding taking responsibility for their own dissatisfaction with the state of their intimate lives. I say this because I was once one of those women. I've since reevaluated some of my feminist analysis of sexual objectification.

When I was growing up in the early 1970s, the received truth on sex was that men's objectification of women was the root of all gender inequality. If men would only stop appreciating, rewarding, and wanting to fuck women because of their looks (to the exclusion of any other traits she might possess), the world would be a better place. I grew up pitying women who only felt comfortable when wearing makeup and feminine or "male-defined" clothing.

Yet I myself loved to look at women of all types. My bisexuality made me wonder what they'd look like naked, made me want to touch them and make them come on my mouth. My feminism made me want to honor and cherish their sexual prowess, not demean them because of it. What was I to do?

For some women, objectification was painful and humiliating. At the same time, other women suffered for never being the object of anyone's desire. My logic told me that certain feminists threw the baby (sex and the mating dance) out with the bathwater (male violations of women's space and dignity). We do not need less objectification (why else does one get the courage to say "Hi" to someone at a party?). Rather, we need to make men more aware of how to act once they are next to a woman. I want women to be treated as people first and sexual beings second.

Women will feel freer to say "yes" to sexual pleasure when men start honoring our "no's." Such a change in attitude cannot take place without men being allied in the struggle. Until and unless men as a group believe that it's more manly to treat women respectfully instead of insensitively, not much will change. Men challenging other men on their sexism, in language that men can relate to, will be an important key.

For all its trappings, objectification is a central part of most, if not all, human cultures. We don't mate by scent, seasons, or instinct alone. As primates, we

learn a great deal visually, by watching and imitating. Since we can't experience most people on deeper levels, everyone is, at least initially, an object to others. Because my professional image is available on videotape, I am an object to most people who enjoy the fruits of my labor. I meet and entertain, on average, upwards of 20,000 men a year, none of whom know me as a full person. I don't have the time or inclination to have all of those men get to know me as a full person. I save that for my family and my private life. This split between public and private is by no means unique to the sex industry.

I present the image I think would be most effective in helping men to change their attitudes about sexual women, while at the same time not forgetting that my primary purpose is to arouse; when I lose sight of that, men cease to pay attention. I've learned that if a woman is presenting a sexual, confident persona, heterosexual men generally listen to all she has to say. Susan Sarandon said it succinctly in *Bull Durham* when she tied Tim Robbins to a bed and read him poetry. "Men will listen to anything if they think it's foreplay." If she also happens to underscore her point by encouraging/facilitating/inducing his orgasm, the point may well stick for good.

In my line of work, the points I've made stick most often have to do with physical techniques for pleasing one's partner, for example in my oral sex demonstration videos. Male and female fans often relate tales of the pleasure they've created from following my advice or example. This is gratifying to me. It is also gratifying to know that if my viewers are too tired after a long day to go to all the trouble of seducing their mate, but still want some shared intimacy before falling asleep, they can use one of my (or my colleagues') videos to help the mood along. That is no more "cheating" than getting a take-out dinner when one is too tired to cook.

Looking back, there are very few things I would have done differently. I still would have chosen the adult-entertainment path. My mates and I have reconciled our collective feminism with porn: if a woman has the right to choose an abortion, she has the right to choose fucking on camera. I have no apologies for finding pleasure in arousing male lust, as I have returned the pleasure and asked them to share it with their partners. For those men without partners, I help them get through another night alone.

I believe that feminist critiques of consensual objectification overlook the potential pleasure therein. Furthermore, I believe that accessing sexual ecstasy and passion can heal some of the deep wounds that divide the genders, even if we choose not to express that sex and passion with anyone but ourselves. But express it we must, as being stingy with passion and pleasure shrinks our hearts, shrivels our spirits, and makes us blind to opportunities for intimacy, to the detriment of all.

The loss of privacy has been difficult, but it has been worth it to be able to help advance sex-positive attitudes and to change behavior. I've been lucky in that, so far, no harm has come to me by virtue of my occupation, but I also take extra measures to keep it that way. I feel I have the same right to label myself a

feminist as those women who hate what I do and call themselves feminists, too. I want compassion and assistance extended to those in my line of work who desire to leave the profession, as well as to those who desire to remain. I would like to do more to help other women whose experiences/resources have not been as fortunate as mine. As feminists, our goals are more alike than not, and we should not let patriarchal biases against female sexuality keep us from working together for change.

Notes

1. "Hard-core" in this context refers to inclusion of masturbation and/or penetration in stage or personal shows.

2. NAM stands for the New American Movement, which later merged with the Democratic Socialist Organizing Committee to form the Democratic Socialists of America.

[6] We've Come A Long Way—And We're Exhausted!

ANNIE SPRINKLE

OVER THE PAST TWENTY-FIVE YEARS I've done virtually every aspect of sex work except lap dancing. When I started, there were very few of us that were open about our jobs. The legal repercussions were too great and the stigma too heavy. Slowly but surely (inspired by Margo St. James and Xaviera Hollander), one by one, we began to speak out about how we weren't all exploited victims, how we weren't all on the side of the patriarchy, and how some of us felt empowered by sex work, grew through it, and sometimes actually enjoyed the sex. We accentuated the positive (in my case, ad nauseam) because the many forces against us (police, religious fanatics, FBI, IRS, jealous wives, politicians, etc.) continuously exclaimed the negatives to keep us down.

However, no sex worker, no matter how much she loves her job, can deny (however how hard she tries) that there is great room for improvement for women in the sex industry. And as I grow older, wiser, more educated about feminism, and the more I learn to love myself and other women, the more I see how we do get wounded and oppressed. Naturally the degree of this varies a lot depending on the individual, her herstory, type of job, race, and perhaps especially class. Although many of our problems are similar to those of women in other professions, the nature and stigma of sex work make ours uniquely challenging.

Women in the sex industry have come a long way. Things have improved. There is now an international network of sex-worker organizations. In some areas, to be a young feminist working her way through college as a stripper has become not only acceptable but chic. Women are making and distributing their own pornography their way. Fetishes and fetish wear have become fashionable. There are some extremely prosperous sex businesses run/owned by women who are on the side of their female workers. Many sex workers of all kinds are out of the closet about their work and take great pride in their profession.

To make our businesses and our lives even better, it is time to be totally honest, to be more critical, to come out of any denial, to speak out about and confront the problems from an insider's, pro sex work perspective. This is

difficult and dangerous to do, because often we can sound terrifyingly like our enemies and can inadvertently fuel their flames, which could get us into a big pickle.

So this time, I am not writing about how sex work can be feminist work, or how it has been personally empowering, or how it benefits the whole darned planet. Nor am I writing about the legal and social contexts of sex work, important topics addressed very well in this volume and elsewhere. No, this is about how to take care of ourselves: how to heal our wounds, and how to be truly happy hookers deep inside. Strong mental health and happiness are our best defenses. Politics and educating the public are only part of what we need to do. Some things we can only get from ourselves. This is the private, "feminine" side of sex-worker feminism.

I've known hundreds of erotic laborers and I've never known one to be immune from bouts of what I call Sex Worker Burnout Syndrome (SWBS, for short). It's one of the hazards—by-products if you will—of our titillating trades. The symptoms vary: depression, tiredness, problems in relationships, feeling like people want to drain your energy, feeling grumpy, low self-esteem, frustration, not wanting to be touched, a feeling of being trapped or stuck, being overly emotional, feelings of dissatisfaction with one's life, hopelessness, self-destructive behavior, and more. It can last anywhere from one day to years.

Learning from my own successes and mistakes and from talking with other women in various forms of erotic labor (namely Veronica Vera, Rosanna Chavez, and Karen Cioe), I have outlined thirteen tips to help cope with SWBS. I offer this prescription to my dear, sacred, sex-worker sisters, whom I love and admire, that they might benefit in some small way from this information. I especially offer it to those of the new generation so that, if possible, they might avoid having to learn some things the hard way. Please take good care of your precious selves. This too is feminism.

13 Tips to Cure Sex Worker Burnout Syndrome

1. *Admit that you are burned out.* Our egos, as well as incomes, are invested in feeling good about our work. Often we are scared to acknowledge Burnout, especially to ourselves. Learn to recognize it, and see it as an opportunity to make positive changes in your life.

2. *Take breaks and vacations* from your work as a matter of course. With enough down time and replenishment, you may never even get crispy, let alone burned out.

3. *Spend time in nature.* Most sex businesses are housed in dark, windowless, closed environments, in busy neighborhoods in high stress cities. Being in nature is a perfect balance. I have found being out on a boat to be my

favorite medicine, but a city park will do. Get some sun, fresh air, hang out with trees, smell the flowers, and roll around in the grass.

4. *Spend some time alone*, go inside yourself, stay quiet, do something very relaxing or meditative, even if it's just for a few minutes. Languorous, candlelit, aromatic bubble baths do wonders. Add mineral salts and herbal extracts to your bath to help release toxins and relieve stress. Close your eyes, relax your mind, take some long, deep breaths and draw in life-force energy to gain psychic strength. You need it.

5. *Be in touch with your feelings* and express them often. Repressed emotions alone can create major burnout. I remember a few times when I had bouts of SWBS, bursting into tears with clients while they were fucking me, and raging at a few clients, or my bosses, when they didn't really deserve it. Not good for business! You will attract a better clientele, and ultimately make more money, if you are emotionally strong and clear. When you are alone, have little cry sessions, or "crygasms," whenever possible. "Angergasms" are also necessary and valuable. Beat or scream into a pillow for as long as you need to. Or, team up with a trusted partner and take turns giving each other nonjudgmental attention: relaxed touching, aware listening, and encouragement from a clearheaded sex-worker friend or understanding ally can facilitate release and enhance the process.

6. *Be aware of what colors you wear and live in during off hours.* Because most of us make the most money wearing particular colors (generally red, black, or white), on your off hours try to wear other colors. Also, if you work in an environment that's a particular color, try to have other colors at home. Almost everywhere I worked was red, gold, and black, so I made my bedroom royal blue and emerald green with hot pink accents, and it had a great equalizing effect.

7. *Get therapy.* Time and again I've seen friends and colleagues with SWBS feel a lot better relatively quickly with one therapy session a week. Be sure you find a therapist who is sex positive and nonjudgmental or, best of all, who has been around the block herself. I strongly suggest a woman, as most clients are men. If you're financially strapped, call women's or community health centers for free therapy. Lots of SWBS comes from repeating unconscious negative patterns created from childhood experiences, learned beliefs about cultural norms, and the like. Therapy can help put you in the driver's seat, as opposed to doing things unconsciously. You can be sure that sex work will bring up lots of personal issues such as money, sex, men, sexual orientation. What's unresolved is what you may continue to attract. Sex work can be a great teacher and healer, especially when coupled with therapy.

8. *Have a good social net of peers* with whom you can have sympathetic, loving, supportive communication. There is absolutely no better cure than this. Sharing your stories and feelings with people who have had similar experiences is absolutely magical. For eight years I was part of a support group consisting of five porn stars, which we called Club 90. For one full evening every three weeks, each of us took a turn to share about our lives. It was a tremendous help and source of strength for all of us, especially when any of us had SWBS.

9. *Take good care of your body.* Because our jobs involve our bodies, it's important to eat well, exercise, and get body work. A good massage can do wonders for a worn-out whore or stripper. Again, it's best to have a session from a woman when possible. Less costly options are gardening, jogging, yoga classes, swimming, or simply a long walk.

10. *Get your mind (and body) off work.* Indulge in your other interests and hobbies. Take a class or two. Go to a funny movie. Get a pet (I prefer pussies). Do something you've never done before. Go to a museum or carnival. Hang out with little kids or old folks. Use your imagination. The possibilities are endless.

11. *Be willing to make less money.* Decide what kinds of people you want to work with and be willing to let go of those that don't fit the bill. Develop your own style. Don't let the client determine the service. Rather, let him know what you offer. Practice saying "NO." Clean out your little black book. Challenge yourself by periodically upgrading or expanding your business. You may in the short run seem to make less money, but taking care of your personal needs will give you longevity in the business and you'll surely come out ahead.

12. *Create other sources of income.* Look into other business or career opportunities, go to college or trade school, make an investment, start a sideline so that you won't feel financially trapped. This way, when you need a break from sex work, you'll have an alternate job.

13. *If your SWBS is chronic, get the hell out of the business.* Perhaps you're simply not cut out for it, it's not fulfilling your needs, or it's time for a change. Sometimes getting out of sex work can be difficult. Sex-worker-positive support to leave the business is available. (See Resource Guide in the appendix of this volume.) You may need to leave gradually until you get your alternative sources of income in place. Or it might be best to go "cold turkey" and make radical changes all at once. In any case, you alone know what is best for you, and have the power to make your life just the way you want it.

[two] Meanings

Performance,

Perspective,

and Discourse

Ethically, there can no longer be a philosophy of prostitution in which there is an absence of prostitute perspectives and prostitute philosophers.

—Shannon Bell, *Reading, Writing and Rewriting the Prostitute Body*

Early modern pornographers were not intentionally feminist *avant le lettre,* but their portrayal of women, at least until the 1790s, often valorized female sexual activity and determination much more than did the prevailing medical texts.

—Lynn Hunt, *The Invention of Pornography: Obscenity and the Origins of Modernity, 1500–1800*

[7] Love for Sale

Queering Heterosexuality

EVA PENDLETON

> You may be a whore, but at least you're going to get paid.[1]
>
> —Angel

WHEN SEX WORKERS DESCRIBE WHAT THEY DO, they often come up with complex and provocative theories of femininity and sexuality. From a more academic standpoint, the practice of sex work stands at the crossroads of feminism and queer theory, providing a unique vantage point from which to critique the regime of heterosexuality. This kind of critique owes much to early lesbian feminism, which attacked heterosexuality as a social system that maintained the subordination of women. But while lesbian feminism utilized utopian strategies of separatism and alternative institution building, sex-worker feminism has a different aim. Much like queer politics, the goal is to destabilize heteronormativity. Destabilization is a partial and provisional strategy, but one that carries the possibility of proliferating sexual deviancies and thus undermining the mechanisms under which women and queers continue to be subordinated.

Sex workers have historically operated as an "other" against which varieties of white female sexual identity have constructed themselves. Heterosexuality as a social system depends upon the specter of unchastity in order to constitute itself; the "good wife" as a social category cannot exist without the "whore," whether she takes the form of a prostitute, an insatiable black jezebel, a teenage mother, or a lesbian. Each of these othered positions exists to reinforce the norm of white procreative heterosexuality.[2]

Different branches of feminism have provided analyses of sex work that disempower and marginalize sex workers.[3] One of the projects of liberal feminism has been to recuperate these "fallen women" in the name of "equality." Under liberal feminism, what it means to be a socially acceptable "woman" requires a bit more inclusivity than my simple dichotomy suggests. If the prostitute gives up paid sex, if the black jezebel marries a nice black man, if the teenage mother goes on the pill and gets a job, and if the lesbian keeps her sexual practices vanilla, liberal feminism will give them a place at the table.

Those who refuse to conform to these conventions remain feminism's "other." Radical feminists continue to call for the elimination of sex work and pornography under the guise of protecting whores from male exploitation of their sexuality.[4] The "sex wars" of the 1980s saw a proliferation of feminist debates surrounding sexual practices: pornography, sadomasochism, promiscuity, and prostitution have been, and remain, contentious issues for feminists.[5]

One of the limits of feminist theory, according to Gayle Rubin, is that it is inadequate for conceptualizing sexuality. In her groundbreaking article, "Thinking Sex: Notes for a Radical Theory of the Politics of Sexuality," she discusses the various hierarchies of value present in western societies that provide prescriptions for, and proscriptions against, specific sexual behaviors.[6] Rubin wishes to consider the persecution of sexual deviants as an issue separate from the oppression of women. This would not wholly replace feminist concerns over sexuality, but rather would provide additional tools for analyzing compulsory heterosexuality as a social system.

"Thinking Sex" functions as a bridge between feminist theory and queer theory. Although the term "queer theory" is relatively new and often highly contested, I am using it to describe a body of work, embedded in politics, that is concerned with the social production and regulation of sexuality. Much of the modern groundwork for contemporary queer theory was laid during the late 1960s and early 1970s in the gay liberation and lesbian feminist movements. It was during this time that scholars and activists began to seriously interrogate the historical construction of "homosexuality" and "heterosexuality" within and against the fields of psychology and sexology.[7]

Contemporary queer politics takes a number of forms. In an effort to map out the multiple vectors of queer politics, Lisa Duggan elucidates the difference between two radically different uses of the term "queer": a militant nationalist, homosexual essentialist, implicitly white male politics, on the one hand, and a diverse, oppositional politics of "dissent from the dominant organization of sex and gender," on the other.[8] It is the latter definition of "queer" that covers all sorts of subcultures, such as sadomasochists, cross-dressers, boy-lovers, lipstick lesbians, and so on, to which my own work refers. The existence of these radically different sexual formations illustrates that there is much more to sexuality than the object-choice focus of mainstream lesbian and gay politics or the antipatriarchy focus of feminism would lead one to believe.

Lesbians who work in the sex industry have recently received a great deal of attention from the queer community, through both scholarly and popular venues. Since both lesbianism and sex work destabilize heteronormativity, linking the two practices is a critical political and theoretical move. Numerous historians and cultural critics have begun to document the rich history of lesbian sex workers; their work often highlights the stigmatized social spaces historically shared by whores and lesbians.[9] Queer periodicals have increasingly devoted space to covering the hidden worlds of lesbian sex workers.

A recent article called "Nobody's Victim," in *10 Percent* magazine, is written

with an aim to refute feminist claims that sex workers are helpless and always enter the sex industry through coercion. The article is based on a series of interviews with sex workers who explicitly identify as lesbians. Throughout the article they tell of how their work lives are positive choices for them, political choices about self-determination and personal freedom. Sex work is in a real sense demystified by the interviewees, who frame it as primarily a means of employment rather than as an identity. The recasting of "whore" from a stigmatized identity to a job not wholly unlike other jobs has been a major project of the sex-workers' rights movement.[10] However, their work lives are also described as separate, contained aspects of their self-definition: "Each of these women is very clear on the distinction between their working, economically-surviving selves and their private and truly intimate selves."[11] These women describe an untouched lesbian "core"; sex work still leaves their lesbian sexuality intact.

The political project involved in such an article must be considered in relation to the context within which it appeared. As its name implies, *10 Percent* is a magazine firmly grounded within gay and lesbian identity politics. For such a publication to produce a substantial article on lesbian sex workers indicates that this is a population that the gay and lesbian community can no longer afford to ignore. The very existence of this article suggests a tension between gay/lesbian politics and queer politics; the acknowledgment of lesbian sex workers is made possible by the proliferation of queer politics and theory. But the article insists upon containing their very queerness by reifying a kind of essential lesbian identity, unsullied by the dirty business of sex. The trope of "private and truly intimate" lesbianism obscures some of the sexual aspects of the work lives described in the interviews, especially those that revolve around body image and physical pleasure.

Standing in marked contrast to this project is a recent documentary by Hima B. called *Straight for the Money: Interviews With Queer Sex Workers.*[12] In a series of interviews with queer-, lesbian-, and bisexual-identified sex workers, including prostitutes, peepshow girls, strippers, and dominatrices, the film explicitly confronts the complexities involved in paid sex and identity formation. Much of the film consists of the women answering questions about their sex and work lives and about the ways in which these presumably distinct worlds overlap and intersect. The most common sentiments expressed by these women are that they have *chosen* sex work and that their work experiences enhance their lesbian sexuality by allowing them another outlet for sexual expression. In fact, some of the women interviewed speak of bringing aspects of their male-oriented sexual employment into their female-oriented sexual identities; engaging in sexual activity with men for money has opened up new possibilities for lesbian sexual practices. On the whole, the film demonstrates that sex work recasts these women's own concepts of "sexual identity" as they negotiate the multiple positionings of dyke, whore, and various permutations of these categories.

The power of Hima B.'s film and the *10 Percent* article is in their juxtaposition

of the subjects' self-described "real" sexuality with their professional, or performed, sexuality. The juxtaposition of paid "straight" sexuality with lesbianism actually illustrates that there is nothing straight about sex work. What these women are doing is *performing* heterosexuality as they perform a sexual service for money. They do not *go* straight, they *play* straight. I would like to argue that the sex work in these texts represents a *performance of heterosexuality,* regardless of the sexual self-identity of the performer. Its defining characteristic is the exchange of money for a sexual service, which is, I would argue, a queer act. Selling sex is quite outside of the normative codes of sexual conduct, whereby sex is privileged as something you do for love or, in a more liberal world view, for fun or, if it is in a Hollywood film like *Pretty Woman* or *Indecent Proposal,* for a whole lot of money.

By focusing on queer sex workers, both the article and the film reveal a tension between notions of sexuality as identity and sexuality as performance similar to the tension between lesbian/gay identity politics and queer theory. Lesbian/gay identity politics, especially when making civil-rights claims in the legal arena, depends upon the construction of a stable homosexual identity. Much of what is called "queer theory" is intent upon destabilizing sexual identities, a project that often seems antithetical to the work of lesbian/gay civil rights advocates. This tension underscores the field of queer theory and has produced some of its more interesting debates.[13]

Testimonies of sex workers who identify themselves as heterosexual also show the ways in which the performance of sex work queers heterosexuality. In the August 1992 issue of *Sassy,* the now-defunct feminist-inspired teen magazine, an intrepid reporter interviews topless dancers at Stringfellows, a highbrow New York City nightclub. The article earnestly seeks to give sex workers a voice; at one point the author objects to the ways in which access to the dancers is controlled by the management and laments the fact that her interaction with them is so highly circumscribed. Of course, this problem reflects *Sassy's* failure to make more thorough efforts to reach strippers for interviews, as the women who work at Stringfellows are hardly representative of New York City strippers. However, the project of the article seems to be to allow some room for sex workers' agency within a highly constrained feminist framework, as it also must avoid offending advertisers or the readers' parents. One interviewee, Monica, said that her work experience makes her less likely to put up with the hetero pickup scene: "When I go out to a club and some guy's trying to pick me up, I look at him and think, Why should I even talk to you? Why listen to your life story and what you do for a living? I don't care. You're not even paying me."[14] Because she now gets paid to perform heterosexuality, that is to say, to play a role of sexual availability and feminine receptivity, she is less willing to play that role for free. She does not claim to have no sexual interest in men; rather, it is the institution of compulsory heterosexuality, whereby women must politely tolerate and respond to male sexual advances, to which

she objects. This critique of female sexual subservience is not incompatible with *Sassy*'s model of feminism.

Glamour, a popular women's fashion magazine, provides a highly problematic venue for sex workers' narratives, even more so than *Sassy.* The cover of the April 1993 issue lures the reader with a tantalizing headline: "Topless Dancing: Why I Do It. Why I Like It." As a vehicle for heterosexual female fantasies, this headline is in keeping with the magazine's promises of sexual desirability through better clothing, makeup, or sexual skills. The article itself, written by a stripper, echoes the women in *Sassy* who describe their growing unwillingness to participate in heterosexual mating rituals. However, this writer speaks in terms of loss: "But dancing does exact an emotional price. I realize that since I started dancing I've undergone a change—almost imperceptible, but real. Before, I saw relationships in terms of possibilities. Now, when I meet an appealing man in my real life . . . it isn't long before I wonder whether he's got some ulterior motive. . . . Dancing has definitely made me a colder person."[15] Both articles describe meeting men in the heterosexual dating scene. But while the *Sassy* girl's street smarts are portrayed as a tool for seeing through the unfair rules of the mating game, *Glamour* casts this knowledge as something that tragically undermines the beauty of heterosexual coupledom. The joys of topless dancing promised in the headline are undermined by this narrative of "coldness" and the "emotional price" of sex work. In case the reader has missed this message, a supplemental article on the dangers of topless dancing is placed in a box within the stripper's story.

For the women profiled in these articles, bringing the terms of the heterosexual economy out into the open has made them aware of its operation in "straight" life, a lesson from which many heterosexual women could benefit. The existence of the overt economy of sex brings to light the greater economy of heterosexuality in general, "queering" heteronormativity and forcing a closer examination of various modes of exchange between men and women. From the vantage point of women who sell sex, the open acknowledgment of sex as something they choose to exchange for money is often described as a move that frees them from the covert heterosexual economy.[16]

By queering heterosexuality in this way, sex workers are able to critique it from an angle largely unavailable to non-sex-worker feminists. They push the notion of heterosexual economy even further by claiming to escape it *only by explicitly entering it;* trading sex for money becomes a marker of sexual and economic independence in a way that entering the "straight" work force can never be. Testimonies by sex workers speak of having to compromise themselves sexually within the "legitimate" working world by putting up with many forms of sexism, from advances by male coworkers to regulations about proper female behavior. Sex work then becomes refreshing for its honesty. The exchange is no longer couched in oblique, yet still patriarchal, language; the terms are clear and the exchange much more equal. Removing themselves

from the uncertain terms of the heterosexual economy allows at least some workers a clarity of vision unavailable to many mainstream feminists.

Carol Leigh, aka Scarlot Harlot, has written a poem called "Cheap," in which the problematics of the heterosexual economy are spelled out:

> Cheap is when you fuck them just to shut them up.
> Cheap is when you do it because they are worth so much.
> Cheap is when you suck them till your jaws hurt so they
> won't say you're uptight.
> Cheap is when you do it to keep them home at night.
> Cheap is when you want less than pleasure, a baby,
> or a hundred dollars.
> Cheap is when you do it for security.
> Cheap is what you are before you learn to say no.
> Cheap is when you do it to gain approval, friendship, love.[17]

There is not much in this poem that most feminists could argue with, considering their stated goals of female sexual self-determination, except with the idea that doing it for a hundred dollars is okay. That is a queer notion, indeed.

There is little element of real choice involved in the institution of heterosexuality. The parameters under which white, middle-class women must operate in order to stay on the "good" side of the good girl/bad girl divide are quite narrow; and the demonization of women of color, lesbians, and working-class women under this binary precludes them from ever fully attaining good girl status. Feminist sex workers argue that feminism must demand the rights of women to choose their sexual partners, on *whatever* basis, be it for money or for lust, for fun or for power. This quasi-liberal agenda is limited; it would not miraculously bring about sexual equality. It would, however, allow whores to contribute their unique perspective on the institution of heterosexuality and provide a mechanism for deconstructing the good girl/bad girl dichotomy. The concept of sex as a commodity sold by women and consumed by men is something that bears further feminist analysis. But this analysis is impeded by legal and moral imperatives against sex work that stigmatize and oppress whores, especially if they come from feminists looking to "protect" sex workers rather than assist them in their efforts at self-determination.

Sex workers operate under complex ideological and political conditions similar to those of drag performers. Within a matrix of power that constitutes what it means to be "female" and "sexual," paid sex performers put on the trappings of femininity in order to reap material gain. In fact, sex work *is* drag in that it is a mimetic performance of highly charged feminine gender codes. In Irigaray's terms, mimesis can be a useful tool for women:

> There is, in an initial phase, perhaps only one "path," the one historically assigned to the feminine: that of *mimicry*. One must assume the feminine role

deliberately. Which means already to convert a form of subordination into an affirmation, and thus to begin to thwart it.... To play with mimesis is thus, for a woman, to try to recover the place of her exploitation by discourse, without allowing herself to be simply reduced to it.[18]

Much of what sex workers do can be described in terms of mimetic play, an overt assumption of the feminine role in order to exploit it. When sex workers perform femininity, we purposefully engage in an endless repetition of heteronormative gender codes for economic gain. Using femininity as an economic tool is a means of exposing its constructedness and reconfiguring its meanings. While some feminists argue that sex workers reinforce sexist norms, I would say that the act of making men pay is, in fact, quite subversive. It reverses the terms under which men feel entitled to unlimited access to women's bodies. Sex workers place very clear limits on that access, refiguring it on our own terms. Rather than face sexual harassment in the underpaid straight work place, sex workers give men limited permission to play out their sexual fantasies and desires. The problem arises, of course, when men do not see their sexual fantasies and desires as so easily contained. The explicitness and honesty of the sexual economy that is appreciated by sex workers is often resisted in customers, who experience a kind of cognitive dissonance in having to pay for sex. Nevertheless, there are men who pay for sex who do so respectfully and without resentment.[19]

The magazine articles about strippers that I cited earlier in some ways reinforce the notion of stripping as drag, although they are constructed in such a way as to look for the "real" woman behind the stripper. Paradoxically, this kind of investigative reporting calls upon the trope that a whore is not a "real" woman while it simultaneously attempts to refute it. The articles address an implicit audience of nonwhores, exposing a hidden subculture while maintaining a critical distance from it. Even the *Glamour* article, written by a stripper, ends on a pitiful note about innocence lost, and is accompanied by an inserted feature on the dangers of topless dancing, lest any of the readers think she might be tempted to try it. These kinds of tactics divert attention from the ways in which *all* women are forced to negotiate various forms of sexual stigmatization, leaving the "real whores" marked as feminism's (and heteronormative culture's) "other."

> Performativity describes this relation of being implicated in that which one opposes, this turning of power against itself to produce alternative modalities of power, to establish a kind of political contestation that is not a "pure" opposition, a "transcendence" of contemporary relations of power, but a difficult labor of forging a future from resources inevitably impure.[20]

Following from this use of the performative by Judith Butler, I would like to argue that, in the sex workers' narratives that I have discussed here, there is

no neutral subject underneath the performance who chooses what construction to wear; the subject is produced by the performance as she at the same time produces a feminine ideal. Performativity involves not a distinct, identifiable "self" playing a role, but a mutually constituting relationship between subjects and the roles that they play. Or, to quote the female owner of a burlesque theater, "You can take a stripper out of the nightclub, but you can't take the nightclub out of the stripper."[21] Hima B.'s film addresses the performativity of sexual identities by focusing on the interrelationship of lesbianism and sex work within the lives of the women interviewed. The magazine features do not attempt such a complex analysis. Still, the articles about straight-identified strippers hint at shifts in the women's sexual identities at the same time that they confront the terms of the heterosexual economy through the women's own narratives. The article in *10 Percent,* which essentializes the lesbianism of its featured sex workers, operates within a gay- and lesbian-identity politics paradigm and demonstrates that theories of gender performativity are hardly universally accepted.

On a more personal note, I entered the sex industry for many reasons, not the least of which was sexual self-exploration. Performing femininity in this way has, quite literally, transformed my own sexuality. This kind of transformation takes many forms in different people's experiences, not all positive, not all negative. To read sex workers' narratives is often to read narratives of change, of transformation, of fundamental sexual restructuring. The investigative reporting of the magazine articles, looking for strippers' underlying, non-sex-work identities, masks real changes in the lives of sex workers that are strong cultural indictments in themselves.

My own experience as a sex-worker-turned-academic has brought many of these lessons home. In addition to deconstructing the heterosexual economy, sex work also deconstructs the academic economy. My background brought me instant notoriety at New York University when I began my graduate work; I immediately caught wind of whisperings among other students about "that sex worker in American Studies." That kind of titillation can work to my advantage; however, I am aware of the many ways in which the whore stigma operates, and I am forced to make crucial decisions about how to present my work in ways that are palatable to the academy without compromising my own convictions. I have presented my writing on sex work in conference settings with an accompanying slide show of me stripping. Performing in written and visual forms simultaneously has given me a way to integrate some of the multiple aspects of my own intellectual and sexual identities, allowing me to think beyond the confines of what normally counts as scholarship.

Judith Butler's work on performativity has a particular relevance for sex-worker feminism. Unlike radical feminists, who dream of eradicating prostitution and pornography in order to "liberate" women from sexual exploitation, sex-worker feminists recognize that pornographic representation is neither wholly exploitative of women's sexuality nor an instruction manual for patri-

archy. We know that the time for utopian feminist revolution is over. The forms of opposition we create are necessarily impure and draw from the very systems of oppression we wish to overthrow. We continue to find innovative ways to fuck with heteronormativity from within the sex industry. This holds more promise for effecting real change than radical feminist tactics such as censoring porn or prosecuting johns ever could.

Sex workers provide a powerful indictment of gender roles by demanding payment for playing them; feminism would be transformed and strengthened by incorporating this analysis. Practitioners of queer sex and politics also have much to gain by forging alliances with sex workers. The growing field of queer theory holds much possibility on this front; we write our dreams for the future through living queer lives in the present. As marginal realities are given a voice, those closer to the center will have to rethink their own positions within heteronormative culture. Feminists, whores, and other queers can only benefit from such an unholy coupling.

Notes

1. Private conversation with Angel, a lap dancer at the Harmony Burlesque Theater, August 1992. On my first day at work, Angel instructed me in how to negotiate with customers over the terms of lap dancing. This paper is dedicated to her.

2. See Gail Pheterson, "The Social Consequences of Unchastity," in Frederique Dela-coste and Priscilla Alexander, eds., *Sex Work: Writings by Women in the Sex Industry* (Pittsburgh and San Francisco: Cleis Press, 1987). See also Michel Foucault, *History of Sexuality, Vol. 1: An Introduction* (New York: Vintage, 1980).

3. "Feminism" is a broad category that encompasses many forms of social critique and political action. For the purposes of this paper, I concentrate on three general categories of feminism: liberal, radical, and sex radical. These do not operate in isolation from each other, and many of their concerns overlap. However, the only identifiable form of feminism that allows sex workers to speak from a position other than that of victim is sex-radical feminism. I consider sex-worker feminism to be a subcategory of sex-radical feminism. For a history of radical feminism, see Alice Echols, *Daring to Be Bad* (Minneapolis: University of Minnesota Press, 1989).

4. See, for example, Kathleen Barry, *The Prostitution of Sexuality: The Global Exploitation of Women* (New York: NYU Press, 1995); Andrea Dworkin, *Pornography: Men Possessing Women* (New York: Perigee, 1981); Catherine MacKinnon, *Toward a Feminist Theory of the State* (Cambridge: Harvard University Press, 1989).

5. See Carole Vance, ed., *Pleasure and Danger; Exploring Female Sexuality,* Boston: Routledge & Kegan Paul, 1984); Ann Snitow, Christine Stansell, and Sharon Thompson, eds., *Powers of Desire: The Politics of Sexuality* (New York: Monthly Review Press, 1983); and Lisa Duggan and Nan D. Hunter, *Sex Wars: Sexual Dissent and Political Culture* (New York: Routledge, 1995) for sex-radical feminist perspectives on those debates.

6. Gayle Rubin, "Thinking Sex: Notes for a Radical Theory of the Politics of Sexuality," in Vance, *Pleasure and Danger*, p. 307.

7. Examples of this kind of work include: Mary McIntosh, "The Homosexual Role," *Social Problems,* vol. 16, no. 2 (Fall 1968); Jeffrey Weeks, *Coming Out* (New York: Quartet, 1977); Foucault, *A History of Sexuality*; Adrienne Rich, "Compulsory Heterosexuality and Lesbian Existence," *Blood, Bread, and Poetry* (New York: Virago Press, 1986); Monique Wittig, "One Is Not Born a Woman," in *The Straight Mind,* (Boston: Beacon Press, 1981).

8. Lisa Duggan, "Making it Perfectly Queer," *Socialist Review,* vol. 22, no. 1 (January–March, 1992), pg. 20. Queer Nation is an example of a group that adheres to the first model of queer politics. The second model is more diffuse, attached more to subcultures than to specific organizations. For additional considerations of "queer" as a political and theoretical term, see the introductions to Michael Warner, ed., *Fear of a Queer Planet* (Minneapolis: University of Minnesota Press, 1993); and Henry Abelove, Michele Barale, and David Halperin, eds., *The Lesbian and Gay Studies Reader* (New York and London: Routledge, 1993).

9. See especially: Joan Nestle, "Lesbians and Prostitutes: A Historical Sisterhood," in Delacoste and Alexander, *Sex Work.* See also Joan Nestle, ed., *The Persistent Desire: A Femme-Butch Reader*; Elizabeth Kennedy and Madeline Davis, *Boots of Leather, Slippers of Gold* (New York: Penguin Books, 1994); and Leslie Feinberg, *Stone Butch Blues* (Ithaca, NY: Firebrand Books, 1993).

10. For an overview of the international sex workers' rights movement, see Gail Pheterson, ed., *A Vindication of the Rights of Whores* (Seattle: Seal Press, 1989).

11. Mimi=Freed, "Nobody's Victim," *10 Percent* (Summer 1993): 53.

12. Hima B., *Straight for the Money,* 1994.

13. See Diana Fuss, ed., *Inside/Out* (New York and London: Routledge, 1991); and Warner, ed., *Fear of a Queer Planet*; for collections that address questions of identity and performance in relation to homosexuality.

14. Christina Kelly, "Bonding With Our Topless Sisters," *Sassy* (August 1992): 115.

15. Jenny Silverman, "Topless Dancing: Why I Do It, Why I Like It," *Glamour* (April 1993); p. 281.

16. One such story is told by Norma Jean Almodovar in *Cop to Call Girl: Why I Left the LAPD* (New York: Avon Books, 1993). See also Delacoste and Alexander, *Sex Work.*

17. Carol Leigh, "Cheap," in Rodney Sappington and Tyler Stallings, eds., *Uncontrollable Bodies* (Seattle: Bay Press, 1994), p. 343.

18. Luce Irigaray, *This Sex Which Is Not One* (Ithaca, NY: Cornell University Press, 1985), p. 76.

19. The relationship of men to paid sex is beyond the scope of this paper. However, some of the complexities of men's reaction to the exchange are touched upon in sex workers' writings. See Almodovar, *Cop to Call Girl* and Delacoste and Alexander, *Sex Work.*

20. Judith Butler, *Bodies That Matter* (New York and London: Routledge, 1993), p. 241.

21. Madeline D'Anthony, private conversation, 1993.

Feminism, Sex Workers, and Human Rights

PRISCILLA ALEXANDER

THERE IS A MAJOR SCHISM IN THE WOMEN'S MOVEMENT over the issue of sexuality, particularly the commercial *representation* and *action* of sex (i.e., pornography and prostitution). The hegemonic stance is that of Andrea Dworkin and Catharine MacKinnon, authors of legislation permitting women (and "men who are like women") to sue for damages if they believe they have been "harmed by pornography." In turn, the antipornography ordinances, which have been found to be unconstitutional, have inspired some antiprostitution feminists to draft laws giving the same right to civil action to women "harmed by prostitution," laws that were enacted in Florida and Minnesota.[1] The ideology underpinning both legal constructs is that pornography causes rape, prostitution is rape, and that women are inherently incapable of consent.

Organizations as WHISPER[2] and the Coalition Against Trafficking in Women[3] aim to abolish prostitution as organized gang rape and a violation of women's human rights. Although these groups say prostitutes should not be arrested or jailed, they want to increase the weight of the law on clients and managers of prostitution (pimps, madams, landlords), including women who have moved up the ranks. They deny the existence of "voluntary" prostitution, define all prostitutes as passive, helpless, degraded victims, and contend that any prostitute who claims otherwise is "brainwashed" or has a "false consciousness." I used to think that the terms they use—such as "degraded," "dehumanized," and "debased"—originated with these organizations. However, an all-male commission that studied prostitution at the end of the nineteenth century used those same terms to describe prostitutes and prostitution, as did the patriarchs who wrote the Torah.[4] Although the abolitionist-feminists don't challenge the self-representations of other oppressed women, such as lesbians or African American women, they turn away as soon as the women are "prostitutes." Like their patriarchal forebears and their uneasy allies in the religious Right, they seek to control the woman who is out of control instead of fighting the enormous weight of patriarchal law that assaults her. In doing so, they have internalized the universal hatred of women and named the sexually assertive woman, the "whore," as the cause of women's pain.[5]

The countervalent discourse is rooted in two parts of the women's movement: sex workers' rights and pro-sex feminism. The first is a loose coalition of sex workers' rights organizations in industrial and industrializing countries.[6] The second involves feminists active in the fight against censorship of sexually explicit materials—some workers in the industry, some from the broader feminist community.[7]

This essay looks at the divided concepts of human rights as they relate to prostitution. The antiprostitution feminists define prostitution per se as a violation of (women's) human rights. The sex workers' rights movement defines state repression of prostitutes as the human rights violation. I focus on female prostitution because I am writing about a feminist response to it, and because the world has defined the prostitute as female in centuries of discourse.

Human Rights Defined

The concept of human rights was developed by philosophers in the seventeenth and eighteenth centuries, through discourse that led to the American and French revolutions, as a rational belief system that could protect individuals from the often despotic incursions of the state. Violations of human rights are thus *actions of the state,* and unless a state authorizes and organizes or is officially blind to a crime, it is not strictly a human rights violation. The execution of Nigerian author and activist Ken Saro-Wiwa was a violation of human rights. The rapes committed by Serbian forces in Bosnia, the American army in Vietnam, and the German and Japanese armies during World War II were violations of human rights. Police brutality, including the extortion of money and "free" sex from prostitutes, is a violation of human rights, as is the police refusal to investigate when prostitutes are raped and murdered. The actions of individuals and organizations outside of the state may constitute egregious crimes, but they are not violations of human rights.

Why Is This Issue Important?

I believe that as long as women are arrested for the crime of being sexually assertive, for standing on the street without a socially acceptable purpose or a male chaperone, I am not free. As a woman and a feminist, I believe we will never have rights, opportunities, choices, work options, or an income equivalent to men's unless we can stop being afraid of being either raped or called "whore." As women, we must watch where and how we walk, talk, and dress, lest someone mistake (or claim to have mistaken) our intent. We know that if we are raped, to the degree that they think we are neither a virgin daughter nor a chaste wife, police, prosecutors, judges, and juries may be likely to deny that the crime has taken place. In the United States, only 19.2 percent of reported rapes end in a conviction, and only 16.5 percent find the perpetrator incarcerated.[8] In thirteenth-century China, laws distinguished between the rape of a prostitute (50 demerits), a wife (500 demerits), a widow or virgin (1,000

demerits), and a nun ("demerits too numerous to count").[9] When some rape is thus condoned, it is as if many of us have no right to say no to any sexual act.

Yet in a way, we have no right to say yes either, because the whore label, the whore stigma, and the laws against prostitution—the setting of financial terms for sex—come at us another way.[10] They deny us the right to signal an interest in sex, initiate sex, or agree to have sex if we set economic terms for it. Although on their face the laws refer only to the explicit exchange of sex and money, police do sometimes arrest women who are not prostitutes but who *seem* to be prostitutes because of what they are wearing or because they are in an area where prostitutes are *known* to contact customers. The laws reinforce age-old conventions regarding female display and behavior, laws that I believe have a chilling effect on all women.

Entrapment: Ignorance Is No Excuse for a Law

Virtually every prostitution arrest is made by an undercover officer masquerading as a client or prostitute, searching for people who will trust him or her enough to talk about sex, money, and perhaps condoms.[11] "Vice" control is often the largest line item in metropolitan police department budgets. It is one of the least dangerous assignments on the police force, since prostitutes rarely carry a weapon. Male decoys drive unmarked cars through stroll districts inviting women to get in, walk down the street soliciting those they think are prostitutes, or sit in hotel rooms calling to ask escort services to send women to see them. Female decoys stand on the street looking for men willing to pay for sex. Even in states that have not criminalized "agreement" to engage in prostitution, police often make the solicitation, although they describe the transaction differently in court. Women have been arrested for soliciting while walking home from the grocery store or while waiting for a bus.

Many states have made it a crime to loiter "with intent to commit prostitution" or "for the purpose" thereof. Such laws define anyone with a prior prostitution arrest as a "known" or "common" prostitute, turning the *act* of standing into the *status* offense of *being* a prostitute. The term "common" doesn't mean "ordinary," but instead that, as a prostitute, a woman is assumed to be "held in common," owned by, and accessible to any or all men, rather than the chattel of one. Indeed, the prostitute's primary offense is that she is polyandrous in a polygynous world. She is the actor in having multiple partners, yet patriarchal society defines her as shared by many, denying her agency, just as the abolitionists do, although to the abolitionists, she continues to be the chattel of one: the stereotyped "pimp" who "coerces" her to be available to the many.

Some Numbers

In the United States, prostitution arrests represent a small proportion of the total number of arrests in a given year (0.4 percent of men and 2.6 percent of women arrested in 1994). However, if one only looks at crimes in which the

complaining witness is an undercover cop (such as gambling, possession or sale of drugs, prostitution, or other consensual sex offenses), prostitution accounts for 3.2 percent of the men arrested but 21.9 percent of the women. Since I began monitoring arrest statistics in the early 1980s, prostitution and "runaway status" (often a surrogate charge for prostitution) have been the only crimes for which more women than men are arrested.[12]

Although it is true that most prostitutes are women (70–80 percent), there are five to eight times as many clients as prostitutes on any given day, most of them male. Thus, if the arrests were not discriminatory, far more men than women would be arrested. While the male portion of prostitution arrests rose from 20.7 percent in 1970 to 38.6 percent in 1994,[13] the increase is more symbolic than real since, to be equitable, five to eight times as many men as women would have to be arrested. Although a few trial court judges have declared prostitution laws unconstitutional on the basis of discriminatory enforcement, higher state courts have reversed them. In a landmark case in Oakland, California, the court held that the practice of using male rather than female decoys constituted a "sexually *unbiased* policy of concentrating . . . enforcement . . . on the *profiteer,* rather than the *customer*" [italics mine]; that pretrial incarceration of prostitutes but not clients was constitutional because clients had roots in the community (e.g., carried proper identification, had a legal job, had no prior arrest record), while prostitutes did not; and that the practice of quarantining prostitutes but not clients was constitutional because "the prostitutes were more likely than their customers to communicate venereal diseases."[14]

Prostitutes and Human Rights: Some History

Prostitutes' human rights have long been violated by agencies—police and public health—charged with protecting people from harm. The desire to isolate the prostitute, to wall her off from the rest of society, goes back almost to the origins of what we call "civilization." Early Sumerian texts, written around 4,000 years ago, described prostitutes as wise women, able to educate, civilize, and tame men. But as men took over the early city states, they separated harlots—often poets, teachers, musicians, dancers, and priestesses—from other women. One of the oldest sumptuary laws, written around 1250 B.C.E., required "wives" to walk veiled in the street. Although Sumerian lawmakers permitted concubines to veil themselves if they lived with a man and his family, they prohibited the independent prostitute from doing so, threatening to take all her clothes, pour pitch on her head, and punish any man who knowingly walked with her.[15] In medieval France, an endless series of laws prescribed prostitutes' dress, or symbols on their dress, to distinguish them from the good women, whom they admonished not to dress like whores. Medieval lawmakers also allowed prostitutes on one street for a while, then forced them to move to another. Sometimes these streets were inside, sometimes outside the city wall. Sometimes authorities required women to work alone, one woman to a house, while at other times they made them work in groups with

a manager. Whenever laws have become more repressive, the management of prostitution has moved from the hands of women to the hands of men, and vice versa, down through the ages to our own time.[16]

Occasionally governments wrote laws designed to protect prostitutes from exploitation and abuse by madams and other managers, but the overwhelming weight of the law has pressed on the prostitutes, routinely described as "disorderly," "vagrant," "parasitic," "dirty," "dangerous," and "diseased."

Regulate the Prostitute/Protect the Client

Since the late fifteenth century syphilis epidemic, government officials have been defining female prostitutes as "vectors" for the transmission of diseases to clients (and clients' wives and children), as they do today with AIDS. However, it was not until the late eighteenth and early nineteenth centuries that France established the first mandatory health examinations in a system of regulated prostitutes and "tolerated" brothels, which survived monarchist, republican, democratic, and fascist governments and was only dismantled after World War II, in 1946. Under this system, regulations governed where brothels should be and how far apart, and required women to remain indoors behind shuttered or curtained windows except at specified hours, when they could walk outside in specified places. The women had to "voluntarily" register with the morals squad or face arrest and forced inscription, and many who were not prostitutes were forcibly inscribed. They also had to undergo regular vaginal examinations in the brothels where they worked or in special dispensaries. If they avoided the examinations, they could be arrested and jailed; if they were diagnosed with an infection, they were quarantined in specialized, prisonlike hospital wards. It was far from a system of toleration of the prostitutes, since the morals squad hounded them, the examinations were brutal (feminists called them "speculum rape") and unsanitary, and the government could decide, at whim, to tolerate the houses or close them, to register, examine, and quarantine the women or arrest them for "unseemly" conduct.[17]

In the 1860s, Italy and England introduced variants of the French *reglementation* system. The Italian system was implemented without formal legislation in the newly reunified republic and persisted through many changes in government until after World War II.[18] In England, on the other hand, there was strong feminist resistance to the Contagious Diseases Acts, which Parliament enacted to protect the health of "innocent" military conscripts. Parliament first introduced them in a small number of port cities in 1864, extending them to additional cities in 1866 and 1869, when the incidence of disease among the conscripts remained high. Feminists objected to the Acts because they felt that the system institutionalized prostitution, labeled women engaged in informal sex trading as "prostitutes," narrowing their ability to do anything else, and subjected them to brutal examinations. Feminist resistance induced Parliament to repeal the Acts in 1886, but unfortunately the solidarity the feminists felt with prostitutes faded after repeal.[19] Few reacted when more punitive

approaches were devised, and Josephine Butler, the movement's leader, worried that the agenda had shifted from antiregulation to antiprostitute.

In Scotland, officials chose not to legitimize prostitution, although they nested the same actions inside the prohibition. They funneled women into "magdalene" homes, "reformatories," and "penitentiaries" to "repent of their sins," wash clothes to pay for their keep, and prepare for work as domestic servants.[20] As one historian pointed out, the system was "more than just a vehicle for controlling venereal disease; it was also a system for controlling prostitution and a means of containing street disorder and intervening in the lives of the 'unrespectable' poor."[21]

Although the regulations neither prevented nor controlled the spread of venereal diseases among prostitutes or clients, many other countries copied them, while Britain transplanted the scheme to its colonies in an attempt to protect the British occupation's military and civil servants.[22] In the nineteenth century, sporadic attempts to institute the system in the United States (e.g., from 1870–1874 in St. Louis, Missouri) collapsed when residents strenuously opposed them. Brothels and brothel districts, on the other hand, flourished, tolerated by police—who were often well paid for their tolerance. That tolerance ended in the first decades of this century, when one city after another closed its brothel district (again, to protect "innocent" soldiers). When that failed to control either venereal disease or prostitution, one state after another outlawed prostitution entirely; some began to test those arrested for prostitution (e.g., New York's 1910 Page Law), and by the 1970s, many states did so.[23] In 1973, COYOTE (Call Off Your Old Tired Ethics, a prostitutes' rights, advocacy, and support organization) successfully pressured the San Francisco Sheriff's Department to stop testing arrested women for sexually transmitted diseases and forcing them to choose between taking antibiotics immediately and getting out of jail, or remaining in jail for two weeks until the results came back.[24]

In the 1980s, as it became clear that AIDS could be sexually transmitted, epidemiologists again defined female prostitutes as a "reservoir of infection," a "vector," a "core group of high frequency transmitters." Twenty-one states passed laws requiring HIV tests of anyone convicted—or, in some cases, merely arrested—on prostitution charges. Eleven also increased prostitution to a felony for those arrested after testing positive.[25] In California, felony prostitution carries a minimum sentence of three years in state prison, compared with forty-five days to a year in the city jail for misdemeanor prostitution. In 1989, one woman was serving a ten-year sentence in Nevada; under a similar law, another had been sentenced to twenty years.

These laws are intended to protect clients from prostitutes, not safeguard prostitutes' health, so it is important to understand who is actually at risk. A multicenter, collaborative study of the epidemiology of HIV infection among female prostitutes in the United States found significant rates of infection among some groups, and no infection in others, depending on where and how they worked and whether they injected drugs. The highest prevalence was

among street prostitutes working in Newark, 94.2 percent of whom injected drugs and 47.5 percent of whom were infected with HIV (58.3 percent of injectors, 18.6 percent of noninjectors). In San Francisco, where 47.6 percent of the women injected drugs, 4.7 percent were infected (9.9 percent of injectors, none of the non-injectors). In Nevada, 27 percent of the women studied had a history of injecting drugs, but none tested positive.[26] Later studies in the United States and other industrial countries have confirmed this pattern.

No U.S. study has found significant rates of infection among men who report sex with a female prostitute as their only risk factor.[27] There are several factors to account for this. First, female-to-male transmission is less efficient than the reverse, as is true for all STDs. Second, fellatio and hand-genital contact, both of which carry a lower risk of transmission in either direction than vaginal and anal sex, are the norm for street-level transactions, which is where the prevalence of HIV infection is greatest. Moreover, most prostitutes work off the street, where the prevalence of HIV infection has been negligible to nonexistent in industrialized countries, and where condom use has become standard practice. It is not that prostitutes are not at risk for HIV infection; it is that the risk has primarily been associated with either their own or their personal sex partners' drug injection and needle sharing, not prostitution per se, and that the risk is similar to the risk of other women with the same socioeconomic status.[28]

Some studies have found high rates of infection among women who smoke crack cocaine and perform fellatio, however, because burns and cuts around the mouth from smoking leave an easy entry point for the virus, especially if they don't use condoms when they are high, drug sick, desperate for money, or threatened with violence.[29]

In many states, police and prosecutors have tried to prosecute some sexually active people with HIV for attempted murder and/or reckless endangerment. The way police—and the press—have dealt with this issue is illustrative of how ideas of women as polluters and contaminators play out. When police arrest men on HIV-related charges, it is usually for having lied about their HIV status, refused to use condoms, and infected one or more women. When police arrest female prostitutes, however, it is often only for having continued to stand on street corners, or talk about sex acts and money with undercover officers, after becoming infected.[30] Neither police, prosecutors, nor journalists covering these cases mention condoms nor whether the women have even engaged in any practices that could facilitate the transmission of the virus. Nor do they mention the low efficiency of female-to-male transmission in the first place, even without protection. That is, heterosexual transmission is overwhelmingly male-to-female, yet the panic is in the other direction.

The Activist Response to AIDS

Sex workers' rights organizations became involved early on in alerting their colleagues to the need to use condoms. In 1987, members of COYOTE put

together a street outreach project, California Prostitute's Education Project (CAL-PEP) with a small grant from the state of California. Organizations in Canada, Mexico, Brazil, the Netherlands, Germany, Australia, and New Zealand did the same, in some cases combined with drop-in centers, also with government funding. While focusing on safer sex and drug use practices, many projects have also offered a range of services for prostitutes, fought proposals for mandatory testing, and pressured their governments for legislative reform.[31]

As for the abolitionists, Kathleen Barry writes, "The receptivity of the sexual-liberal public in the West to the promotion of prostitution, the tendency for some countries to treat prostitution as *a form of work like any other,* correlates with the escalation of AIDS and women becoming the highest-risk group" [italics mine].[32] She thinks it is wrong to promote condom use among prostitutes because, she says, since condoms sometimes fail, giving them condoms increases the women's risk. "AIDS prevention, which should be oriented toward getting women out of prostitution," she concludes, "is reduced to massive marketing of condoms to keep the sex industry and condom manufacturers going."[33]

Barry's recommendation that we cease promoting condoms and instead rescue women from prostitution is not only absurd, it is genocidal for the women who continue to work as prostitutes. The prostitutes who are the most vulnerable to HIV infection are usually the poorest women with the worst working conditions, which are conditions most countries ignore. Because no country treats prostitution as a "form of work like any other," none has used such tools as occupational safety and health regulations to improve prostitutes' working conditions. That is, although some countries have legalized and regulated some forms of prostitution, usually the legalized prostitutes pay taxes but are denied benefits other taxpayers receive, such as health insurance and social security. Meanwhile, as the industrialized economies continue to tumble, more people turn to formal or informal prostitution to survive; if they have and are able to use condoms, they may live long enough to make other choices.

Migration vs. Trafficking

Abolitionists consider all prostitution and all migration associated with prostitution to be "trafficking," and all "trafficking" to be for the purposes of prostitution. They ignore the much larger realm of indentured or slave labor in, for example, garment industry sweat shops, toy and oriental carpet factories, and restaurants, in this country and abroad. They focus on "trafficking" in order to frame prostitution as a cross between forced labor and rape, and to present prostitutes as passive bodies, victims who must be rescued. However, women, like men, migrate from farms to cities, from one country to another, often fleeing both poverty and traditional restraints as they have for centuries. Some, perhaps many, are prepared to work as prostitutes, although they expect a

negotiated, time-specific contract, not the captive labor with endlessly increasing indebtedness characteristic of underground and unregulated debt bondage. Rather than protecting women from forced prostitution, however, laws restricting migration and prohibiting prostitution create the perfect conditions for trafficking to flourish.

Virtually every country in the world has laws on the books against pimping, pandering, procuring, promoting prostitution, encouraging someone to work as a prostitute, running a disorderly house, etc. Moreover, although soliciting or engaging in prostitution is usually classified as a relatively minor offense, many countries bar prostitutes from legally entering the country as a tourist or immigrant, even if the prostitution took place long before. Under U.S. immigration law, anyone who has worked within ten years of applying, whether legally or illegally, arrested or not, can be barred from entry, denied a visa or residence permit, or deported. With other crimes, migrants can be excluded only if they were convicted of an offense, either within the previous five years or repeatedly.[34] As for migration within the country, in 1910 the U.S. Congress made it a crime for one person to transport another across state lines for the purpose of prostitution. Although the Mann Act was inconsistently enforced (and often used against noncommercial and/or mixed-race relationships), it remains on the books, ready to use against prostitutes who cross state borders.[35] Some other countries, for example Japan, bar prostitutes from official entry, while they issue so-called artists' visas to women who have been hired to work in red-light district bars and clubs.

Robin Morgan says women should stop migrating from farms to avoid being caught up in trafficking and prostitution.[36] The Coalition Against Trafficking in Women, founded by Barry and now codirected by Janice Raymond and Dorchen Leidholdt,[37] contends that it is "regulation" of prostitution that causes the migration of poor women and "trafficking." The Coalition wants to criminalize and punish the clients as well as tighten the enforcement of laws against trafficking, running sex-work businesses, promoting prostitution, and living off the earnings of a prostitute. Without drastic changes in society, however, it is unlikely that any government will use such laws in the way the Coalition envisions.

Moreover, I interpret the relationship between the legal status of prostitution and trafficking quite differently. When it is illegal to migrate to work as a prostitute, those who migrate have to say they will do something else. If it is difficult or impossible to get working papers, migrants may only be able to work underground in illegal establishments, whether as prostitutes, garment workers, or in some other trade. The managers of illegal businesses are people willing to risk arrest, some of whom have no qualms about using violence and extortion to control their employees. If prostitution were an above-ground occupation, and if immigrant sex workers could obtain work permits *on the same basis as other immigrant workers,* then it would be easier to change the context within which prostitution takes place.

Human-Rights Violations are State Crimes

Human-rights violations committed by the state consist of both actions and failures to act. In Kenya, for example, police arrest a woman when a man they have never seen before identifies her as the source of his sexually transmitted disease, but they refuse to act if a woman tries to report a rape. In Nevada, prostitutes are not allowed to live outside of the brothels where they work legally, nor to leave them without a chaperone or pass. In Germany, prostitutes are forbidden to obtain health insurance, even as they are required to submit to regular STD examinations; judges refuse to enforce contracts on behalf of prostitutes whom they deem immoral but are quite willing to act on behalf of clients. In the Netherlands, one of the least repressive countries, a proposed law would permit residents of the new European Community, and possibly Eastern Europe (i.e., mostly white women) to work legally in regulated brothels, but not allow those from outside the EC—women from Africa, Asia, and Latin America (i.e., mostly women of color) to do so.

Police, prosecutors, and judges all too often believe that a prostitute, by definition, cannot be raped, and refuse to enforce the law when one is. When prostitutes are murdered, police make little effort to find the killer unless or until he kills someone who is not a prostitute. Far too often, the murders go unsolved, even unacknowledged.[38]

Societies tolerate this blatantly discriminatory, random, and corrupt use (or non-use) of the law because they define prostitutes as outside of the common law, entitled to no human rights protections. In the United States, prostitution laws remain on the books and are intensively enforced on the street, while most other laws dealing with mutually voluntary adult sex have been repealed, declared unconstitutional, or are ignored,[39] and many other countries continue to register and test prostitutes in order to protect others from them—not to keep the prostitutes healthy.

There are some days when I feel overwhelmed by the woman-hatred that shores up these policies and practices. In every century, on every continent, in every country, societies use such measures to control women who dare to step outside of the normative role of virgin daughter/chaste wife. Although the stigma and repression have been greater in some times and places than others, they have never been absent. I have trouble understanding why—in the face of all the documentation provided by individual sex workers and sex workers' rights organizations to show the enormous cost to them, and to society, of the continued enforcement of laws prohibiting prostitution—anti-*prostitution* activists are calling for greater enforcement of those laws. I can only conclude that they, like most of society, are anti-*prostitute.*

What Do Prostitutes Want?

Sex workers' rights organizations are active in many countries, including Australia, Brazil, Canada, Germany, India, Indonesia, Italy, Mexico, Nepal, the Netherlands, New Zealand, Norway, Peru, the Philippines, Senegal, Thailand,

the United Kingdom, and Uruguay. Although the context of prostitution differs from one place to another, prostitute activists everywhere are adamant about distinguishing *forced* from *voluntary* prostitution or, as the 1st World Whores Congress put it, "adult prostitution resulting from individual decision."[40] Adult prostitutes are concerned about adolescents and children turning to sex work to survive or being pressured to do so by parents and brokers. Prostitutes who work for third parties want limits on the proportion of income managers take, since they, like other workers, are often exploited, paid far too little, and denied adequate benefits. Prostitutes want clean and safe places to work with the absolute right to refuse to engage in unsafe sex practices. All these demands could be addressed through occupational safety and health regulations and child labor laws.

Prostitutes also want the right to choose whether to work on their own or with other sex workers, collectively or with a manager. They want the right to form professional associations or to organize unions when they work for others—actions that current law defines as illegal pimping, pandering, procuring, or "encouraging someone to work as a prostitute," and which the abolitionists define as "coercion." Prostitutes want access to training—to prevent sexually transmitted diseases, detect and avoid or exert control over dangerous clients, defend themselves if attacked, and reduce other occupational safety and health hazards. Existing law classifies such training as a felony. Prostitutes want the right to travel across state and national boundaries and to obtain work permits on the same basis as other immigrant workers. Perhaps most of all, they want the laws against coercion—including rape and other sexual or physical assault, kidnapping, extortion, false imprisonment, and fraud—enforced against their abusers.

Human-rights violations are not individual crimes committed by "bad guys" outside on the street, be they clients, lovers, pimps, or vigilantes; they are crimes of commission and omission perpetrated by bad guys inside legislatures, police departments, and sometimes public health departments and ministries. If we want to make life safer for women who work as prostitutes, we must make sex work amenable to the same kinds of regulations that have reduced the harm to workers in coal mines, textile and garment industry factories, construction sites, chemical and nuclear plants, and other sometimes hazardous work sites. And to do that, we must bring prostitution, sexual labor, above ground.

Notes

1. These laws give women the right to sue if they were coerced into working as a prostitute. Unfortunately, they include offers of money, legal assistance, or unionization as examples of "coercion," indistinguishable under their law from rape, physical assault, kidnapping, false imprisonment, and extortion.

2. See Sarah Wynter (aka Evelina Giobbe), "WHISPER: Women Hurt in Systems of Prostitution Engaged in Revolt," in Frederique Delacoste and Priscilla Alexander, eds., *Sex Work: Writings by Women in the Sex Industry* (San Francisco: Cleis Press, 1987), pp. 266–70; Evelina Giobbe, "Prostitution: Buying the Right to Rape," in Ann Wolbert Burgess, ed., *Rape and Sexual Assault III: A Research Handbook* (New York: Garland Press, 1991); Jane Anthony, "Prostitution as 'Choice,'" *Ms.* (January/February 1992); 86–87.

3. See Kathleen Barry, *Female Sexual Slavery* (Prentice Hall, 1979; Avon, 1981); Kathleen Barry, Charlotte Bunch, and Shirley Castley, eds., *International Feminism: Networking Against Female Sexual Slavery* (New York: The International Women's Tribune Centre, 1984); Kathleen Barry, *The Prostitution of Sexuality: The Global Exploitation of Women* (New York: New York University Press, 1995).

4. Committee of Fifteen, *The Social Evil,* ed. Edwin R.A. Seligman (New York: G.P. Putnam's Sons, 1902, 1912).

5. See Christine Overall, "What's Wrong with Prostitution? Evaluating Sex Work," *Signs* (Summer 1992) 705–22. "Leviticus," 19.29, *Tanakh: The Holy Scriptures* (Philadelphia: The Jewish Publication Society, 1985).

6. See Gail Pheterson, ed., *A Vindication of the Rights of Whores* (Seattle: Seal Press, 1989), which includes the proceedings of the Second World Whores Congress, organized by the International Committee for Prostitutes' Rights, held in Brussels in 1986. A European congress was held in Frankfurt, Germany, in 1991, with the first participation of sex workers from Eastern Europe. The Global Alliance Against Trafficking in Women, based in Thailand, was founded by organizations that work with migrant women and/or on the issue of slavery from a sex workers' rights perspective.

7. See Lisa Duggan and Nan D. Hunter, *Sex Wars: Sexual Dissent and Political Culture* (New York: Routledge, 1995); Ann Snitow, Christine Stansell, and Sharon Thompson, eds., *Powers of Desire: The Politics of Sexuality,* (New York: Monthly Review Press, 1983); and Carole S. Vance, ed., *Pleasure and Danger: Exploring Female Sexuality* (Boston: Routledge & Kegan Paul, 1984).

8. Kathleen Maguire and Ann L. Pastore, eds., *Sourcebook of Criminal Justice Statistics 1993.* U.S. Department of Justice, Bureau of Justice Statistics. (Washington, DC: U.S. GPO, 1994), pp. 246, 418, 430, 536.

9. Reay Tannahill, *Sex in History* (New York: Scarborough, 1980, 1982), p. 196.

10. Gail Pheterson, *The Whore Stigma: Female Dishonor and Male Unworthiness* (Den Haag: Ministry of Social Affairs and Employment, 1986). See also, Gail Pheterson, "The Social Consequences of Unchastity," in Delacoste and Alexander, *Sex Work,* pp. 215–30, and Gail Pheterson, "The Whore Stigma: Crimes of Unchastity," in *The Prostitution Prism* (Amsterdam: Amsterdam University Press, 1996), pp. 65–89.

11. The practice of confiscating condoms during an arrest is still common in such disparate cities as New York, London, and Bombay, as it was as far into the AIDS pandemic as 1994 in San Francisco.

12. Federal Bureau of Investigation, *Uniform Crime Reports* (Washington, DC: U.S. GPO, 1995), pp. 225, 226. Prostitution-related arrests include soliciting/engaging, patronizing, and managing/receiving income from a prostitute. In 1994, of 85,783 people arrested for prostitution, 997 were under the age of 18. Another 101,816 people were charged with curfew/loitering arrests and 151,899 with being a runaway, all of whom were under 18 (pp. 226, 283).

13. Ibid., p. 283.

14. *People v. Superior Court*, 19 Cal. 3d 338, 63 P.2d 1315 (1977). This contrasts sharply with the reasoning of an earlier state court that in 1920, as women were fighting for the right to vote, held that the discriminatory imposition of penalties was, indeed, discriminatory, as "[T]he men create the market, and the women who supply the demand pay the penalty" (*People v. Edwards*, 180 N.Y.S. 531, 534 [1920]).

15. Gerda Lerner, *The Creation of Patriarchy* (New York: Oxford University Press, 1986), pp. 193, 123–40. The legends concerning Enkidu's education by a harlot may have been the origin of the creation legend of Jewish, Christian, and Islamic history. After all, it was Eve who was curious—the researcher—not Adam.

16. Leah Lydia Otis, *Prostitution and Medieval Society: The History of an Urban Institution in Languedoc* (Chicago: The University of Chicago Press, 1985).

17. Physicians used one speculum to examine many women in succession. It was rather a miracle if any women in the system did not become infected, although some of them never did. Jill Harsin, *Policing Prostitution in Nineteenth Century Paris.* (Princeton, NJ: Princeton University Press, 1985). See also Alain Corbin, *Women for Hire: Prostitution and Sexuality in France after 1850*, trans. by Alan Sheridan (Cambridge: Harvard University Press, 1990).

18. Mary Gibson, *Prostitution and the State in Italy, 1860–1915* (New Brunswick, NJ: Rutgers University Press, 1986).

19. Judith R. Walkowitz, *Prostitution and Victorian Society: Women, Class, and the State* (Cambridge: Cambridge University Press, 1980); Richard Davenport-Hines, *Sex, Death and Punishment: Attitudes to Sex and Sexuality in Britain Since the Renaissance* (London: Fontana Press/HarperCollins, 1990).

20. Not surprisingly, many women managed to escape the rescue operations, climbing through windows and over high walls. See Linda Mahood, "The Domestication of 'Fallen' Women," in *The Magdalenes: Prostitution in the Nineteenth Century* (London: Routledge, 1990), pp. 75–102.

21. Ibid., p. 141.

22. See Abraham Flexner, *Prostitution in Europe*, (introduction by John D. Rockefeller, Jr.) (New York: The Century Co., 1914) for a thorough examination of the systems in different countries in the early part of this century; and Ronald Hyam, *Empire and Sexuality: The British Experience* (Manchester: Manchester University Press, 1990, 1991, 1992), for a look at colonial practices. Today, Austria, Poland, Singapore, Indonesia, Thailand, the Philippines, parts of Kenya and Germany, as well as the state of Nevada maintain similar systems, in some cases declaring

prostitution to be legal for those prostitutes who submit, in others maintaining the prohibition.

23. See, for example, Allan M. Brandt, *No Magic Bullet: A Social History of Venereal Disease in the United States Since 1880.* (New York: Oxford University Press, 1985) (paperback, 1987). See also Ruth Rosen, *The Lost Sisterhood: Prostitution in America, 1900–1918* (Baltimore: Johns Hopkins University Press, 1982); and Mark Thomas Connelly, *The Response to Prostitution in the Progressive Era* (Chapel Hill, NC: University of North Carolina Press, 1980).

24. The U.S. military practice in Vietnam of giving prostitutes antibiotics on a regular basis to "protect" the soldiers contributed to the development of penicillin-resistant gonorrhea in the early 1970s.

25. Lisa Bowleg, AIDS Policy Center, Intergovernmental Health Policy Project, George Washington University, personal communication, January 1994.

26. William Darrow and the Centers for Disease Control Collaborative Group for the Study of HIV-1 in Selected Women, "Prostitution, Intravenous Drug Use, and HIV-1 in the United States," in Martin Plant, ed., *AIDS, Drugs, & Prostitution* (London: Routledge, 1990), p. 28, table 2.2. See also P. Estebanez, K. Fitch, R. Najera, "HIV and Female Sex Workers," *Bulletin of the World Health Organization* (1993) 71 (3/4): 397–412; Judith B. Cohen and Priscilla Alexander, "Female Sex Workers: Scapegoats in the AIDS Epidemic," in Anne O'Leary and Loretta Sweet Jemmott, eds., *Women at Risk: Issues in the Primary Prevention of AIDS* (New York: Plenum, 1995).

27. Kenneth G. Castro, et al., "Investigations of AIDS Patients with No Previously Identified Risk Factors," *Journal of the American Medical Association*, March 4, 1988, 259 (9) :1338–42. See also, Centers for Disease Control and Prevention, HIV/AIDS Surveillance Report (October 1993) 5 (3) :17.

28. Darrow, "Prostitution, Intravenous Drug Use, and HIV-1," p. 29.

29. J. I. Wallace, A. Weiner, A. Steinberg, and B. Hoffman, "Fellatio Is a Significant Risk Behavior for Acquiring AIDS among New York City Streetwalking Prostitutes," International Conference on AIDS, Amsterdam, 1992 (abstract no. PoC 4196).

30. "Prostitute: HIV Did Not Deter Her," *Philadelphia Inquirer*, April 23, 1994, p. B3; "HIV Prostitute," Associated Press, 14 March 1994. See also, Donald E. Woodhouse, Lovice Riffe, John B. Muth, John J. Potterat, "Restriction of Personal Behavior: Case Studies on Legal Measures to Protect the Public Health," *International Conference on AIDS,* 1992 (abstract PoD 5443).

31. See my article, "Sex Workers Fight Against AIDS: An International Perspective," in Beth E. Schneider and Nancy Stoller, eds., *Women Resisting AIDS: Strategies of Empowerment* (Philadelphia: Temple University Press, 1995).

32. Barry, *The Prostitution of Sexuality*, p. 242.

33. Ibid., p. 248.

34. Title VI—Exclusion and Deportation, Public Law 601, Revision of Grounds for Exclusion, part of the omnibus revisions to the immigration law introduced by

Representative Barney Frank to end the exclusion of homosexuals. 104 STAT. 5067–5068.

35. See David J. Langum, *Crossing over the Line: Legislating Morality and the Mann Act* (Chicago: University of Chicago Press, 1994).

36. Morgan said this in a speech she delivered at the California NOW Conference, San Francisco, 1994.

37. Janice Raymond has authored controversial books on transsexualism and alternative means of reproduction, both of which she opposes. Leidholdt is an attorney who was active in Women Against Pornography, and was coordinator of services for battered women in New York City.

38. The "Hillside Strangler," in Los Angeles, who killed several "prostitutes," only became the target of a major hunt after he killed a woman who was not a prostitute. After that, women all over the city were frightened and pressured the police, who then seriously looked for and found the two killers involved. In another case, Joel Rifkin murdered seventeen women, most of whom he kidnapped from the same stroll district in New York City, and the police only acknowledged the murders after police in another jurisdiction stopped Rifkin for driving erratically, without license plates, and discovered the body of his most recent victim in the back of his truck.

39. I don't wish to minimize the threat to gay rights and decriminalized sodomy posed by the right-wing fundamentalists in this country, which is presumably a signal for an assault on all sexual rights and liberties.

40. Pheterson, *A Vindication of the Rights of Whores*, p. 40.

[9] Peepshow Feminism

TAWNYA DUDASH

Introduction

I WAS A COLLEGE STUDENT IN CONNECTICUT in 1988 when I first heard about the particular peepshow that is the focus of this article. Several women in the feminist collective to which I belonged were discussing a friend of theirs who worked as a nude dancer in San Francisco. The theatre she danced in was woman-owned and operated, and had a reputation for being more supportive, worker-friendly, and "pro-woman" than other sex entertainment establishments. In addition, the job was lucrative and flexible in terms of time. My curiosity was immediately piqued. How could it be that something so obviously degrading to women as a peepshow was gaining acceptance among my feminist peers? What kind of place was this? What would it be like to dance in a peepshow? Could I do it? What would the customers be like? Would it be as sleazy and demeaning as I had always been taught such places were?

Several years later I relocated to San Francisco and had the chance to answer some of these questions. Soon after arriving in the city, I auditioned at the infamous Lusty Lady theater and was hired despite my obvious nervousness. Before auditioning I had never set foot in such a place, and the newness of it all was overwhelming. The walls and ceiling of the stage were mirrored, and I was not used to seeing myself naked from so many angles. The customers seemed not quite real, since all I could see were their heads and shoulders peering through little windows, which were at the level of our crotches. I hadn't expected that the customers would be masturbating, and this was rather shocking at first. I was struck most, however, by the other dancers. Instead of conforming to my stereotype of sex workers as downtrodden, victimized, or helpless, I found these women to be strong and outspoken. Many were politically active and/or writers and artists, and I was dazzled by the richness and diversity I found. I was working alongside women who were straight, lesbian, and bisexual; high school graduates and multiple degree holders; women of all races and class backgrounds. Never had I seen so many naked women of such different shapes, colors, and sizes. There was a higher amount of body ease than I had ever before experienced with a group of women; the dancers seemed completely comfort-

able in their bodies and with their sexualities. I also began to notice how they interacted and what they talked about backstage, how they referred to their jobs, to men, and to their relationships with the rest of society. It became apparent that these women were constructing feminist discourses in ways that seemed much more "real" than any academic feminism I had studied. My prior experiences with feminism and sex work consisted of rather abstract discussions of pornography and censorship or the legalization of prostitution. In these discussions, the opinions of sex workers had never been included. Suddenly, however, I felt immersed in the "trenches"; the dancers I met were engaging in and *living* feminism in ways that were completely new to me.

I realized that I had stumbled into a very special world of which I had previously been entirely ignorant. I started paying close attention to the interactions among the dancers, between dancers and customers, and to my own experiences. After several months I felt the need to document what I was witnessing and experiencing. I began to interview my co-workers about their lives and work. All the women I approached for interviews were supportive and enthusiastic; many felt that sex workers are consistently misrepresented by academics and journalists from outside the industry, and I was told by several dancers that they would not consent to an interview by anyone, male or female, who was not a sex worker.

I interviewed fifteen dancers between November 1991 and September 1993. Their ages ranged from nineteen to thirty-one, with an average age of twenty-three. Ten self-identified as white, Caucasian, or European-American; two as Black or African-American; one as Latina; one as half Black and half White; and one as Black-Arab and Irish Catholic. Concerning sexual orientation, three women self-identified as heterosexual; five as "primarily" or "mostly" heterosexual; four as bisexual; two as "bi/queer"; and one woman as exclusively homosexual. These women had grown up in all regions of the United States, and most had come to California within the past several years. Four women described their socioeconomic backgrounds as upper-middle class, six as middle class, three as lower-middle class, one as working poor, and one as poor. All fifteen women had completed high school, seven either had some college education or were currently in college, one was attending a trade school, and six had undergraduate degrees.

Certain aspects of the Lusty Lady are unique: the theater is owned and managed by women, and for the past five years all managers have themselves previously been strippers or peepshow dancers. Therefore, conclusions drawn from my experiences should not be used to make generalizations about other peepshows or about the larger sex industry. However, while the circumstances for most other sex workers may be different, my hope is that by documenting the subversion of and resistance to oppression and traditional beliefs about female sexuality that I saw, I may call attention to the potential for similar activities to occur in other parts of the sex industry, an environment often thought of as the quintessence of female sexual oppression.

The Structure of the Peepshow

The Lusty Lady is an adult theater that is distinguished from prostitution in three ways: (1) no physical contact exists between dancers and customers because of glass barriers that separate dancers from customers at all times; (2) there is no direct exchange of money from customers to dancers—customers pay the theater in order to watch the dancers, and dancers are issued weekly paychecks from which taxes are deducted; (3) while some people may label *any* exchange of sexual entertainment for money as "prostitution," I wish to maintain a distinction between sex work that is *illegal* (i.e., prostitution) and carries with it the accompanying fear of arrest and police persecution, and forms of sex work that are *legal* and therefore relatively free of these concerns.

At the Lusty Lady, customers can enter small, private booths and place money in a machine (25¢ for every 20 seconds), causing a window covering to lift, thus revealing a central stage where several nude women are dancing. There is glass in all thirteen of the windows, so there is no physical contact between customers and dancers. The theater employs fifty to seventy dancers, who are paid an hourly wage starting at $11, with the top wage being $24 per hour. Raises are granted according to punctuality and performance, and it usually takes about one year for a dancer to reach the top wage.

Another section of the theater is called the "Private Pleasures" booth. From a hallway, customers can enter a cubicle that adjoins a small booth in which a dancer sits. The two rooms are separated by glass, but performer and customer can see and hear one another in a private setting. Customers pay a minimum of $5 for three minutes of time, although the performer sets her own rates for "special shows" including verbal domination or submission, dildo shows, and other special requests. For example, I may decide that to watch me penetrate myself with a dildo, a customer must pay $20 for three minutes. As is the case with the rest of the theater, no money is exchanged directly. The customer places money in a bill acceptor, and the amount is tallied automatically. Performers keep half of everything earned in the Private Pleasures booth, which can range from $15 to over $50 per hour for the dancer. Experienced performers often average over $30 per hour, which makes the Private Pleasures booth lucrative even for those dancers who earn the top wage on stage.

There are several structural elements of the Lusty Lady that make the atmosphere conducive to empowerment among dancers. On a physical level, the stage structure allows dancers to move about freely. An individual dancer who does not wish to dance for a particular customer is free to ignore him or walk away. Because there are four to six women dancing at once, performers have a sense of solidarity and camaraderie. Because glass separates performers from customers at all times, the lack of contact makes dancers feel safe, protected, and distanced from customers. For some women, this physical boundary allows for more uninhibited exploration and expression of sexuality. One Lusty Lady dancer called Rosetta attests to this:

I couldn't do any customer contact thing, because that is too much of an invasion for me. . . . This way there's already a wall, so I don't have to put up that much of another wall within myself. . . . For me I like the glass because it does create a safe space for me to explore [my sexuality].

On a social level, management has created a structure that allows dancers to maintain a certain amount of authority and control over the environment. The two managers are women and former peepshow dancers themselves, which is reassuring to most dancers. As one dancer called Lola comments, "It makes a difference in my mind. Not just that they're women, but that they're workers themselves or have been. I would not be willing to do this for men who would not be willing to do this themselves."

Because performers on stage are paid an hourly wage and therefore do not depend on tips from customers, competition among the women for customers' attention is minimized. As noted, in the Private Pleasures booth, performers set their own rates, and decide individually what their limits are regarding which acts they will perform. Management has also given employees a measure of control over customers by allowing dancers the authority to have someone removed from the theater for any reason. Customers are not permitted to speak rudely or make demands. These rules have helped to create an environment conducive to empowerment among dancers, as well as to encourage positive interactions between dancers and customers.

In effect, the physical structures and working conditions of the Lusty Lady help to provide an environment where dancers can produce feminist discourses of resistance. Below I will illustrate these discourses, focusing on the body and sexuality. First, however, it is necessary to discuss the term "resistance" as it relates to the Lusty Lady dancers.

Resistance to Gender Ideology

Emily Martin's book *The Woman in the Body*[1] is useful when discussing the resistance taking place among peepshow dancers. An environment such as a peepshow is often thought of as oppressive and misogynist, and little thought has been given to sex workers as resisters. Yet Martin points out that "the criteria for what counts as resistance have been held at an unreasonably stringent level and . . . researchers have not been looking for resistance to dominant views in the right places."[2] Martin instead states that "[There] are a multitude of ways women assert an alternative view of their bodies, react against their accustomed social roles . . . and in general struggle to achieve dignity and autonomy."[3]

At the Lusty Lady, performers have devised numerous ways to do just that. On stage, dancers have several methods of asserting their autonomy. Lola, whose common greeting to customers is, "What's a man like you doing in a nice place like this?" is selective about the men she will dance for:

> I've gotten to the point where I will not dance for people who look like they hate me. I understand there are customers who think that what they're doing is wrong and . . . sinful and that women are sinful for tempting them into doing it. . . . They think they are coming in against their will, tempted by those evil women, and they do their thing and they get their enjoyment out of it but they like to blame us. If I see that in someone's eyes, and I can almost always see it, I won't dance for him.

Another dancer describes her reaction when she feels a customer is trying to take advantage of her by pretending not to hear or understand what she says. She explains, "Sometimes I won't even give them a real show either. I will just kind of put my butt in the window or something. 'Dude if you are going to fool with me, I can fool with you too.'" A dancer called Dita utilizes a similar method:

> I had a guy try and shoo me away, tell me to go away because he wanted to look at a different dancer. I just said, "You can't tell me what to do." He was being so ridiculous. And I stuck my butt in the window and wouldn't let him see anything, and I was like "You want to see ugly? I'll put my asshole up against the glass, you know, for the next twenty minutes. I'll give you ugly."

Another dancer, feeling objectified by the fact that customers seemed to be looking only at her genitals, wrote her name across her stomach so customers would be forced to consider her as "more than a pussy."

In the Private Pleasures booth, performers sometimes stop the timer prematurely or, if very annoyed, simply shut the curtain before the time has run out. Blane feels compelled to assert her sexual autonomy in a manner that does not always conform to male expectations. She comments, "I have had some customers be surprised— like one guy [in the Private Pleasures booth] was waiting for me to [achieve orgasm] and I was like, 'I *did*.' He said, 'That was really quiet.' I was like, 'Yeah. I *always* come that way.'"

In a dancer-created annual 'zine sold to customers, dancers fabricated a "Dear Dancer" letter from a customer asking why he was ignored when he knocked on the windows, and signed, "Sincere Customer." The response, indicative of dancers' resistance to being treated disrespectfully, was:

> Dear Sincere
> If you are truly sincere, then you would not try tapping on the glass. To be honest, we really hate it. Gesturing, yelling, waggling your tongue, pointing at our genitalia, or knocking on the glass does not, WE REPEAT, NOT turn us on. If you give us a big smile, sit back and relax, enjoy yourself masturbating, then you are sure to get a great show.[4]

One dancer wrote a poem, deemed "man-hating" by the management, which was printed in the aforementioned annual 'zine. Management was very

upset about the poem and the dancer was verbally reprimanded, but the 'zine had already been distributed. The poem is entitled "Ode to My Wig":

> My wig, my wig, I love my wig.
> A wig is something I sure dig.
> When I'm at work I wear a wig.
> To make me attractive to sexist pigs.
> It's really curly and big and red.
> It swallow my entire head.
> Pigs have a thing for hair that's big.
> And thus, I have to wear a wig.
> Surely, not all men would keel over dead,
> At the sight of my crewcut, spiky and (occasionally) red.
> But intellect sure scares a pig.
> And so I wear a big red wig.
> I guess they think the weight on my head,
> Suffocates my mind and makes me brain-dead.
> Extremely high heels and hair that's big,
> Are reassuringly feminine to your average pig.
> I wouldn't want to challenge the preconceptions
> In their heads—Goddess forbid!
> Was it something I said?
> Anyway, I wear a wig.
> It's easier than getting my hair to grow big.
> Those pigs sure love me when I wear my wig.
> My wig, my wig, I love my wig.[4]

Several dancers view the work as political and assert that resisting misogynist views is an important part of the job. As Rosetta states, "I feel like the men that come in [who] want to take my power, or want to be in power, I see retraining them as part of my job. . . . I almost make it political work to do that." One other woman comments,

When women come in with their boyfriends . . . I like . . . to pay attention to the women, not to the men. I think it fucks with the dynamics that the men are trying to create and I think it empowers the women. I like that we often ask the women whether or not they want to be there and that they have the right *not* to be there, because . . . if the stripper . . . says to the woman, "You don't have to be here, you have a choice," or in front of the woman tells the guy, "You can't tell me what to do, you can't tell any woman what to do'" that is making some difference.

More overt forms of resistance have occurred only recently, when politically active dancers spearheaded a successful and nationally recognized campaign to

unionize Lusty Lady employees. Several Lusty Lady dancers also belong to orga-
nizations such as COYOTE (Call Off Your Old Tired Ethics) and the Exotic
Dancers' Alliance, both of which are organized to improve working conditions
and to demand public acceptance of sex work. In effect, there are many ways in
which peepshow dancers resist the dominant models regarding expected female
sexual behavior and dancer/customer dynamics.

Empowerment Through the Body

From earliest childhood on, women are given countless messages about what
our bodies should look like and what our relationship to our bodies should
be. We are surrounded by images of "ideal" feminine beauty and trained to
emulate these ideals, largely through the use of diets and consumer products
designed to "enhance" our faces, hair, and bodies. For many women, the way
we view our bodies is intimately connected with our self-image and self-
esteem. As Chris Shilling states, "The image of the body in these processes is
particularly important given the ideological weight invested in the view that
the 'weak' female body is *directly* responsible for women's position in society."[5]
The intricacy and complexity of women's relationships to their bodies in patri-
archal society is intensified for those of us who earn our living through
exhibiting our bodies in a sexualized context. Broad concepts such as gender
inequalities, sexual autonomy, and power are magnified and condensed when
we depend upon our physical bodies for income. We must reconcile our
thoughts, feelings, and beliefs about our bodies and sexualities with this
dependence.

Gender greatly affects women's orientations to their bodies. Women of
every class have fewer opportunities than men of their class in our male-dom-
inated labor market for converting physical capital into social, economic, or
cultural capital. Sex workers are perhaps more aware of this than most
women, for, as Rosetta states:

> I think that's a really big problem with our society, because it's one of the only
> places women can even out the male-to-female pay ratio. And so society gives
> us this thing to do, by using our bodies, and puts us in this position, which is a
> really powerful position, but at the same time, it's a trap. . . . As soon as you
> leave, you realize, oh well, I'm not really valued for my other skills as a woman
> in our culture. I am valued for this one thing. . . . The problem is with the cul-
> ture as a whole, it's not necessarily with the [sex] industry itself.

Dita expresses a similar sentiment: "The line I use is, I don't mind being a
whore, I just mind not being able to *not* be a whore. . . . The work that's available
to us at all is so limited, *so* limited, that I'm actually in a position of being grate-
ful . . . [to] work in the sex industry. That's not right."

In addition to gender, class status also affects women's orientations toward

their bodies. People of different social and economic classes tend to develop very different orientations toward their bodies. Whereas the "ruling classes" treat the body as an end in itself, working-class people may acquire an *instrumental* orientation to their bodies,[6] since their income often depends upon manual labor. Keeping healthy is viewed as a means to a desired end, not as an end in itself. Regardless of our class backgrounds, dancers fall into this instrumental category because we must use our bodies to earn our livings. In this context, dancers often define certain foods, clothing, makeup, accessories, or exercise as "investments" to help us earn more income, instead of regarding them as beneficial in their own right.

In an article entitled "The emBody-ment of power: gender and physical activity," Sarah Gilroy argues that in social theory dealing with the body, "the body has been treated as an object, something that has power done to it. . . . Rarely is the body, particularly the female body, seen as the agent or source of power."[7] One Marxist-influenced approach to the body that does recognize its potential power is the *dialectic* approach, which views the body as a material object located in nature but subject to social forces within the specific historical development of economic, political, and cultural factors.[8] The body is not only constructed by social relationships, but it also enters into the construction of these relationships and thereby contains the *agency* that is crucial for enacting change and resistance. As Shilling states,

> The power of agents to act differently provides the opportunities for individuals and groups to change the orientations they have to their bodies. Despite the difficulties involved, those with appropriate resources may take steps to increase their autonomy and adopt a new orientation to the body and body implicating activities. In so doing, some women have found themselves exposed to new rules and resources which they have used in improving their opportunities to produce and convert physical capital into other forms of capital.[9]

It is my contention that the Lusty Lady Theater, despite its location in what is popularly viewed as a misogynistic sex industry, is an "appropriate resource" through which women are developing feminist discourses about the female body and its activities.

Traditionally, women have been encouraged to remain ignorant of their bodies and sexualities. The following experience related by Dita illustrates this point:

> I knew I had a clit. . . . I had this information, but I'd never put the mirror between my legs. So I kind of had this really intellectual information about my body and about women's sexuality, but I didn't masturbate, I didn't look at my body. I was *very* afraid to. And I remember the first time I put a mirror between my legs. It was really traumatic.

While this quotation reveals the continued prevalence of isolation and ignorance, the silence surrounding women's bodies and sexualities began to be broken in the 1960s and 1970s by women who took it upon themselves to increase self-awareness. Shirley Ardener notes that "women began to gather in small groups in order to conduct practical explorations of female anatomy for educational purposes, to 'demystify' their bodies."[10] One such group was the Boston Women's Health Book Collective, which eventually published the book, *Our Bodies, Ourselves*, now in its third edition. The collective firmly states the positive benefits of body self-awareness:

> Body education is core education. Our bodies are the physical bases from which we move out into the world; ignorance, uncertainty—even at worst, shame—about our physical selves create in us an alienation from ourselves that keeps us from being the whole people that we could be.[11]

For many dancers at the Lusty Lady, seeing and interacting with other naked women can serve similar educational and empowering purposes. In some respects, these interactions resemble a 1990s version of the now-defunct consciousness-raising groups of the 1970s. An example of this occurred once while I was on stage. A dancer complained that although she had seen more vaginas since working at the theater than ever before in her life, she still could not locate "the hole you pee out of." Other performers crowded around to point out on our own bodies this part of our anatomy. This kind of freedom does not exist at most places of employment, and it heightens the rapport and contributes to a sense of self-awareness. Vendetta describes the impact that being with other naked women in this context has had on her:

> [Prior to entering sex work] I myself [did] not see a lot of women in a sexual context except in movies. . . . The [dancers] are all great. They have had a big impact on me just personally. . . . When I don't even talk to people outside of work, seeing them on stage . . . I feel like I have gotten to . . . understand a lot about a lot of people there and I find that it is just great learning. Just to be in a room naked with four women is just like . . . a little exploratorium or something.

At the Lusty Lady, all dancers have time to become comfortable with their physicalities. Both the stage and the Private Pleasures booth are entirely mirrored, so women are able to see their own reflections for hours at a time. There are both positive and negative reactions to the mirrors. As one dancer comments, "If you weren't comfortable you would lose it with nine pairs of eyes and 100 mirrors reflecting back at yourself." Joelle, on the other hand, states, "I have a lot of time to look at my pussy, it's not just a blank space down there. I have much more of an idea of what it is." For some women, sex work is the vehicle through which we can gain power and control through an increased

sense of connection with our bodies. One sex worker states, "We decide when, where, and with whom we'll do what ... we are more comfortable with our bodies and sexualities than most people. We don't have 'private parts,' dismembered from the rest; they are part of the whole."[12]

In addition to increasing body awareness, being naked for hours each day causes many dancers to question and reject the dominant ideology regarding female standards of beauty. This may seem contradictory since we are being paid to *represent* this very ideology, but after working at the theater dancers begin to realize that while we do not all conform to the feminine "ideal," we are all beautiful nevertheless. The ability to look at and interact with actual naked women has a profound impact on many dancers. Often it is the first time we have had the chance to stare at female nakedness that is not part of a magazine advertisement. Dewdrop explains:

> I am not warped with the shame of my body because the only images of my body that I get are media images, print or television stuff. I have this whole sample of all these different bodies that I see up close all the time. It has really just helped my whole perception of my body. . . . Other people have problems with their bodies still because they don't see their bodies. . . . Before [beginning sex work] I was just really shameful and I wouldn't make love in the light and I had problems with people seeing my body.

Not only is it affirming that there are other bodies like our own, but also we discover how difference—from one another and from standard conceptions of beauty—is valuable. Heather comments, "I really realized how beautiful women are and how much diversity is beautiful. They are all so attractive."

By representing the "feminine ideal" at work we begin to see how literally *constructed* gender is, which allows us to begin *deconstructing* it. Many dancers feel less inclined to get "dolled up" outside the theater, because we realize how artificial this type of "beauty" is. As one dancer comments, "If people only knew ... that *any* woman can look like a model." Women of different body types are employed at the theater, and dancers realize that "sexiness" reaches far beyond the confines of fashion magazines and Hollywood. Rosetta comments:

> It definitely shows me even more clearly how much bullshit Madison Avenue puts women through, that every different shape and size is beautiful, and can be beautiful. . . . I've thought recently about writing an article about how since most women have cellulite, why don't we bring it back as a beauty object, rather than something to be scorned [laughs]. That's one thing I like about our job, is that we're there unairbrushed, and they just have to look at it. And customers like it.

Some of us realize for the first time how oppressive this gender ideology can be, while for others of us who have long been aware of these structures, the

process of gender deconstruction and reconstruction going on every day in the dressing room can offer us different but equally empowering insights. Damiana avows:

> I loved dressing up in wigs and costumes and putting on makeup—all things that I had for some time rejected as "sexist oppression." I was reintroduced to the feminine role as a playful thing in a way that was really good for me, which is primarily how I see it in my life today. I think I owe this bit of reclaiming the gray area of gender socialization politics to the dykes who dug their long wigs and lipstick, and who actually had a great time.

An important part of the process of resistance to misogynist ideology is not just noticing the beauty in diversity but also speaking about it. Compliments paid by dancers to one another are a boost to everyone's self-esteem. I can recall several work shifts where, after many meaningless "thank you's" to vocally admiring customers, my spirits soared after a compliment from a dancer. On one occasion, a dancer called April who joined me on stage looked particularly striking that day. When I mentioned how beautiful she looked, her response was, "That's because my beauty's reflecting off of you." This same dancer has made a habit of complimenting women who are strangers to her, if she finds them beautiful. She enthusiastically comments, "When I see people on the street like a woman that's really sexy, I'll go up to her and go, 'You look really, really good!'"

Because the theater is structured so that performers are not competing with one another for money or male attention, women can openly admire one another's bodies in a noncompetitive environment. Dancers frequently compliment one another's looks with genuine admiration, without much of the jealousy often associated with female interaction. This can be a new and affirming experience for many.

One other factor contributing to our body image and awareness is the dancing itself. The benefits of regular exercise are widely touted, and dancing in particular can be a positive and affirming form of movement. "It's a great way to express emotion and moods physically without words.... Each time [you dance] your body comes more alive, grows stronger, more coordinated and balanced."[13] For many dancers, one of the most positive aspects of the job is the ability to dance and perform, and dancing in an erotic or "sexy" manner can be a playful and fun way of experiencing movement. Rosetta comments that "dancing has really opened up my sexuality, because it's gotten me so much more in touch with my body.... So it's been a really freeing thing for me." She expands on this theme:

> When I first started there it just seemed really silly to me, and I had a hard time.... I've never been a "sexy" person, and never been trained to act that

way, so it was pretty silly for me, dancing around and trying to act sexy. . . .
But then I ended up really enjoying it, and it brought out this whole other
aspect of my personality . . . the ability to be a sexual, really sensual per-
son. . . . And to have fun with it. . . . And to be okay showing my body to peo-
ple and . . . dancing around.

As I stated previously, the entire experience of being naked and interacting
with other naked women can be liberating for some dancers. However, for
other women this situation brings insecurities about their bodies to the sur-
face. One dancer I spoke with told me that her bulimia returned when she
began dancing, after being gone for many years. Another described how she
could never be on stage completely naked; she must keep her midsection cov-
ered because of her discomfort with that part of her body. After doing poorly
in the Private Pleasures booth one day, a third dancer was convinced it was
because she was "scaring the customers away" by being "too fat." While I do
not believe the Lusty Lady creates poor self-esteem or negative body images
where none existed before, clearly it can aggravate the situation for some
women with prior negative feelings about their bodies. Making matters worse
is the fact that weight is one of the qualities regulated by management.
Although the range of body types permitted at this theater is far greater than
at other sex work establishments, if a women gains too much weight or
becomes too thin, she could lose her job. Dancers have been put on "fat pro-
bation" in the past, and may not return to work until they lose weight.

It may seem that a woman with a negative body image would not choose to
work as a nude dancer, but this ignores the fact that *all* women are taught to
become concerned with appearance as young girls, and it is very rare for a girl
or woman to have never had negative thoughts about her body. As a dancer
called Summer states, "There is part of me that just can't ever be happy with
[my body]. It's ingrained. . . . When I was younger I used to compare myself to
everybody. It was always like a 'me against her' kind of thing." Similarly,
another dancer's experience vividly reflects this reality:

Body image started coming into my life as an issue . . . in high school. I went
to an all-girls prep school, we all had a collective body image and eating disor-
der. Basically, there was no comment so valued as "you look thin." There was
definitely a *moral* aspect to how we dealt with [the] body—I mean, you were
bad if you weren't thin. Thin was good, and not being thin was bad.

It can be extremely disempowering for a woman to be confronted daily
with other women's bodies, as well as her own in the many mirrors, and feel as
though she doesn't "measure up." Women are taught to compare and com-
pete with one another, especially for male attention, and it is hard to undo a
lifetime of socialization. As Dita honestly acknowledges,

I do still feel physically inferior to the other women that work there. I feel like everybody else has a better body than I do, and my success . . . is in my show and not my body itself. And I feel like if I stop moving, if I stop that energy, or I stop dancing, that the customers won't look at me because my body in and of itself isn't interesting enough to look at.

In fact, every dancer has days at the Lusty Lady when she feels that no one is looking at her. Dewdrop explains, "It shoots you right in the self-esteem because in the market we have to be in . . . looks are everything." The situation can be even more difficult, in some ways, for women with a feminist consciousness. Instead of thinking, "I feel fat and fat is bad," these women express feelings such as, "I feel fat, and while I know intellectually that fat is not bad, I still feel bad about it, and then I feel guilty for feeling bad." Or, as one dancer passionately states:

I have mixed feelings on it. On the one hand, I feel very good about my body. I feel like my body is beautiful. Most of the time, I don't want to be skinny. . . . On the other hand, it really has reinforced some things. . . . I have muscles, and I really like feeling strong. And usually what I tell people is "Oh, I like feeling strong." Well, that's a lie, I also like being thinner. And I don't *like* that I like it. . . . I don't want to have feeling good about my body be dependent on looking this way. . . . I just wish I cared about different things . . . [like] being healthy and capable, and being strong. That's part of it, but it's not all of it, and the other stuff is real evil and sick. And I know it's not my fault, it's not like I blame myself for it, but it's there and I hate it. . . . Standing in a mirror next to someone who—both their butt cheeks would fit into one of mine, even if we're two different body types, there's still something that tells me, "You should look like that. If you were a good person, you would look like that." And I know it's wrong.

Such shame and guilt about one's body is common among women throughout our culture, and nude dancers cannot fully escape the repercussions of this ideology. However, we are resisting on several levels, including the refusal to be ashamed of our nakedness. Many of us are asked by those outside the industry if we're embarrassed to be naked, or if we feel like there is a power imbalance because the customers are, for the most part, clothed. One reply, which I have heard expressed in many ways, is that the customer is embarrassed by the dancer's nakedness, not the dancer. Being naked can be, and at this theater often is, a very powerful experience. Vendetta explains, "I think some [male friends] have looked at it [as if] it lowers me down a notch [that customers see me naked]. . . . I don't know if I see it that way. It is something I am proud of and it is something I do for a job and I don't really feel like I am one down from them by it." In our own manner, therefore, we are adding our methods to the "various ways in which women have attempted to manipulate

the dominant discourse and conventions, which require that women, especially, should see their 'underparts' as shameful and unspeakable."[14]

Empowerment Through Sexuality

The dialectic approach, which views the body as a material object located in nature but subject to social forces,[15] is also useful in examining theories of female sexuality. Though sexuality is often experienced through the physicalities of our bodies, sexuality itself is socially constructed. As Carole Vance states in the introduction to *Pleasure and Danger*:

> Sex is a social construction, articulated at many points with the economic, social, and political structures of the material world.... Although sexuality ... is grounded in the body, the body's structure, physiology, and functioning do not directly or simply determine the configuration or meaning of sexuality....[16]

As a social construction, sexuality and sexual politics are now acknowledged as far more than "secondary, even a luxury for the self-indulgent,"[17] as had been thought by previous, often Marxist-influenced, social and political activists. Indeed, part of the discourse of women's liberation that emerged in the late 1960s and is epitomized by the slogan "the personal is political" was that something once thought completely private and personal is actually a major site of both oppression and liberation.[18]

Patriarchy and capitalism, as two of the "economic, social, and political structures" Vance mentions, play a large part in the conceptions of female sexuality. Often these conceptions are restrictive and oppressive, such as the notion that for women, sexual pleasure must be pitted against sexual safety.[19] Until recently, "safe" or socially acceptable zones for women to experience sexual desire existed within heterosexual marriage only. Although in the latter part of the twentieth century the "safe" zones have expanded somewhat, many forms of sexuality, including promiscuity, lesbianism, and sadomasochistic sex, are still considered violations of the social "rules" regarding female sexuality. These departures into sexual danger zones are thought of as violations not only by those seeking to control female sexuality, however; women themselves have often become afraid of the "danger" of their own sexualities.[20]

One manner in which this internalized fear is manifested within the realm of sexual politics is through a dread of sexual variance. Whether rooted in a "deeply felt need for merging, for similarity—to no longer be different, be other"[21]—or in a desire on the part of feminists to maintain a semblance of group cohesion through the minimization of difference,[22] the results are debilitating.

> Feminists, like all members of the culture, find it difficult to think about sexual difference with equanimity. The concept of benign sexual variation is a relatively new one.... Our relative ignorance about the actual range of sexual behavior

and fantasy makes us into latterday ethnocentrists.... The external system of sexual hierarchy is replicated within each of us, and herein lies its power. Internalized cultural norms enforce the status quo. As each of us hesitates to admit deviations from the system of sexual hierarchy, nonconformity remains hidden, invisible, and apparently rare.[23]

A major task, then, is for women to recognize themselves and one another as sexual agents and to create a space where women can honestly express feelings and experiences of sexual variance.

Dancers at the Lusty Lady have crossed into the danger zone simply by becoming sex workers; we are so marginalized that there is not even a mention of contemporary sex workers in the introductions to either Vance's *Pleasure and Danger*, or Snitow, Stansell, and Thompson's *Powers of Desire*, two major anthologies about feminism and sexuality. Yet our venturing into the forbidden realm of "deviant" female sexuality means it no longer holds as much of a threat for us. The bonds among us as women are strengthened, and we are able to discuss sexual variations in a nonjudgmental format, thereby breaking down notions of "normal" and "abnormal" behavior. In the "undressing room" backstage, sex, lesbianism, bisexuality, and relationships are openly expounded upon, along with the normally taboo topics of S/M sex and masturbation. Dancers trade information on subjects such as yeast infections, birth control, menstrual pain, dental dams, tampons, lubricants, and dildos. As we discuss our insights and experiences on these and other related issues, the atmosphere of camaraderie and sexual openness is expanded. At times, painful memories associated with sex are honestly broached, as when one dancer confided that she had been afraid to masturbate for most of her youth. As a child, she had once been caught masturbating by her parents, who burst into her room and "beat the shit out of [her]." The Lusty Lady becomes an arena in which dialogues surrounding female sexuality are actively and continually taking place. As a modern analogy to the feminist consciousness-raising groups of the 1970s, these unstructured sessions provide a unique forum where honest discussions of sexual variance occur.

The implications of this should not be underestimated. Most of the women at the Lusty Lady were children when feminists of the 1970s paved the way for women to change radically the orientations toward their bodies and sexualities, in part through grassroots efforts such as consciousness-raising groups. However, the impact of such revelations as "the personal is political" on the lives of individual women some twenty years later is limited. For many women at the Lusty Lady, the sex industry has been the only venue for analogous experiences. Moreover, unlike the consciousness-raising groups of the 1970s, which interested women had to seek out purposefully, the Lusty Lady allows such dialogues to occur as a by-product of the employment itself. Therefore, it has the potential to affect the lives of women who may have had neither the time nor the inclination to seek out such an experience.

A vast majority of dancers emphasize how interacting with the other women at the theater has impacted their views on sexuality. Many women I interviewed spoke of becoming aware of and comfortable with sexual variations they had previously had little or no contact with. Comments such as Vendetta's, "I have become less homophobic," and April's, "I've never been around gay people before, and I've learned to accept that," are commonplace. Rosetta explains, "I'm a lot more exposed to the S/M community now than I used to be, which is interesting. I appreciate all the ways in which people are positive about their sexuality." Some dancers, such as Blane, have become "more inclined to explore" and expand their own sexualities, while others can become comfortable with their own sexual limits. Athena states, "It's exposed me to different things that I probably wouldn't have come across otherwise. . . . [I] have figured out I'm pretty straight."

For dancers who already self-identify as belonging to a sexual minority, the Lusty Lady's atmosphere can be refreshing in its support of sexual variation. Lola's statement attests to this:

> One important thing is that I've gotten more support for my bisexuality than in any other context in my life. . . . Up until [my employment at the Lusty Lady], I think I'd never walked into a room with people and had [the] assumption . . . [that] no one is going to hate [me] because of who [I] like to have sex with. . . . It's been extraordinary, the acceptance from both [gay and straight] sides. . . . It really has been the first time I've felt widespread support for my sexuality.

A common phenomenon among dancers is an increased feeling of comfort and ease with physical aspects of sexuality such as touch. Vendetta asserts that, through her job, "I have gotten more comfortable with masturbating and touching myself, with expressing myself sexually. . . . Not being embarrassed by the way I want to touch myself." In a similar vein, Blane states, "I am more comfortable touching myself and talking about sex to my partners," and Rosetta comments, "As far as touching myself, I think it's made me a lot more comfortable with my body, which is a great opening thing for me." She goes on to describe a related positive benefit of peepshow dancing: "I've been celibate for quite awhile now, and I have actually taken it upon myself to explore more of my own [sexual] limits and push myself through stuff. And I probably wouldn't have done that before. So I guess [the job] has had this effect on me, which is really great."

Customers, too, can positively influence dancers' perceptions of sexuality and raise awareness and sensitivity to issues of male sexuality. The phrase, "You can't judge a book by its cover," takes on a new meaning for us, as we interact daily with conservative or average-looking men who reveal an unlimited capacity for sexual variation. Observes Summer, "Regardless of how someone looks on the outside, I know that some things are very private, and I never

really thought about normal-looking people having alternative ways of being sexual." Cross-dressing, S/M fantasies, foot fetishes, bondage, anal play, and exhibitionism are but a few of the myriad activities we are able to watch our customers engage in. Some dancers formulate negative views of male sexuality from these encounters, coming to view men as "jerk-off machines." Others are disturbed by what is perceived as an "unhealthy" attitude toward sexuality displayed by some customers, as in Dita's comment, "So many men don't give themselves pleasure, you know. The way that they touch themselves is with a lot of angst and guilt and rage." For many of us, however, our positive interactions with customers serve to enlighten us to new activities and issues surrounding sexuality. The following are two examples:

> One time I did the [Private Pleasures] booth with Lola, and that one man came in who can fuck himself with his own dick. He was so incredible, and so open, and so friendly, and just so great about his sexuality and all the different, amazing things he could do with his body. And . . . he wanted to share that with us. I just thought that was fantastic. (Rosetta)

> I had a customer my second time in the booth and he had built this particular sex toy. . . . He took the clear plastic tubing from a vacuum pump . . . and put a Christmas tree light and battery pack in it and put it in his ass, all the way in his ass. . . . And that was really, really cool because I never expected that there could be anything that anyone could show me that I never saw before. And I was like, "All right dude! I've never seen anyone's colon!" And I was really excited to see something I'd never seen before. . . . I loved it. . . . I was just like, "Thanks, dude!" (Dita)

For women, true sexual liberation entails not just expanding our awareness and acceptance of *women's* right to sexual variance; we must also be sensitive to the ways in which men are attempting to redefine their own sexualities in creative and healthy ways. Many men who frequent sex entertainment establishments, along with many more who do not, are doing no such redefining, preferring instead to accept and maintain the status quo by remaining deeply attached to notions of sexual inequality. Rosetta states, "I do acknowledge that there are people who come in that have fucked up ideas about women, but I think those problems exist anywhere." However, for those men who *are* attempting to discover and explore positive aspects of sexual variance, theaters such as the Lusty Lady may be one of the few supportive venues in which to do so. Without exception, the dancers with whom I have spoken say they were initially surprised by the diversity of the customers, both in terms of demographics and sexual proclivities. Heather states, "It is pretty much a random sampling of the entire spectrum of all the walks of life, all the kinds of guys." Lola echoes this sentiment:

It simply didn't dawn on me until I started working there that there would be a greater variety of men as customers than I'd ever interacted with in my life. . . . It just feels so much healthier to me to be interacting with people of a variety of races and ages and classes and . . . physical abilities, it's just much more real and much more what the real world is.

Many dancers are also forced to confront myths and stereotypes surrounding sexuality, because perhaps for the first time we are dealing directly with groups of people considered sexually invisible by most of society. Lola continues:

I hadn't realized until I worked at the Lusty Lady how much our culture can dehumanize older people. I think we completely desexualize the elderly and I think it's incredibly dehumanizing. . . . I think as a culture we need to examine this. . . . I have ceased to be able to look at old men as nonsexual. I *have* to recognize that old men are sexual beings because I have been masturbated at by some of them! I think that there are races that are desexualized. . . . I think we certainly desexualize the handicapped. . . . I do think that as a culture we have to look at who we treat as nonsexual, but doing sex work has forced me as an individual to do that.

All dancers value the positive interactions we have with our customers, and many of us believe that being exposed to such racial, class, age, and sexual diversity in both dancers and customers has given us "more knowledge about [ourselves] and about people, and . . . more compassion," as Rosetta states. It is precisely this knowledge and compassion that form the basis of our resistance to socially accepted and repressive ideologies surrounding sexuality.

Empowerment Carries Into the "Real World"

For many dancers, the sex industry has allowed us to fully realize the autonomy, power, and control we have over our bodies and sexualities, especially in relation to men. Our ability to set and articulate limits regarding what we will and will not do with our bodies increases, sometimes dramatically. Especially in the Private Pleasures booth, we are faced each day with a variety of requests— and sometimes commands—from customers. A dancer who only recently started doing booth shifts commented, "I'm still not quite comfortable with my booth show and I have a tendency to give too much away." Neglecting to define limits can result in a dancer feeling coerced and invaded, although the glass barrier provides a physical safety net. Often dancers must learn through trial and error what we are comfortable with, and how to say "no" to what we do not want. Lola describes the evolution of her ability to set limits:

I have stopped doing things that were nonconsensual. That sounds like a weird thing to say, but when I first started doing booth, I felt like I did things that

weren't okay with me . . . things that hurt, for not enough money. . . . When I
first started doing [the booth], I felt completely out of control and I was
breaking all kinds of limits that I set for myself long ago in terms of what I do
and don't do sexually. . . . Not because the money was more important but
because I think I hadn't set up any rules for myself. . . . I think I've found ways
to deal with it so that I feel less powerless in the booth. In fact, I feel pretty
powerful in the booth now. I'm very capable of dealing with the guys who
harass me, very capable of dealing with the men in the hallway . . . and much
more willing to tell a customer to fuck off. . . . I feel like I stick to my guns and
I really do feel in control.

All women who work at the Lusty Lady get practice learning what our own
limits are and verbally communicating them to customers. Rosetta professes,
"I think most of the men know, and the way I deal with most of the men [is
that] I'm definitely the one in power and taking control of the situation. . . . For
the most part, it's a pretty powerful experience."

For many dancers, our limit-setting abilities and our power experienced in
relation to men at the theater carry over into the way we relate to men outside
work. Once we realize that we do not have to "take any shit" from customers,
we recognize that we do not need to take it outside the theater either. A dancer
who also works as a massage therapist recently told me that, had she not
worked in the sex industry, she would have a much more difficult time setting
limits with her male massage clients, some of whom mistakenly think there is
sex involved.

Many dancers also respond differently to street harassment than they did
prior to entering the sex industry. On one occasion in the dressing room, sev-
eral women had a conversation about their reactions to street harassment. One
dancer described how a man reached out and grabbed her buttocks as she was
exiting a bus. The dancer whirled around and shouted to him, "How *dare* you
touch my body! You apologize to me right now!" She then held open the back
door, thus holding up the bus by preventing the driver from moving. She
waited until the man apologized before exiting the bus. This dancer claimed
she would have lacked the confidence to do this before becoming a sex worker.
Amid the cheers of support from the other women present for this story,
another dancer chimed in to say that, since working in an industry that com-
modifies her body, she has realized that *she* owns her body; it is not public prop-
erty always and automatically available to men. She is therefore much less
likely to put up with harassment from men. Dewdrop reflects on her experi-
ences with street harassment: "I meet it with much more power, power from
having dealt with it all day and managed it. It is almost like, 'I have figured you
out. I know what you are all about.' . . . I feel a lot more powerful and not pow-
erless with men because I know exactly where they are coming from." Dami-
ana, who no longer works at the theater, similarly describes the effect dancing
had on her relations with strange men: "If anyone looked at me funnily on the

street I had an easy time ignoring them. I actually once told a guy 'Hey, I get paid for that.' If my body was a commodity, I was using it for my own benefit." Rosetta explains:

> Working in the sex industry has made me even more aware of just how much power I do have in my relations with men that I didn't recognize before. Like before, if a man had asked me to come over and show him something or talk to him about something . . . on the street . . . I probably would have said "Okay," and now I refuse. And I'm very firm about that sort of thing, and about my boundaries, and about what I can and cannot give to people, have or don't have to do. [Working in] the sex industry has made that very clear.

Notes

1. Emily Martin, *The Woman in the Body* (Boston: Beacon Press. 1987).
2. Nicholas Abercrombie, Stephen Hill, and Bryan Turner, *The Dominant Ideology Thesis* (London: George Allen and Unwin Ltd. 1980), Cited in Martin, *The Woman in the Body*, p. 183.
3. Martin, *The Woman in the Body*, p. 200. See also Ruth Behar, "The Body in the Woman, the Story in the Woman: A Book Review and Personal Essay," in *The Female Body: Figures, Styles, and Speculations*, ed. Laurence Goldstein (Michigan: University of Michigan Press, 1991), pp. 267–311.
4. Playday '92: Tales from the Lusty Side, 1992 p.5.
5. Rogue, "Ode to My Wig," *Playday '92: Tales from the Lusty Side* (1992), p. 7.
6 Chris Shilling, "Educating the Body: Physical Capital and the Reproduction of Inequalities," *Sociology*, 25(4) (1991): 657. Emphasis in the original.
7. Ibid., p. 655.
8. Sarah Gilroy, "The emBody-ment of power: gender and physical activity," *Leisure Studies* (1989): 166.
9. Shilling, "Educating the Body," p. 664.
10. Ibid., p. 666.
11. Shirley Ardener, "A Note on Gender Iconography: The Vagina," *The Cultural Construction of Sexuality*, ed. Pat Caplan (New York: Tavistock, 1987), pp. 113–42.
12. Boston Women's Health Book Collective, *The New Our Bodies, Ourselves* (New York: Simon and Schuster, 1984), p. xix.
13. Peggy Morgan, "Living on the Edge," *Sex Work: Writings by Women in the Sex Industry*, ed. Frederique Delacoste and Priscilla Alexander (Pittsburgh: Cleis Press, 1987), p. 25.
14. Boston Women's Health Book Collective, *The New Our Bodies*, p. 49.
15. Ardener, "A Note on Gender Iconography," p. 135.
16. Shilling, "Educating the Body," p. 664.

17. Carole Vance, "Pleasure and Danger: Toward a Politics of Sexuality," In *Pleasure and Danger: Exploring Female Sexuality*, ed. Carole Vance (Boston: Routledge & Kegan Paul, 1984), pp. 1–27.

18. Ann Snitow, Christine Stansell, and Sharon Thompson, "Introduction," *Powers of Desire: Politics of Sexuality* (New York: Monthly Review Press, 1983), p. 21.

19. Snitow, Stansell, and Thompson, "Introduction," p. 24.

20. Vance, "Pleasure and Danger," p. 3.

21. Ibid., pp. 3–4.

22. Snitow, Stansell, and Thompson, "Introduction," p. 41.

23. Vance "Pleasure and Danger," 19.

24. Ibid., p. 20.

[10] The Littlest Harlot

Barbie's Career as a Role Model

TRACY QUAN

The Mattel Barbie doll—more familiar to us as Barbie—has, in the last four decades, taken on a life and persona of her own. In 1994, an unofficial biography revealed that Barbie was modeled on a German cartoon character, an ambitious hooker called Lilli. At a 1995 exhibit, *Art, Design and Barbie: The Evolution of a Cultural Icon* at New York's Liberty Street Gallery, Lilli's role in Barbie's evolution was heavily underplayed. This subterfuge was part of a larger controversy, in which columnists and curators accused Mattel Inc., the sponsor, of being excessively meddlesome.[1] While Mattel purged the exhibit of certain works of art inspired by Barbie, the company also did its best to camouflage the doll who had inspired the creators of Barbie. To understand why this was inevitable, we must put ourselves in Barbie's shoes, and follow the progress of a very hard-working plaything.

To make the most of the present, many prostitutes are creative with the past. Barbie has always been one of the girls in this respect—utterly pragmatic with the truth, especially when a gift for fantasy is required. In 1994, thirty-fifth anniversary celebrations were held throughout the land—some sponsored by Mattel, some not. At a time when Barbie was admitting to a well-preserved thirty-five, she was at least thirty-nine.

Until recently, few Barbie owners were conscious of Barbie's true age—or of the life this all-American prom queen once led in another land, under another name. But Barbie's first playmates are now old enough to handle the truth. M. G. Lord, the author of *Forever Barbie: The Unauthorized Biography of a Real Doll*, is one of those women. In *Forever Barbie*, Lord reveals that Lilli—"an eleven-and-a-half inch, platinum-ponytailed" German doll—was the pre-American Barbie.[2] The Lilli doll was the three-dimensional version of a popular postwar cartoon character who first appeared in the West German tabloid *Bild Zeitung* in 1952. A professional floozy of the first order, *Bild Zeitung*'s Lilli traded sex for money, delivered sassy comebacks to police officers, and sought the company of "balding, jowly fat cats," says Lord[3]. While the cartoon Lilli was a user of men, the doll (who came into existence in 1955) was herself a plaything—a masculine joke, perhaps, for West German males who could not afford to play with a real

Lilli. A German brochure from the 1950s confided that Lilli (the doll) was "always discreet,"[4] while her complete wardrobe made her "the star of every bar." The Lilli doll who made it into the *Art, Design and Barbie* show was dressed in her most (perhaps her only) demure outfit. This was a literal cover-up. Easily overlooked by anyone who did not understand Barbie's history, Lilli was dressed like a prostitute who didn't want to be noticed—lost among the other non-Barbie dolls who were provided for educational purposes.

It seems fitting that Lilli dolls were manufactured in Hamburg, a city where government-approved, licensed prostitutes are a fact of life. In the United States, where legal hooking is virtually unheard of, Lilli had to tone down her act. (Perhaps she changed her name in order to get around a U.S. immigration law barring prostitutes from becoming residents —but that is just conjecture.) While it is still unsafe for a foreign prostitute to reveal her trade in the United States, Barbie—decades later—is no longer foreign. She is more American than many Americans, and perhaps even more hypocritical.

As you can imagine, Lilli did not become Barbie overnight. Like Vivian, the awkward streetwalker in the movie *Pretty Woman* (who transmuted into a social swan), Lilli "cleaned up real nice." But her transformation from adult hussy to quasi-virtuous teenager was a painstaking miracle of art and science. Jack Ryan, a Mattel designer with a Yale engineering degree, worked on making the doll look less "like a German streetwalker"[5] by changing the shape of her lips and redoing her face, says Lord. When the ex-hooker's body was recast, her incorrigible nipples were rubbed off with a fine Swiss file. Although she submitted to corporate mutilation, I do not regard Lilli as a victim of prudery—or of capitalism. She was up to her own perverse tricks, an agent of her own future.

To get to the American public, Barbie had to capture the buyers at the annual American Toy Fair. Working the 1959 Toy Fair as a respectable ingenue did not come easily, and the Sears buyer, a man, didn't fall for this makeover. While we have no reason to think he had known her as Lilli, it's clear that Barbie's sexiness betrayed her, for he refused to stock her. This initial rejection didn't prevent Barbie from overcoming her scarlet origins and selling herself into the hearts and lives of middle America.

Barbie's not the first canny harlot to have shaved four to seven years off her mileage, or to have changed her name. But compared to other enterprising trollops who delete whole decades in a day while renaming ourselves every other week, Barbie is quite restrained. She has changed her name only once.

Over the years, millions of people have found her respectability utterly plausible. Now, Barbie's past has returned—not to haunt her, but to be flaunted. The disclosure of her history was perfectly timed. Heidi Fleiss, Norma Jean Almodovar, and the Mayflower Madam (aka Sydney Biddle Barrows) have paraded their collective, commercial past on television talk shows, making it trendy for Barbie to open the closet door. Activist hookers like Margo St. James (whose 1996 bid for a San Francisco Supervisorial seat was supported by many gay Democrats) have politicized the prostitute's image, making Barbie's past

appear more wholesome. In this era of Sex Worker Chic, Barbie the ex-hooker is no symbol of shame. Instead, she is "the girl who got away with it"—a role model for ambitious young women who will have their cake and eat it, too. You can't keep a good pro down, and the success of Lord's *Forever Barbie* has turned Barbie's hidden past into an official piece of our country's social history.

Marketed as a harmless plaything for thirty-five years, the all-American prom queen turns out to have been a foreign whore on the run. Somehow, the kind of girl your brother couldn't take home to Mom became a role model for millions of young girls. How did this unthinkable change occur? Picture a little girl on Long Island (or in Westchester) openly playing with a facsimile of the New York call girl her suburban father secretly visits during his lunch hours. If *I* am startled, shouldn't middle America be horrified? More amazing is the thought that this whorish facsimile could be a gift from her parents. But that is exactly what has happened—and what continues to happen—in homes all over North America. Barbie has become one of the family, and nothing can stem this tide. Even the most committed feminists have been known to buy Barbie dolls for their daughters, as have fundamentalist Christians. She is everywhere, even in the enemy's nursery.

Is Barbie a sneaky trollop who hid the truth when it was convenient, revealing it now to keep up with the *Zeitgeist*? Or was she, perhaps, one of the great powers behind this cultural shift, helping to make prostitution more acceptable? During the 1980s, Western Publishing was marketing *Barbie's Dream Date*, a board game that Lord says could easily be called *The Hooker Game*. Players find ways to make Ken spend "as much money as possible"[6] before the clock strikes twelve, then "tally their date and gift cards."[7] (Could this make her a role model for hookers who need to get their beauty sleep?) "What I objected to, in this game, was its *covert* prostitution," Lord told me. In *Forever Barbie* she suggests that it's contradictory to market *Barbie's Dream Date* alongside *We Girls Can Do Anything*, a Barbie game in which girls strive to become doctors and designers.

But the covert behavior makes perfect sense to me. Like many women who use their bodies to pay the rent, Barbie has had to have a straight cover. Almost every successful call girl I know has a customer who can only get it up for a part-time pro with a cute, respectable career—as an interior decorator or journalist, perhaps. A smart hooker's entire Rolodex may be composed of guys who think they are helping out a Good Girl who has temporarily lost her way. In adult magazines, phone-sex ads entice jaded callers to chat with a "blonde coed," as do the not-very-pristine stickers plastered strategically (next to the tow-truck stickers) on public phones. As I write this, one of the few remaining peepshows in New York's Times Square area still attracts business with this neon message: "LIVE MODELS WORKING THEIR WAY THROUGH COLLEGE." In the adult entertainment classifieds of many publications, men are regularly tempted by "nonprofessional" talent. Nobody would seek out, or feel good about paying, an amateur dentist. But a private stripper's "amateur" status is

often a selling point, as is a prostitute's. Purity is a hot commodity in the sex industry. I have been told by clients and colleagues alike that my great allure is that I "don't look like a hooker." Friends who have seen Bombay's notorious "cages" tell me that a whole section of Bombay's sex district is devoted to "virgins" (who presumably have no repeat customers).

Closer to home, some call girls have told me that they refuse to exploit the good girl/bad girl dichotomy because it's dishonest. One Toronto activist told me she would never let a client think he is "saving her" from prostitution, no matter how lucrative the deal. I believe she is part of an earnest, politcally motivated minority. I have had generous (and otherwise worldly) clients who needed to believe I had never turned a trick before; prostitutes at all price levels have told this story because that's what some customers want to hear. In a society too enlightened to value clinical virginity, a prostitute simply offers the next best thing: her commercial innocence. And Barbie serves as our guide.

"We Girls Can Do Anything" has more than one meaning. Barbie can do anything she wants as long as she knows how to dress and act like a respectable career gal. Or, Barbie, like many prostitutes, can embark on a career in the public sphere while getting men (or Ken) to support her in private. She *can* do anything, as long as she keeps her public persona separate from her covert sexual behavior. By the standards of many in the prostitutes' movement, a politically correct board game would be *We Girls Can Do Anything* merged with *Barbie's Dream Date*: the hard-working yuppie seamlessly integrated with the girl who can work a hard-on. In such a world, *We Girls* might include a stint as a lap dancer to finance a player's way through med school. But that kind of social realism would never work in the toy stores.

And Barbie wouldn't go for it. No matter how obvious Barbie might seem, she is not a militant or brazen prostitute. She wants to get maximum bang for her bod without suffering the consequences of being labeled a whore. She enjoys her double life with its secret motives, and does not really want to tear down the barriers. That is Barbie, and that, whether you like it or not, is your average American call girl. The prostitutes' movement is uneasy with this contradiction. Preferring to blame the prostitute's secrecy on stigmatization, we have assumed that some of the highest paid call girls in this society are simply victims of a social attitude, just as many feminists have assumed that Barbie is a victim of culture. But prostitutes who hide from public scrutiny are usually agents of their own fate who prefer to be in control of their lives.

Some will accuse Barbie of being the ultimate female eunuch: without a pussy to call her own, Barbie has no business marketing herself as anyone's wet dream. Or has she? One might also argue that I, never having possessed a Barbie, have no business claiming her as a role model. But you did not have to own a Barbie to be touched by her, to know her as part of your childhood landscape to emulate her. And Barbie did not have to have a pussy to benefit from the *power* of pussy. I once watched performance artist Penny Arcade re-enacting an exchange with a guy who had leered at her in the street: "Look!" she screamed,

lifting her skirt in exasperation. "No hole! I'm just like Barbie! There's no hole!" Because she had "no hole," Barbie flaunted her sensuality without having to deal with emotional, legal, or physical consequences. Long before abortion was legalized, she had the system beat. I sometimes wonder how many unplanned pregnancies and unwanted "date rapes" could be pinned on Barbie's unrealistic situation. Her idealized breasts, the otherworldly span of her waist—these things did not make her vulnerable. An intensely desirable body can get other girls into trouble, but Barbie's plastic perfection has never been threatened by rape, conception, or herpes. Barbie paid no price for her fabulous curves or her erotic power because she had no working orifices. She could be totally involved in the drama of her own image, oblivious to men's forceful desires. Barbie could stick those amazing breasts in Ken's face just for kicks without even getting a rise out of the guy—he had no penis.

For better or worse, Barbie's lesson to young women has been: "We girls can get away with anything." In real life, we get away with some things and not with others. It's clear to me that many of us believe "we girls can wear anything" without expecting men to react normally. And Barbie has persuaded a number of prostitutes that we girls really *can* do anything. Is she to blame for the naiveté of so many middle-class prostitutes who enter the profession unprepared for their own illegality? "You can get away with anything" could pump up a girl's self-confidence while she lets down her guard in a dangerous universe. Whether dodging the law, thumbing our nose at conventional taboos, or playing with a man's sexual appetite, we are wiggling through a minefield, running a tab that can be presented to us for payment at any time. At worst, Barbie has spawned a generation of sex-positive flakes who aren't prepared for this.

And yet, she has also passed down some useful lessons about her own femininity. A topless dancer who flaunts her synthetic breasts could well decide to keep her gyrating crotch covered throughout her career. And the prostitute who relies on hand jobs or blow jobs (rather than intercourse) is doing something remarkably old-fashioned: symbolically, or in fact, she is saving her vagina for the highest bidder. These women are practicing what Barbie preached: your pussy, a form of power in itself, can be more effective when you don't have to use it. This approach to power is what separates pros from amateurs, skilled sex objects from the exploited. Similar observations have been made in less erotic areas of industry. Charles Peck, a compensation specialist, observes that power can be "bracketed or taken out of play" when its existence is acknowledged.[4] In my view, Barbie's vagina is not really missing from the equation after all. Girls who have paid attention to her teachings have figured that out for themselves. And Ken, who has nothing to hide, is no match for them.

Recently, I had a tense discussion about Barbie with a NOW (National Organization for Women) member who supports the prostitutes' rights movement. When I poked fun at feminist Barbiephobia, she began to bristle. To oppose Barbie was *de rigueur*—until I told her about Barbie's status as a former

prostitute. I could hear her ideological wheels spinning, as Barbie's credibility grew. "Really?" she said brightly. When I argued that a hatred of Barbie might suggest prejudice against sex workers, she listened intently. But I felt somewhat guilty about exploiting a friend's political sympathies. For I have to admit that Barbie, in her previous incarnation, could never be anything as mundane as a *sex worker,* and she would never have joined a political movement or party unless there were wallets to be plundered. Lilli was a scheming floozy, perhaps—a fickle slut, a child-woman seeking the protection of money, a bitch after your wallet, a shopaholic temptress. Lilli might even have been all these things at once. But she was never one of those faceless, clock-watching laborers on the erotic assembly line. If Lilli glanced at her watch, a man didn't feel like a neglected consumer in an impersonal sex mill. Instead, he felt like a patsy — *her* patsy. Lilli was a holdover from a sexier, harsher era—the era of Josef von Sternberg's *The Blue Angel.*

But Barbie lives today, in a different time and place. If Barbie could don an astronaut suit when Woman had yet to conquer space, why not a Decriminalized Barbie with her own Little Black Book, working the Sex-Positive '90s? Or a Legal-in-Nevada Barbie? Recent developments in Barbie's life suggest that it could happen, but a part of me hopes it won't. I'd like Barbie to stay slightly out of reach, two steps ahead of the sex-positive thought police. For if Barbie becomes a *sex worker*, she'll forget about the immense power she wielded as an ambiguous *woman with a past.* Lying about her name, her age and her origins, she trained a generation or two of hussies, and we have been surprisingly shameless, despite the fact that our teacher's power derived from her ability to keep a secret.

Notes

The author is immensely grateful to Cynthia Connors, Dana Friedman, Melissa Hope and Cedric Sumner for their assistance, input and research.

1. M.G. Lord, "The Question Is: What Would Ken Think?" *The New York Times,* December 1, 1995, page C-1; and Grace Glueck, "A Zaftig Barbie? A Gay Ken? Mattel Guards Its Bosomy Icon," *New York Observer,* January 8, 1996, page 19.

2. M.G. Lord, *Forever Barbie: The Unauthorized Biography of a Real Doll* (New York: William Morrow and Company, Inc., 1994), p. 25.

3. Ibid, p. 26.

4. Ibid, p. 27.

5. Ibid, p. 32.

6. Ibid, p. 153.

7. Ibid, p. 154.

8. Charles Peck, "The Implicit Employment Contract and Compensation," *Human Resources Briefing,* Special Issue (Winter 1994–1995), p. 6.

[11] Sex Radical Politics, Sex-Positive Feminist Thought, and Whore Stigma

CAROL QUEEN

I GROW MORE DISAFFECTED FROM POLITICS—both traditional and progressive—with every passing year. Only one sort of politics keeps my attention, feels relevant, stays vital: the politics of sex. I don't mean primarily feminism, the politics of gender, but rather what some people call sex radicalism. Sex radical thought departs from both right- and most left-wing ideologies by honoring sex and desire and by positing as important the power relations of sexual orientation and behavior vis-à-vis the culture's traditional sexual mores. What is illegal? What is despised and why? What is transgressive, and what systems are shored up by the boundaries we transgress?

Sex Radicalism and Feminism: Not Always in Bed Together

As we will see, sex radical thought is both deeply feminist and also profoundly challenging to many attitudes and assumptions promoted by contemporary mainstream feminism. While I continue to identify with feminism, I also regard it with some disappointment; though I feel that most of its core principles go without saying, I certainly do not feel their unmodified relevance to all areas of my life, particularly to sex.

Feminism has greatly influenced the intellectual development of sex radicalism, many of whose earliest theorists—Gayle Rubin, Pat Califia, and Carole Vance, to name just a few—were (and are) outspokenly feminist women. Feminism itself, however, does not embrace sex radicalism completely, nor is a feminist political analysis that is untouched by sex radicalism enough to unravel the various sources of sexual, not just gender, oppression. Gayle Rubin notes in her influential essay "Thinking Sex"[1] that sex radicalism's analysis focuses on oppression sourced in "the stigma of erotic dissidence"; feminism, by contrast, is a theoretical attempt to analyze and act against gender oppression, having no position on sex except where sexual issues are seen as devolving from gender inequality. Feminism finds no shortage of gender-linked problems with sex—rape, spousal abuse and abortion rights are three examples that have spurred much feminist organizing and action—though I will argue that it is possible to cast this net too widely, seeing gender as the primary or sole

issue where matters are more complex, as in lesbian oppression, S/M, pornography, and prostitution (just a few issues that have challenged mainstream feminism).

I myself grew up into feminist thought when it was fresh from its dalliance with '60s-style sexual liberation ideology. A woman ought to be able to do what she wants with her body and her sexuality, I read in books like *Sisterhood Is Powerful* and *Our Bodies, Ourselves.* In my wholehearted agreement these became my feminist foundation. I was treading water in a sea of hormones, beginning to experiment with partner sex, learning to masturbate, slyly managing to access forbidden books. I wanted to know about sex, I wanted to feel powerful in it, I wanted to experiment, have lots of lovers, love both men and women, be sexually free and sophisticated in a way I knew most women of my mother's generation—and certainly my mother herself—were not.

For a time it seemed—at least, I believed—that feminism was my straightforward ally in these desires. But mainstream feminism, as it turned out, had never been entirely comfortable with sex. While I was happily devouring *Sisterhood Is Powerful* at the age of thirteen, the National Organization for Women was trying to purge lesbians from its membership; not long after, Betty Dodson caused a heated stir—accompanied by walkouts—at one of NOW's national meetings when she showed slides of vulvas. Sexual representation, even that produced by women, was controversial within orthodox feminism long before the mainstream media discovered Andrea Dworkin and Catharine MacKinnon.

The trail of my sexual fascinations, no less than my sexual politics, led me into the lesbian and gay community, and I stayed there from late adolescence through my twenties. There I learned a lot about sexual freedom and living as an outlaw; I was out as a lesbian in a small city, where I got my share of hate mail and death threats. I learned that many people are profoundly unwilling to let others live their own (especially sexual) lives. I saw the politics not only in gender but also in sexual behavior and sexual identity. Within a culture, power accrues not only according to class, race, and gender but also by virtue of sexual orientation and behavior, actual and presumed. Uneven access to power formed the very basis of the way my generation learned to understand politics, even though within feminism the phrase "sexual politics" meant something quite different from the politicized sexual dramas I saw playing out all around me.

The next fork in the road came when I explored S/M with a lover. She was too nervous about other people's opinions to let anyone know about our experiments in power-erotics, although I had heard rumors that in fact there was a small lesbian S/M support group within our community. I learned from this how fearful of discovery over a sexual "kink" even someone who was sexually well-adjusted—and already living counter to social norms—could be. Not long after, I began reading in the lesbian press that many women all across the country were conducting similar explorations, and that my lover had in fact been right to be worried about our community's response. The lesbian/feminist

community nationwide was being torn apart by heated disagreements about what constituted appropriate lesbian sex. In this context, more than from the Maoism that had also influenced early radical feminism, I became familiar with the term "politically incorrect." (That this term has been co-opted and used against feminists and progressives is only one of the bizarre political reversals faced by those of us whose politics were forged in '60s-era notions of liberation.)

I had now learned that a key point in my understanding of feminism—that it is my and all women's right to explore and define our own sexuality—was not universally accepted in the community of women who called themselves feminist. Arguments raged about sex and about sexual representation, that is, porn. Increasingly I found myself on the side that was being termed politically incorrect. So when I heard the term "sex radical" for the first time, I knew before I even heard the definition that it applied to me.

Sex Radical, Sex-Positive

Sex radicalism means to me that I am automatically on the side of the minority sexual viewpoint or behavior; because our culture carefully and narrowly circumscribes what is acceptable, much of the sexual world gets left on the wrong side of the fence. Sex radicalism also means that when I hear the voices of those who have been left out of the discussion, I choose to believe what they tell me about their own lives, even if it contradicts some "expert's" opinion; it also means that I maintain my own sexual integrity, if not cultural popularity, when I follow my own desires and trust where they lead.

Sex radicalism is also profoundly feminist, and with good reason. While many men are oppressed (in reality or potentially) for their sexual desires and practices, women are encouraged never to explore or experience our alternative sexual feelings in the first place. We are supposed to exist sexually within a (married, monogamous) relationship with a man, or else not at all. When we do step across the boundaries of compulsory heterosexuality and "good girl" propriety, we are often treated viciously. Women need each other's support (although we do not always get it) to navigate the rough waters of living non-traditional sexual lives. Mainstream feminism learned this lesson from lesbians, who would not withdraw their demand for support from feminist organizations and institutions; it has not, however, extrapolated what it learned to women elsewhere on the sexual fringe.

Upon further exploring sex radical thought, I learned the concept of "sex-negativity," which most of us in this erotically benighted culture drink in along with our mothers' milk. I learned that there is indeed a community of people who are sex-positive, who don't denigrate, medicalize, or demonize any form of sexual expression except that which is not consensual. In our general society—where sex is sniggered at, commodified, and guiltily, surreptitiously engaged in—being outspokenly sex-positive is sex radical indeed, for even those of us who love sex are usually encouraged to find someone else's preferred sexual expression abhorrent.

I discovered sex-positive community in various places: through my study of sexology; through my friendships with sexually adventurous others, especially gay men; in the leather community; and, perhaps most importantly, through meeting women who were both outspokenly sexual and feminist and who refused to let one quality cancel out the other. These "sex-positive feminists," as many of us have taken to calling ourselves, embrace the feminist analysis of gender inequality, but challenge the silence or conservative positions of Dworkin- and MacKinnon-influenced feminism on sexual issues. Many sex-positive feminists are veterans of the feminist sex wars over pornography and S/M, and many are current or former sex workers. Coming to a radical sexual world view, especially through my contacts and friendships with women I could relate to and who were willing to mentor me through my confusion about sex and feminism, actually proved to be excellent preparation for becoming a whore. When I did so, I discovered a world very different from the one for which the vague warnings of mainstream feminists had prepared me. My comments are sourced in the whores' world I have known; I do not intend to encompass the experience of those whores who do not work voluntarily, who are underage, who are not sex-positive, and who act out the negative expectations imposed on them by a sexist and sex-negative culture.

Why Whores Need Sex-Positive Thought

Sources as disparate and discordant as Hollywood movies, right-wing Christians, and prominent feminists tell us that women in the sex industry make a career of pandering to men's desires because, as victims of histories of abuse, we have no boundaries and sometimes no choices. For some of us there is some truth to this; there are certainly people whose mental and spiritual health would benefit from getting out of the business, and they are well served by support in doing so. But we learn next to nothing about those women for whom sex work is an excellent occupational choice and nothing at all about male sex workers—isn't it a bit ironic that men are present in the sex industry in every capacity that women are, yet their lives, failing to fit neatly into theory, are simply ignored?

One orthodox feminist argument against whoring is that it gives men further sexual access to women; leaving aside whether reality is so simplifiable, how might they choose to argue against men having access to men? And why aren't more of them clamoring for women to have equal access to sexual entertainment and service? These questions point to more fruitful areas of exploration about the nature of female and male sexual socialization, the reasons males patronize prostitutes (of whatever gender), and the place of sexual pleasure in male and female lives. Sex-positive feminists find these questions compelling; mainstream feminists often do not even ask them.

As an activist in the sex-work community, I have met well over a hundred prostitutes, as many exotic dancers, a few dozen dominatrices, and a number of models and porn actresses—far more than have most anti-sex work activists

and even most sex researchers. Just one factor stands out to distinguish those who live well, with no loss of self-esteem, from those who may find sex work a difficult or even damaging career choice. Most of the former have sufficient sex information and are sex-positive. Most, too, are staunchly feminist, even though some of them refuse to embrace that term, associating it with women who do not understand their circumstances and who do not support their right to work and to control their own bodies. Most of the latter have internalized negative attitudes about sex, especially divergent sexual behavior, and certainly about sex work itself.

In this respect, the latter are no different from those who have devoted their lives to agitating against sex work. None of these crusaders, whether they emerge from the religious Right or the feminist Left, voices respect for sexuality. (Rubin, in fact, calls mainstream feminism a "system of sexual judgment"[2]—an accusation its adherents have not yet managed to disprove.)

If these activists truly wanted to improve the lot of sex workers (which, of course, they don't; they merely want to do away with the sex industry) they would insist upon thorough and nonjudgmental sex information for clients as well as whores. One basic piece of information would be that women—and whores—do not exist to be sexually used by men, but that any sexual interaction, including a paid one, benefits from *negotiation*. This would facilitate the climate of respect that anti-sex-work demagogues claim is absent in a paid act of sexual entertainment or gratification. The paucity of sex-positive discussion about what is possible in a commodified context often negatively affects sex workers themselves.

In fact, when we whores see a client or when a peepshow worker or stripper interacts with a customer, the presence or absence of respect has much to do with how sex-positive the client or customer is—and something to do with our own sex-positivity. It also depends upon each person's degree of self-respect and presence or absence of sexual shame. Men who have taken (and internalized) the most damaging blows around their right to sexual pleasure are among the most unpleasant clients to deal with. Unfortunately, the well-publicized opinions of the anti-sex-work crowd are highly judgmental about the motives of those who pay for sexual pleasure and entertainment. I have encountered many men whose self-acceptance—and social skills—have been impaired by hearing too much media credence given to the opinions of people who are in no position to make even an educated guess about what friendly relations between whores and their clients could be like. Sex-positive feminists are only now beginning to get enough media attention that their message can trickle down to these men and to other women.

Combined with our treatment by a sex-negative law enforcement and legal system and the notorious tendency of the police to think of aggressions against us as something other than crimes, many of us are routinely victimized—by police if not by our clients and customers. Meanwhile, most of society looks the other way, including many feminists who are quick to point out how

egregiously our clients are "abusing" us simply by giving us money for sex or erotic entertainment. Feminists should be among the first to clamor for decriminalized prostitution, yet many remain silent and even vigilant in the fight to further criminalize prostitution. Feminists should raise their voices in protest when police abuse whores or ignore our need for police protection. Yet too often these voices are silent, even though these socially sanctioned abuses fall disproportionately on those most lacking feminist and other support: women of color, poor women, transgendered women.

Even when a supportive hand is extended, it often comes with a stipulation: get out of the business or do without help. The not-so-silent message is, if you elect to stay in the sex industry you can expect abuse, and we can (will) do nothing to help you. Parallel this to the deep (and deeply legitimate) concern feminists have shown to women in battered and abusive relationships; current thinking in the battered women's movement emphasizes that women be supported where they are, not offered conditional assistance.

Some of us want out of the business, but many of us simply want to see conditions improve, with everybody else out of the way. All of us would be served by a dose of sex-positive thought, which might allow us—many for the first time—to think of what we do as a worthy professional service, not demeaning, on-the-fringe behavior. An ever-increasing number of us want our sexually schizophrenic culture to look at the realities, not the lurid myths, of what we do, and to see that when sexual pleasure is seen as a positive and honorable goal, much of the negative fruit of the sex industry is deprived of soil in which to grow.

Why Johns Need Sex-Positive Prostitutes

One stereotype has it that sex workers provide sexual relief to society's "wretched": the old, the unattractive, the unpartnered. This myth can fetch us a certain amount of grudging respect even as it lets others (who can't imagine having sex with such people) distance themselves from us—as if only the young and the firm are allowed to have a sexuality in the first place, and as if whores render a service by keeping unacceptable sexualities out of the public eye. Certainly we count among our clients those who fall outside the rather narrow limits of the erotically entitled. We also count among our customers the married, the well-off, the conventionally attractive, the famous, the socially skilled: the inheritors of patriarchy. Whores know, if no one else in society is willing to admit, that outside their relations with us, these men often have as little luck getting their erotic needs met as their "less fortunate" brothers.

One also frequently hears that whores are sought out by kinky clients whose desires are unacceptable to other people. This, I think, is the source of part of the contention that clients want to abuse us: in spite of the fact that all over the country women are slurping on their partners' cocks for free, experimenting with bondage, and arranging or at least fantasizing about threesomes, a large percentage of the U.S. population still considers activities like these

beyond the pale, degrading, and abusive, even when consensually performed. In fact, many clients bring socially unacceptable desires to sex workers—or at least desires that are unacceptable in their own bedrooms. And until the climates in their bedrooms change, sex professionals will be among their only outlets. The anti-whore sentiment that grows out of the conviction that there is only one kind of appropriate sex and that all others are sinful and/or abusive (depending on the sort of morality embraced by the critic) is precisely the cultural norm in opposition to which sex radical politics grew.

Sex radicals see a problem—and a source of potential oppression—in anyone's conviction that their own sexual patterns and desires are right while someone else's are wrong. Getting between the lines of the anti-sex-work ideologues' reasoning, we find various concerns embedded but often not articulated: a married man is wrong to take his sexual desires to anyone but his wife; a married man is wrong to have sexual desires if his wife isn't comfortable with them; oral sex is depraved; giving men an outlet for getting blowjobs will just make the man want them at home, and blowjobs are demeaning to women; sex is demeaning unless a romantic bond (or a Christian bond) exists between a couple; giving men an outlet for any kind of sex, including sexual looking, will make him want more sex/kinkier sex; if a prostitute isn't immediately available he will harass/rape other women; getting sex from a professional is the same as infidelity; men should not have access to sexual variety; prostitutes spread HIV (to "innocent victims"). (This says nothing of the numerous heterosexually married men who actually patronize male whores; but again, this common situation is scarcely ever recognized and commented on by sex-work abolitionists, especially feminist ones.)

It is as though sex, especially male sex, is a bubbling cauldron of trouble, and if we don't keep a lid on it, awful things will result.

In fact, this is precisely the lesson my mother tried to teach me. Her example, however, was not inspiring; and if all the women who rail against the sex industry have sexualities as miserably closed down as hers, the culture is in a painful, festering state indeed. "Do you know," she whispered to me wide-eyed some months after my father's death, "your father tried to convince me to perform oral sex on him *six times* during our marriage!"

"Dad," I thought, "you animal! Once every five years! Have you no self-control?" More than once I've wished my distressingly buttoned-down dad—whose sexual unhappiness rubbed off on everyone in my family—had turned to a whore to let off some steam.

Like my parents, a majority of our clients have marriages marked by desire discrepancies and difficult communication about sex. Many women have grown up fearful of sex, either because of unpleasant experiences or because these feelings were inculcated in them at (sometimes literally) their mothers' knees. Others have grown up believing that sexual experimentation is wrong. Feminism, when it successfully reaches to these women at all, rarely contradicts the deep sexual antipathy they carry.

The availability of paid sexual gratification and entertainment does nothing to improve these partners' sexual relationships except, perhaps, to take the pressure off; it has been argued that having a valve on the pressure cooker actually preserves marriages like this by minimizing the impact of their sexual contradictions. I'm inclined to believe this is true, but it still doesn't cast a very rosy light on the situation; for one thing, are the women's sexual desires being met in relationships such as these? Not very likely! My answer to the problem—universal sex-positive education and sexual empowerment of women—lies far away on the horizon.

Wives Need (and Can Learn From) Whores, Too

In the meantime, I think the unequal lot of these couples could be balanced somewhat by a growing availability of sexual entertainment for the women whose partners are going out and getting theirs by hiring professionals. Of course, this scenario would involve that our culture take a whole new look at women and sex. The gander may not be ready to share the playground with the goose; but, just as importantly, women may not be prepared to take into the marketplace desires they've been trained to romanticize. Much feminist theory has spotlit the ill effects on women's self-esteem and autonomy of channeling sexuality into a relationship, but few feminists have suggested women could learn something by having more options for sexual fulfillment in the marketplace. As with the question of pornography and its appeal/availability to women, many sex-positive feminists support more female-centered choices in sexual service and entertainment, the proliferation of which might well affect the entire sex industry for the better. And if conflating sex and romance keeps women available for marriage (usually implying their acceptance of male control over their sexuality), how might detaching sex from romance serve to change what women desire from sex?

Viewed through a sex radical lens, whore stigma derives from whores' sexual availability and presumed copious sexual activity. From a sex-positive feminist perspective, most whores are available and sexually active *on their own terms*. It's no wonder that whore stigma attaches itself more viciously to women than to men, for in this society a sexually emancipated woman is threatening and despised; neither "slut" nor "whore" is a name most women want to wear. Sex workers cross this line, either proudly or not, for money, adventure, or rebellion. Would our clients' wives—or even many mainstream feminists—be willing to brave that stigma for a chance at sexual agency? What about for the promise of greater solidarity among all women? Early feminism tried to erase the whore stigma for just that reason; today's feminist orthodoxy would often rather do away with whores. Any issue that divides women—and this is one of the most potent divisions of all—is crucial for feminists to consider and resolve.

Other whores won't necessarily agree with me, but I'd be glad to see sex work wither away because everyone became so sex-positive that a market for our services no longer existed. Perhaps then we could become the sexual healers and

sex educators so many of us believe we (potentially or already) are. Of course, we're nowhere close to that utopia; in the meantime sex workers can help facilitate gratification for those who wouldn't ordinarily get it, and we can all—whores, sex radicals, sex-positive feminists, and critics alike—continue to ask questions whose answers point to an increasing level of comfort and safety for sex workers (as well as, incidentally, for our clients).

A Sex Radical, Sex-Positive Feminist, Whore's-Eye View

The stereotype about sex workers that says we are driven to this demeaning lifestyle by a damaged history must be exposed as the sex-negative and, yes, sexist crap it so often is. (How eerily this parallels what used to be said about lesbians!) This image is neither universally truthful nor even helpful for analyzing the situations of those whores whom it describes, unless the question is also asked: What separates those sex workers who experience their lives negatively from those who do not? Abolitionists won't ask this question, because it implies that there might be a strategy for creating a positive sex industry, but we whores and all of our supporters, including sex-positive feminists, must ask it continually. Abundant and accurate sex information, as I noted above, is a key determinant.

And while I maintain that it should be everyone's right to do sex work, I hope people will consider their motives for it whether they are thinking about entering the sex industry or are already a veteran. It is never too late for anyone to begin to root out his or her own sex-negativity, and the whores who haven't done so—those whose damaged lives and horror stories are so eagerly pointed to by the anti-sex-work activists, and even those who disrespect their clients' desires—may lack the most important qualifications for the job. It is the responsibility of the culture to work on its negative attitudes about sex and about us and our work; but it is whores' responsibility to work on our negative attitudes about ourselves.

The movement for sex workers' rights should acknowledge that we have professional responsibilities and should assist every whore in meeting them. Giving sexuality, the basis of our trade, the respect it deserves must be foremost among these. In fact, as of this writing the North American Task Force on Prostitution has a subcommittee that is developing a code of ethics for whores.

Women and men who do sex and sexual entertainment for a living are targeted by laws as well as social opprobrium, and so are our clients and customers—though the latter form a shadowy, hard-to-recognize army. We are regarded more as outlaws than they are, and this can be one of our strengths: seeing, often with the support of other sex workers, that we constitute a group with different sexual norms, oppressed because of these differences, is the first step toward embracing sex radical politics and understanding that we are only one group out of many that has been culturally labeled and mistreated. A feminist analysis, too, helps us see ourselves as a group with shared circumstances, one for whom gender is by no means irrelevant. Cer-

tainly we should have pride in ourselves and hopefully in what we do, and sex radical politics, along with a sex-positive belief system and a sex-positive feminist analysis, can go a long way toward ensuring that we develop that pride.

There *is* no sexual majority, although the whole society conspires to behave as though there were. Our clients—mostly married heterosexual men who show an illusory exterior of "normalcy" (whatever that useless concept means)—are also cross-dressers, submissives, anally erotic, bisexual, fetishistic, wrapped up in wild fantasies no traditional heterosexual marriage could ever contain. And what the "poor abused whores" lobby will never tell you is that many sex workers, too, are fetishistic, sexually curious, nonmonogamous by nature, and exhibitionistic, delighting in the secret proof our profession provides us that restrictive sexual mores are rupturing everywhere.

No one should ever, by economic constraint or any kind of interpersonal force, have to do sex work who does not like sex, who is not cut out for a life of sexual generosity (however attractively high the fee charged for it). Wanting to make a lot of money should not be the only qualification for becoming a whore. We in this profession swim against the tide of our culture's inability to come to terms with human sexual variety and desire, its very fear of communicating about sex in an honest and nonjudgmental way. We need special qualifications, or at the very least we need access to a way of thinking that lets us retain our self-esteem when everyone else, especially do-gooders, would like to undermine it.

Activist whores teach, among other things, a view of our culture's sexual profile that differs from traditional normative sexuality. Every whore embodies this difference each time s/he works. It is time for all whores to embrace this difference, to become ambassadors for sex and gratification. The politics of being a whore do not differ markedly from the politics of any other sexually despised group. We must include radical sexual politics in our agenda, becoming defenders of sex itself. Our well-being and our own defense depend on it.

Inviting Feminism into Bed with Us

And in the end, what does this have to do with feminism?

Today, mainstream feminism is a site for anti-whore activism, a locus for demagogues like Andrea Dworkin, Catharine MacKinnon, and Kathleen Barry to agitate for the abolition of our livelihoods and to lobby for our silencing. Ordinary feminist women are often swayed by their rhetoric and may have no opportunity to hear our side of the story. (Certainly every letter I've ever sent to *Ms.* has gone unpublished.) We have learned to our dismay that a woman's feminism is no guarantee she'll be open to sex radical thought; sometimes, sad to say, the very opposite seems true. Whores make other more traditional feminists defensive around issues of sexual stigma, boundaries, and the nature of women's sexual relationships with men. However, we could equally powerfully raise consciousness around these issues, since sex-positive whores have learned to sexually negotiate at the intersection of our clients' desires, our limits and boundaries, and with regard to issues of safety and emotional well-

being. Were we to be acknowledged by orthodox feminists as the experts we are, our voices could help push the feminist analysis of sex in positive, productive directions. This could only strengthen feminism's appeal, since sexuality is such a powerful, and often problematic, issue in so many women's—and men's—lives. If feminism were to take seriously my question about what separates the experiences of women who hate sex work from those who thrive doing it, would that not have profound implications for the lives and sexual strategies of ordinary women?

Further, taking whores—whores, not just "degraded" ex-whores—seriously would support a feminist claim that is at the moment fatuous: that feminists care about the experience of all women and are open to learning from the experience of all women. Whores are only one of a multitude of groups who do not get an open-minded hearing in mainstream feminism today.

It can be argued that whores labor on the front lines of patriarchy. Feminists really ought to be more interested in the things we see, hear, and experience there. Sex-positive feminists are, of course, and support the issues we consider important, including improved working conditions, safety, and freedom from harassment. They, unlike so many orthodox feminists, understand that we do not consider our work itself a form of sexual harassment; that many of the abuses committed within the sex industry have little to do, in fact, with sexuality; that we are not *selling* ourselves or our bodies (a reprehensible turn of phrase repeated, often as not, by feminists, who ought to have more concern for the power of language to shape reality) any more than does any worker under capitalism; sex-positive feminists remember that any worker under capitalism is subject to mistreatment.

They also understand that we value our work when it allows us autonomy, free time, and a comfortable income; we often like living outside the narrow circle society circumscribes of ladylike behavior; we are not "good girls," nor do we aspire to be; and we often relish the opportunity our work provides us to learn secrets, to support our clients' forays away from traditional masculine sexuality, to transgress restrictive boundaries and rebel against the rigid limitations created by our own fear of sex.

To what degree is the failure of mainstream feminists to educate themselves about us and support us a result of their fear of sex and/or of being labeled a whore? Like many feminists' antipathy toward lesbianism, this is a feminist issue with implications far beyond the politics of sex work.

Sex-positive feminist whores invite all women to consider these issues, confront their own whorephobia, and learn from us.

Note

1. Rubin, Gayle. "Thinking Sex: Notes for a Radical Theory of the Politics of Sexuality" in *Pleasure and Danger: Exploring Female Sexuality*. Carole Vance, ed. Boston: Routledge & Kegan Paul, 1984, p. 293.

2. Rubin, p. 282.

[12] 500 Words on Acculturation

JESSICA PATTON

SHE FUCKED ME FROM BEHIND WITH A NINE-INCH BLACK RUBBER DICK, pounding my pussy like driving a stake. She pinched my clit with two sharp fingernails, as if killing a flea, and smacked my ass with the other hand.

"Harder, please!" I begged.

"You want it harder, you greedy bitch?" She teased, pulling my hair—letting go casually when she realized it might come off. I screamed and I came, wet like an accidental milk spill on the table beneath us. She held me and touched my face lightly with a glove with my smell and whispered, "Good show."

Later, I stood next to Cassandra at the dressing-room sink. Still in costume from our performance (sparkly body oil and high heels with little oval traction pads glued on the soles), we washed our dildoes.

Cassandra was straight. (I had just left my girlfriend, a one-finger special, and moved from Northampton, Massachusetts.) I knew it was the best fuck I'd ever had. It just happened to be on a platform the size of a cocktail tray, my cunt at nose level to a skinny guy with an incest fetish. He bounced up and down on the puffy vinyl rose-colored bench, hollering, "Love me cousins, love me!" and paid us each a hundred dollars. So began my girl-girl, femme-on-femme-with-an-audience sex life.

At Smith College, I had come out and gone home with my first woman. She traded her Junior Miss Texas past for Birkenstocks and MacKinnon over the course of her four years but was still thoroughly femme. Gone home with her, period. We sat for hours in her chandeliered dining hall talking about feminist theory, talking about the inherent power imbalance and oppressive sexual contract between men and women, talking about just how logical lesbianism is, talking and waiting, theorizing yet still being at the mercy of our nasty conditioning as we each waited for the other to *make the first move!*

The sex I actually had at Smith was tentative and pitch dark. At its earliest it was still in the dying stage before "lesbian bed death." "Give me a power imbalance!" I screamed (quietly, to myself) as I whacked off in my twin sized dorm bed to the image of the beauty queen fucking my brains out on that dining-room table during lunch rush.

In San Francisco, the city of sex positivity, I chose the sex industry with the privilege of a girl privileged enough to know she has a choice to choose to rebel against her privileged education.

But the actual sex took me by surprise. It snuck up from behind with the metaphorical and literal impact of that nine-inch dick. All my snotty Ivy League assumptions about strippers went down the dressing room toilet. Here I was in the Ivy League of strip theaters. These women knew about sexual contracts, and they knew about women's space—with two critical differences from Smith: They knew how to *fuck*, and they knew how to *look good doing it*.

[three] Turnabout

Reversal,

Subversion,

and Re-vision

If one is always bound by one's perspective, one can at least deliberately reverse perspectives as often as possible.

—Gayatri Chakravorty Spivak,
"Translator's Introduction"
Of Grammatology

[13] It's Different for Boys

JULIAN MARLOWE

FEMALE PROSTITUTION TAKES ON NEW MEANINGS when analyzed alongside male prostitution. Within the gay male world, prostitution is, for the most part, regarded with indifference. This is probably because many gay men have learned not only to accept but also to take pride in sexual deviance.

The arguments against female prostitution are familiar: prostitutes are victims, have no self-esteem, degrade all women, and need to be forcefully removed from their circumstances. However, when one applies these arguments to male prostitutes, and if one treats men and women as intellectual equals, then these arguments contradict the very essence of feminism; instead, they propagate patriarchal and antifeminist values.

My first argument centers on the notion of victimhood. The stereotypical Hollywood female hooker is regarded as helpless and pathetic, waiting to be rescued by a man (Julia Roberts in *Pretty Woman*, for example) whereas a stereotypical male hooker is regarded as tough and invulnerable, turning tricks just to be deviant (Keanu Reeves in *My Own Private Idaho*). The sugar daddy of a former acquaintance of mine once admitted that he used to get a rush from picking up hustlers on his lunch break due to the sheer element of danger: the person he picked could conceivably beat him to a pulp.

Whenever concern is expressed in the media for male prostitutes, it's inevitably in the context of a child prostitution ring. The use of the word "child" is intended to portray innocence, when in fact male prostitutes are usually adolescents above the age of consent. In contrast, women of *any* age are treated as childlike victims, even if they entered prostitution well into adulthood. It would appear that age confers maturity and autonomy upon male, but not female, prostitutes, who are rarely represented as anything but exploited.

"Exploitation" evokes a zero-sum game: one person gains at the expense of the other. However, prostitution—and especially male prostitution—is almost always a commercial transaction in which both parties agree on a price beforehand. The exploitation argument seems to rest on the spurious claim that women find sex inherently unpleasant, and that any woman who engages

in it for reasons other than love is having something taken from her, no matter what fee she commands. In comparison, consider the same transaction between two men. Who is exploiting whom? Is it the client, who has the financial ability to buy sex from a younger man with (presumably) less financial freedom, or is it the conventionally attractive hustler, who cashes in on the fact that he's younger and more desirable than his client? Whose erect penis represents the "weaker sex"?

Looking at a commercial sex transaction between two men thus highlights the ambiguity of traditional feminist notions of exploiter and exploited. While there is exploitation in the sex industry—pimps who take a hooker's entire earnings, clients who refuse to pay, men who secretly videotape encounters and then sell them—there is nothing *inherently* exploitive about two adults engaging in consensual paid sex. It is only when the prostitute is female and the client is male—or when the prostitute is a minor and the client isn't—that the issue of exploitation arises at all. Perhaps it's time we ask ourselves why women and children are regarded as a homogenous group in this regard, while men are subject to an entirely different set of rules.

My second argument has to do with the presumption that prostitutes have low self-esteem. Adolescents learn that "good girls" abstain from sex while "bad girls" don't, and that good boys and bad boys alike strive to have sex as often as possible. Because of this conditioning, we believe that young women who engage in casual sex must necessarily be bad girls and, moreover, that they themselves must agree with society's assessment of their bad girl status. Only a handful of feminists have bothered to suggest that good girls can enjoy sex for its own sake. In contrast, boys who engage in casual sex are considered to have a normal and healthy sex drive.

For better or for worse, gay men have mastered the art of the one-night stand. As such, prostitution is merely a variation on a well-established theme within gay circles, namely the anonymous, no-strings-attached fling. Many of my own clients have confided that they seek the services of a professional simply as a matter of convenience—they'd rather not waste their time playing mind games in the bars, they know exactly how much it's going to cost them at the end of the evening, they know exactly how far they're going to get, and they don't have to worry about any romantic expectations on the part of their partners.

Concern for the mental health of female sex workers rests on a normative view of female sexuality as connected to love and relationship, reflected in the stereotype that female prostitutes must not value themselves as anything more than receptive sex organs. Yet, among gay men, hustlers are not stigmatized in this way—more likely, they are envied. Why would a man have low self-esteem if he's being sought out and given money for his body? In gay male culture, knowing that one is attractive enough to command payment raises, rather than lowers, one's self-esteem. It is only if one believes that the ability to have sex without love is damaging that this aspect of prostitution appears to

be "unhealthy" or a reflection of low self-esteem. In fact, the required linkage of sex with love (or the injunction to be "good girls") has historically functioned to keep women under the control of one loved man—their husband, who may or may not demonstrate equal monogamy and devotion.

Unlike the link between female prostitution and roles and perception of women in general, male prostitution is quite separate from the roles and perception of men in general, both within the gay world and without: few would argue that the presence of street hustlers in any way influences how society perceives men in general. This dichotomy arises from the different ways in which we perceive and treat women and men in society, rather than anything inherent in the sex trade. If prostitution were patently destructive, then presumably male whores would find themselves as stigmatized as their female counterparts.

Measures to abolish street prostitution are typically geared toward women. In many cities, "schools" for johns are popping up, in which men arrested for soliciting an undercover female officer can circumvent a police record by paying a $500 fee and sitting through a lecture telling them how they have degraded *all* women through their actions. The ex-prostitutes who inform these men of their evil ways claim to be speaking on behalf of all prostitutes, which is yet another example of women having their opinions decided and voiced for them on their behalf; just because in this instance they are being eclipsed by other women doesn't make it any less condescending. Further, these programs rarely if ever target the clients of *male* sex workers, perhaps because proponents realize that a man standing at the front of a room trying to convince johns that their actions degraded *all* men would be regarded as comical at best. While these programs are purported to "help" victimized women, their effect is to erode the client base for all female prostitutes—essentially to abolish one of the only professions in which women typically earn more than men.

In debates about prostitution, it is often women—the same women who correctly argue that women are intelligent and independent beings—who selectively invoke antiquated notions of helpless victimhood when trying to abolish the profession. If one truly believes that men and women are equal (or at least should be regarded as equal), then it should be clear that prostitutes require neither pity nor salvation on the basis of their profession alone. All of the arguments against prostitution break down when sex roles are held constant. Men can engage in commercial sex without being regarded as victims of exploitative men or as propagators of demeaning attitudes. Any prostitute (or anyone else) may be a victim of circumstances beyond his or her control, and measures should be in place to help those who wish to get out of oppressive circumstances. However, to suggest that prostitutes who do not see themselves as victims just don't know any better is patronizing and contradicts the very essence of feminism—the freedom to make one's own choices.

The juxtaposition of male-female and male-male prostitution helps to highlight a fundamental flaw in the arguments of antiprostitution feminists:

the objection relates not to the actual transaction (which is fairly mundane when all is said and done) but rather to preconstructed sex roles that attempt to stigmatize women for being anything other than the traditional passive partner. Rather than advocating a manifestly patriarchal view of female sexuality, perhaps feminist energy would be better spent trying to eradicate the whole good girl/bad girl paradigm altogether.

[14] Professional Dominance

Power, Money, and Identity

LIZ HIGHLEYMAN, aka MISTRESS VERONIKA FROST

PROFESSIONAL DOMINANCE HAS GENERALLY BEEN ABSENT from the feminist discourse surrounding sex work. However, I believe that pro doms are not inherently different from other women in the sex industry,[1] and that an examination of the dominatrix's sexual power and agency can carry over to all types of sex workers.

Professional dominants occupy a unique position in the sex industry. The professional dominant tends to receive more respect than most other sex workers, often along with greater financial stability, relatively less societal censure, and a less precarious legal standing. For these reasons, the professional dominant may have a special responsibility for solidarity with the sex work community.

Professional dominatrices receive money or other compensation to engage in erotic power exchange, commonly known as SM (sadomasochism), D&S (dominance and submission), or B&D (bondage and discipline). Some pro doms also "switch" and do submissive sessions, and many more have done so during their training. Typical activities include bondage, spanking, whipping, painful stimulation ("torture") of the nipples and genitals, "puppy" or "pony" training, and feminization (cross-dressing) of male clients. Fetish elements are typically part of a session, and may include leather, rubber, high-heeled shoes or boots, or costuming suggestive of mommy, nurse, or school teacher roles. Negotiation is an important part of a session, and responsible dominants (also known in various contexts as mistresses or tops) emphasize the consent of the submissive (also known as the slave or bottom).

Professional dominants tend to enter the profession by one of two routes, either through a previous interest and involvement in SM or via other areas of the sex industry. My own path was somewhat mixed. In the late 1980s I ended a seven-year relationship, came out as bisexual, and began to explore a long-standing but latent interest in SM. At about the same time, I became aware of the sex industry through my political involvement in anticensorship, anarchist, worker empowerment, and AIDS activism, and through a girlfriend who worked occasionally as a stripper and escort. When I attended events dressed in

femme fetish attire (in part an outgrowth of my earlier punk rock style), I was sometimes asked by submissive men if I was a professional dominant. At some point it occurred to me that I might as well get paid to do something I enjoyed anyway, and I began sporadically to see clients for money. I have since worked as a phone dominant, a performer in SM/fetish shows, and a pro dom in a B&D house. In the future I would like to work independently or as part of a small partnership.

I did not "fall into" sex work because I lacked alternatives. I thought professional dominance would be an exciting, anti-establishment kind of thing to do, and hopefully interesting, educational, and fun as well. I glamorized the image of the dominatrix and aspired to be one myself.

Pro Doms and the Sex Industry

Some professional dominants distance themselves from sex workers, in part due to the stigma and illegality surrounding that industry. They feel that the work they do is about power, education, therapy, ritual—almost anything except sex. While most pro doms do not have what they consider to be sex with their clients, there is no doubt that most clients see their sessions as an erotic experience. Most moral conservatives don't make a distinction between erotic dominance and other types of sex work. There is little point, and much danger, in maintaining a false wall of separation between professional dominants and other sex workers, given our similarly tenuous positions in the eyes of mainstream society. Given the professional dominant's greater respect and financial stability, I believe that pro doms have a responsibility to support sex workers in more precarious situations and to advocate for sex workers' rights. I feel a sense of solidarity and shared experiences with people in other areas of the sex industry. I have attended international meetings of sex workers, worked on HIV/AIDS prevention projects for people in the sex industry (including needle exchange programs in Boston and San Francisco), and am a member of the sex workers rights group COYOTE.

The Feminism/Sex Work Connection

At an anarchist gathering in 1989, I attended a workshop on sex work that was my first exposure to feminist, queer, politically radical, well-educated women in all areas of the sex industry. My previous anticensorship work had led me to erroneously believe that most feminists were opposed to pornography, SM, and sex work. In fact, I resisted calling myself a feminist for many years because of my negative associations and interactions with what we then called "anti-sex" feminists (more fairly known, perhaps, as antiporn, antiprostitution, abolitionist, or cultural feminists).[2] In recent years I have come to know many sex-positive feminists who advocate strongly for freedom of expression, freedom of choice, and improved conditions for women in the sex industry.

Sex work has been a point of contention among feminists from the social purity debates early in the century to the "sex wars" of the late 1970s and 1980s.

If there has appeared to be a monolithic anti-sex-work line among feminists, it is only because the voices of many women, including sex workers themselves, have been excluded from the discourse. Abolitionist feminists have claimed that prostitution is always rape and that no one can genuinely consent to engage in paid sex. Those women who claim they do sex work by choice have been labeled as deluded or as victims of "false consciousness."

Professional dominance has generally not been included in feminist discussions of sex work. Abolitionists find it difficult to make the case that pro doms are exploited victims with no control over their situations. At times they have gone so far as to regard dominatrices as "imitation men," since all expressions of power and dominance are branded as inherently male. Pro-sex feminists who advocate for sex workers' choices and rights have also avoided the issue of professional dominance. I suspect this is because the trappings of SM can be frightening to those who are unfamiliar with them, and because the use of dominant/submissive power roles appears to substantiate the abolitionists' most strident claims. This is especially true when the issue of professional submission is introduced. The idea of a woman allowing herself to be tied up and beaten for money seems to reinforce everything the antiprostitution forces say, although they believe that all sex workers are in such a debased, victimized situation, not just those who explicitly take on a submissive role.

Not All That Different

Looked at more closely, I believe that many of the purported distinctions between professional dominants—and professional switches or submissives—and people who do other types of sex work fall apart. Most sex work, after all, is in the service of the male orgasm, however that may be brought about.

Sex workers do not sell their bodies—they still have them when then the commercial interaction is over. Rather, they sell their time and skills, and perhaps rent the temporary use of parts of their bodies, as do most other workers. It is more widely recognized that professional dominants are in fact selling their skills and experience, but this is true for many types of sex workers; it is, after all, why an attractive client might pay good money to spend time with a pro rather than on an ordinary date. While skills are the pro dom's principal asset, "packaging" is also very important. Some clients merely wish to gaze upon the dominatrix's leather-clad form, touch her stockinged legs, or lick her thigh-high boots. In fact, somewhat of a dual market exists, with older, specially trained, expert dominants on one end, and young, beautiful women with fewer skills and less experience on the other. The latter segment has quite a bit of overlap with other areas of the sex industry. Many of these pro doms may also work (or have recently worked) as strippers, phone-sex operators, or prostitutes. Likewise, many strippers own some leather or latex items and may work a riding crop into their act, and many prostitutes own fetish clothes and SM toys and include elements of dominance or submission in their sessions.

As for the professional switch or submissive, she is not a "sex slave" but

rather a professional who has agreed to act out a prenegotiated fantasy for a set period of time. It's a skill to make a client think he's getting what he wants when he's really not; the pro sub learns to appear submissive while in fact controlling the interaction. Some dominant women occasionally enjoy this type of role play and the opportunity to relinquish the difficult creative work of orchestrating a session. It's worth noting that many service-industry jobs require more or less continuous servility toward bosses and customers; a typical waitress or secretary must play a submissive role for an entire full-time week to earn what a professional submissive can make in a few hours.

The Economics of Commercial Sex

Among the various critiques of sex work, I am most interested in those that stem from economic concerns. It is certainly true that there are sex workers (or those engaged in survival sex) who are badly exploited, hate their work, and do it solely because they have no economic alternatives.

From an anticapitalist perspective, sex work is perhaps the ultimate expression of worker ownership of the means of production, as expressed in the slogan "my body is my business," as a person's body is the one asset that usually cannot be taken from them. Mind labor typically requires resources, both in terms of education and infrastructure. Body labor has often been the last resort of those who lack these resources. Just as men often rely on hard physical labor in times of need, women often rely on sex work. It is important not to take this option away before alternatives are available.

I believe that no one should be forced to do any type of work they detest or find degrading in order to keep food in their stomachs or a roof over their heads. Yet most of the arguments against sex work are not criticisms of "wage slavery" or of economic systems that exploit the labor of some for the benefit of others. A thoroughgoing critique of the global economic system would have to encompass not only men who exploit poor women for sex but also residents of wealthy nations who benefit from the cheap factory and agricultural labor of poor residents of developing countries—exactly the types of labor that are often proposed as worthy alternatives to sex work.

It is antisex sentiment, or erotophobia, that leads to such a strong distinction between sex work and the other types of work available to women on the bottom rungs of the economic ladder. Many women have left jobs as waitress or secretaries for sex work, which they find gives them better working hours, more freedom to work as they wish, and a better economic return on their investment of time and effort. Everyone should have the opportunity to leave the sex industry if they choose, but antiprostitution crusaders should not assume that women—either in the industrialized or in the developing world— would necessarily be better off doing low-wage domestic, factory, office, or agricultural labor than they are doing sex work.

A better goal for those concerned about sex workers would be to empower workers to improve the conditions of their work, not to eliminate their liveli-

hood. Such improvement could take the form of decriminalization, so that workers aren't at the mercy of police or exploitive pimps and could have the same legal protections, benefits, and responsibilities as other workers; implementation of health and safety standards and development of safe, pleasant places to work; training in self-defense, sexual techniques, money management, and other job-related skills; and the creation of mutual aid and support networks. While there is a place for administrators and managers in the sex industry, it is crucial that most of the money made from sex work should benefit those who perform most of the labor.

Would there be a sex industry in an economically just society? Many people object to the concept of sex as a commodity; they feel it is too "sacred" to be bought and sold. But why should sex not be part of the economy in the same way other valued services are? There will probably always be people whose lack of attractiveness or social skills (by whatever rubric the community measures these qualities) makes it difficult to find partners. Others may desire sexual interaction with a specialized expert, or sex without the social and emotional overhead of establishing an ongoing relationship. I would expect that even in the most egalitarian society there would continue to be some sort of exchange for desired items and services (whether by money, barter, or some other means), and I see no reason to assume that this would not include sexual goods and services.

But what about professional dominants? There is a stereotype that pro doms are wealthy, and in a sense we must uphold that stereotype in order to maintain a dominant image—we can never let on that sometimes we want the session as much as he does! Yet the truth is, a dominant mistress can still be a wage slave. Most pro dominants outside the most well-paid upper echelons would probably prefer to be more selective about clients, hours, and specific activities if finances were not a consideration. At the very least, like most workers in any field, we'd sometimes rather stay home than get dressed up, made up, and psyched up for a session. Income from professional dominance, as with all sex work, can be extremely variable, and the influx of potentially large sums in a "feast or famine" manner can lead to dangerous spending habits. I increasingly find myself thinking of costly items in terms of how many sessions it would take to pay for them and of wasted time in terms of how many sessions I could conduct during the period. I advise novices not to rely on professional dominance as their sole source of income until they are well established, lest they be tempted to do things they really don't want to do (and will kick themselves for later) when bills are hanging over their head.

Femininity and Power

The professional dominant is the stereotypical representation of female power over men; she is the embodiment of the combination of power and femininity. As such, she bears the brunt of the scorn with which powerful women are treated by mainstream society: where a man is assertive, a woman is aggressive;

where a man is an effective leader, a woman is pushy or a nag; where a man speaks his mind, a woman is bitchy. Similar attitudes also exist in gay and lesbian communities. Aggressive and domineering behavior is accepted and even admired in butches who have divested themselves of the trappings of femininity, but such behavior is looked down upon in femme women who display the traditional signifiers of femininity. Perhaps queers are as fearful as the mainstream of power and femininity coexisting within the same body. Because of the persistent belief that power is somehow inherently masculine, a woman who openly and proudly combines the traditional signifiers of both femininity and power strongly challenges accepted gender roles.

In a sexist society, what woman doesn't occasionally fantasize about exercising power, sexual or otherwise, over men? Even women who can't imagine working as a prostitute or a stripper often express delight at the idea of making a living by tying up and spanking men. Yet don't all types of sex workers potentially have this power? In a very real sense, sex can be an arena in which women have considerable power over men. While men as a group have physical, economic, and political power over women, women control something that most heterosexual men desperately desire. Some girls and women learn early in life to use this power for their own gain, and sex work is an extension of this practice.

Sex work relies upon, some might even say exploits, the sexual neediness of men. Working as a dominatrix has shown me how enslaved men can be to their desires, and playing upon a man's sexual fetishes can be a powerful (albeit often temporary) means of exerting control. Men spend large sums of money, face shame and guilt, and risk family and societal censure to satisfy their sexual desires, especially those that are considered unusual or illicit. It is sad that so many people are terrified of openly expressing sexual fantasies that diverge from the presumed norm, and it is tragic that people do not feel able to discuss and negotiate their sexual needs with their partners. But I also know that it is society's erotophobia that keeps me and other sex workers in business.

Professional dominance is not about hating or being cruel to men. Some pro doms clearly do despise their clients, but I suspect they do not last long in the business. If I hated most of my clients, I'd quickly succumb to burnout. Professional dominance is a balancing act between exercising control over a client and providing him with a service. Certainly, if a client is pleasant you want him to keep coming back—and to keep giving you money!

Modern western society tends to devalue women as they get older and lose their youthful looks, in contrast to certain other cultures in which the wisdom of old women has been revered. Professional dominance is unique in the sex industry (and perhaps in any line of work) in that older women are valued as much as or more highly than younger women. Older dominatrices are respected for their experience and authority and are in demand for fantasy roles such as mother or headmistress. A pro dom can continue her career well into her senior years if she develops the skills and specialties to take her beyond the youth-and-beauty market—perhaps with minor adjustments to accom-

modate reduced strength and a decreased ability to totter about on stiletto heels. Because professional dominance is so skill intensive (and perhaps because formal training is an accepted part of the SM scene, unlike sex, which people are supposed to just know how to do), training of younger women by older women is widespread and institutionalized—a model that other areas of the sex industry could fruitfully adopt.

The Pros and Cons of Being a Pro

For me the most interesting and valuable aspect of working as a professional dominant is the insight it gives me into human nature, how people think and behave and what makes them tick. Professional dominance—indeed, each type of sex work—is a sexual anthropologist's dream. I have the opportunity to observe and participate in a vast array of sexual fantasies and behaviors. I have learned secrets and been entrusted with confidences about men and male sexuality that most women (perhaps especially women with male partners) never discover. I enjoy working in an atmosphere in which sex, gender, relationships, and sexuality are topics of everyday discussion. Professional dominance (and sex work in general) is a portable career that allows one to travel and move around at will, and it allows for flexible hours and generous time off.

If being a professional dominant is so great, why don't more women—or at least more women in the sex industry or into SM—take it up? Professional dominance is hard work, and it requires the time and dedication to learn and practice several specialized skills. The responsibility is heavy: people can get badly hurt, or worse, if a dominant doesn't know what she's doing. While their situation is certainly better than that of prostitutes, pro doms must constantly be wary of legal harassment. Even though professional dominance is not strictly illegal under most prostitution laws, those statutes are often vaguely written and open to widely varying interpretation. For example, California's "lewd and lascivious conduct" statute includes as prostitution any contact between any part of one person's body and the genitals, buttocks, or female breasts of another person—a definition that certainly includes a spanking! Depending on where one lives and works, competition with other women for clients can be fierce and may hinder the development of solidarity and support networks. As with all types of sex work, dealing with difficult clients, walk-outs, and no-shows can engender feelings of rejection and a lack of confidence about one's appearance and skills, which leads to a high rate of burnout.

Yet I suspect the major barrier is the cultural mental block against the exchange of erotic or sexual activity for money. Sex work is seen as the ultimate bad-girl activity, and professional dominance is seen by many as a particularly egregious branch of sex work since it involves SM, which itself is a highly stigmatized form of sexuality. Even women who do not themselves regard sex work as bad can't help but be aware of the negative stigma that surrounds it, and many are unwilling to face censure and condemnation from family, friends, and society at large.

But What About Sex?

As with many sex workers, pro doms may have difficulty separating their professional and personal lives, and their work may negatively impact their romantic and sexual relationships. I have in some ways become more blasé about sex, SM, erotic/fetish attire, and sexualized situations; they have become routine for me, and no longer hold the aspect of titillation or forbidden erotic thrill—and I do miss that thrill.

I am careful to maintain my personally defined sexual boundaries. For me, sex and SM have always been separable, which makes my work less complex, since I can put clients on one side of a pre-existing mental barrier (although clients frequently try to cross this barrier in the guise of body worship, "sensual touching," cock bondage, etc.). As with other sex workers, it is not unusual for a pro dom to face the situation of a favored regular client who comes to see the professional relationship in romantic terms or even falls in love with the dominant; some dominants will milk such an arrangement for a considerable length of time, but others feel uncomfortable enough to sever the professional relationship.

Sometimes I do find my professional sessions to be erotically arousing. The exercise of sexual power can certainly be a turn on. Yet the arousal for me more often comes from seeing myself arrayed in fetish wear, acting out a dominant or submissive role, and being paid to do so: it is a powerful form of autoeroticism in which the client is almost incidental.

Identity: How I See Myself

I find that the longer I work in the profession, the more I take on an identity as a professional dominant. While I have done office work for many years, I have always resisted thinking of myself as a secretary. In contrast, I'm happy and proud to call myself a dominatrix. I'm still learning how being a pro dom affects how I interact within SM communities. Do I present myself as an interested player and editor of a local SM community newspaper, or as "Mistress Veronika—Professional Dominatrix"? While the latter role can be a lot of fun and reflects a real aspect of who I am, it's often too one-dimensional for daily wear.

Working as a pro dom has had a noticeable effect on my gender identity. Throughout much of my life I have felt like I didn't really have a firm gender identity. I know that my body reflects what our society calls a "woman," but I don't possess an internal gender—the sense that some transsexuals describe as "just knowing" what body one belongs in. I've long thought that if woke up one day in a male body, I'd be equally happy and would be just as much "me." Since working as a professional dominant, though, I've become much more comfortable with identifying as a woman. In retrospect, I think I resisted identifying as a woman as long as being a woman was associated in my mind with powerlessness and victimhood. As a pro dom, I can combine womanliness and power in a seamless whole.

My body image has been affected both positively and negatively by my work. Many of the other dominants with whom I compete for clients are younger, thinner, and more conventionally attractive. On a bad day I feel old, fat, and ugly in comparison. Such feelings can make no-shows, walk-outs, and clients who prefer someone else's style or specialty seem like personal rejections. In other ways, working as a pro dom has done wonders for my body image. Clients often compliment my appearance and beg to be allowed to worship my body. The form I usually see as pudgy and out of shape becomes voluptuous and shapely when displayed in the right fetish wear. I still get a sense of "Wow! who's she?!" when I catch an unexpected glimpse of myself in the dungeon room mirror.

Finally, my work as a professional dominant has affected my sexuality, including my perceptions of men and women. I perhaps feel more contempt for men as a group, but also more sympathy, seeing the extremes to which they can be driven by their sexual desires. More than anything, though, my belief is reinforced that it's not very useful to generalize about a group on the basis of identity characteristics. Although many people wonder how lesbians could possibly interact sexually with men on a professional basis, I suspect sex work may in some respects be easier for lesbians, since they can look at men as potential clients and not as potential lovers, and do not have to make the tricky intracategory distinctions required of heterosexual and bisexual women. Conversely, working as a pro dom has given me a higher regard for women. In my early life I was never close to women and I never grasped the sense of victimization and powerlessness that many women seem to feel. The women's SM, sex worker, and pro dom communities were my first exposure to large numbers of powerful, self-confident, unabashedly pro-sex and non-victim-identified women. I relish the erotic charge and intimacy of interactions between women within SM and professional dominance contexts, including the dominant/apprentice relationship, co-topping (sharing the dominant role) with another worker, and interacting with female clients who come in as part of a male-female couple.

Sex Work Dilemmas for Feminists

There are a few issues that seem quite important to a feminist discussion of sex work that are generally neglected in the face of the often simplistic abolitionist versus pro-sex-work debate. As an advocate of radical sexual and social change within a feminist framework, I am concerned that certain aspects of sex work may be retrogressive.

It disturbs me that sex work can abet dishonesty in relationships and impede solidarity among women. As with most sex workers, I know that a large proportion of my clients are married men who are availing themselves of professional sexual services without their wives' knowledge. As an advocate of honest, open relationships, I am bothered by this kind of secrecy. I believe that each partner in a relationship deserves to know about the activities of the

other(s) so as to make fully informed decisions. In the age of AIDS this is especially important. Although the types of pro dom work I do hold minimal risk of HIV infection, the issue of nondisclosure of sexual activity outside of a probably presumed-to-be monogamous relationship is of concern. I also feel somewhat guilty that I am an accomplice in the deception of other women.

An issue that many pro doms share with other queer sex workers is the exploitation of our bisexuality or lesbianism for the sexual pleasure of men. It is common for clients to have fantasies and fetishes about woman-woman sex. They may ask us to tell them stories about such activities, or they may hire more than one woman for a "show." Although I very much enjoy doing sessions with other women, I have some problems with using my bisexuality in this way. It is also disturbing for me, as an advocate of queer liberation, to be asked to abuse and humiliate a client as a "faggot."

Professional dominants often see clients who are cross-dressers or transvestites. Some of these men genuinely admire and seek to take on the qualities of women. Others, however, clearly regard being dressed as a woman or being "forced" to "act like a woman" as degrading and humiliating. It is a paradox how some men can simultaneously look to a dominatrix to exert power and control, yet at the same time regard her, as a woman, as an inferior. Other clients want to be humiliated and degraded as "sluts"—a daunting task for one who advocates reclamation of the term and of active female sexual agency. Many clients have homosexual or bisexual fantasies—considerably more than the ostensible 10 percent of the population. These men often have fantasies about anal penetration, with all the cultural baggage about submission, "being used," and "being treated like a woman" that the activity is associated with. How, then, do I promote the idea that an enjoyable sexual activity need not be seen as either "masculine" or "feminine," thus smashing the "male equals active/female equals passive" paradigm?

On the positive side, professional dominance, like all responsible SM, places a great deal of emphasis on negotiation and consent. I have honed negotiation skills in both my professional and personal life, and through my work I am able to impart these skills to others. I feel that the development and application of good negotiating skills could benefit everyone's erotic life. Consent is an element of all responsible sexuality, but in few arenas is it more emphasized—or practiced in real life—than in the SM scene. A crucial part of overcoming ingrained and dangerous sexual role playing—the kind that leads to rape—is for men to learn the necessity of consent and for women to learn that they have the ability to either withhold or give their consent. I hope that my interactions with my clients drive home the importance of consent.

A considerable number of clients wrestle with feelings of guilt, self-hatred, and shame about their "perverse" sexual desires. I am often called upon to take on the role of counselor or therapist. As such, I can provide education about the diversity of human sexual desires and fantasies, and let my clients know that such desires are normal, acceptable, and worthy of expression. Regardless

of the content of their desires, such permission and safety help them to shed layers of shame and guilt, permitting clients to both enjoy their predilections and regard them with a more relaxed clarity.

Maybe in time society will recognize and honor the skills that sex workers bring to their work and to the world. Maybe the erotic pleasure and sexual enlightenment we impart to our clients will be passed on to others. Maybe we can systematically use the talents and special insights of sex workers to change outdated and harmful conceptions of sex and human sexuality. Maybe sex workers, clients, SM practitioners, queers, and other erotic minorities will recognize the value of working together to achieve sexual and gender liberation for everyone.

Notes

1. Male professional dominants are few in number, and their issues may be quite different from those of female dominatrices. This piece confines itself to female dominants and their relationships to other female sex workers.

2. Sometimes this tendency self-identifies as "radical feminism," although that term has been used by enough other factions—for example, communist or anarchist feminists—that I avoid this term as ambiguous.

[15] First Ladies of Feminist Porn

A Conversation with Candida Royalle and Debi Sundahl

JILL NAGLE

1984 SAW THE INCEPTION OF BOTH FEMME PRODUCTIONS AND FATALE VIDEO, woman-oriented adult video production companies begun by Candida Royalle and Debi Sundahl, respectively. It was also the first year of *On Our Backs*, the lesbian sex magazine Debi Sundahl started with money she earned as a stripper. The following conversation with Ms. Sundahl and Ms. Royalle looks back on that time and traces the development of what Debi Sundahl calls the "women's erotica industry" into the present day.

JN: *What were you both thinking immediately prior to these watershed events? What was driving you?*

CR: A big personal transformation was happening for me. I had acted in adult movies from 1975 to 1980. In 1981 I went into therapy; my therapist was a former prostitute, which allowed me to feel that I wouldn't be judged. I needed to know what drew me to an industry that would bring social scorn into my life. At a certain point I realized that, on the one hand, I thought performing in adult films was perfectly fine. On the other hand, I felt some embarrassment and confusion.

DS: Why *did* you put yourself in an industry that socially scorned you?

CR: I realized I was allowing society's judgment of what I had done as a woman to influence my feelings. I had to step back from societal opinion, including feminist opinion, and decide for myself what I thought. I decided there was nothing wrong with the *concept* of sexual entertainment, but most of the actual films reflected this sexually shame-based society and its negative attitude toward women. I saw that there was nothing wrong with what I had done, or with the notion of pornography inherently, but rather the underlying societal attitudes toward sex that were revealed in pornography.

I decided that the answer was to create materials that bespoke a more lov-

ing and healthy attitude toward sex and women. Were women exploited? Yes, because while we were essential to the production of porn and in fact were what drove the sales of pornography, our sexual needs were not addressed: we might as well have been blow-up dolls. This inspired me to create an alternative form of erotica or pornography, if you will.

JN: *So sexism was not inherent in exploitive pornography, but rather in the way it was rendered and viewed.*

CR: Of course I had to ask myself, how could I be a feminist and do this? I came to feminism in college. After working for a year as a secretary in the New York corporate world, I joined the Bronx Women's Coalition near Bronx Community College, though I was attending school at the City University of New York (CUNY). Working had opened my eyes up to how awful conditions were, especially for women. My boss made me kiss him goodnight every night. In those days, women did not report incidents of sexual harassment. I needed support. Finding the women's movement was a crucial turning point in my life. We had a cafe in a storefront, tables on Fordham Road where we handed out women's lib literature, and once a year ran a free clinic where doctors performed pap smears for neighborhood women.

JN: *So you did grassroots activism that dealt directly with women's lives.*

CR: Yes, and we were reclaiming who we were as women, our true essence, what we deserved as human beings. We were shedding political preconceptions. These efforts highlighted a wonderful sisterhood, and the right to sexual pleasure. Then, suddenly, sex was a battleground. . .

DS: . . .a painful battleground. Fighting the stigma is exhausting. I've been doing it for twelve years. Look at the battle Kat Sunlove is embroiled in [publisher of the *Spectator*, a weekly adult news magazine currently being targeted by California censorship laws]. One can't just do one's work; we have to defend it, risking jail and the loss of all our hard-won assets on top of it all.

CR: Are you going through this painful stuff right now?

DS: It's always been there—it comes in waves. You really put yourself out there. In the past, my cockiness was covering up lots of fear.

CR: It's almost as if you need to surrender to it, and face it headon. We have broken the biggest taboo that women can break.

DS: It's a scary one.

CR: We have performed sexually, for people to view us, and now we make sex films. In this madonna/whore culture, we are the whores.

DS: We risk ostracism, risk being viewed as something *other than*. I can't just go to a party and have a casual conversation about what I do—all of a sudden, people's buttons are pushed and all their repressed sexual issues come tumbling out at me. Questions follow, and suddenly I'm relating my whole life story and intimate opinions to a stranger.

CR: Before I enter a social situation, I ask myself: am I Candida or Candice? I make up my mind. If I decide I'm Candice, which is usually private parties and intimate gatherings, don't you dare start asking me about my career! I spend about a quarter of my professional life giving interviews, so I need to protect my private time.

When I started Femme Productions, and people would ask me what I do, I was nervous about telling them, but I would take a deep breath and tell them that I create erotica from a woman's perspective. Women's eyes would light up and they would ask where they could find it. It made me realize how needed this was, and how I should not be afraid to speak up about what I do. The main thrust, no pun intended, is that there is finally something that women and men can share together. Of course, we're also dealing with how self-contemptuous we are of our own sexuality, like the guy who fucks the whore and then puts her down.

DS: Part of women's role has been that we should have self-contempt for the whore, the sexual side of ourselves. The whore is the guardian, the teacher of women's sexuality. One Webster's dictionary defines pornography as "the writing of harlots." Hail to the harlot! Reclaim her sacred art! I'd like to ask Mary Daly right here to verify that etymological fact.

DS: In 1981 and 1982, I was a women's studies major. I read Audre Lorde and Shulamith Firestone: I was a radical feminist. I easily embraced lesbian separatism: I saw men as controlling women, their bodies, their lives. I saw the patriarchy as a real thing causing women's oppression, making us homemakers, mothers, and sex slaves. I entered my first lesbian relationship. I discovered sexual feelings I did not know my body was capable of feeling. That kicked open the door to explore personal exploration of women's sexuality, my sexuality.

In 1982, Nan Kinney and I moved to San Francisco, the gay mecca. I had met Nan at a Women Against Violence Against Women meeting. Nan was teaching women's self-defense and women's weight training, and I was working at a shelter for battered women. It was Nan who pointed out, as we marched past the sex theaters on a "Take Back the Night" march that it seemed kind of clas-

sist, the neighborhood that was chosen. I smelled a rat. We started to question feminist values around sex and race. Once in San Francisco, I became interested in exploring the sex industry, answered an ad for dancers...

CR: Smelled a rat?

DS: The marchers pointed at the sex theaters—and chanted [anti-sex-worker] things. Why, when abuse happens across all class and race lines, did we choose to march in poorer sections where the sex theaters were, and where poorer women made a living?

CR: Class also shows up in the sense of cultural perception. This is where the doctor's wife frowns upon girls who strip in clubs.
 What I find so interesting, Debi, is that we were in such different places—psychologically, socially, politically. You've gotten the additional stigma of having dealt with lesbian themes.

DS: Different communities, straight and gay, different coasts. Politically, I was very radical. Nan and I had actually tried to firebomb a porn store. We made a Molotov cocktail—thank God the building was brick.

CR: I was more moderate. In 1972, I moved to San Francisco because that's when radical lesbianism was infiltrating the [women's] movement. I felt that movement was starting to blame everything on men, which I did too, but it became so radical that we were forgetting our own responsibility. I decided to look within myself. By 1983, I had been in and out of movies, had married a lovely young man who was a producer from Sweden who was respectful of me and the other women in the industry. I formed the most loving home I had ever had, and was able to go into therapy. At the time, I was doing journalistic writing for magazines about the industry.

DS: As a lesbian feminist separatist, I totally bought into the idea that men were the cause of all our problems. In a way, it was a justification for being lesbian, because lesbianism was so invisibilized.

JN: *It helped legitimize your sexual choice.*

DS: Lesbians were hiding by appealing to political feminism for legitimacy. In so doing, we downplayed our sexuality. Then, one of the reasons Nan and I started Blush was to come out from under the feminist cloak and state boldly, we are lesbians *because we love women—*

JN: *—because we have sex with women! [Laughter]*

DS: —and not because we hate men—a radical departure from lesbian feminism.

CR: This is so fascinating, It's only at this moment that I am beginning to understand what happened. I was one of the early movement organizers in 1969. I felt eventually discriminated against and frowned upon by the women's movement—it's only now that I understand what was going on.

DS: It became a movement for lesbian visibility.

CR: It became that.

DS: Lesbians were involved from the beginning, but were not accepted because of their sexuality. They were pushed out—

CR: Heterosexual women also felt pushed out.

DS: Lesbians felt pushed out altogether. Lesbians were involved in feminism from the beginning but were not accepted because of their sexuality. Whenever a lesbian got into a position of public prominence in an organization, like the manager of a battered women's shelter, she would be asked to leave. We got fed up with being called "the menace." To retaliate, we poured on the man-hating attitudes.

CR: I was reacting to being ostracized for being heterosexual. Even as a young feminist who was very angry at men, a real ballbuster, I had a boyfriend who drove a Fiat, I was always fashionable, even though it was hippie gear. I was viewed as "sleeping with the enemy," and I was told that the men in our mixed-gender group were upset because I looked too good.

DS: Lesbians thought you looked too good, too, attracting attention, giving women a bad name, and we blamed you for harassment on the streets.

CR: Men were being made to feel guilty for sexually responding to an attractive woman. It was amazing! These were young men in their late teens and early twenties, and they were being made to feel guilty for responding in a normal way, and they would turn around and get mad at *me*. These are some roots of what would become a very antisex movement in the country!

DS: A lot of unacknowledged sexual undercurrents fueled feminist infighting. Straight women were trying to redefine sexual relations with men, while lesbians were trying to get acceptance for being sexual with women.

CR: This was the beginning of a lot of confusion around sexuality.

JN: *Candida, you were getting shit for your brand of heterosexuality, while Debi was also struggling with the same kind of censure around her lesbianism. All within lefty feminist circles. Why do you think sex is such an issue for feminism?*

CR: Sex has historically been key to controlling women. The hatred of women began with the fear of our sexual power. The beginning was religion, men's fear and contempt of their own sexuality and fear of women's sexual power. Sexual women were branded "whores" in a successful attempt at repressing our sexuality through shame, while at the same time it was acceptable for men to take sexual favors from us whether through owning us in marriage, buying us as whores, or forcing us through rape. In a land-owning society, it was important to control women's sexual behavior and keep them monogamous and faithful to their husbands so that the men could know who their rightful heirs were. People often ask me why I consider women's sexual liberation to be so important. I point out that human beings forced to function without full access to every part of their being, including, and especially something as vital a force as their sexuality, are functioning at only partial capacity. It keeps us down.

DS: My son has a girlfriend who's nineteen, a born-again Christian. She was bulimic, hated her body. [In her religious circles,] they treated women as nothing—just there to do what a man wants wants and to serve his sexual needs. Well, she met *my son* ... [laughter] who's been shopping at Good Vibrations, rubbing elbows on the street with gay men in drag, brought up with, and at eighteen, working for, Blush. Her eyes have slowly been opened. She's reading the same books about reclaiming our bodies that I read twenty years ago, she's learning that her needs are valid, that she can communicate and be satisfied, and that homosexuality is okay, which is not what she's been taught.

She said, "I'm finding that taking control of my sexuality has spilled over into other parts of my life. I'm no longer afraid to walk on the streets. Instead of just a two-year degree, I'm getting a Master's." Her whole world has opened up as a result of reclaiming her sexuality. This is evidence of what the women's erotica movement has accomplished in the field of feminism in its fifteen short years: that a nineteen-year-old woman can have this information and power at her disposal, power that was not available to Candida and me when we were nineteen! We are over forty now. Many of our generation and older had to wait until we were thirty-five to fifty to have our first orgasms, much less have all this information at our disposal. We had to create it and make it up as we went. And there were few men like my son who even had a clue to relate to.

CR: Deb's story is a perfect segue. Historical repression of women's sexuality led to the notion of protecting the little woman from men's sexuality, when in reality, it was the power of *women's* sexuality that men were afraid of. In their eyes, women's sexuality would upset the whole institution of the family.

DS: I read in my women's studies history texts about how women's chastity was necessary to control men's sexuality.

CR: If women were allowed to run free sexually, they wouldn't be at home to raise the children.

DS: Men feared that if women were allowed to run free...

CR: Dr. Masters (of Masters and Johnson) related a story that, when they began to research sexuality in the '50s, prostitutes were the only ones they could work with. They said that the first thing they as researchers realized was that women's capacity for sexual pleasure would put any man to shame.

JN: *Looking back, what went the way you expected and what didn't?*

DS: I expected that women's erotica would grow but I didn't expect *On Our Backs* to spawn children. Look ... in the last *few* years!

CR: The amazing thing is that I was right. Women want their erotica. My ex-husband's family heard me speaking during my first meeting back in 1984 with Lauren Niemi, who wanted to make erotic rock videos from a woman's point of view. I had been contemplating doing women's erotica and wondering how I would make it different from men's. Rather than just adding some big soap opera plot, I felt it was essential to change the stale and formulaic portrayal of sex. When [Lauren] came along with this idea, I said, "Yes! Let's do it." My ex-father-in-law liked the idea and put up the money.

When I approached the big distributors, they said, "Oh, Candida, that's a nice idea, but women aren't interested, and there's no such thing as a "couples' market." VCA, one of the biggest adult-film distributors, did agree to distribute it. Two years later after I drummed up tons of recognition and media response, half the movies being released were being called "couples' videos."

JN: *So you essentially created the heterosexual couples' market.*

CR: Yes.

JN: *How has this impacted heterosexual couples' sex?*

CR: Aside from letting men see what many women actually want in bed, it gives people more opportunity to play out fantasies, open up communication, foster intimacy, and probably gave rise to the booming amateur video business.

JN: *Keeping the family together—an all-American tradition! [Laughter]*

CR: This keeps the man at home, and the woman.

DS: I was told the same thing by gay men—that there's no such thing as a lesbian market. We started Blush Entertainment, which consisted of *On Our Backs* magazine and Fatale Video production and distribution companies, and Blush mail order, because both gay men and straight had tons of sexually explicit materials, and lesbians had *zero*. I was told repeatedly that there was no lesbian market, and here I was making a living off it. Fatale created the genre of authentic lesbian erotic videos, directly challenging the ruling stereotypes of lesbians created by men for men through their girl-girl videos. More importantly, Fatale gave lesbians their erotic voice for the first time in modern history.

JN: *Debi, how did you fare with the big distributors?*

DS: Big distributors wouldn't touch us with a ten-foot pole. We had to create our own distribution system, a gargantuan task because of the obstacles we faced, number one being carving out a niche market that was gay, female, and erotic. *Ms.* magazine wouldn't take our ads because we were erotic; the mainstream male-dominated adult industry wouldn't take our products because we were women knocking on the bars of the big boys club with an all-women product that didn't look like theirs. *Playboy* wouldn't sell us their mailing list because "women didn't buy *Playboy*." Feminist bookstores wouldn't take our product because we were overtly sexual. Still, there were renegades in all these groups, so, name by name, year by year, we pieced together our distribution and mail order lists, *On Our Backs* becoming the biggest marketing tool for the videos.

CR: You did it before we did it. We ultimately chose to do our own distribution, as well. I worked with Lauren for the first three films, then we went our separate ways. The second year I did a marketing campaign. Third year, Per [pronounced pear], my ex-husband, produced while I wrote and directed. VCA distributed those first three movies. In that third year, 1986, I did *Three Daughters* (the fourth film after Lauren left) on a $75,000 budget. At that time, the adult industry went through severe change. They stopped paying royalties, and were only offering about $35,000 to buy out a film. Then I struck out on my own. Luckily, I got back those first three films from VCA, and we started Femme Distribution. While it was an essential move, and helped to establish Femme in the marketplace, running the distribution took my creative energy away so that I could almost no longer do movies.

Now, I'm happy to report that I've gotten Femme to the place where I was able to get just the kind of distribution deal I wanted, with PHE Enterprises, who will take over all sales and will finance three new Femme movies a year.

We're back to being just Femme Productions now, and I've already released my first new film called *My Surrender*.

DS: *We* had to do it *all* ourselves: finance, publicity, distribution. Distribution did drain creative energy, which is why I had to sell *On Our Backs* after ten years. I had just become a manager, watching with creative hands tied while an entire second generation of women jumped in on the momentum we had created and worked so hard to build without having the burden of building and maintaining the foundation.

JN: *Sounds like you would like more credit and appreciation.*

DS: I see a parallel with *Ms.* magazine, who had to struggle to get a lousy car ad. We had to do the same kind of wall banging. This effort deserves historical recognition: that the women's erotica industry was created on our backs. In fact, I call *On Our Backs* a boot camp—so many women came through and learned all these skills: editing, erotic fiction writing, designing, distribution, publicity, marketing, management, publishing, all facets of video production, acting, selling—a huge labor pool to grease the wheels of the women's erotica industry was groomed there, not to mention some of the best erotic ideas, inventions, and products. The wonderful part as mother of this is to see it continuing to grow—my dream unfolding. The hard part is feeling pushed aside and sometimes unnecessarily stomped on by other women. We are in this together, after all, and the field is wide open.

CR: As a sister in support, I think it's good that you recently moved to Santa Fe to heal and regroup. It doesn't have to be over for you. I am seizing back the reins. I will once again emerge. You just need to figure out what it is that you really want to do—it's always there for you. They can't take away that streak of brilliance that made you the beginner, the pioneer. Everyone knows the truth.

DS: Thanks, Candida.

CR: I have put those who claim otherwise in their place. Brian DePalma would never fail to credit Alfred Hitchcock.

DS: When I talked about energy exchange [in an earlier, unrecorded conversation], I meant that for this industry to successfully grow into its second phase, we must begin to dialogue with each other about ethics: how will we interact with each other as producers, distributors, creative talent? What will be our code of ethics? Will we tear each other apart? Or build cooperative relationships?

JN: *Would a separate, woman-oriented distribution company free you up some?*

CR: Number one, when it comes to business, women are no different from men. Two, as women, we have been crippled by this notion that we will be rescued. It took me many years to get my strength and courage to go and find the right distributor. Until women grow up and claim our power and realize that success comes only with strength, courage, and hard work, they will sit and wait forever for that knight in shining armor or Prince Charming, whether they call that a distributor, a husband or . . .

DS: I think it's crucial at this point in the women's erotica industry that women develop their own distribution networks. This has been true with Good Vibrations and Eve's Garden [woman-oriented sex product stores/mail order companies]; [they] are the successful seeds from which more will grow.

The tide has changed already. Therefore, I no longer need to be a distribution company. More alternative venues are available, to the point where I now need only sell my videos to wholesalers. So now I'm back in the creative seat, joyously focusing on what I do best: creating the product. This recent distribution development is my validation for having hung in there so long and betting on the women's erotica industry to take off and become a legitimate thing.

CR: Debi, I think it's so amazing—we're on the same parallel paths. We started the same time, and have gotten to this hard-earned place at the same time.

DS: I financed *On Our Backs* from my earnings as a stripper. It's interesting you brought up the husband as a rescuer. I married a rather well-off man. I could no longer keep up dancing at night and working at Blush during the day. He did rescue me, financially. I didn't have to worry about making a living; I could focus on the business.

JN: *Was that a conscious thing, marrying him for money?*

DS: Semi-conscious. I loved him very dearly. I considered the financial support a gift. My point was that money to keep afloat, to keep going, had to come from family and friends, because no bank or investment company would touch a lesbian sex business.

CR: There's a difference between sitting around waiting for Prince Charming and going out and getting his money!

DS: Men have traditionally assumed that women's sexual energy is theirs for the taking. I feel men give back some of that energy to women in the form of supporting financially our erotic business ventures. Still, I want to make it perfectly clear that it was not a man or men who supported Blush all those years.

I stripped nights for the first four. Gay *and* straight women kicked in money to support us the last few.

JN: *As a bisexual activist, I have to ask about this straight-gay divide.*

CR: I see a 50−50 split between women who want scenes with other women, and those who are completely upset by it. I won't put it in simply as titillation for male viewers. It has to be intrinsic to the story, or they have to be lovers in real life.

DS: For me, the market is the key factor here because it has to be supplied with product. I was with my husband because I wanted to explore sex with men again, based on having developed a strong sexual foundation for myself in the safety of an all-female space. As is my creative habit, I naturally wanted very badly to explore bisexual themes in my products, based on my personal life. (*On Our Backs* was very much a personal record of my individual sexual growth in partnership with Nan.) Yet, I had created a company with an exclusively lesbian market who would not tolerate men in their erotic materials. I was frustrated creatively, but I felt that creating had to take a back seat to establishing a legitimate business, so that I *could*, or someone or something could, have a place to *sell* their creations.

JN: *What would you like to say to women getting into the business now?*

DS: Just do it. There's so much more to be said and done. You'll be seeing more bisexual videos from me now. My hands were tied, but no longer.

JN: *I'd like to see more women with two or more queer men.*

DS: People expect a lot out of two women's erotic video companies! We can't produce everything. We are limited by size and resources.

JN: *There's a lot of closeted bisexuality.*

CR: I've come to believe that that which most offends us might be what most turns us on, as in the case of the women who write me angrily protesting lesbian scenes. It's very complex. But Debi's right; as Layne Winklebleck [editor of *Spectator, California's Original Adult Newsmagazine*] said, you can't expect all of these demands to fall on the shoulders of two women—so get your asses out there and start putting your money where your mouth is!

JN: *Yes, ma'am!*

[16] No Girls Allowed at the Mustang Ranch

VERONICA MONÉT

I FIRST HEARD ABOUT THE MUSTANG RANCH, A BROTHEL IN NEVADA, when I was about seventeen. I remember feeling curious and jealous. My boyfriend at the time cracked some joke about "the Ranch" to one of his friends and my face burned with embarrassment because I didn't know what he was talking about. When I asked for details the information I got was pretty sketchy; this was forbidden territory: No Girls Allowed. I hated that feeling, because if a man could do something, so could a woman. After all, I had cut my teeth on toy trucks and cars, raised live snakes and lizards, target practiced with all types of guns, and ridden dirt motorcycles. Suddenly, here was another male bastion I wanted to force my way into.

Years passed (more than I care to admit) and I became, in turn, a college graduate, a sober alcoholic/addict, a sex worker, and then a wife. But I still hadn't fulfilled my wish of going everywhere the boys go. I thought being a sex worker might solve some of my angst, but working in the sex industry just isn't the same as playing in it. The former is about pleasing others while the latter is about having it your way. I wanted to find out for myself. So when my husband asked, "What do you want for your birthday?" I didn't have to give it another thought.

Why hadn't I tried to fulfill this wish on my own? I once walked across the street from my apartment when I lived in the Tenderloin in San Francisco and knocked on the door to a massage parlor. A woman peered through a small crack she made with the door and asked what I wanted in a gruff voice. I said I wanted a massage, she said "We're closed." "What's the matter? Don't you see women?" I demanded. "Sure we do," she replied as she slammed the door in my face.

I called the Mustang Ranch in advance to see if they would accept female customers. There was no sense in driving all the way to Nevada just to get another door slammed in my face. It turned out that they only saw women with their male partners. My only solution was to get a male escort into "men-only country." It did get me in, but not necessarily with open arms.

We drove to Reno and then further into the desert. It was dark and at first

seemed very desolate, but we soon saw the famous Christmas lights I had heard about. Three plain one-story buildings stood in a row surrounded by chain link fences decorated with those lights. The middle building sported a small sign proclaiming, "The World Famous Mustang Ranch," and my stomach got a little upset from nervousness and excitement.

My husband and I walked up to the building on the right called the Old Bridge Ranch. We rang the bell and the madam opened the door with a smile on her face. She stopped us before we went in to ask us what we wanted. I had an urge to say "How about a haircut," but I resisted the temptation and let my husband tell her we wanted to "party with a girl." The madam then welcomed us in and escorted us to a private room where we were asked to wait for the girls who would be willing to "party with a couple." I wondered why we didn't get to pick our girl from the traditional lineup. One woman caught my eye. She was cute, and reminded me of Shirley McClaine in *Irma La Douce*. She also seemed very friendly and fun. But I still wanted to "shop," so we went off to the Original Mustang Ranch next door.

We rang the bell on the gate, and this madam came to the door with something less than a smile. I saw the women start to form a lineup, but as we headed up the sidewalk to the door, they all scattered like they had seen a ghost. The madam suspiciously asked what we wanted. When we said sex, she quickly had a big security guard escort us into a room. I protested that I wanted to see the bar and pick a girl from the lineup, but this husky guard said they couldn't allow that since "non-working women" aren't allowed in the bar. At this point I wanted to go back home to San Francisco where queers like me aren't treated like we have a disease. While we interviewed women in the private room, I was able to talk one of the women into getting me water and giving me a tour of the bar after all. There wasn't much to see, but it was the principle of it all. I wanted to be treated like one of the boys. And if I couldn't get a lineup like the guys do, just because some of the girls think that eating pussy is gross, at least I could walk through the joint like a real customer instead of getting shoved behind closed doors like some criminal. In the interest of continuing my shopping spree, we finished our interviews of the available women and headed to the third and last house.

The Mustang Ranch No. 2 didn't impress me. Most of the women weren't what I had in mind and the reception was pretty cold. I got a couple of sneers from some of the "working women" in all three of the houses. I'd say homophobia is alive and well in the desert. We eventually went back to the Old Bridge Ranch and picked the friendly girl whom I had noticed the first time around. She was available and talked me out of $400. I didn't know this at the time, but the house had microphones installed in all the girls' rooms so that management can eavesdrop on the financial negotiations (I hope this is all they listen to). After she took my money, she left the room to give the house its half and returned with a couple of nonalcoholic drinks for us.

She began the session by dancing seductively. I love that. Then she began to

undress me. When she was finished, she jumped in the middle of us and laid back waiting for our "attack." We obliged enthusiastically. As the three of us worked our way through many of the positions three people can assume in bed together, my husband came but I still wasn't quite there. When I complained, our hostess got a determined look on her face and pulled out a vibrator and a large double-headed dildo. I was lying on my back with my head in my husband's lap, so I'm not exactly sure what she did to me with those implements. But I am sure that people having drinks in the front lobby heard me have a great time at least twice.

I stood up with shaky legs, and the three of us had a group shower. As we were dressing, I asked her how she liked working at the brothel. She said it was all right, but the house charged the girls for everything, including ten dollars for laundry! She "partied" and lived in this room for weeks at a time while the house restricted her comings and goings and guests. It started to sound like prison. I wanted to take her to a COYOTE (Call Off Your Old Tired Ethics, a San Francisco prostitutes rights activist group) meeting and liberate her. I was sure I'd be even less welcome if management knew I was a member of COYOTE. As she escorted us to the door, she hugged us and patted our butts goodbye. I left satisfied and a little sad to think she was sharing so much of her earnings with the house.

My urge to rescue this woman was eventually replaced with an increased determination to continue my efforts to educate people about the abridgement of sex workers' rights. I also came away with the conviction that the service prostitutes offer is worth every penny they charge. Being a customer for one evening gave me a deep appreciation for what a wonderful service prostitution is. I hope it will always be available legally and in settings that do not oppress, degrade, or shame the prostitute. Prostitutes should be revered and respected as the great healers, therapists, and entertainers they are.

Yes, working in the sex industry is different from being a customer. I couldn't believe how involved in the fantasy I became as a customer. I felt affection for the woman I spent an hour with, even though I knew it was just business for her. I felt that she was special, and I had a hard time accepting that we were just another appointment to her. But it didn't make any difference in the end. If I had wanted emotional involvement, I would have placed a personal ad. I sought out a prostitute precisely because I didn't want to risk emotional involvement—and it was erotic, fun, exciting, and fulfilling. She was the one in charge of the hour we spent together. And that was great—to relax and turn everything over to a professional. It's delightful to pay for what you want and then let someone else orchestrate it for you. After all, we pay professionals to do what they are good at. And she, like me and all the other whores I know, is very good at what she does. That's why we get paid.

[17] Butch Gigolette

LES VON ZOTICUS

MY STORY IS A RATHER ODD ONE, SO A BIT OF BACKGROUND might help to contextualize it. Born in Washington, DC, to parents who blindly worshiped the god of electoral politics, I became keenly aware of that religion's extensive shortcomings. I resolved early on to make my contribution to society through my deeds and not to rely on the ballot. Throughout college, I was a social critic committed to praxis; graduation and moving to San Francisco opened doors to further possibilities.

The issue that motivated me to action in my twenty-third year was the lack of fuel for the fire of women's sexual imagination. As a butch lesbian who sexually desires femme women, I saw a great deal more sexual entertainment (both from within and outside the lesbian world) geared to my tastes than to those of women who desire butch sexual energy. I believe that the nurturance of sexual pleasure provides a necessary respite from other exhausting tasks of advancing the lot of humanity. The sad yet pervasive notion that the feminine should always be at the sexual service of the masculine and never the opposite disturbed me to the very core of my feminist sensibilities. The answer was not to eliminate the feminine as cultural sexual icon—that would be an exercise in futility. The only viable solution I could find was to offer myself as a sexual object and become a butch gigolette.

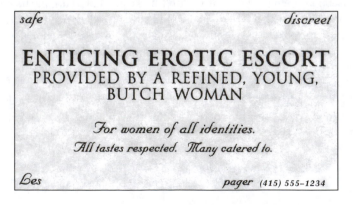

safe discreet

ENTICING EROTIC ESCORT
PROVIDED BY A REFINED, YOUNG, BUTCH WOMAN

For women of all identities.
All tastes respected. Many catered to.

Les pager (415) 555–1234

SEX A LA CARTE
A GUIDE TO NEGOTIATING YOUR DESIRES

Please circle those activities that you would definitely like to engage in, as well as the role you would like to play in those activities.

Please cross out those activities that you would definitely <u>not</u> like to engage in.

The activities that remain unmarked will be engaged in as appropriate.

If there is an activity that you would like to engage in, but not with certain regions of your body, make sure to specify the off-limit areas.

All activities will come to a halt with the use of the phrase "safe word", unless another safe word or phrase is agreed on before the beginning of play.

Remember, this is for <u>your</u> pleasure. No judgment will be passed on you for any activity or scene you propose, so go for it!

Lastly, all play will be done with appropriate body fluid barriers to follow current guidelines to prevent the transmission of HIV and other STDs. This is the one detail which is not negotiable.

Vanilla activities

activities	I will...
o massage	perform/receive/both
o kissing	
o tribadism	
o masturbation	perform/watch/both
o oral-nipple stimulation	perform/receive/both
o oral-clitoral stimulation	perform/receive/both
o oral-anal stimulation	perform/receive/both
o manual clitoral stimulation	perform/receive/both
o manual anal stimulation	perform/receive/both
o manual vaginal penetration	perform/receive/both
o manual anal penetration	perform/receive/both
o vaginal penetration with dildo	perform/receive/both
o anal penetration with dildo	perform/receive/both
o other (specify):	_____

(over, please)

S/M activities & scenes

activities

<table>
<tr><td>°</td><td>bondage</td><td>perform/receive/both</td></tr>
<tr><td>°</td><td>spanking</td><td>perform/receive/both</td></tr>
<tr><td>°</td><td>flogging</td><td>perform/receive/both</td></tr>
<tr><td>°</td><td>fisting</td><td>perform/receive/both</td></tr>
<tr><td>°</td><td>hair pulling</td><td>perform/receive/both</td></tr>
<tr><td>°</td><td>face slapping</td><td>perform/receive/both</td></tr>
<tr><td>°</td><td>breast slapping</td><td>perform/receive/both</td></tr>
<tr><td>°</td><td>nipple clamps</td><td>perform/receive/both</td></tr>
<tr><td>°</td><td>hot wax</td><td>perform/receive/both</td></tr>
<tr><td>°</td><td>ice cubes</td><td>perform/receive/both</td></tr>
<tr><td>°</td><td>other (specify):</td><td>_____</td></tr>
</table>

I will...

scenes

I will be...

<table>
<tr><td>°</td><td>daddy/boy</td><td>daddy/boy/both</td></tr>
<tr><td>°</td><td>daddy/girl</td><td>girl</td></tr>
<tr><td>°</td><td>master/slave</td><td>master/slave</td></tr>
<tr><td>°</td><td>mistress/slave</td><td>mistress</td></tr>
<tr><td>°</td><td>other (specify):</td><td>_____</td></tr>
</table>

My first task was to find meaningful language to describe a new (or at least, very young, to the best of my knowledge) branch of the oldest profession. During varying stages of my experiment I must have tried them all: "escort" (open to wildly differing interpretations), "butch whore" (a little too crass for my gentlemanly sensibilities), "gigolo" (too closely associated with male-female sexual relations). I often used a combination of these titles to fully describe the nature of my work. Despite the problems with descriptive language, I decided to embark on my experiment. I placed my advertisements in some local gay papers, and some exclusively lesbian publications.

My next task was to determine the parameters of my experiment. I set a limit of six months, after which I would continue only if my income exceeded my costs. Unlike many other sex workers, I had the comfort of a day job to pay my bills, so I wasn't reliant upon sex-work income. This allowed me the luxury of serving only female clients. I believe this afforded me a greater level of physical safety than my sister whores who must work with male clients. Additionally, the fact that my line of work was so new helped me to escape notice (or at least interference) from the police.

Finally, knowing that I was breaking some new ground on a number of levels, I created a business plan deliberately tailored to women. One of the issues I anticipated was the newness of women to the role of john. In order to ease their transition into a world where their sexual desires would be paramount, I designed and offered an extensive menu for my clients. Printed on parchment with elegant fonts, I presented it not as a definitive list of sexual possibilities, but simply as a launching pad for their imagination:

In preparation for a call, I would pick out a dapper suit and complement it with the trappings of masculine elegance more common to an earlier time. In my understated attaché case, I packed a full range of sex toys, lube, and safer sex supplies. I designed my appearance to allay any of my client's fears that their visitor would be interpreted by curious neighbors as anything other than a respectable businessman.

It would be rather like a tease for me not to reveal the outcome of this experiment. Since that particular mode of sexual play would cost more than the price of this book, I shall not withhold the reader's satisfaction. At the end of the six months, I had not broken even financially. Sadly, I gave up my pager, canceled my newspaper ads, and returned to "polite society." Well, almost. On occasion, I still strip at nightclubs for the erotic entertainment of my sisters, so if you happen to come to San Francisco, be sure to look for appearances by "Les," the butch stripper.

With only a handful of brave women able to overcome deeply embedded social proscriptions against sexual assertiveness, my initial attempt at butch whoredom was bound to be less than an unparalleled success. However, I do not remotely consider my time wasted nor the experiment a failure. During the six months I plied my trade, I averaged approximately one call a day from intrigued women. I'd like to think that even if most of the women I talked to

could not or would not actually purchase illicit erotic entertainment, the very act of considering doing so just might have broadened their sexual horizons beyond the limitations imposed by our misogynist culture.

On a final note, I encourage any women with the chutzpah, time, and money to continue the experiment I began. I do believe that if I had the wherewithal to continue to offer my professional services to women, in time the business would have flourished.

[four] Uncovering

Myth,

Stigma,

and Silence

THEY SAY SHE IS VEILED

They say she is veiled
and a mystery. That is
one way of looking.
Another
is that she is where
she always has been,
exactly in place,
and it is we,
we who are mystified,
we who are veiled
and without faces.

—Judy Grahn, *Queen of Wands*
Freedom, CA: The Crossing Press

[18] All Stripped Off

STACY REED

I BEGAN STRIPPING SEVEN YEARS AGO. What started as a scholarly inquiry at the University of Texas concerning feminist theory and the sex trade turned into a commitment to eradicate the host of assumptions and myths about stripping. Like the old-school, sex-negative feminists I had studied, I just knew that strippers were pathological, rape victims, brainwashed into the field by a sexist culture, constant drug abusers, objectified themselves, could do nothing else, held no power, and opposed feminists. I imagined their clients as abrasive losers lurking in seedy bars. In 1990 I began my three years of research and employment believing every misconception I have since debunked.

Myth: Strippers Are Drug Addicts

Even though cocaine and XTC do drive some strippers, these exceptions are the stereotype. I've also seen managers, DJs, and bar-backs indulge similarly. Few strippers in the Texas clubs I've worked in—including two in Dallas, three in Houston, and five in Austin—abuse drugs. Rarely do managers need to audition strippers or run drug screenings. Since performers work solely for tips, an incompetent and haggard stripper will make little money and quickly resign. The parallel stereotypes about drug use among physicians, lawyers, and executives do not diminish the respectability of these nonsexual, male-dominated professions, whereas strippers have gained notoriety for drug abuse.

Yes, some strippers are drug addicts. To the extent that their addiction is job related, one reason to seek an altered state might be to alleviate the shame of stripping. If for some the job both allows and requires drug use, then the clearest means to fighting the phenomenon is to destigmatize the profession.

Myth: Strippers Are Incapable of Informed Consent

One common argument against stripping runs like this: "Poor deluded girl. She can't possibly know what she's doing. Let us take it upon ourselves to save her from her ignorance and impending ruin." In other words, the brainwashed stripper proves her powerlessness by virtue of her occupation, which is itself unqualifiedly perverse.

The attitude that the virtuous concerned citizen stands obligated to rescue the misled stripper should strike any feminist worth her salt as far more sexist and patronizing than any of the so-called evils these old-school feminists presume to fight. In essence, sex-industry abolitionists are claiming that strippers, like small children or dogs, don't know what's in their best interest. Never mind that most of those who would close topless bars have never visited any to find out what, exactly, they're opposing.

Myth: Strippers Are Victims

Any female-dominated profession in this culture will have a high percentage of rape, abuse, and assault survivors, reflecting statistics on women in society at large. Just because a woman who was raped strips does not mean she strips because she was raped. To proceed from the assumption that all rape survivors are permanent victims at the mercy of circumstance may render as much damage as the rape itself; no woman is helped, in the midst of addressing the many emotional, legal, and physical hardships of being raped, abused, or assaulted, by finding herself branded incapable of consent and informed decisions.

Perhaps some women who were raped view stripping as degrading and have become strippers because they have internalized the humiliation of being sexually abused. Hence, they think stripping becomes them. By this line of reasoning it follows that these women wouldn't strip in the first place if the profession were respected, just as job-related drug abuse might decrease if strippers did not internalize victimization. Again, the answer lies not in abolition or extreme regulation but in confronting the various fabrications about stripping.

Some women strip as a way to work through various psychological, sexual, and physical abuses. Since I have never been traumatized severely in these ways, I cannot speak from personal experience. However, colleagues have described to me the cathartic purging they gain from "jumping back into the water." No one forces them into the element; they enter it freely. For some, it is an ongoing discipline, like meditation or a study, which therapeutically transforms them from "victims" into "survivors."

Myth: Strippers are Powerless in their Work Environments

Despite efforts from outside to establish their victimization and depravity, Texas strippers run the clubs. In terms of the occasional pinch or solicitation, my colleagues and I hold the authority to have abusive men expelled. I directed my lighting and music if I chose to dance on stage at all; decided whether, when, and for whom to perform personal dances;[1] took breaks as I saw fit; and even danced barefoot when I liked. The managers and owners may be pushing the papers and paying the bills, but no one doubts the strippers' ultimate authority. Since strippers are the main attraction and have the freedom to work anywhere for considerable compensation, Texas managers and owners realize that their livelihood rests in the women's control. Since more

men want to watch strippers than there are women who will strip, a manager will usually side with the stripper before he bows to an abrasive client. In three years I had my ass pinched only once, and the offender got tossed. Moreover, given a stripper's income, she can exercise the luxury to refuse to dance for any man who offends her. Since strippers in Texas are free contractors, the management knows that unhappy strippers inevitably lead to fewer entertainers, dissatisfied clients, and low bar sales.

Myth: Commercial Beauty Reigns

It reflects well on men who patronize gentlemen's clubs that it is usually the more talented stripper, and not the Barbie doll, who makes more money. A performer who is agile and vivacious will consistently attract more clients than one who is angry and bored but sports a $5,000 pair of silicon implants.

Though strippers must be relatively attractive, most look real. The majority of them have sagging breasts and cellulite just like everybody else. Being professional athletes, many strippers have breasts so small they will never sag.

In this respect, gentlemen's clubs are infinitely preferable to *Vogue* or *Cosmopolitan*; those airbrushed renditions of femininity barely resemble the models who pose in them, much less the average woman. I would prefer a man admire a real woman with wrinkles, sweat, and a voice than a processed, polished, and silenced image. Topless bars present men with a more realistic expectation of female beauty.

I considered myself mediocre looking before I started dancing. I had always thought that I had a pretty face, but my body remains far from our societal ideal: I'm a modest "A" cup, my ass is "too large," and my skin is milky white. To my amazement, I found men complimenting me on what I had previously considered flaws. When I began stripping, my confidence and self-esteem rose substantially, just as they did when I began writing and editing professionally—although my income plummeted. "We" writers simply don't command the economic reward that "we" strippers do.

Another surprise came when I discovered the central role conversation plays in dancing. I had thought that the business was wholly sensual: the music, lights, costumes, and movement. But a conventionally gorgeous woman who has nothing to say will fare about as well as one who can't dance. After she dances on stage at most Texas clubs, an entertainer will circulate and perform personal dances at customers' tables. When she approaches a prospective client, she had better speak as smoothly as she moves. Most men expect a stripper to talk to them for a while before or after she performs. And unless he wants her to dance immediately, which is not usually the case, she needs the wit to engage him in an intriguing conversation.

Myth: Dancing Objectifies Women

A favorite myth of mine had been the Big O. Yes, both feminists and conservatives have long heavily relied on the objectification theory as a cornerstone of

their arguments. Yet, when caught up in the spirit of fervent debate, few stop to consider the term.

Objectification literally means to hold oneself as subject and everything and everyone else as object, the object of one's actions and thoughts. According to this definition, traditional feminists objectify strippers. This paradox grows increasingly obvious considering the us/them construct such discussions inevitably employ. "Those strippers undermine our ends." Are not strippers and their patrons the objects of these women's disapproval?

Or maybe they mean "object" as a thing devoid of humanity. But a stripper's humanity, including her sexuality, is intrinsic to her profession. In my experience, few men would talk to me at length and grow aroused by my personality while simultaneously denying my personhood.

I maintain that a man isn't denying a woman's humanity if he admires her breasts and not her intellect in the appropriate context. Human physicality takes precedence in many arenas. As long as these instances remain free of sexuality, no one complains. Few people argue that Martina Navratilova and Mary Lou Retton, much less men such as Michael Jordan or Mikhail Baryshnikov, are dehumanized when others admire their physical prowess.

It is only when I am valued for my sexuality to the exclusion of all else that I feel oppressed. I often find it hard to "get around my sexuality" in order to establish equal grounding with men. What is an asset in one context (gentlemen's clubs) can be a hurdle in another (academia). Sexism, or the combination of sexism and sexual desire, often precludes perceiving a woman's sexuality along with more cerebral parts of her personality.

A major obstacle is this culture's stigmatization of sexual pleasure for its own sake. Charles H. Keating Jr., who served on the Commission on Obscenity and Pornography during the Reagan administration, advocated censorship and articulated many Americans' sensibility vehemently in his dissenting statement. "Any form of sexual activity which is impersonal, which uses the body alone for pleasure, violates the integrity of the person and thereby reduces him [sic] to the level of an irrational and irresponsible animal."[2] Thus, he found every form of pornography immoral because it involved the pursuit of pleasure for its own sake. He probably would have had Austin, Texas's maverick statute that allows women to cast off their shirts wherever men do repealed on the grounds that it was "impersonal."

Keating's breed of legal moralism operates on the principle that pleasure is wrong and that we should experience it only accidentally in the pursuit of higher ends. So people should watch Monday night football only to foster a sense of community, children should eat candy only to strengthen their jaw muscles, and wine should remain bottled except when used to unclog the arteries. Though most contemporary U.S. citizens don't frown on entertainment or culinary pleasures as much as the Victorians or Puritans did, we still carry the stigmas and alternately vilify or glamorize sexuality in general and female sexuality in particular.

The surest way, then, to eliminate topless bars would be to lift nudity prohibitions and encourage open sexual discourse. Any gentlemen's club would perish in a society—such as Europe—in which women frequently go topless and people discuss sex as frankly as politics. Though topless women adorn many advertisements, only two topless clubs thrive in Paris. Why would Berliners go to clubs when people run nude in the parks?

Myth: Strippers Can't Be Feminists

The industry often attracts feminists by its very nature. In Texas, gentlemen's clubs provide one of the (unfortunately) few outlets in which women exercise unchallenged command over their bodies. Women freely express their sexuality in an environment that upholds their authority over it. Beneath much of the rhetoric against topless bars may lie a fear of women realizing their sexuality while simultaneously holding complete control of it.

Granted, men and women can speak and behave in a sexist manner in a gentlemen's club, but that doesn't mean the industry generates sexism any more than restaurants or offices. Most of my customers struck me as respectful. Likewise, many feminists, like myself, dance.

Myth: Strippers are Psychopathological/Otherwise Incompetent

Popular psychologists contribute to the wealth of misinformation. "Dancers act out a perpetual vendetta against men. They are neurotic exhibitionists, sex-crazed vixens." Critics fail to consider that a healthy desire for wealth, not psychological deficiencies, may attract women to the industry. Pathologizing women for earning money in one of the only fields in which women earn more than men is sexism, not psychological insight.

Strippers are performers. I was no more in the throes of ecstasy on stage than salesmen are sincere, though some women may get sexual enjoyment out of their performance. I am no more a nymphomaniac than Robert DeNiro is the psychopath he played in *Cape Fear*.

As I said earlier, I have no qualms about people viewing me sexually as long as the context is specific, appropriate, and does not preclude other possibilities. Since the best strippers earn up to $1,000 a night, no one should be surprised that women who are competent, even expert, in other fields choose to dance. I'm a writer. I've danced alongside Ph.D. candidates, teachers, comedians, law students, and novelists. Since dancing, with its worker-designed flexible scheduling, can facilitate the pursuit of other careers, a woman may reasonably opt to exploit her beauty, social skills, and physical strength.

Many gentlemen's clubs are becoming more upscale, and the demand for them is rising. Currently, the industry grosses $3 billion annually in the United States. Texas' Cabaret Royal grosses around $85,000 each week in alcohol sales alone. More than 2,000 clubs already pepper the United States and Canada. Though these figures will probably be dated by the time this anthology hits the shelves, Detroit boasts forty-six clubs with Houston and New York[3] closing in

at thirty-nine and thirty-seven, respectively. By contrast, San Francisco, known for its openness to diverse sexual expressions, has fewer than twenty clubs.

Gentlemen's clubs continue to turn a profit in the face of other industries' losses because competition remains fierce at every professional position, particularly at the most crucial: the stripper herself. Excepting a few laws, nothing separates the buyer and the seller; strippers in Texas deal directly with clients. Despite the minimum tip the club suggests, performers take the liberty to charge whatever the market bears. Though I once worked at a club that suggested $15 a song for personal dances, I would not perform for less than $20. Other strippers undercut the minimum. When competition rises to the surface, capitalism runs free. A skilled stripper in Texas who works four nights a week with a two-week vacation earns around $75,000 a year. Though owners make the most money, of course, strippers make about $30,000 a year more than their (typically) male managers, and even more than the predominantly male bar, technical, and security staff.

Maddeningly, stripping and modeling are among the only legal female-dominated careers in which women can earn as much as men who work in more traditional, respected professions. More infuriating, women tend to be relegated to low-paying female-dominated careers and rarely manage to bust their way into male-dominated professions in which they too could make $75,000 annually—with their clothes on. Feminists ought to be wary of reinforcing a stigma against women in one of only two industries that confer economic rewards superior to those of men in the same profession.

Myth: Feminists Should Oppose Stripping

Even when all the myths have been debunked, today's strip clubs still leave a lot to be desired. However, just as more sexual openness would reduce the demand for topless bars, declaring them illegal would only raise it, as surely as Prohibition raised the demand for alcohol and the illegality of drugs increases their prices. If the aim of feminism is to secure and defend women's status as men's peers, then, far from banning it, feminists ought to participate in the industry—whether as entrepreneurs, employees, consumers, or allies; for as long as this culture retains its sexual attitude, stripping will thrive with or without feminist support, legal or not. With greater feminist participation, the abuses and inequities of the industry could be more quickly remedied.

Rather than oppose stripping on principle, our feminist allies should commit themselves to ensuring women's dignity at work, regardless of the profession. Rather than placing their ideologies before women, feminist lawyers or reporters could help eliminate biases and defend work-place safety by demanding consistently reliable security and responsible managers; either would prove more useful to strippers than unemployment. Rather than take it upon themselves to tell other women which professions to choose, feminists should defend every woman's work-place rights.

Grassroots feminist activism is needed within and around the clubs to improve them, not distant legislation to eliminate them drafted by those unfamiliar with strip clubs or strippers. Women customers themselves have a vested interest in such reform. For example, in Texas, women are allowed to enter topless bars only with male accompaniment. Since this rule distinguishes between male and female clients, it is intrinsically sexist. Worse, the reasoning behind it is prejudiced both toward prostitutes and women generally; managers won't allow any unaccompanied woman or group of women in for fear that they may be hooking, which itself should be legal. Not that owners care about prostitution; they simply don't want their clubs shut down for illegal activities. Finally, lesbians and bisexual women are denied a luxury reserved for men (and their occasional female companions). I'd like to see clubs owned, run, and managed by equal numbers of women and men. Likewise, I wish as many women as men went to clubs and that these venues would offer both male and female strippers.

I'd also like to see strippers themselves demand better working conditions. Though strippers in Texas are among the wealthiest and best treated in the nation, they could still stand up more frequently and more firmly to their managers. The one manager who refused to escort a rude client to the door on my behalf never saw me again. All strippers should exercise their ability to boycott or use other creative means of making change, raising consciousness, and fighting back. We must remember both our intrinsic and our instrumental value: we deserve respect, and without us, the industry would perish.

Myth: Clients Are Pathetic/Unfaithful/Dangerous

Though most gentlemen's clubs' clients are strikingly normal, many lonely and awkward men benefit from watching dancers. Sexual voyeurism alleviates some of their suffering. Also, impotent, disabled, and conventionally unattractive men are sexually stigmatized and frequently rejected as partners. One of my old regulars used a wheelchair. Until prejudices subside, he believes such clubs will be his only legal source of sexual interaction.

Traveling businessmen who are married often choose to turn to topless strippers rather than commit infidelities. My own husband has frequented topless bars for this reason. Many of the men I danced for fell into this category. They clearly find in gentlemen's clubs a balance between their sexual desires and their commitments. For many, clubs offer a venue for satisfaction and variety without transgression because of the distance between performer and client that Texas law requires. If these bars were banned, some men who want direct interaction with women, and not merely films or phone sex, might slip into adulteries they'd rather avoid.

Like strippers, clients rarely live up to their caricatures. Though he can be anyone from a seasoned businessman to a blue-collar worker, the patron pays not to demean women but to watch them and talk to them. If a man wanted to degrade a woman, he wouldn't pay her for anything; money is a form of

acknowledgment and appreciation. Furthermore, a man cannot subjugate a woman if he acts under consent. A gentlemen's club with armed security is a poor venue for anyone planning to harm women.

Myth: Strip Clubs Encourage Sexist Behavior in Society at Large

Though the conversation is important, no one pretends to go to topless bars merely to talk politics. No one buys *Playboy* only for the articles. The clients are visually excited and aroused by a variety of strippers. Within a gentlemen's club, unlike in most other work or public environments, openly fantasizing about women's bodies is absolutely appropriate. The bar creates a clearly defined, consensual arena for this behavior. This distinction provides strippers with both lucrative employment and clearer lines between the public and the private, between fantasy and reality, and between roles and persons. I have found that this increased inner clarity about boundaries and context-appropriate behaviors has helped me project an outward attitude of intolerance for context-inappropriate behavior. I believe this demeanor has helped to discourage potential assailants.

Interestingly, I encountered less harassment from men in gentlemen's clubs than anywhere else. The few confrontations that arose were squelched immediately by security. Again, if a man intends to offend women, a topless bar is not the place to do it; neither the strippers nor the management will tolerate him. I was safer at clubs than in my home.

Myth: Dancing Is Easy Money

Strippers in Texas make $20 for three minutes of undulation. A half hour of seductive behavior and two taxing deadbeats could precede that money. Four-inch heels ruin the back and feet. Few clubs offer health insurance. Every several weeks the drunken asshole turns up. Other strippers, DJs, and managers can all drain a dancer. Suffocating smoke and blaring music are no picnic either.

Stripping was the most profound change of lifestyle I have experienced and possibly ever will experience, unless perhaps I have children. Despite the requirements of talent, confidence, stamina, empathy, and the appropriate personality, stripping is obviously body oriented. This is perhaps the toughest part, both practically and theoretically. Even "real-looking" bodies require maintenance to look their best, and theatrical preparation takes time.

A stripper committed to the profession, as opposed to a college student dancing once a month for those "must-have" shoes, has a schedule that runs like so: the day begins around noon, with a fanatically healthful, low-calorie breakfast, followed by exercising, which includes about forty-five minutes on the Stairmaster and an hour and a half lifting weights—sometimes with a personal trainer—ending with another 45 minutes of hopping among the sauna, steam room, and whirlpool. By the time she's back from the gym and has eaten another small low-fat dish, it's time to "get ready," a process involving a thirty-

minute shower to meticulously remove all body hair, another thirty minutes of hairstyle-perfecting, and a good hour on immaculate make-up and nails. Then the drive (up to forty-five minutes) to the club, an eight- to ten-hour shift, and back home to count the money, eat a health bar, and crash until noon the next day. The three days off are consumed by doing laundry, house cleaning, grocery shopping, social obligations, finance management, at least minimal tanning, and lots of recuperation.

Myth: Once A Stripper, Always A Stripper

Though I know a few women who have stuck with the business for years, including one former *Playboy* model turning forty, most strippers move on. I also know women capable of dancing six nights a week for ten years straight. However, because of the industry's nature, by about age forty-five or after a few years, the majority quit.

After three years, I resigned and found a steady job editing. I woke up one morning, barely six months out of college, and realized the time had arrived sooner than I had expected. At eleven A.M. I drove out to the club and cleared out my locker.

To begin with, I'd grown bored. I had danced in various clubs for three years. I knew the ropes. The environment had grown mundane, and the glamour of infiltrating a forbidden element had faded. A thrilling adventure had become just another job.

My knees, back, and feet hurt. I had to sleep most of the time I wasn't working or working out. After the house was cleaned and the fridge restocked, I found I had no time for my true calling: writing. Ironically, funding my writing was the main point of my night job.

I'd formed my opinions. Once I had unveiled the truths about dancing, my only interest in the work was monetary. After buying all the clothes, C.D.s, and vacations I wanted, I began investing: several mutual funds and an I.R.A. By then I was down to simple accumulation of money for its own sake, and my motivation plummeted.

The $500 or so I counted out a few times a week seemed ordinary. When I began dancing, I felt incredibly rich and exhilarated to make $40 a night. By the time I had worked six months, I always broke $250. Then I wouldn't leave before taking $400. It wasn't until my third year that I became single-minded enough to continuously earn $450 to $550 a night— simply because I could.

And sadly, my tolerance for the occasional pincher, solicitor, or grabber had reached an all-time low. I'd lost all empathy with my clientele and began "accidentally" spilling drinks. My generosity had worn thin.

Granted, I've lived far more humbly as a writer and an editor, but my work engages me more (and is easier on my back). But I'd neither trade the fun I had during those three years nor refuse to consider stripping again.

Without having stripped, I'd now be leading a different life. I'd own no stereo system, TV, microwave, car, diploma, scores of appliances, expensive art,

nor two closets overflowing with beautiful clothes and shoes. I'd never have seen Canada, Mexico, Central America, the Northeast, the Pacific, France, Holland, Germany, Czechoslovakia, Austria, Italy, Switzerland, nor Great Britain. I'd still perceive myself as a vaguely attractive awkward girl at men's mercy. I would not control my sexuality as thoroughly as I now do.

Freedom from sexism rests upon embracing our sexuality as well as asserting our intellect. We need not reserve women's sexual expression, physical safety, personal choice, and economic freedom for gentlemen's clubs alone.

Notes

1. Personal dances in Texas consist of the stripper performing a foot away from the clients, no touching allowed. Though she may bend over or plunge her breasts into the client's face, a stripper must keep both feet on the ground at all times— a challenging technique. She may not touch other strippers. Nor is she allowed to get on the floor or simulate "sexual expressions or noises." These are the laws. Their enforcement varies somewhat from club to club and among strippers, but stepping too far beyond the perimeters gets strippers arrested and clubs closed. Generally, managers enforce these rules and strippers adhere to them.

2. The Report of the Commission on Obscenity and Pornography, September 1970, Washington, D.S.: U.S. Government Printing Office, p. 516.

3. This includes the Bronx (4), Brooklyn (7), Long Island (5), Manhattan (6), New York City (9), Queens (2), and Staten Island (4).

[19] Confessions of a Fat Sex Worker

DREW CAMPBELL

"OH MY GOD, WHAT ARE YOU DOING?"

Shit, I think, *I'm going to lose this call.*

Somewhere in Arkansas, an angry wife has caught her husband on the phone with me. He's jacking off while I tell him stories about my first blow job and my first woman. I am safely curled up in an office in downtown San Francisco. All around me, women cradle phones against their shoulders and murmur sweet nothings—at $3.99 a minute—to horny men across the nation.

"Are you talking on that filthy line again, you pig?!" I hear him laugh at her, and realize that they are both drunk. It's 4 A.M. in Arkansas.

"YOU HOME-WRECKING WHORE!" she screams into the phone. I get called bitchcuntslutwhore all night. This does not faze me.

But what she says next stops me cold.

"You know, all those phone-sex girls weigh about 500 pounds!"

"How much do you weigh, honey?" he asks, chuckling.

"135," I purr.

That night, Tara, my phone-sex persona, gained 2 inches in her bust, 3 in her hips, and got 4 inches shorter.

Still nothing like me, of course. Well, we both have red hair. But I'm not a 22-year-old coed from Berkeley, and I sure as hell don't measure 36D—28—36.

Most of the men who call phone-sex lines know the woman they're talking to probably isn't prancing around her apartment in six-inch heels and a G-string. She probably isn't a Playboy bunny, either, or she wouldn't be working for $8 an hour. The success of the call depends on my abilities as a storyteller, not on my dress size.

But after telling hundreds of men, night after night, that you look like Jessica Rabbit, it starts to get to you.

Because Ms. Arkansas wasn't exactly wrong. Sure, she may have exaggerated a little, but most of the women in the office aren't fashion models. Most are straight and married. Many have children. And most are what the Metropolitan Life height-weight charts would call overweight or obese.

I've done lots of different jobs in the sex industry. I've been a "phone ho"

off and on for two years. I've written reams of porn and publish a 'zine about erotic submission. I starred in a fat-fetish porn video called "Big Thighs and High Heels," or something like that. Men I've never met have written me letters about how they tie up their dicks, put on lacy red panties, and masturbate, thinking about me standing over them with a whip. They've even sent pictures. A lesbian S/M magazine published photos of me licking boots and dripping wax on my own tits. Men have paid $120 an hour to beat my ass with a riding crop.

But nothing ever made me feel quite as dirty as that woman's voice, with its Arkansas drawl.

Because I've heard it all my life. That fat equals ugly equals undesirable.

What I do for money on the phone, on video, or in a San Francisco bondage house is like writing fiction: an artful lie that still manages to tell the truth. I've told the real story of my first girl-girl fuckfest over and over: a college dorm room in Westchester County; Elvis Costello on the stereo; my best friend and her boyfriend and a bottle of Southern Comfort. I like giving blow jobs—but only to my dyke Daddies—and I like getting fucked in the ass–but only by women with really small hands who know how to say bitchcuntslutwhore. I like watching submissives eat out of dog bowls and I like kneeling at the feet of a woman who's just put six perfectly spaced cane stripes down the front of my thighs.

Sex work is like real life. Only straighter. And thinner.

Sure, I worry about the political implications of what I do. Are the divorce courts in Arkansas that much busier because of me? Am I oppressing my sisters by perpetuating myths of feminine beauty? What about the men I've seen in person? Have I shifted their perceptions of what a hot woman looks like? And is there anything so bad about American dollars making their way from the pockets of rich straight white men into the pockets of fat leatherdykes?

Sex work has taught me that I own my body. It has taught me that sex is a choice. That work is a choice. That what is attractive about me is not a lie. That telling stories gives me power.

That people don't always hang up when they know the truth about me.

The First Woman Who Broke My Heart fell in love with me when I weighed over 200 pounds. She left me when I had starved myself down to 143.

Love and desire do not depend on my weight.

I had to sit down and do the math: If I think so-and-so is gorgeous and fuckable and everything I ever wanted in a woman, and she's fat, and I'm fat, then ... then ... (Say it: I might just be gorgeous and fuckable and everything she ever wanted in a woman, too.)

Math never was my best subject. But I've always liked word problems.

Sex work is the place where the great powers of our culture–sex and money–come together. And like the high-school prom, it's one party I never thought I'd be invited to. So I went and threw my own. And everybody came. And came. And came.

[20] They Say I Write Sex for Money

The Dike Writer as Sex Worker

RED JORDAN AROBATEAU

THEY SAY I WRITE SEX FOR MONEY, that I'm prostituting myself. As a dike writer, I never thought of myself as being in the same oppressed league as a sex worker. My only association with the profession was that it happened to be the job of a lot of the women I used to sleep with—strippers, prostitutes, massage parlor chippies, and others in spin-off or borderline jobs of the sex industry. There was my friend the topless bar waitress; a lap dancer at an erotic theater; some dominatrices of an S/M dungeon. And there were those few not-so-exotic/erotic beauties I dated who hustled to make their room rent and pay for food and clothing in peepshow booths, and those who did time in nailed-together, tacked-down plush, red-velvet-carpeted, storefront sex-work palaces such as nude photography studios.

No, I never thought it was the books I wrote (into which, in addition to my sexuality, I poured my soul, my ideas, my philosophies, my spirituality, my political views, plus my dismay over the abuse of women and my subsequent CALL TO ARMS) that would cause me to be controversial among lesbian feminists, to be an outlaw, an untouchable and unmentionable author down at the bottom of the literary caste system, downright ignored for years by all manner of publishers.

Of course, most lesbian authors were completely ignored and unwanted by the straight press back in the early 1970s. And so, as with many dikes, the only venue through which I'd hoped to get into print was feminist publishers. Back then, one problem with getting my writing accepted was simply that I have always tended to describe the sexual activities of a human being in any given day to the same extent I describe their other aspects. For example, "She walked into the blue room of pink furniture, poured a glass of water, and drank, deeply." This descriptiveness extended to sexual urges, needs, and acts, because I believe a book that contains the sexual ideas and performances of the protagonist as well as the rest of their mental and physical environment is a more complete book. Books that don't are usually missing something.

A flood of women's literature beginning in the '70s shed light on some key pieces of women's plight but skipped a few other important issues. Sex was one

of those gaps left in many novels, particularly those about middle-class, white-washed heroines written by academic feminists. I recall some lesbian fantasy novels in which, page by page, a heroine goes about her days, apparently living in a nice house, driving her car (which runs), and paying for meals, while her source of income is only sketchily alluded to. Just tell that to the working girls on the street.

Probably the author herself was not concerned with economics because of being supported by a trust fund, a grant, a former husband, or a family with the means to attain a higher education. Meanwhile, lower-class dikes hustled to make ends meet by flipping hamburgers, driving school buses, working as nurse's aids ... jobs in which foremost in their mind was how many hours they managed to work that week for some ghoulish employer, how many dollars they earned, and what food and shelter those dollars would afford them, all of these subjects of much talk and concern.

In these nondescript, whitewashed, middle-class books, often what passes for sex scenes goes something like this:

"They lay down together and automatically violins began to play."

"They walked off into the sunset arm in arm."

"They were straightaway changed into dolphins and swam together through the churning waves of their desire."

Well, an Arobateau book will properly say, and I quote:

"Shelly felt her love dry up and instead of hurt, just pure desire. Frozen inside, as she watched Stormy carefully kneel before her like a virgin, tired, tenderly, hands parting her saliva-wet pubic hair, hands wrapping around her ass to pull her sex close into her mouth."

—*Dirty Pictures* (New York: Masquerade Books, Hard Candy Edition, 1995), 161.

"Mickey stood at the bar, one trousered leg up on a barstool, ran a hand through her wavy black hair, and silently took stock of her working lesbian parts; 'there's my fingers, tongue, my own cunt, clit, thighs, and I'll pack my cock in a tote bag. Wonder what she's gonna want to do first?'"

—*Lucy & Mickey* (New York: Masquerade Books, Hard Candy Edition, 1995), 346.

You get my drift.

My first major publishing effort was *The Bars Across Heaven*, written circa 1975, a self-financed novel done with my last money, which I scraped together. Into it, as into all my works, I poured my heart, my soul, and my sexuality. Basically, *Bars* was written during a very troubled period when, having gone from years of poverty to a good job and new affluence, I had simultaneously become disenfranchised within the lesbian community, dropped out of the gay world, and begun dating prostitutes along the "'ho strolls" of Oakland as well as in San Francisco's Tenderloin. It was no minor accomplishment to kick out a trousered leg and a booted toe and to step tentatively into a world not set up for dikes like me.

I wrote all this down (as a good writer does) and later made several books of my experiences, to join the other forty-odd unpublished works in my file cabinets. I must add, as a person of mixed-race heritage who writes about white, African American, Latin, and Native lives, that *Bars* just happened to be a black novel as well, thus throwing gasoline on the fire.

Nowadays, I ask people close to the business why *Bars* didn't earn me a contract with some alternative book press. Why has it gone nowhere? Because it's about street life? Because it happened to describe African-American dikes? Because it has quite a bit of sexually explicit material? "All Three!" came the verdict, "Guilty as Charged!" To date, this book remains nowhere in publishing land. In fact, I have two boxes of copies left sitting in my attic.

So now it is 1996. Sex writing has come into its own. And the hue and cry is, sex writing pays! It pays big bucks! Big bucks for big fucks! I found a publisher, Masquerade Books, whose printing press wheels are now busily grinding out my trashy, lower-class dike writings around the clock.

And *they*—those amorphous, critical, social, amoeboid collective voices—say, "She's writing sex for money! She's prostituting herself and is growing richer than us! We, who have doctoral degrees! And are legitimate! That sex—It pays!" when in fact, I must remind that world that in former times, it paid not!

Yes, they say I write sex for money, just like some of my old girlfriends doled out affection for currency long ago. But also, long ago, my sexually graphic material prevented success in the major lesbian feminist presses. Judging in hindsight, in comparison to other books that were turned out during that era (i.e., "She touched her hand as they walked into the sunset, lay down in the surf, and the dolphins began to play violins . . ."), if I had wanted to make money and to get published alongside definitive literature like that, I would have been cutting my own throat.

At first, other people's emphasis on the sex in my novels surprised me. At a Gay Day parade in San Francisco in the mid-'80s, Susie Bright, then the editor of the vanguard lesbian sex magazine *On Our Backs*, came up to me and my woman. Susie was wearing a black leather halter top, miniskirt, and knee-high boots. She said, "I like your work. Why don't you send us a submission?" Then she gunned up her motorcycle and rode away. I pondered. I hadn't thought of myself as a sex writer at all . . . just a poet . . . an artist in turmoil . . . a storyteller . . . a feminist, and a bulldike . . . a big bulldike. I simply included sex in my stories because it was part of my characters' lives. Like "real" prostitutes, I bore the stigma of other people's negative focus on sex to the exclusion of the rest of what I offer.

Now that I have finally found a publisher who likes my stuff—a producer of chiefly erotic books—there is another factor, heralded by the seizure of suspect texts at the border of Canada. Customs agents search for pornography. Due to laws stemming from legislation begun in the United States, vice cops at the border can seize any titles that seem to fall under their new blue antiporn codes. And guess who those customs sex police are busting! Not hairy-armed

gorilla Mafia goons with snuff videos, but dike books and periodicals with lesbian erotica. As long as straight folks hate us, we will be the first to be outlawed!

Needless to say, I am vindicated by sex-positive activism. Nothing I have written is so heavy-duty that someone else hasn't said it even more heavily. I've finally found my time and place through all the heartaches. As it says in the Bible, "If you have a light, don't hide it under a bushel—let it shine!" I'm glad for having put my foot through that doorway back in 1975!

[21] Showing Up Fully

Women of Color Discuss Sex Work

Blake Aarens, Hima B., Gina Gold, Jade Irie,
Madeleine Lawson, and Gloria Lockett

MODERATED BY JILL NAGLE

ML: My name is Madeleine Lawson. I'm known also as Diana, Terry, Kit, and as many names as I could find to match my alter egos each time they decided to do something different. I've been an escort, phone girl, pro dominatrix, swing hostess, as well as various things in between. I've been in this community for a year, so I'm still green, according to some people. I'm also a senior at the University of California at Berkeley and a bank teller. Overall, I am an educator, liberator, and advocate of sex.

BA: My name is Blake Aarens. I worked for two and a half years on the street in Boulder and Denver, Colorado. Now my place in the sex industry is mostly as a pornographer. I was called a pornographer for the first time three years ago and it made me absolutely happy. It was in the *San Francisco Examiner*, and they thought it was an insult. My background is Afro-Caribbean-American. My paternal grandmother was Jewish. So I'm a little bit of a lot of different things.

GL: I'm Gloria Lockett. I started working as a prostitute a long time ago— 1967. I started in Oakland and worked for eighteen years off and on, all over northern America. I've been to jail many, many times, mostly for solicitation. I never did any time, but I've been arrested lots of times. I worked on the streets, mainly in Oakland and San Francisco, and then later as an escort.

Now I'm the executive director of a nonprofit organization, CAL-PEP, California Prostitutes Education Project, that works with prostitutes, IV drug users, homeless people, and other people on the streets. I hire "ex-" prostitutes and "ex-" IV drug users and "ex-" housewives and "ex-" everybody. I have two children, a five-year-old granddaughter, and a two-year-old grandson.

JI: My name's Jade Irie and I've been stripping at strip joints for one and a half years. I've had several sugar daddies. I guess it's considered prostitution,

but they're really sweet sugar daddies. I'm mainly more focused on being an artist and being myself. I like to work inside out.

My philosophies about stripping and the sex industry are really different from other girls, and for that reason I haven't been making much money. If you ask anybody, I'm the girl with the short blue hair and honking boots and punkish outfit who dances to strange, avant garde music wearing a gas mask on stage. Mainly, I do performance art on stage and performance art off the stage—lap dancing—and tell weird stories to guys.

HB: I'm Hima B., and I also go by Surina at work. I've been stripping for four years. At first, I was expecting to work only until I finished grad school, which I did last spring, and then I decided, well, I really need to save up some money. I'm a filmmaker and I've made a few films, one about lesbian and bisexual women who were in the sex industry, which I funded through stripping. I got some interesting financial and other kinds of support from different nonprofit places.

I was surprised because when I started making that piece, I hadn't really considered the politics of it. I figured I was just looking at lesbian and bisexual women who, for the most part, weren't really feminist identified. Through the course of hearing what they were saying, I thought, "God, these women are really feminists, in more ways than they think." Some were very strongly identified and knew that what they were doing was taboo to women's organizations like NOW. They had a perspective that I didn't and I learned a lot from listening to what they had to tell me about their experiences, their childhoods, their reasons for being in and staying the sex industry, and what they were getting out of it.

Right now I'm trying to figure out how much longer I can work at the [Market Street] Cinema. I mean, I knew they were pimps from the very beginning, but now they're larger than life and they won't let me do the work that I want to do. So now I've started seeing a few people outside.

I was just inspired this weekend. There's another woman at work and we're talking about doing like a *Roger and Me* version of the Cinema, exposing people like Sam Conti, as well as the politicians and the whole industry that's supporting his practices.

GG: My name's Gina Gold and I was a stripper for five years. I started in 1988 and quit in 1994. I began with phone sex, and then worked at the Lusty Lady. I went by the name China Blue the whole time until the Mitchell Brothers made me change it because they said it sounded like a drug name. [Laughter]

I went on a ten-day silent meditation retreat in 1994 and afterward quit the sex industry and wrote a novel called *Island of Misfit Toys*. The novel is about my experience as a stripper, and includes the experiences of other strippers as well. I hope that the book—the first half of it is about my childhood and the second half is about stripping—will show people exactly who strippers are, who

women in the sex industry are and where they come from, so those outside will have more of an understanding and hopefully more compassion.

I've done some public readings from the book, and was a little concerned because some people perceived that I had lifted myself up out of degradation and that I'm now doing really well, which is not what I'm trying to say. I have to be really careful that what comes across is the strength of the women in the business, which I hope my book will convey. It will be good if Hima does this *Roger and Me*-type thing, because it'll come out probably around the same time. My agent was cautioning me against using real names, like Market Street Cinema, which really bums me out. I'm changing all of the girls' names and their descriptions, but my point is also to expose Sam Conti for who he is, but I might have to just call it Market Street, you know, *Enema*. [Laughter]

Blondes with Big Boobs

JN: Can we talk about racism and white supremacy in the sex industry?

JI: Well, I certainly see the advantages of being blonde and having big tits at the Cinema, as opposed to being a short-haired, Asian dyke with blue lipstick. [Laughter]

GL: It's probably just the blue lipstick. [Laughter]

JI: No, you would be amazed. I mean, I get a lot of crap from the guys, and also the girls. Like, "Why don't you wear a wig? You would make so much more money if you wore a wig." You know?

GG: I don't know about the "so much shit" as them trying to help you, so you're making money, because that's the whole point of being there.

JI: For most girls, yeah.

GG: Isn't it for you?

JI: Not entirely, no. I really do enjoy stripping. I like getting on stage with my makeup on and doing performance art for the guys. And I like being in that environment and being myself because no one's doing that and somebody needs to do it.

GG: But I could see why the girls would want you to make more money because we deserve to be making a hell of a lot of money.

JI: But we should get the money because of who we are and what we do not

because we have long hair, red lipstick, and big tits. [Laughter] I know that people have different fetishes but people are exotic or beautiful or sexy for different reasons and I think I am sexy in that way for that reason.

GG: I've thought of that many times myself, like, I don't want to give in to this bullshit because it's insulting. And at the same time, I don't want to sit there for five hours and not make any money. So what do you do? Do you— you know, can you say, "Well, eventually, maybe if I keep doing this, maybe even more girls will do this."

JI: Exactly. Well, it's not even about changing the girls or changing the guys for me. It's about myself. I think I get a lot of crap, period, because people in certain joints—girls and the guys—have problems with this, obviously. And so I'm the little goat, you know, and I have to kind of block off from all the politics, saying, "This is who I am. I don't care what you say." Because a lot of girls would be like, "You think you're being better than anybody? You think you're better? You know everything? You're doing this just to make us mad."

ML: Obviously, some of them are jealous that you are ignoring the pressure to conform to certain sex standards and are expressing your individual persona. In this industry, it is very hard to be your ethnic self if it doesn't sell. That's just one of the many issues you understand and learn to deal with when you get into the business. You can either have an understanding and strength about who you are and put on a role for the boys like an actress would, or you can try to fight the system and convert the perverts.

GL: I think that in the industry, regardless of what it is, people are in it for fantasies and what they want is what everybody else wants, which, unfortunately, is tall, blonde, big-busted women with long hair. And, unfortunately, that's what the majority of people are comfortable with.

I can tell a quick story. I always worked with a lot of women, most of them white, and I was working with this one woman who, I'm sorry, but she was very homely: very big, very ugly, and smelly. [Laughter] And so me and her were standing on the corner in Emeryville [near Oakland, CA] together. And there was just no comparison between me and her, period.

But this car kept circling and circling and he kept watching me and watching me, and finally when he picked her up, I jumped in my car and followed them. I waited until they got into the apartment she and I shared. I waited until she got in her room and got her money. I said, "Now, you're going to tell me why you went with her. I do not understand." And he looked at me and said, "I was twenty before I even seen a Black woman." He said, "Of course I like you, but I was scared." And the man was trembling. He was literally shaking and I had to literally say, "Stop shaking. Now, give me my money. I didn't come up here for nothing and it's okay, just get used to me." And I went in and shared the bed with her.

BA: It's weird because my experience around this is so different. I cut my hair off and I walk around looking like a butch dyke from hell, and I get the guys looking, coming over, and wanting to talk to me. It's shocking to me. This is not in the industry. This is just me out in the world. And I wonder, what do you see that's saying that I'm available for this? I think it's that piece of strength that is this erotic charge for guys.

GG: But they don't always want that when they come into the strip clubs, they want what's safe and comfortable, which is what they see on TV. I have to admit that when I would have my wig and everything on and a girl would come on with short hair, the sight of you being yourself and just like dealing with just yourself is kind of a bit much for me because I've made the decision to change the way I look. It's like, "Okay, I've got the wig on. I'm going to be okay with that. I've got these ridiculous heels on, you know, and they're killing my feet, and I've got the lipstick and I know that this is totally not me and I know that I'm not even necessarily comfortable, but I'm doing this to make money and I'm doing this to please this man, so don't remind me, just don't remind me that I'm not being myself or that I'm not . . .

JN: Oh, so it's a reminder.

GG: Yeah, or it's almost like because something in me would like to just take my wig off and go on with short hair and just be, like, "Fuck it. Either you look at me or fuck you." But you can't and you're doing the best that you can just to deal with that situation, so any sort of reminder of what's real is scary.

JI: Yeah, but my performance focuses on that. In a lot of the songs that I use, they scream at the top of their lungs, "Double dare you, dare to be who you are."

ML: I have a hard time distinguishing my work from my real sexual personality. I enjoy many of the kinky and sexual things as much as the men. This, too, is a part of me, but it is also my job. Sometimes this connection is unappealing. I find my Blackness beautiful, but ironically, I don't enjoy it when clients eroticize it. I get all these guys who just want me to put my hands on my hips, crack gum, and speak with a ghetto dialect. [Laughter]

GG: A lot of times it's a jungle fantasy. Once when I sat on someone's lap, he said, "Do an African rain dance."

GL: But you know what, I really think that it has something to do with work and not work because when I was working as a prostitute I had a friend who was Black and a prostitute who looked a lot like me—a lot thinner and sort of taller—and she would wear long ponytails, okay? Her hair was shorter

than yours but when she worked she wore this long ponytail and they called her Pocahontas. They wanted her to be anything but Black.

JN: They?

GL: The tricks, who were mostly white, as most of our customers have always been white. Even though they like the Black women, they still didn't want us to be Black. They wanted us to be something else. They wanted to believe that we were Pocahantas. And that we were young. You could wear your hair so it was way down and you would have guys say, "How old are you?" And you would say, "How old do you think I am?" And they'd say 21 when I was 33. And I'd say, "Yep, that's how old I am."

It didn't matter. When I went home I took my wig off and I was me. As long as they were paying me, they could call me whatever they wanted to. To me, it was totally work, completely separate from my life. My life was not about being a prostitute. I am a Black woman and have always been a Black woman.

Speaking of Black women, I'd like to talk about the feminists. When I first started working out of the sex industry, trying to get into the real world, as some people call it, or the square world, as I called it, I joined a lot of different organizations. And what's the name of the one—NOW. I cannot believe how many women were so biased against prostitutes. I heard, "How dare you think that you're a feminist. You're a prostitute. How can you do both of them?" And it's like, "How can I not?" I am a Black woman. I have always been the head of my family. I am the oldest of all the kids of my family. I take care of everybody. I am a feminist. When I walk through the door you do not see a prostitute. You see a Black woman. It was never, in my head, that I was anything else but a feminist. And I have a real hard time with women saying, "On one hand, you can do anything you want to," and the second is, "Anything you want to as long as it fits under my umbrella." Well, screw your umbrella! Your umbrella is not my umbrella.

Fetishes and Other Boxes

JI: I don't have problems with guys sitting with me because I'm Asian or Japanese. I have problems with guys assuming that, because I'm Asian, they can get away with something. Sometimes they speak a certain way and say certain things to me that they think Asian women would like or can handle, and that makes me nauseous.

For example, trying to speak Japanese in weird accents. Stuff like that. Or, "Are your parents from Japan?" They expect me to listen to all their Japanese stories and their Japanese experiences and I'm supposed to smile and listen to him as they say, "This is Japanese. I know what Japanese is." And I'm sitting there thinking, Well, I'm Japanese and I don't think that's very Japanese, but should I sit here and listen to him just because, you know, he has a fetish?

HB: So do they want you to be more submissive? You mean, they talk to you like you're supposed to be this little wimp, right?

JI: Exactly.

BA: The problem arises with me, too, particularly now in my writing. People who know something about me out in the world expect me to write a certain kind of thing and get really bent out of shape when my writing doesn't conform to what they think Blake Aarens, a Black dyke, mid-thirties, should write. And I've come upon this a lot of times where I'll be at a reading and people get like, "You can't write that." And I say, "Well, yes, I can."

I have a story that's coming out in anthology called *Switch Hitters*, edited by Carol Queen and Lawrence Schimel. It's gay male porn written by lesbians and lesbian porn by gay men, thus the title. My story is about these two Black men, one of whom is an artist, and the other is an artist's model. It's a really nasty story, but it's also really fun. And there's race stuff in there, too, because I write about people's whole contexts. Well, I've already talked to friends about this story and I get this sort of stunned silence as a first response. It's just like, wait a minute. I write about all kinds of sex. I have a story that's about a human and an alien.

Another piece is that having been married to a man, I get a lot of grief around that. I actually had a lover tell me that I needed to make a choice between my friendship with my ex-husband and my relationship with her. And I am one of the first people who could admit that I sit in some privilege because of my former marriage. I sit in some economic privilege which is clear and present in my life.

JN: You mean he gives you money still?

BA: Oh, yeah. And at the same time one of the things that's been really important to me is to end that. It's been about me framing that as patronage, as somebody paying for my living expenses while I work on my art. While that's a positive way of framing it for me, I have so many artist friends who struggle with the nine-to-five. I try to make peace with it by believing that these things have come my way for a reason. At the same time I look at the circumstances, because I have two older sisters who didn't marry a blonde, blue-eyed, wealthy Jewish man.

And I look at how the way we were raised influenced the fact that that wouldn't happen to them. The seven kids my mother actually gave birth to—starting with me, number five of the seven, the names get really anglicized. My older brothers and sisters have family names that have been passed down, that you hear and think "Black southern family." And in terms of color, me and the brother who's directly thirteen months younger than me are the two lightest people in town. And I've had to look at the way that color and birth

position and where we grew up have played a part. I also look at the person that Doug met and fell in love with and married who was bulimic, had long straight hair, high heels, the whole deal. That was the role I was playing.

And I look at who I am now—short, kinky hair, a hundred and fifty pounds—very comfortable in my real body size, and I know that the person I am now would not end up married to a blonde, blue-eyed, Jewish man from a wealthy family. So I look at all of those things and try to make peace with what the spirit has brought into my life, including the privilege. And I haven't made peace with it all. There are still more questions than answers.

JN: But yet there's a context. Privilege and profit have been taboo for feminists, as well as most of the rest of us.

BA: Well, see, I just got the largest single payment for a short story I've ever gotten about a month ago from *Penthouse* magazine. I wrote a piece of Ken and Barbie sex—not actually Barbie and Ken, but you know the characters I'm talking about. And there's a lot of stuff in me about *Penthouse* magazine. Oh, God!

I meet with two other Black women every three weeks to sit down and talk about what's going on in our creative lives. I had photocopied the check and showed it to them and they were just whooping and hollering and congratulating me. I started talking to them about how I was having some political discomfort about this. And one of the women—and I will never forget this, it was such a blessing—turned to me and she said, "You know, something, Blake? The only thing wrong with tainted money is *'tain't enough of it.'"*

The thing that has really, really given me a lot of permission as an author, is researching and learning just how many of these people whose work we hold up as classics in literature have supported themselves writing porn, like Anaïs Nin, Henry Miller, for example. Ernest Hemingway wrote little snatches of porn in Paris when he was there. And I felt like I was taking my place in this long line of literary giants, that this was my literary legacy.

Another way in which it comes up for me, is being advised by people to write my purely sex stuff, under a different name. I succumbed to that the first time I had a piece of sex writing published. I wrote it under a pseudonym. My first piece that's in *Herotica 2* is published under Cassandra Brent. Susie Bright tried to tell me not to do that and I wouldn't listen to her. Then, a friend of mine, someone who had also urged me to use my real name, called me from New York and said, "Go get the *Village Voice* and call me back when you get back." Knowing her, I wasn't going to get off the phone until I agreed to do this. So I went and got the *Village Voice*, and called her back. She said, "Okay, turn to page 37." And on page 37 was review of *Herotica 2*, which mentioned my story as one of the best in the collection. But it's not under my name.

GROUP: Ohhh!

BA: I learned my lesson. The piece in *Penthouse* is going to have my name on it and people will just have to deal. I was telling Gloria about this when we were on the way here—when I get called a pornographer, it feels wonderful because I looked at the definition of pornography and it's like, "Yeah, I write this shit to get people off, and you're calling me a pornographer. You're telling me I'm succeeding in what I set out to do." And that makes sense to me. This is why I sit down at the computer and write this stuff—because I want somebody to be jacking off in Minnesota reading this.

ML: In many ways, I think you are fortunate. You remind me of one of my idols, Anaïs Nin. It's wonderful when you are able to write erotica that puts money in your pocket. I think about accomplishing the same goals. I want to help people heal and become comfortable with their sexuality and loosen the sexual binds we are forced to tie ourselves up in. Unfortunately, working a nine-to-five is really hard for my sexual interests and pursuits. Nine times out of ten I can tell when a guy recognizes me from the *Spectator*, because he gives me that kind of look, and I am uncertain whether or not he will tell my boss, try to blackmail me, or hit on me!

BA: I want to respond to what you were saying, Madeleine, about the people that have to work nine to five. I am really aware of the ways in which I sit in privilege because of that. I am also aware of the dues I paid. My ex-husband Doug and I were together from 1982 until 1989 and I put in seven years of heavy-duty labor and I feel like I'm getting paid for that work.

ML: I'm not saying, "Oh, look at you. You're a privileged bitch and you can't speak." I'm saying it's fascinating hearing someone have the strength to say that this is what they want to do and to hell with being fired and ostracized. So many of us want to be "out" and proudly tell our friends and families about our sexual activities but can't. If I told my grandfather that I was a proud whore, he would beat the shit out of me. It would kill him to know that I even had a white man touch me in that way. My mother is my only support force right now.

BA: The quote that I couldn't remember before, when we were talking about patronage, was that men should have really thought hard about making *widowhood* women's primary road to self-sufficiency!

But, to get back to the sex industry, there's an incredible book by Sally Tisdale called *Talk Dirty to Me*. In it, she talks to a friend of hers who has been a whore for years, who has this fabulous apartment and takes vacations and this and that and the other, and this woman says, "Well, look at what my pussy got me? This wonderful home, these wonderful things. I get to go on trips everywhere." So working in the sex industry has made this wonderful life for her and then, at the same time, the work that she has done to get what she's got is so stigmatized.

But then you've got this guy who is a corporate CEO who has exploited people for forty years, who has this great house and these trips and all that, but it's like he's a CEO. He's got all this prestige.

JN: It's not like he didn't do it with his dick. [Laughter]

BA: Exactly, exactly.

ML: But the question I would pose is are you happy with what your pussy got you? My first trick was a dominant from England. He was at the exclusive Mark Hopkins in Nob Hill. I was scared to death to go in, because most women don't do submissive outcalls for fear someone will tie you up and beat the shit out of you or kill you. I brought this paddle and whip, and he found a hairbrush, and for an hour, I bent and touched my toes while he flailed on my ass. Afterwards I could not sit for two days. But I had $285.00, did not have sex, and felt guilt-free and proud. I am an SM switch in real life and enjoy pain personally. So I was paid for having fun!

GL: Oh, you let him paddle you?

ML: Oh, he paddled me.

BA: I love that she's sitting there with a smile. [Laughter]

ML: But I'm just saying for women who aren't, they pretend like the money's a form of happiness but when you think about your pussy being irritated from fucking too much and getting yeast infections—

BA: But my pussy being irritated from fucking a lot is a happy thing for me. [Laughter]

ML: For you! But in general, in terms of having the puss get you things, it's like yeah, your pussy gets you things, but are you happy physically and spiritually with that?

BA: Well, wait a minute. How is that different from my brain getting me things? And how different is that from, you know, I've got a headache from studying so hard but I get my As or whatever. How is it different?

JI: I think by the time I stopped stripping, just this month, I was finally realizing that wow, all this energy and creativity, all my shows and stuff, went into this hell hole. I could probably turn all that creativity around for something else absolutely wonderful outside the industry. Then I thought maybe I could just put on a wig, make a lot of money, go out as fast as I can and turn that

around to something else. And most people probably realize that when they get in because they have other things to do—I didn't.

Sex, Work, and Health

GG: One thing that worries me about my book is that sex workers will have a problem with me thinking that sex work is an unhealthy thing. I mean, I think that there are some healthy things about it. I'm glad I did it and think that sex workers are the strongest people in the world. But, however, the bottom line is I don't think it's healthy to be sitting on someone's dick while they're handing you a few dollars and then he comes on your ass, and you have to get alcohol and get the slime off. There's no way that that can be a healthy thing. Because I think that the mind and the pussy are connected. And not so much that it's a bad thing to make money off your pussy, but there was a point where I was so strong and I was so confident up in here [points to crotch] that this was so potent that if any man stuck his dick in it, it would just blow up. It was that potent. But working in the community and the industry and stuff, a lot of times you lose that sacredness in your pussy. It's not a gift anymore and it's kind of generic.

GL: I just need to say this about sex. I feel like that the whole eighteen years that I worked, I was waiting to get out of it and, believe me, all of it wasn't down. Some of it was lots of fun, but it was just having to do this every day and all the time and not knowing how I could ever get out of it, mainly because I was making so much money. But I think that the power that I have in my pussy was the same power I had in it then. I've never felt like I was degraded. I knew exactly what I was doing. I know what I'm doing now. And I feel like a woman's sex is so important to her and that there is nothing that anybody can do to degrade that, as far as I'm concerned. And I know some women feel like they've been degraded and this and that, but I've never felt that. I never felt like I was used. I felt like yeah, I was used, but I was using them. Hey, it balanced itself out. I'm fine. And right now I feel like sex is just wonderful. It ain't taking nothing away from me. [Laughter] I still feel sacred.

GG: I think that what happens is, you know, because people are always on our case about being whores and calling us shit, that we have to be like, "We're okay, we're okay," and we are okay, but it's also okay to say but there are some unhealthy things going on and that's all I'm saying.

BA: It's interesting because I consider that some being married *was* doing sex work—*and*, there were times when we had a lot of fun. Being able to claim that, too, is really important and it's something that has freaked some of my lesbian friends out.

GG: Well, but that's really different because it's safe, you know that like if you don't want to deal with Doug, you know, like if he's grossing you out, you can stop, or if he's—

BA: I was not raised with the knowledge that in your marriage you have a right to say "no" to your husband if something is grossing you out. I was never taught that.

GG: Okay, okay. Right. And that's how I feel about sex work. I think that I've had a lot of fun doing it, I've got a lot of strength doing it, but it's also okay to say that it started from an unhealthy place. I came from an unhealthy background and that's how I got into sex work. I think that's okay to say. And that it's okay to say that it was—there were times when it was very, very unhealthy. And it's important for me to say that only because when the book comes out, I am nervous about a lot of sex workers having a problem with me saying that, as if I'm betraying them, and I'd want them to know that it's not about me betraying them. I'm saying that you're the strongest people in the world and it's okay to say that I sat on this man's dick and he grossed me out and I feel like shit now. It's okay to say that. The shit was *nasty!*

ML: Personally, I just have to say that my experiences in the sex industry have been, for the most part, lonely and unpleasant. Being a Black woman, I have to deal with a lot of bullshit in society. Being in the industry just intensifies that because it is all the more racist and sexist. At a certain point I was so angry and frustrated that I started to question my physical and mental well-being in such an environment. I remember one day when we had lots of business. Each of about seven women had about four or five clients. I was the only Black woman there, and I did not get one booking. Eventually, I felt like the maid, because when you're working in this house, we're all supposed to pitch in. If you get a session, great, but if you don't you still have to take care of the house domestically, because it's a play house for everybody, right? So here I am, cleaning dishes, doing laundry, throwing away used condoms, answering the phone, and I'm not getting a dime. When I answer the phones to book sessions and mention myself, they're all gung-ho until they hear that I'm Black and then it's like, "Sorry. I don't want a Black chick. Who else do you have?" I felt so angry because it confirmed my feelings that, in the sex industry, just like in the vanilla world, you have to try twice as hard to get anything, and you're still not given any recognition.

GL: I think it was different for me because the girls that I was working with that were white were in my family and so I would just double date. [Laughter] I would answer the phone and set up everything and they would come in and they would want the girls and I'd say, "Fine." After you got their money, then I'd say, "Now, how much are you giving me?" And that's how I would make my

money, but it was part of it. Yeah, I think the thing that was really shocking to me is how much people lied and how racist, so racist they could be, and how they would risk everything rather than not be racist.

For example, when I worked in the Burlingame Hyatt House and guys would hand me the keys to their room so no one would see me enter with them. And I'd be up in their room with their Rolexes and everything else, and I knew that I had to go back there tomorrow so that I wasn't going to blow the place and steal stuff. But they would rather me steal everything from them—because they still wanted to screw me—than to risk being seen with me.

BA: It's interesting because in my experience with the white boys in Boulder, it was primarily about getting to fuck a Black girl. It was like their chocolate fantasy. And you got these little privileged white boys who probably haven't seen a handful of Black women ever in their lives and they're just like, "Oh, I get to stick my dick in that. Oh, God. Here, take my money." It was wonderful for them as exploring foreign territory, but taking me seriously and interacting with me *as a peer*? [Laughter] Oh, no, oh, no.

ML: Well, I'm sick of it. I'm tired of being around all these naive white women who don't know the meaning of fighting the system. They just sit there all wide-eyed, feeling philanthropic. They're like, "Oh, do you want to come in on my session? I can give you some." Like something out of *Uncle Tom's Cabin*. And I feel like, "No, I want my own session. I don't want your fucking crumbs. I want my own piece of cake, thank you." Being around all those white women who just don't get it, the strength that I had as a Black woman slowly began to diminish. Contrary to what many of my white colleagues believe, for the most part, they are getting paid, being worshiped, and don't *want* to get it.

GL: And they need the money, too. Exactly.

BA: They're not going to say, "Oh, I'm not going to take this session because you need it," you know?

GL: Yeah, I can totally relate to that. I've been there before.

HB: I mean, there's a couple of times when I've had customers say some really fucked-up things about Black women and I just don't sit with them. Because I'm not that different. I'm Asian, but I'm still a brown person and they sort of can overlook that because they're like, "Oh, but she's Indian, at least." And so, you know, this is a little bit more okay than if I were—

ML: It's a little bit more white.

BA: Well, it's like Gloria was saying. They wanted you to be anything but Black.

ML: It bothers me because I am a sexual person who wants to be desired, admired, and honored just as much as the next woman. I am not small-boned with creamy skin, light eyes, and long silky hair, but in my way, I am just as beautiful. Why is it difficult for me to be touched, talked to, and considered attractive?

GL: Most of it is because of society. It's not you. It has nothing to do with you! This is what our society projects. And I separated it, which is why I'm not bitter and evil at some of the ways that people tried to treat me. It wasn't about me. It was about themselves, and I was playing the game.

Final Comments

ML: I want to let people know that I am an intelligent and beautiful Black woman who refuses to be at the bottom of the sexual totem pole anymore. Black women are more than just these stereotypical, unapproachable jungle bunnies. I want to be a Black woman who educates and stimulates others to explore Black female sexuality. People need to hear a Black female voice that makes them say, "This sounds like a woman who is strong, sexy, and hot!"

BA: I think that the thing that I have the most energy behind in all the stuff we've talked about today is that, you know, this is Blake and there are a whole lot of people here inside me, and I get to express all of them. I get to write really nasty sex stories and I get to quote Shakespeare.

HB: What I find as far as the race stuff is concerned, there are all these schisms. There's Black women versus white women versus Asian women versus Latinas, and there are so many cliques at work. And, for me, I feel like I don't quite fit in with any of them. Like the white girls are friendly enough and it's easy to sometimes get along with them, but they don't quite understand the oppression. And then with the Black women, sometimes I feel like I'm more privileged than they are because I'm Indian and so customers will be more likely to sit with me, and I feel like they feel pissed off with me that I'm getting these customers and they're not.

However, we all face the same sort of racial shit, so we can sort of bond around that. But then, even with some of the other Asian women, I don't think they consider me Asian and there's very little point of connecting with them. You're dealing with the customer's racism, the women's racism, yet somehow everyone's making money. It's all based on certain stereotypes, manipulation, and power dynamics, and it's interesting to see how far people

will take it sometimes to make their money. And how you need to, because for most, it is about survival. Jade said she was there because she likes to dance, but I can tell you for a fact that the majority of the women are not into it primarily for the performance art of it.

GL: I think that's a cultural thing, because I don't know any Black women that say, "I'm doing this because of the power and the energy and I'm doing this because I like to have sex with all these people," where I know lots of white women have said that before, who have said, "I'm in it for the sex. I'm in it for the power."

BA: I really appreciate what you were saying about not fitting. I have friends who consider themselves political who don't think that I'm political enough. Among sex writers, since I write sex stories that are about more than just sex, I also don't fit in with them. And I write about more than just lesbian sex, so I don't fit in with the lesbian writers. And I write about more than Black people, so I don't fit in with the Black writers. So there are all these ways in which I sort of get a foot in these different groups but there isn't a place where I can show up fully. It's so frustrating. I've gotten to a point where I'm doing most of my writing and most of my thinking about my writing in isolation.

GG: It's a good thing sometimes to be in isolation, just because it really makes you look to yourself and really support yourself. But at the same time, you want to be able to share that with somebody and you need that.

BA: Yeah. To be able to talk about the process and actually feel like you're getting heard.

[22] Working It

NORMA JEAN ALMODOVAR

IN APRIL 1982, AFTER TEN YEARS AS A TRAFFIC OFFICER for the Los Angeles Police Department (LAPD), I was completely burned out. It was time for me to leave the safe harbor of a well-paying public-service job with its health benefits, special privileges, and even an opportunity for promotion, and go out on my own. Whatever new job I chose, it had to allow me enough time to write—the only catharsis I had available to overcome the crippling anger within me. In those ten years on the LAPD, I had both witnessed and experienced sexism, physical violence against women, and inhumanity beyond my wildest imaginings. Though I'd never thought of myself as an outspoken person before I joined the LAPD, I was now determined to find a way to speak out publicly about my experiences.

I had been keeping a journal, which I intended to turn into a book. Now that I was assessing my future employment options, I had to think of a way to publicize my observations about the LAPD. What work could I do that would be likely to grant me a public forum? I entertained thoughts about working as a prostitute. Not a street prostitute, of course—I was tired of working outside. Besides, I knew how the police treated them, and given that I was writing a book exposing the LAPD, I didn't want to make myself an easy target.

I was intrigued by a call girl I met, who lived in a beautiful house, drove an expensive car, wore nice clothes, and seemed to have plenty of self-esteem. Contrary to the stereotypes, she was no air-headed bimbo, and she wasn't angry and burned out, as I was. She also liked her work, something that I no longer did, even though I had a job that society approved of and she was an outcast. After a long talk with her one afternoon, I decided to earn a living by selling the one favor that I freely and foolishly gave away to the many cops I dated. But even though I had a reputation for being "easy," I never slept with any of the high-ranking cops who expected it from all the female employees they considered attractive—at the time it was the only way a woman could get a promotion within the police department. I didn't want to be a "whore." Of course, I never got promoted, either.

The thought that I might enjoy being a prostitute never entered my mind.

My only concern at that point was to get people's attention and perhaps persuade them to take more responsibility for their police department. Among other things, I wanted to expose the hypocrisy in police abuse of prostitutes within a larger system of unchecked police corruption. Prostitutes were treated in an outrageously degrading manner by the very agents of the law who were supposed to protect them, but the cops' abuse of public trust, property, and human life caused far more harm than commercial sex ever could. Observing this and other forms of the LAPD's state-sanctioned violence against unarmed citizens seriously eroded my emotional health as the years passed.

The Beat and the Beaten

In 1972, I felt privileged to be one of the few women hired by the LAPD to work in the male-dominated field of civilian traffic enforcement. I didn't meet the height requirement to be a full police officer. The alternatives for women at that time generally comprised working indoor day shifts answering phones and filing reports. Instead, they assigned me to a pilot program designed to determine the safety for women in patrol cars. I was assigned a patrol car and given night watch duties. Because I technically was still a civilian officer, I had no gun, and usually no backup partner, though I was answering traffic-related radio calls from 6:00 P.M. until the wee hours of the morning in some of the most dangerous parts of the city. That made me one of five people—and the only woman—traveling in a patrol car without a gun and without a regular backup partner. So in effect, as an experiment, they sent me alone and unarmed into the same situations usually confronted only by fully armed policemen in pairs.

I was appalled to see how the other police officers treated street prostitutes. In the nightly roll call, the male officers laughingly described how they rounded up prostitutes, using what they called the "whore car" to collect these hapless working women and bring them to the police station for booking. Often, the women were rounded up like cattle and forced to entertain the officers by running a barefoot race on the street. The women who finished last were then arrested and dragged to the police station, booked, fined, and permitted to return to the street early enough to make the money to pay the fine. The women became so immune to this abuse that they, too, began to think of this violation of their rights as a game—they laughed with the officers when they were tagged for the night.

There was one pregnant, fifteen-year-old prostitute with a broken arm, whom the cops arrested every night for a week. Night after night when I returned to the police station to do my paperwork, she would be there, shackled to the bench at the rear of the station, begging to be allowed to use the women's bathroom, since pregnancy makes one need to urinate more frequently. Because there were no police women around to take her into the ladies' room and I wasn't allowed to, she was told that she would just have to "wet her pants." The poor pregnant teenager with cast on her arm and tears

smearing her mascara did just that, and soon a puddle of liquid trickled down the hall from where she sat on the bench. I never spoke to her, but I wondered if this pathetic woman-child, sitting there embarrassed, frightened, and lonely, could possibly understand that this treatment was meant to teach her that she was in a degrading profession and that the police believed they were actually doing this to her for her own good. Weren't they, after all "rescuing" her from a big, mean pimp who didn't care anything about her, and from life on the street? So they claimed.

Not long after this incident, which left an indelible brand on my psyche, I encountered further evidence of the callousness toward women from a system that is supposed to protect us. A man twice my size who brutally attacked me for attempting to tow his van was arrested, taken to the station for booking, and then released on his own recognizance. The city attorney advised me that the city did not really want to prosecute him because, as he put it, I wasn't "really hurt," and besides, the man was a member of the Hollywood Chamber of Commerce. I replied that I was lucky I wasn't killed because the man obviously intended to cause me bodily harm. I refused to drop the case. The city attorney behaved as though the incident were my fault and proceeded to handle the case with as little interest in winning it as I now have of returning to the LAPD—none at all. The man defended himself and was acquitted.

Employees of the LAPD are considered "city property," so I could not sue the man for emotional damage. Angrily, I thought of the many felony assault cases that were filed by the DA against citizens who dared to defend themselves physically against male police brutality. Some had merely grabbed a cop's arm in at attempt to curtail a violent beating. Male police officers frequently used the beating tactic to provoke an individual they had no other cause to arrest. Once the person so much as touched the male cop, even in self-defense, that individual was charged with assault on an officer and resisting arrest and hauled off to jail with no bail. Even when the male police officer involved was unharmed and indeed instigated the incident, these individuals were prosecuted to the fullest extent of the law.

Meanwhile, the very same city attorney who didn't want to inconvenience the businessman who attacked me was waging an all-out war on the women of the street. Prostitution was being vilified in the media as the worst plague to hit Hollywood since the inception of Sin City. Years before the cops could arrest anyone "suspected" of "possessing the intent to commit prostitution," the police detained all women who were "known prostitutes" in any public place, such as the grocery store. Not even "good" women were safe from the dragnet of the moral squad, as several housewives can attest.

It hurt me beyond all reason to learn that it was more important to the city attorney to spend Los Angeles taxpayers' money prosecuting and incarcerating women for selling sex to willing customers than it was to aggressively prosecute a man who had deliberately and with malice aforethought attacked me, a female member of the Los Angeles Police Department.

Further Abuse of Power

My rage continued to boil as other nefarious activities erupted in the Hollywood division where I worked. Some officers were caught having sex with minors (in some instances, girls as young as ten), an offense normally garnering moderate to severe penalties. However, police officers charged with such crimes went relatively unpunished, and in many cases weren't even fired. In a burglary/drug ring scandal that involved dozens of officers, one officer admitted under oath during his trial that he and his partner had committed over one hundred burglaries on duty in their police car and had sold the stolen property to the other cops in question. The other cops who were on trial with him were not convicted because the potential collaborating witnesses, including the partner of the testifying officer, had been murdered or killed in "accidents" prior to the trial. The one cop who admitted his crimes to the jury was convicted and given a six-month suspended jail sentence with three months probation. This was our "justice" system? I was outraged! Other examples abound and boggle the mind.

By this time, I felt completely overwhelmed, psychologically battered, bruised, and incapable of controlling my emotions. When I was called before the captain and chastised for not taking my dinner hour each evening (I chose to work through it instead), I could not stop crying. The rage, humiliation, pain, and indignation welled up inside and left me without my normal coping mechanisms. Every incident now reduced me to tears. I could not communicate with anyone without crying, and I was embarrassed. This was just not like me: I had always been independent, determined, strong and capable, not a psychologically weak and helpless victim! I had survived a childhood with eight brothers and five sisters in mind-numbing poverty and religious oppression, complete with child abuse. At eighteen, I had packed up and moved to New York with no money and no job prospects. Six months later, in the same financial situation, I had moved alone to California.

Independent and strong though I was, I wasn't recovering. I began seeking psychotherapy through my disability claim with the LAPD. One of the city-appointed psychologists who examined me stated in his report that my intelligence was "grossly above average." So, I wondered, shouldn't a smart woman like me be able to use my brains to shrug off the deplorable behavior I was surrounded with? Then I wouldn't have to cast aside ten years' investment into a pension fund as well as other invaluable benefits that government employees reap, a situation to which I had no comparable alternatives. Surely I could keep my mouth shut and stick it out another ten years until retirement. Then, I could rail on all I wanted to about the hypocrisy and corruption on the LAPD without worrying about where my next paycheck would come from. But then another idea struck me. Rather than continue in the dead-end job as a traffic officer where I felt so ineffectual and impotent, I could do one better: I could become a sworn officer.

Thanks to my ten years' experience and the changes in the discriminatory

practices of the police department that had kept me from that position for so long, I could have made the transition from civilian to sworn officer with no problem. However, before that could happen, my LAPD career thankfully ended. In April of 1982, as I was patrolling Hollywood Boulevard, my police car was struck by a drunk driver, which I immediately took as an irrevocable sign to leave the job altogether. Although I was not seriously injured physically, I was already emotionally damaged almost beyond repair, and that accident was the last straw. It was time to heal my soul.

After I spent several months on disability leave, the city informed me that my worker's compensation benefits had run out and I would have to return to duty. I opted not to go back to work, filed a lawsuit against the LAPD, and eventually won a small disability settlement. It was while I had no income at all that I decided to contact the call girl I knew and seek employment in her profession while I wrote my exposé of the police department.

A Calling

In the beginning, I feared that I would hate working as a prostitute, but when I discovered that I really liked "whoring," I felt an immense sense of relief and liberation. It was wonderful to enjoy the work that subsidized my writing career! I planned to tell my friends and family that I was a prostitute because I didn't want them to hear it on the evening news before I was prepared to begin my public battle with the LAPD. I steeled myself to deal with the loss of their affection and support, but was delighted that instead of rejecting me, they all chose to stand by me.

It wasn't long after I began working that I had my first opportunity to explore my commitment to "the cause." In August of 1982, the vice squad conducted a sting operation that resulted in the arrests of two of Los Angeles' most important madams and some of their girls, including me. It was during this sting that the police learned I was writing an exposé about them, and they unsuccessfully attempted to confiscate my manuscript.

The arrest both startled and terrified me. I wasn't prepared for the extreme emotional distress that I felt in the custody of the same men I used to sleep with for free. The old feelings of helplessness and rage returned and left me temporarily incapacitated. For a time, I was certain that I was under constant police surveillance and couldn't eat, sleep, or work. Eventually that feeling passed, and I resumed all my activities—including writing the book that would eventually cost me eighteen months of freedom.

It turned out that the police really did want to get their hands on my manuscript. Nearly a year later, I was set up on pandering charges. The police seized my unfinished manuscript as "evidence," and I went to trial and was convicted. Thus began my seven-year ordeal and the long public battle to avoid an unjust incarceration. One thing was certain: I now had the full attention of the press!

Working the Press

"She has smoky-green eyes, burgundy tinted hair, Barbie doll features and a body that makes it hard to believe she left the Los Angeles Police Department with a physical disability."[1] One might conclude from this description given by one male reporter that the media dismissed me as an air-headed bimbo who had nothing to say and wouldn't know how to say it if she did. But in 1984, it wasn't yet politically incorrect to allow prostitutes to have a voice, so, after they used sex to sell their story, the media allowed me to speak, quoting me correctly and often. As planned, I gave the press juicy, salacious material to quote. In exchange, they gave me a soap box from which to discuss serious issues.

During the years that I fought unsuccessfully for my freedom, there were ample opportunities for the press to deride my efforts to educate the public about police and government corruption, but instead they chose to applaud me. When I ran for political office in 1986, several reporters who had previously gone out of their way to try to discredit me wound up being avid fans and supporters. One reporter who attended a speech I gave wrote in his column: "A lot of whipped cream in her delivery, perhaps, and not to mention an irresistible and vulnerable quaver in her voice that fools you into not taking her politics seriously, but this is where her shrewdness and street smarts come into play.... Irate that call girls get the same prison treatment as do killers and rapists, she spoke eloquently about victimless crimes." He concluded, "She's a sharp woman wielding a daring schtick during a boring campaign in a time that grows more and more repressive under . . . the moralists. She's worth a listen as well as a look."[1]

Things have changed, though, and in 1994, when I attended the farcical trial of now-convicted madam Heidi Fleiss, I saw none of the reporters who had covered my trial ten years previously. Instead, I saw a new generation of female and male reporters who, in keeping with the politically correct radical feminist rhetoric, refused to believe that any woman could or would willingly choose prostitution as a career. Even those who knew better avoided giving a voice to any of us associated with the sex industry.

At the beginning of Heidi's trial, the media mentioned briefly that both Sydney Biddle Barrows (the "Mayflower Madam") and I were in attendance. The news reporters completely ignored the press releases from COYOTE LA that I distributed, focusing mainly on the outfits we wore. The media also ignored the fact that, of all the people in the courtroom, I was the one whose experience most closely resembled Heidi's. At that time, it was exactly ten years since I, too, had gone through a kangaroo court trial that ultimately cost me eighteen months in prison, two months in solitary confinement, and another three years on probation and parole. History was repeating itself, a decade later, a fact that went unmentioned. The reporters ignored all relevant context, as well as everything I had to say about Heidi's case.

Instead, opinions were sought from women who had never been in prostitution. Tammy Bruce (of LA NOW) and well-known feminist attorney Gloria Allred were quoted in the press, while the opinions of those involved in prostitutes' rights were ignored. Did Ms. Bruce or Ms. Allred suggest that the media solicit the opinions of prostitutes themselves? And if not, why not? Are prostitutes assumed to be unable to speak for ourselves? Who, other than ourselves, could truly represent our experience and interests? These questions remain unanswered. Today's media, when confronted with women in the sex industry who are bright, articulate, well adjusted, and who have positive things to say about prostitution, turn a deaf ear. The Kathleen Barrys, Catharine MacKinnons and Andrea Dworkins have only furthered the antisex sentiment that underlies the silencing and stigmatization of prostitutes. Rather than condemning prostitution, feminists should instead help reinstate independent outlaw hookers. We need all the support we can get. Our issues are *all* women's issues.

Fortunately, I am not easily discouraged, and I am not going away. I have found my voice and I will be heard, no matter how many books I have to write before I am taken seriously. I am one prostitute that no one and nothing can silence—not eighteen months in prison, not the women of the Coalition Against Trafficking in Women, not an apathetic media, and certainly not the police!

Notes

1. Michael Dorgan, *San Jose Mercury News*, Friday July 13, 1984, 17—A. "Oldest Profession Holds its Own SF Convention."

2. Peter Anderson, *Marin Independent Journal*, Thursday August 7, 1986, p. A—2. "Call Girl Turned Candidate Tells All."

[23] Sedition

VERONICA MONÉT

I READ A REVIEW IN THE *SAN JOSE MERCURY NEWS* about a 1995 Home Box Office cable television dramatic series titled "Band of Gold." In reporter Ron Miller's words, the program, which was produced in the United Kingdom, was about the "sleazy world of hookers" and featured such familiar themes as a serial killer who prefers prostitutes and "hasty, loveless sex." Apparently, "hasty, loveless sex" is the service Miller assumes prostitutes offer their clients and no one at the *San Jose Mercury News* saw fit to edit that assumption. Miller insists that the show provides "an education in what turns some women to prostitution and why few ever get out of the game without some kind of lasting damage." The belief that most prostitutes never get out of the business without being damaged is of course another unexamined stereotype. While I haven't had the dubious pleasure of viewing this TV series, and I can only assume that Miller's assessment of the show is accurate, I am frustrated at his automatic acceptance of such one-dimensional representations of my profession.

Like most stereotypes, this television series' representation of prostitutes has some basis in truth. The trouble with stereotypes is that they often derive from a small subset of the members of the group in question, whether prostitutes, doctors, politicians, priests, housewives, etc. When public perception of a minority is being manipulated by the media, the outcome is rarely representative of that minority.

In May 1993, when I was interviewed for the television show *Hard Copy*, I expected that kind of slanted "reporting," so I attempted to speak in "sound bytes" (small phrases that can be taken out of context and retain their original meaning). Nonetheless, interviewer Diane Diamond and her editors used key statements from a five-hour interview to paint a picture of me as a desperate woman forced into prostitution by the recession. By blasting the television viewers with headlines like "Recession Hookers" between all the commercials, *Hard Copy* presented me in a way that conformed to their stereotypes about call girls. All the positive statements I made about my work and my life were simply edited out.

Television programs, movies, and news stories that tell only about finan-

cially desperate, drug-addicted, sexually abused, uneducated, and/or street tough prostitutes are taken as representative of who and what most if not all prostitutes are like. Those representations of prostitutes make me feel invisible, *especially* if it is a twisted profile of *myself* I'm looking at. I think about the reality of my and my colleagues' own work and and lives as prostitutes, or sex workers. If I weren't so angry, I'd laugh, because those realities are so very different from the popular stereotypes.

I woke up this morning with a word playing in my head over and over again. I didn't even know what it meant, so I looked it up in Webster's dictionary. The word was *sedition*. It is defined as: "Conduct or language that incites others to rebel against the authority of a state." What a great word for me! Through my writing, public speaking, and television appearances,[2] I hope to incite others to rebel against the current "state" of affairs, i.e., the standards and prohibitions used to control women's sexual behavior. Central to that end is the destigmatization of the whore.

I knew a lot about prostitutes before I became one. In 1982 I graduated from Oregon State University as an honor student with a degree in psychology and a minor in business administration. At that time, I "knew" that all prostitutes were victims. They were mostly addicted to drugs and abused by pimps. Even the ones who thought they liked their work were probably unable to get "legitimate" work because of a lack of education and/or resources. The prostitutes that had an education, resources, and alternatives to the profession obviously had severe problems with their self-esteem and did not understand how their behavior oppressed themselves and ultimately all other women. I "knew" that prostitutes could not be feminists no matter how much they might like to think of themselves as being liberated. I "knew" that prostitutes needed to be liberated by us "true feminists."

In 1989 I met a real, live prostitute. A friend introduced us because he thought we might like to date each other. He was right. We were very attracted to each other. I had some problems with her work, though. I thought maybe I'd rescue her from prostitution when we had known each other longer. She certainly did not impress me as a feminist. She catered to men and laughed at all their stupid jokes. Until she met me, she referred to her sexual encounters with women as "swinging." That burned me because it referenced her sexuality to her husband—the man in her life. So far this woman was not busting any of my stereotypes about prostitutes.

But I was far too sexually attracted to this woman to spend *all* of my time pondering the political ramifications of her work and lifestyle. We continued to see each other, and eventually it became very apparent to me that she had something all my feminist friends didn't have: money. With her money, she paid for dinners, designed and built a house (more of a mansion, really), took me to Calistoga in her Mercedes for a romantic and pampered weekend, and she even hired a private detective to investigate the local police when they were trying to bust her. She was looking more liberated to me all the time. The

dynamics between her and her husband were even different from those typical of my feminist friends. Unlike these other women, she was the "primary wage earner," so she wasn't financially dependent on him. The confidence of knowing she could support herself, support a family, even defend herself against the police if need be, permeated every life choice she made. This giggly, silicone-enhanced woman was not about to do anything she didn't want to do.

I contrasted her life to mine and the lives of my straight friends. We were college educated. We understood feminist theory. We didn't giggle. We were serious. We were professional, upwardly mobile, and career oriented. We marched in "Take Back the Night" rallies and we read *Ms.* magazine. We dumped abusive men. We lived alone or with our children and struggled to pay our basic bills. On those rare occasions when we went to lunch or dinner together, one of us would get out the calculator and determine exactly what each of us owed. And there was always one of us that couldn't or wouldn't leave a bad relationship. At least not yet. How many times had we heard ourselves or another worry whether she could *afford* to leave him? How would she make it on her own?

This is where the theory and the reality collide. No one wants to reduce the question of "equality" to money. Sure, we harp on the unfairness of seventy-four cents to the dollar. And when discussing domestic violence issues, we remind people that the woman is often economically disadvantaged in the abusive relationship and may feel trapped because of it. But how about putting it in plain terms? Money is a major determinant of how and why people interact with each other in this western industrialized culture, though, it is not the sole determinant. Just a major player in the game of human relationships. I could have all the money in the world and still remain in an abusive relationship. I might hand all my money to my abusive partner, never even entertaining the idea that I had the option to make my own choices. But at the other end of the continuum, I could be full of feminist thought and theory and have all the courage in the world and yet if I'm dead broke and have children to support and care for, I might have no option but to stay in an abusive situation, especially if all the shelters are full and I have no sympathetic friends or family.

My point is that most feminist theory doesn't offer concrete solutions to the realities of money or sex. It tends to remain in the arena of "nice girls." And nice girls don't pursue things like money or sex unless they have humanitarian or nurturing motives (e.g., supporting a child with money or loving a partner with sex). This seems ironic to me, given the long history of oppression of women around money and sex. In other cultures and in this culture in the past, some women have been forbidden to work outside the home. This guaranteed their financial dependence upon men (their fathers or their husbands), which kept them powerless in other arenas. Women's sexual behavior has been severely controlled as well by a patriarchal system that requires knowledge of paternity, which means restricting women to one sexual partner (and hence one potential sperm donor). Consequently, women's sexual independence has

been curtailed, even to the point of killing and/or blaming rape victims for "allowing" themselves to be "damaged" by the rapist.

Recently, Cosi Fabian commented to me that the nice girl often feels shame and guilt and a compulsion toward incessant people pleasing. On the other hand, the bad girl is empowered to have desires and satisfy herself. Strength and freedom—there it is! That is the core of my feminism. I refuse to adopt the currently popular stance as a martyr in order to legitimize myself as a woman or a feminist. I will not channel all my desire for sex into love, romance and "meaningful relationships." I reserve the right to fuck. I reserve the right to pursue physical pleasure just because it feels good. And I refuse to eschew money and all that it can buy so I can earn merit badges for doing without and leading a life of self-sacrifice. I claim the right to want, to procure, and to be satisfied. I also refuse to pattern myself after stereotypical male behaviors and motivations. I don't want to be violent or sacrifice long-term gain for short-term profit. I am interested in finding a workable marriage between the human traits that have been divided into categories called masculine and feminine. I want to embody characteristics and behaviors from both camps. Blame it on my bisexuality if you must, but I feel most like me when I am being assertive and receptive, sexual and romantic, material and spiritual, angry and forgiving, generous and selfish.

Prostitution and the sex industry in general have exposed me to a lot of divergent realities about money and sex. I experienced for the first time what it felt like to "pay for everything," as had all the men I used to date. I started my own business, paid all my own bills, traveled, took men and women out, invested, shopped till I dropped, and walked away from hundreds of dollars because I had more important things to do with my time. I found that making money was a rush and choosing not to make money was even more powerful. It has all come down to choice for me. I chose to see some clients and I chose not to see others. I chose what sexual activities I was willing to engage in for pay and I chose what was not "on the menu." I asserted my boundaries and I honored the unique sexuality of individuals. I discovered that people are people no matter what they do for a living, how much or how little money they have, what the color of their skin is, how old or young they are, or even what equipment they have between their legs. Female clients wanted the same things male clients wanted: to be pampered and accepted and receive sexual pleasure.

I am not suggesting that prostitution is the only way to acquire this information and experience. But I do believe that prostitution affords a unique opportunity to see some truths about the way women are expected to interact with sex and money in our society. Once I lost the approval and acceptance of the good girl and felt the punishment and rejection of the bad girl my view of reality changed drastically. At that point, it became apparent that mainstream feminism just wasn't radical enough. A feminist theory that allowed me to complain about wage discrimination but failed to show me how to make more money to pay my bills was of little practical use. And sexual liberation that gave me permission to have sex out of marriage and with women, but warned me

not to indulge in sex just for the sake of sexual pleasure, was not sexual liberation at all. Mainstream feminism had the gall to claim respect for all women and turn around and treat sex workers like children who didn't know any better and needed to be protected whether they wanted to be or not.

In many respects, prostitution is like any other service industry. It just requires a little more sensitivity to the psychology of the customer, which is the point at which it intersects with therapy and the healing arts. It also has elements of theater in it at times. Yet prostitution is not perceived as a simple exchange of money for services rendered. Although prostitutes are males and females and transgendered people, textbooks and the media usually refer to prostitutes as women. Male and transgendered prostitutes, most of whom serve a predominantly male clientele, are often treated "as women" because our culture equates male with "fucking" and female with "getting fucked." Those who "get fucked" are considered bad or of less value than those who are doing the fucking.

Prostitutes have often been referred to as "working women," harking back to the days when women were provided for by their fathers or their husbands; the only kind of paid work women could engage in at that time was prostitution. So a working woman was one who got paid for sex. This is the real reason female prostitution is stigmatized: it violates society's antiquated ideas about sex being somehow degrading to a woman's body (devaluing her) and the ridiculous notion that a woman is the property of first her father and later her husband. Today, we as a society are too sophisticated to believe women are the property of anyone. But almost everyone believes the "wrong" type of sex can be degrading to women. Mainstream feminism's insistence that certain kinds of consensual sex are degrading to women reinforces the belief that women are property that lose value with use or at least certain kinds of use. To be truly liberating, feminism needs to embrace the fact that sex does not equal shame or degradation. Sex in general and sex for money really is something that a fully feminist woman can choose to engage in. And that choice can liberate, empower, and raise her self-esteem.

Sex work has been empowering and liberating for me. My self-esteem has improved drastically in the last six years since I entered the sex industry. I have been able to reclaim my sexuality by becoming aware of my bisexuality and becoming multiply orgasmic (I use to be nonorgasmic). I reject the idea that a penis entering a bodily orifice is an act of violence or a claim to territory or the use of a resource. I am not degraded by sex. I am not a resource or property that can be devalued through use. I am not hurt by such terms as "slut" or "whore." I proudly assert that I am both. I am financially independent. I am self-employed. I have time and resources to express myself creatively in other fields such as writing and public speaking. Prostitution and sex work have been integral to my progress in all these areas. Perhaps I could have accomplished the same things in another profession. More likely, someone else could have accomplished the same things in another profession. The sex industry is the

only place where I believe I could have forged the feminist ideals peculiar to me and feminist sex workers like me. If I had not experienced life as a prostitute and a sex worker, I would not have understood the extent to which our culture and indeed the cultures of the world punish bad girls. I would not have comprehended how central to feminism the liberation and the vindication of the bad girl must be.

My feminism recognizes words like "slut" and "whore" as core elements of the oppression of women worldwide. If we as feminists use these words to stigmatize some women—any women—then we are part of the problem. We must embrace these labels or we will continue to be controlled by them. One need not become a sex worker to experience being a bad girl; one can simply refuse to wear the label of the good girl, and let people assume she is sexually experienced, forward, and promiscuous, even if she is not. For those who dare, the world will never look the same.

Notes

1. Ron Miller, *San Jose Mercury News*, July 17, 1995, p. 3—D, "The Working Women of the Streets."

2. Since 1991 I have been published in various print media, and made close to thirty public appearances including workshops, classroom lectures, and television and radio talk shows.

[five] # Politics

Activism,

Intervention,

and Alliance

Instead of fighting porn, feminism should oppose censorship, support the decriminalization of prostitution, call for the abolition of all obscenity laws, support the rights of sex workers, support women in management positions in the sex industry, support the availability of sexually explicit materials, support sex education for the young, affirm the rights of sexual minorities and affirm the legitimacy of human sexual diversity. Such a direction would begin to redress the mistakes of the past. It would restore feminism to a position of leadership and credibility in matters of sexual policy. And it would revive feminism as a progressive, visionary force in the domain of sexuality.

—Gayle Rubin, "Misguided, Dangerous and Wrong:
An Analysis of Anti-pornography Politics."

[24] Inventing Sex Work

CAROL LEIGH, aka SCARLOT HARLOT

I INVENTED SEX WORK. Not the activity, of course. The term. This invention was motivated by my desire to reconcile my feminist goals with the reality of my life and the lives of the women I knew. I wanted to create an atmosphere of tolerance within and outside the women's movement for women working in the sex industry.

As a red diaper baby, the daughter of disenchanted ex-socialists, I was raised on discouraging tales of the failure of political struggles. My parents' cynicism challenged me. Why not subscribe to a philosophy of hope and belief? I would be an optimistic rebel, an artist, a poet, and live as an embodiment of peace and love. My parents told me to put on a bra...and not be so naive.

My political development paralleled that of many "third-wave" feminists. In the '70s, I noticed that the politicos I admired were hypocrites invoking conscience and fairness but treating me "like a girl." They were 'male chauvinist pigs.' Feminism was a revelation for me. Apparently my mother, her friends, my grandmothers, and aunts had accepted their status as second-class citizens. This was a new modern world filled with utopian models for social change.

In the early '70s, I read feminist authors starting with Betty Friedan, Germaine Greer, Kate Millet, Phyllis Chesler, and Ti-Grace Atkinson, who helped me understand how my power was thwarted by "internalized oppression." Misogyny echoed in my religion as my male relatives recited Hebrew prayers praising "God" for not making them women. Where were the great female artists and leaders? Previously shy and hesitant, I became proud of myself, and that pride was my source of inspiration and power.

Feminism would not be doomed by the same foibles that destroyed my parents' socialist dream. I recalled accounts of how their comrades defended Stalin, and about the self-destructive infighting of the sectarian left—the Trotskyites against the Leninists against the Marxists. Women were different from men, more nurturing and caring. If women could participate fully in the world we might see an end to poverty and war. Maybe patriarchy was the root of hierarchy and oppression. Perhaps feminism would provide guidance on the road to equality and peace. Through my antiwar activism I had developed a

what I considered a "feminine" politic based on compassion. If women had more power, we would realize justice in the world.

What would my role be in this movement? Artistic and philosophical, I aimed for basics, beginning the betrayal of my gender by the language. The editorial "he" rendered women anonymous. In *Language and Women's Place*, Robin Lakoff explained how linguistic revisions could be used as an activist tool by feminists. As a poet and a wordsmith, I was intrigued by the potential of linguistic activism to bring women out of anonymity and proudly write our new herstory.

I had a strong sense of being both witness and participant at the inception of the reinvention of womanhood. From the beginning, however, I confronted the contradictions. The "new woman" could be butch and intellectual. She could encompass the reality of all women, *except* she should not be traditionally feminine. Although I began disdaining "femininity," I wondered, didn't this rejection of "femme" often translate to condemnation of women? I wasn't exactly androgynous with my romantic poetry, my Miss Clairol hair, my voluptuous body, and my "promiscuous" lust for men. Was a feminism that respects real women and at the same time points toward wider possibilities even possible? In this tight corner of the patriarchy, where we struggled over the crumbs of self-determination, horizontal hostility was the rule. I decided that maybe women weren't so "nice" after all. I tried to hide my sexual preference, cut my hair, and stopped writing poems to Sara Teasdale.

In the '70s, I attended graduate school in creative writing at Boston University. After graduate school in the mid-'70s, I founded a women's writing workshop, the Hampshire Street Women's Poetry and Fiction Cooperative. The group was dedicated to "improving women's images" by reinventing both language and women themselves. The feminist principles we developed centered on women finding our voice and consequently our power on the planet. *The truth about women would be based on the reality of our lives, rather than on the patriarchal stereotypes.*

Relationships within our women's writers group were the background for many of my beliefs about what is now known as sex work. Here I met my first feminist mentor, Marcia Womongold, who wrote *Pornography: License to Kill*. Marcia introduced me to Merlin Stone's work on goddess mythology, *Ancient Mirrors of Womanhood*. I admired Marcia's warrior stance and her unabashed criticism and jealousy of male privilege. Although I appreciated my mentor's fiery brand of feminism, Hinda Paquette, a stripper-poet in our writing group, complained that Marcia's antiporn stance was judgmental and condescending. I was interested in this dichotomy—and in their quasi-torrid affair. I discussed my questions about feminism and the sex industry with my friends, but most had little to say. Finally Celeste Newbrough, an admired older feminist, poet, and lesbian activist, confided in me that she turned tricks when she needed money. I was shocked and intrigued.

In the mid-'70s, I took Women Against Pornography's tour of the Boston

porn stores. I remember an inspired young woman picking up the magazines with pictures of naked women in bookstores and ranting against the images. Her approach reminded me of ways I'd been called a "slut," and of the shame I felt about being feminine. I felt protective of my naked sisters—now we call it "whore-identified."

I came to realize that feminist perspectives of the antiporn activists did not match my own beliefs. Being chastised as a slut was part of the way I was oppressed by the patriarchy, my sexual proclivities condemned. Antiporn ideology echoed that condemnation. I did not want to take sides, however. The women in the porn magazines made me feel exposed and jealous. I longed for an analysis that would incorporate my contradictory needs: to be free of sexual shame, and also to criticize and change the sexual imagery in our culture. I would have to look further.

By 1978, I had had enough of Boston's mean and repressive atmosphere. "New England is for Masochists," my T-shirt said. I wanted excitement, adventure, and inspiration for my poetry. I moved to San Francisco, and found myself suddenly quite alone. My lover, who had moved with me from Boston, broke up with me. My self-esteem was at an all-time low. I started working as a waitress, but couldn't earn enough to pay the bills I accrued while moving. My boss started coming on to me. With no friends and no money, I felt desperate. I also had fantasies of being a prostitute, but had never considered actually doing it. I saw the signs on the streets, "Sex! Massage! Girls!" Marcia Womongold might have disapproved, but she was 3,000 miles away. Why not? After all, Gloria Steinem had worked as a Playboy Bunny and written about it. Ernest Hemingway had gone to war and written about it. Ti-Grace Atkinson in her *Amazon Odyssey* had portrayed prostitutes as streetfighters in the front lines in the battle of the sexes. Maybe I could work as a prostitute. At least I could try it. . .just try it.

I took a job at a massage parlor. From my very first day I was fascinated. I walked into the parlor and was hired immediately. They say once you cross the line, you can't ever go back, so would I be a woman permanently tarnished by sex? It sounded like patriarchal propaganda to me. I took the dare. My first client was a regular at the parlor, handsome, quick and sweet. He asked for French. I didn't know what it was, but I guessed right. I was thrilled to make that thirty-five dollars so fast.

As feminism had been a revelation to me, so was prostitution politics. The reality of my daily life as a prostitute was a startling contrast to my prior assumptions about prostitution. I had always been a risk taker (hitchhiked through New York to Canada, so danger was no stranger to me. I was excited and intrigued to be in this environment, working with women from all over the world, who were surprisingly strong and smart. Over time I developed friendships with the women, stretching my social awareness past that of a middle-class college girl. Feminist analysis of prostitution as the ultimate state of women's oppression didn't fit the strength and attitudes expressed by the diverse women I met. My relationships with these women and others I met in

the course of work have formed the basis for the political analysis I have developed over these last eighteen years.

My own experience was the opposite of what I had been told it would be. Sex in my personal life became very exciting. Sex with clients annoyed me sometimes and interested me other times. Because I'd learned my lesson as a feminist, I would not be ashamed of this "women's work." In fact, I was proud—proud to have broken this taboo, and proud that I wasn't ashamed. Familiar with the dynamics of sexual shame, I knew how to resist its tyranny.

I examined my feminist ethics in light of my new found occupation. From one perspective, feminism taught me to resist sexualization of my persona, so I'd cut my hair, ceased wearing lipstick, and renounced "femme." The contradiction was always obvious to me. I was supposedly embracing my woman-ness, but censoring every cultural expression of "femininity," from behavior to occupation to wardrobe. But now, the snake had reared her head and offered the forbidden fruit—a patriarchal myth that makes me, the sexual woman, responsible for original sin and all the suffering in the world. I needed to help develop a feminist politic that would help me and my friends navigate these contradictions.

Why was there so little information in feminist circles about prostitution and porn from the point of view of the women in the movies, in those magazines, and from people like my friend Celeste? Many lesbians were "out" as lesbians, but where was the prostitute in this new woman we had been inventing? She was degraded and objectified anew by the feminist rhetoric, and she did not exist in feminist communities as a real person.

I had spent years working with women to improve women's images, invoking goddesses and inventing female warriors in our prose. Prostitutes, I thought. Now there was an image that needed improving. When I first looked into that mirror, and said, "Now, there's a prostitute," I knew that redefining prostitution from prostitutes' perspectives would be my life's work.

Although female artists throughout history had engaged in nude modeling and prostitution to support themselves, there is little record of them except from the perspective of the male artists who depicted them. The women were successfully silenced and censored—if not by others, then by their own immobilizing shame. But from now on, it would be different.

I began attending events with a paper bag on my head that read, THIS PAPER BAG SYMBOLIZES THE ANONYMITY PROSTITUTES ARE FORCED TO ADOPT. At one such event I met Priscilla Alexander and immediately began working with COYOTE. I spent much time developing ideas in conjunction with other prostitutes I met in the massage parlors; through COYOTE; in sex-worker support groups such as the New Bohemian Prostitutes Club or COW (Can of Worms); and with women like Lilith Lash who I met through the San Francisco poetry scene. I felt again both witness to and participant in the beginning of a new vision. The revelations kept coming, chiefly about how my role as a prostitute related to women's roles in general, and about how the stigma and shame accorded prostitutes kept other women from fully understanding these roles.

It became clear to me that, like many other women, I was raised to trade sexuality for survival, or some social advantage (i.e., a good husband or boyfriend). As a result of the combination of slut stigma, training to trade sex for security or survival and fear of rape (the likelihood of which supposedly increased if one was promiscuous), women were often in a state of paralysis. Women could not acknowledge this "state of prostitution" in which they lived because one cannot admit one is a whore. It seemed impossible to break out of this bind without acknowledging that we were all part of some form of prostitution—the "good women" (the girlfriends and wives) and "bad women" (the whores and dykes)—alike.

My priorities became aligned with the goal of ending those divisions between women based on the the contracts we made with men for the purposes of our survival. This quest for commonalty was only the start, a direction, and not a comprehensive analysis of sexual relations. In fact, rather than developing a "comprehensive analysis" based on middle-class presumptions (which usually informed the feminism I knew), I wanted to begin supporting women from all walks of life to create strategies for change based on our diverse experiences. In other words, I wanted to create a place in feminism in which even the bad women could tell the truth about their lives and then begin analyzing and strategizing from there.

But how could women who worked as prostitutes and porn models tell the truth about their lives within the hostile environment of the women's movement? The words used to define us contain the history of centuries of slurs. Some feminists used slurs against us such as whore, and the censure of pornography[2] as weapons against the contemporary sex trade. How could we be proud and strive for self-representation and self-definition? Would Hinda have to wait another century to take her place in the family of women?

What words could we use to describe ourselves? The word "prostitute" was tarnished, to say the least. In fact, "prostitute" is yet another euphemism, like lady of the night, hooker, *filles de joie*, etc. "Prostitute" does not refer to the business of selling sexual services—it simply means "to offer publicly." The euphemism veils our "shameful" activity. Some prostitutes don't use the term to describe themselves, as they want to separate its from the negative connotations (e.g., to compromise one's self). In political contexts, I refer to myself as a prostitute to imbue it with some pride, although we rarely used that word referring to ourselves, preferring the term "working girls." But that term definitely grates against my feminist linguistic training. We needed a new term.

In 1979 or 1980 I attended a conference in San Francisco by Women Against Violence in Pornography and Media. I had intended to be a sort of ambassador to this group, educating feminists about prostitution. I planned to identify myself as a prostitute, which was almost unheard of at that time in a public and political context.

I found the room for the conference workshop on prostitution. As I entered I saw a newsprint pad with the title of the workshop. It included the phrase

"Sex Use Industry." The words stuck out and embarrassed me. How could I sit amid other women as a political equal when I was being objectified like that, described only as something used, obscuring my role as an actor and agent in this transaction?

At the beginning of the workshop I suggested that the title of the workshop should be changed to the "Sex Work Industry," because that described what *women* did. Generally, the men used the services, and the women provided them. As I recall, no one raised objections. I went on to explain how crucial it was to create a discourse about the sex trades that could be inclusive of women working in the trades. I explained that prostitutes are often unable to reveal themselves in feminist contexts because they feel judged by other feminists. The workshop participants were silent and curious. At the end, I believed I had made my point. One woman, another writer and performer, came up to me after the workshop to tell me that she had been a prostitute as a teenager but was unable to discuss it for fear of being condemned.

The term "sex worker" resonated for me. I used it in my one-woman play, *The Adventures of Scarlot Harlot*, also titled *The Demystification of The Sex Work Industry,*, which I have been performing since 1980, including at the National Festival of Women's Theatre in Santa Cruz in 1983. "Sex workers unite!" says Scarlot. "Sex is as dirty as power and money. Whore means get more!"

I was also aware of the humor in the term, mostly because sex is funny, and getting respect for prostitutes is, unfortunately, often a joke. When Scarlot tries to "come out" to her mother, she says, "The truth is, I'm a sex worker, ma." Her mother replies, "What? Are you working in a dildo factory?"

Created in the context of the feminist movement, at a junction of opposing views of prostitution, the term "sex worker" is a feminist contribution to the language. The concept of sex work unites women in the industry—prostitutes, porn actresses, and dancers—who are enjoined by both legal and social needs to disavow common ground with women in other facets of the business.

Since *Sex Work*'s publication in 1987, the term has been used widely. Internationally, "sex work" and "sex worker" have been used by health agencies around the world, as well as by the World Health Organization. It is used in the AIDS activist movement and the harm reduction movement.[3] The term is translated literally into numerous languages.

This usage of the term "sex work" marks the beginning of a movement. It acknowledges the work we do rather than defines us by our status. After many years of activism as a prostitute, struggling with increasing stigma and ostracism from within the mainstream feminist movement, I remember the term "sex work," and how powerful it felt to, at last, have a word for this work that is not a euphemism. "Sex work" has no shame, and neither do I.

Notes

1. For example, in Dworkin-MacKinnon's antiporn legislation, images were termed "degrading" if they portrayed a woman as a "whore by nature." The term 'pornography,' then, was being used as a weapon against women, margin-

alizing us and casting us outside of the approved feminist circle. The root word of porn is *porne*, a Greek word for prostitution. Pornography, then, is descriptions of or by whores. Yet, to anti-porn feminists, "pornography" always meant degrading images of women.

2. Harm reduction is an international movement opposed to the current abstinence or criminal model of dealing with addictions and other illicit activities. Harm reduction philosophy was developed out of AIDS outreach service providers, who stress the importance of helping users and others in the criminal underground to manage their health and welfare.

[25] Organizing in the Massage Parlor

An Interview with Denise Turner

LYNDALL MACCOWAN

Denise T. Turner was born in 1949 to a working-class family and identifies as butch. Twenty years ago, at the height of radical lesbian organizing in Ann Arbor, Michigan, Denise began working in a massage parlor. Others from the lesbian community soon began working there also. Because of problems with the owner, they went out on strike within a year, taking their case to the Labor Relations Board, where they won a settlement. Then they opened their own parlor. Several years later, during a porn scare, Denise and five others were arrested for soliciting. Undaunted, they used the resulting publicity and their standing in the lesbian community to organize a decriminalization drive. The laws against prostitution were not rescinded, but their Prostitution Education Project did give Ann Arbor a feminist education on sex work.

Denise is a licensed therapist and an incest survivor who has worked with other survivors for the past twelve years of her practice. She and her partner of sixteen years met as a result of Denise's arrest for soliciting.

I CAME OUT WHEN I WAS TWENTY YEARS OLD in Ann Arbor, Michigan, with one of my roommates who I'd been in love with for two and a half years. We became lovers, and came out, and started Radical Lesbians. This was 1969, 1970. About three years later I was living in a household with five other lesbians, my lover and I, and two other couples, all in three bedrooms. I was into all this political stuff, I'd been into SDS [Students for a Democratic Society], and then I started doing Radical Lesbians. I'd dropped out of college. I was too busy rioting and rock throwing to be serious about a degree. At the time I was in auto mechanic school, actually, with a friend of mine. We were two butches.

At that point, you kind of knew every lesbian in town. Or at least we did. One woman who was staying at our house for awhile had been working as a maid at the Holiday Inn. Anna had started turning tricks out of there and then she got a job at a massage parlor on 4th Avenue. The porn store was there. It was a mini, mini-red light block. There was a pornography store on one side of the street, and across from it was the American Massage Parlor. Anna would keep telling us about all this money she was making, and how easy it was. I was working in a restaurant for $2 an hour, and Beth, my lover, was working for

$2 an hour at a bookstore at the university. And here's this woman saying, "You can make *lots* of money."

We were fascinated. We'd ask how she handled the tricks, and she'd tell us. She kept telling Beth, who was really pretty and had big breasts, how much money she could make. Finally Beth decided she was going to try it and see what it was like. We had never had any money. She did two tricks, two blow jobs, and came home with $100. And she'd worked a total of half an hour. So Beth started working at the massage parlor. She kept coming home with all this money and it came around to my thinking, "Well, why don't I try it?" That's how we got into the parlor. We had a lot of friends from the lesbian community who ended up getting into the business, just through our friend and then through us. People wanted to make money. And Anna trained us very carefully. She role played everything out, fed us the lines for what you say. We were all trained before we walked in.

So working in a massage parlor fit in with the politics and the community you were part of?
Since we had been in SDS, we were already pretty radical. We had been gay for about three years, and we kind of saw ourselves on the outside of society. We already experienced ourselves as fringe, as not subject to the conformity that other people were subject to. We already saw ourselves as "bad." The bad girls.

This was a bad you enjoyed?
Oh, it was a bad that we felt righteous about. We had principles behind our badness. When you were a dyke in those days you knew you definitely were out on the margins. You felt more on the fringe than people do now, and you didn't feel like you had that much to lose. We had, pretty much, a feminist point of view about the whole thing. We saw prostitution as sex work. It was just work like any other kind of work, and we thought it shouldn't be criminalized, that this was just a way of controlling women. The main criteria for deciding whether or not the job was humiliating, or shameful, was how you were treated, how much control you had on the job. We thought the job should be judged by the same criteria that any other job is judged by. Basically what made it not a good job was the fact that you could get busted and that there was a lot of social stigma.

People have a lot of misconceptions about what the job is. People have the idea that if you're a prostitute you turn your body over. That you give up control of your body, and that it's humiliating. Well, you don't give up control of your body. You perform services and there ain't a whole lot of layin' down involved. Not in what we did. The clients lay down. They take off their clothes. You tell them what to do. You tell them what you will do and what you won't do. And how you'll do it.

Did you have trouble negotiating with guys who wanted things you didn't do?
Not really, no. For a lot of women, including myself, there was no kissing.

They might try it, and you'd tell them, "No, that's one thing I don't do." They'd say, "Well, why not?" and you'd say, "Because I've got to keep something personal." They would accept that. They'd say, "Yeah, I understand." People wouldn't push you.

Mostly you do hand jobs and blow jobs. That can be distasteful at times, but what's truly distasteful is when someone's treating you in a disrespectful way. That's what feels bad, not their penis. It's fine as long as they're treating you with respect and going by your limits, and you feel in control of your limits. A lot of the men are very polite about the whole thing, you know. For some men, if they don't have the social skills, it's an easy way for them to get close to a woman. With tricks, a lot of times you get right down to business. You go in there and you start massaging them, the negotiation starts immediately, and they get off in a matter of minutes. It was pretty easy, actually, because I was trained on how to do a blow job. I never knew how before Anna taught us. The whole thing takes fifteen minutes, from them walking into the room, including their getting undressed, and getting dressed again. And you're out of there. You'd feel like you were competent, and you wouldn't work that hard.

You don't fuck that much. And I didn't want to. I didn't want to lay down. They had to bring up some big money if they wanted to fuck: over $100. It was a situation where it was, "I'll do you," which fit right in with how I am anyway.

Being butch wasn't a disadvantage, then?
I didn't dress butch when I was working. I wore some makeup, and earrings. I had hair that was longer than what I've got right now. I never wore a wig. I had my outfits on. Hot pants, or halter tops and harem pants. Silly stuff. It was fun because it was so out of character for me. I would feel like it was Halloween. It felt like drag, definitely, but it was okay. I've always felt good about my body, and I don't like to wear clothes, so that part wasn't hard for me. But I didn't have big tits and that was always a big seller, if you could show a shelf out there in the waiting room. They liked my legs a lot of times. I had men who just wanted to jack off, and so what they wanted was for me to pose. I had my regulars. Everybody had their regulars. The ones who liked me were a little different. They liked women who were dominant, or had muscles, or something like that. Who weren't very feminine. Butches don't make as much money. We can't quite pull off or inspire the fantasies in the men. Well, for certain men you do fit into their fantasies. I've always been amazed at the men who've been attracted to me and wanted somebody like me, because a lot of times men have been put off by my butchness. My aggressiveness. I wasn't a big time money maker, but I did okay. It made it worth my while.

Did you have to have a massage license? Did you do much legitimate massage?
No, no massage license. Since it was the seventies and everybody was trying everything, I knew how to massage. If you had to sit in there for half an hour

and massage, then you did it, but usually if someone wanted a real massage they went to the Y. I mean, it was pretty obvious, with the porn place right across the street. There was also a porn shop right underneath the parlor for awhile. When a guy walked up the stairs, he was greeted by the manager, a man, usually, who'd say, "Here are our girls. Who would you like?" And we're all dressed in these whorish outfits, sitting there posing on the chairs and smiling. And there was all this red velvet. I'll never forget that. The walls all had red velvet.

Did you work full-time?
No, I didn't work that much. Maybe three shifts a week, for a six-hour stretch. We didn't have a lot of customers, so a lot of times I was living off of seeing three or four customers a week. In our second parlor we had a weight room, so I used to work out while I was there. But it was giving me plenty of money at that time. My rent was really cheap. I was able to get all the sports equipment that I could ever want. I had all the best stuff. I had all the Nikes, and the best professional baseball glove, and best spikes. I was in heaven, buying that. It's all I cared about. I went back to school to get a degree in physical education. I was going to school full-time and I only had to work a little bit.

How long did you work, all told?
About five years, off and on. Mostly on. I used to see some of my tricks outside of the parlor, especially after we got busted in '77 and our parlor was closed down. I had some tricks for the next couple of years after that, probably up until I was about thirty-two. When we had our strike at the American Massage Parlor, before we got our new parlor opened, we'd seen our tricks outside, too. And after I moved here, when I'd go back in the summer they'd finance my vacation because my friends would tell the tricks that I was coming to town, so they'd line up to call me.

Tell me about the strike at American Massage Parlor.
Oh, the owner there was a real macho asshole. We were all these feminists and political types working there, radical feminists, radical leftists. There usually were managers who were pretty nice guys, and who the women liked, but the owner was a real jerk. He came in there and he tried to strong-arm some of us, and he was trying to pull stuff with our hours. He didn't realize who he had there. We had a strike. We were picketing out there, and then we quit.

You had a picket line out in front of a massage parlor? I love it! Did you get any media coverage?
I don't think we did that time. After we got busted when we were at the second place we got media coverage because we started a petition drive to decriminalize prostitution. We made a stink. But this was management/labor stuff. We went to the Labor Relations Board, had a hearing, and settled out of court. We

paid the lawyer, and had a little money for ourselves. We'd had it in the works that we were starting our own place, so we didn't go back to work there. Instead, we got a hippie carpenter to fix us another place.

It amazes me that no one at the Labor Relations Board said, "This is a prostitution business, so we won't consider your claim."
That didn't enter into it at all. This was a management/labor dispute. Neither side wanted anything else to enter into it. The owner had no reason to bring it out. And we got some old Commie for an arbitrator. We were all a bunch of twenty-two year olds. Righteous, and kind of innocent, too, at the same time. How young we were! We had fun, though, because we were all together and were supportive of each other. It was one of your girl gang situations, basically.

How many women worked there?
It changed. Over the five years that we were working in the parlors, some of us worked the whole time and others didn't. Then there were people who came in later. So maybe, fifteen, from the lesbian community.

That's so different from the ideas put forth now, and the history they imply, that feminist lesbians never approved of prostitution, or worked in the sex industry, that lesbian prostitutes are some kind of freak phenomenon.
I think the opposite is true. I think the reason why you have so many lesbians in this business is because of what I said earlier about us being on the outside and already having an identity that's outside of social norms. Feeling alienated, and not believing in the bullshit. You've already lost your faith by the fact that you've come out and you realize how bad the attitudes are and how unfair it is. You're not getting the goodies, you're not acceptable anyway. It's just an extension. It's real easy to make the jump. I think it's very common.

One thing about being a prostitute is you know you're rebelling against hypocrisy. There's something satisfying about that. This madonna/whore bullshit is so irritating to women, the double standard, that men are allowed to be sexual, but women aren't. I was a dyke since I was little and I really wasn't interested in being heterosexual, so it didn't come up for me as much around sexuality. I was always a butch and an athlete, and I sort of had a male identity, but I was aware of a double standard, of things that were unfair. The way that I came up against it was in not being able to do what I wanted, like play in a Little League baseball team. But I was sensitive to women being bad around sex, partially from the incest.

What were the connections for you between the incest and working?
The main thing that I noticed was that it was very empowering for me to work as a prostitute under the conditions that I worked. It kind of brought me into reality about dealing with men. Particularly adult men who were as old as my

stepfather, who looked like my stepfather, and were being sexual toward me. I felt that I could take charge of the situation, and I could handle it. I could speak for myself. I wasn't silent, and I could take control. It was really positive for me in that way.

It helped you to deal with the incest?
Yeah, I think so. It helped me separate the wheat from the chaff, sort of. I could focus toward my stepfather, and the experience didn't have to spread out towards men in general. It kept the incest where it belonged.

What about people, especially therapists, who say that incest and abuse survivors who go into prostitution are only ever acting out, that it's a repetition of the abuse by definition, and therefore all the more damaging?
They don't know what they're talking about. They're overgeneralizing. It is true for some people, but to say that's true always, I'm sorry. A lot of people who are abused don't remember it, and some of those people might be the ones who you find are acting out. There is something to be concerned about, with some of the people who get into the business and get exploited and are not in control. But even if you're not real aware and conscious, you do not last in the business if you do not take control. You've got to learn how to be the boss, and that is not like incest. The part about it being a sexual arena with older men is similar, but you're coming at it from a whole different angle. The power dynamics have shifted toward the woman who's offering the service and men are coming because they want this. You can take power. The sex is up front and negotiated. It's not like incest, where someone is sneaking around and trapping you and you're putting up with it because you're afraid of the hell that's gonna break loose if you blow the whistle, or because they've threatened to kill your mother, or kill you. The thing that prevents the power dynamic from shifting even further in favor of the woman is the fact that prostitution's so stigmatized. Your power is lessened by the fact that it's criminalized.

It wouldn't have been good if I couldn't handle it. If I couldn't keep control of the situation and was getting pushed around by these guys. Then that would have been bad, that would have been a repeat of some kind of trauma. Since that's not the way it was, and I was trained, and I was up to taking that kind of control, it was fine. There were some people who worked at the parlor who would just do it for the money, but it was really intimidating for them, and they shouldn't have been there. But it wasn't intimidating for me once I did it a couple of times.

What about the statistics that say some 50 percent of the women who work are abuse survivors?
That's not much higher than for the general population. Prostitution is a different situation. Maybe some people feel abused in prostitution if they associate it with the abuse to such a strong degree that they just, no matter how

much control they have, feel humiliated just to be sexual with a man. If they've really bought into the stigma of prostitution, then that would be their feeling.

So some of the equation of prostitution with repeating abuse would come from the assumption that prostitution is inherently degrading and disempowering?
Right, right. And I don't subscribe to that. A lot of people don't buy into that; they're smart enough to know it's bullshit. It's just sex. No matter what your emotions are, it's important to know that a thing is something besides what your emotional attachments to it are, that it can be something else besides what your bad experiences have been. Sex is a lot of different things, and I learned that.

It's easy to get mixed up when you've had those situations, easy for women in general to get mixed up. Is sex bad? It's like the baby and the bathwater. Even though I didn't initiate the incest, and I didn't want it, just because it happened I was contaminated. When what you experience about sex is negative, is hypocritical, is a molest, is predatory, or it's stigmatized, you get confused. What is sex by itself, without sexual abuse? I didn't know for a long time. Sex, to me, was sexual abuse. I mean, I knew it wasn't, but I would react. When I had to confront sex, especially heterosexual sex, it would bring up the incest for me.

I told people about the incest. I told my first lover when we were both on acid one time, and I started telling people after that, even though I wasn't connected with my feelings about it yet. I knew it had happened, and I knew it was fucked up. This was before I was working in the business. I was aware that it had affected me sexually, made me uptight about sex. I had negative feelings about sex, and I'd kind of flinch around sexual things, but I was fighting it. I didn't want to be defeated by that experience. I experienced sex that was great with my women lovers, that felt so different. So I kind of had an idea of what it could be on the other side, what the difference was, and I could separate the baby from the bathwater a little bit more.

So I remember when I was working I was making connections around all this stuff, and I started realizing consciously that I was empowering myself. I thought about it, and I spoke about it. I still hadn't gone through the shit with my family, in terms of coming out to them about the incest. After we got arrested my mother found out and that blew everything open. And after we had done the PEP thing, and organized a hooker's ball, I dropped out of doing that and got involved with incest stuff instead.

So your sense is that working enabled you to confront the incest?
It helped empower me.

Tell me about having your own parlor.
Probably within about a year of working in the one parlor we got the other parlor going. We rented out space, and this hippie carpenter built a set of rooms

for us. U.S. Health Spa, we called it. It was real low-key. Unobtrusive. You wouldn't know what it was if you walked by it; that was really the only way to keep it open or else we'd get busted. We eventually got busted anyway.

Did you run it collectively?
No. The hippie carpenter owned it. He didn't make any money, really. He got a cut of the massage, and the manager got paid, and the bills got paid out of that. He kind of stayed out of it. He was a nice guy. I liked him. We got part of the money for the massage.

Did the clients pay you directly?
They paid for their massage in the front, and they paid you for the extra. The house doesn't get any of that money because they don't want to be involved for legal reasons. If you tip your manager, that has to be under the table, but that's not something that you have to do.

How'd you get busted?
I didn't even notice it at the time, but the local newspaper, *The Ann Arbor News*, began a series of articles in July of 1977, a sort of expose, on pornography and prostitution. It started with something innocuous, and then led up to kiddie porn, and I guess there was a reaction. After it ran, then the police started doing their setup for the bust. Doing their entrapment. They went undercover and came to the parlor, and found out that we did extras, and tried to entrap us.

We were busted for accosting and soliciting, and that wasn't true. We were trained to not solicit. You made them say what they wanted. You didn't say, "Here's the menu." They'd say, "Do you do extras?" And you'd say, "Yeah, I do some extras. What are you interested in?" You made them say what that was. Of course we didn't solicit the cops. It was just a setup to hassle us. Once they've come in there they're basically there to identify you. They can say whatever they want in court, but they basically need to know who you are, so they try to get your name.

I remember the cop that I got. I remember the session. I'd thought he was kind of weird, but I didn't do anything with him, and I didn't solicit him. There was nothing I could do. He was basically there to know my mug; they just were in there trying to get us to say something, but even if we didn't say something, they could recognize us. I think they busted five of us. My lover, who'd been doing it a lot more than I did, didn't get busted.

I wasn't there when they made the bust. They arrested the women they had warrants for, who were there, and the rest of us had to turn ourselves in. They had a warrant out for me, but they couldn't find me, they didn't know my name. I found out the cops were looking for me, and I wasn't just going to keep hiding, 'cause they eventually were going to find me. I turned myself in in less than a week. I was coaching a girl's basketball team for a private high

school. I was afraid they were going to bust me right off the court, were going to come and get me when I was with my kids.

So I went and got my lawyer, which is the way to do it. Then you can't get harassed at the police station or when they're booking you. They're not going to act up in front of the lawyer. In fact, you can say stuff to them. I was calling them Starsky and Hutch, saying weren't they proud that they got these real criminals, and didn't they have better things to do. Course, my lawyer told me to shut up.

What happened after the arrest?
Everybody who could pled "no contest," and it was over with. But I couldn't plead "no contest" because I had a prior for shoplifting when I was nineteen that I'd never gotten expunged off my record. So I had to have a lawyer throw a lot of constitutional arguments at them. Pages and pages that they didn't want to deal with, so they finally dropped it. It took a long time, about a year. It cost me a couple thousand dollars that I didn't have. I never had that kind of money saved. And I was fired from one of my coaching jobs. Not both of them. My name was on the front page of the paper, but the other guy didn't find out about it.

Did the massage parlor stay closed?
Yeah, it closed down for good. But then we started organizing for decriminalization, started Alleycat/PEP. I made that name up, PEP: Prostitution Education Project. We got Margo St. James to come to town, and had a hooker's ball to raise money for the organization.

When we got busted it was the biggest thing in town and in the lesbian community. So when we had a meeting everybody in town showed up for it. Out of that we found that we had to really talk to our supporters about the issue, that they had all of the typical conflicts and questions and all the stereotypes about what it meant to be a prostitute. So we started doing an educational thing almost immediately. That expanded outward when we had the idea that we were going to push for decriminalization. Not that we really thought that we were going to get it. But we were going to get a lot of publicity and feel like we were doing something, at least doing some education, speaking on the radio, doing interviews, that type of thing.

How long did PEP last?
I don't remember. We had the hooker's ball, and after that I got involved in incest stuff. I moved on, and then about a year later I came to San Francisco.

You didn't come under attack from other feminists who said that supporting prostitution oppressed women?
There were a few people who wanted to say that. But I think that we had enough power, and enough big mouths among our group, so that side lost. They didn't mess with us. You know, people knew us.

So the response and support of the lesbian community was basically good?
Yeah, because they all knew us, and we were respected in the community. And there wasn't that much happening in a town like that, so it was something. I got a girlfriend out of the deal. She joined my defense committee, and I'm still with her.

MAPping Accountability

LARRY GRANT

AT FIRST GLANCE, THE POSITION THAT MEN AGAINST PORNOGRAPHY (MAP) present in "A New Principle of Accountability for Profeminist Men's Activism Against Pornography and Prostitution" (reproduced below), seems reasonable and thoroughly admirable. However, a second look reveals unspoken (and perhaps unconscious) assumptions and inherent contradictions.

The first line of the statement exemplifies the excessively broad generalizations with which the piece is rife. Certainly ending rape and battery are laudable goals, but not all profeminist men accept "a twofold accountability" as a principle. Speaking as a profeminist man (though I doubt MAP would acknowledge me as such), I am accountable to myself, to humanity, to the Earth, and to God. I am not necessarily accountable to ideologies or interest groups unless they are consistent with my own values.

For profeminist men to hitch their wagon to the horse of victimhood is a disastrously short-sighted action. When Men Against Pornography say "feminism," what they mean is not feminism as a whole, but a particular flavor of feminism—antiprostitution, antipornography feminism. By claiming the word "feminism" exclusively for themselves and their allies, they are excluding from the feminist movement millions of women and men who think of themselves as feminist but do not fit into the narrow ideological category that MAP calls feminism. This parochialism dishonors the proud history of feminism and puts many of feminism's greatest thinkers and leaders in the camp of the enemy. When MAP says that they are accountable to feminists, they mean the feminists that they have decided are legitimate feminists. So, rather than be accountable to feminists, they, in effect, make feminists accountable to them.

A similar problem stems from being accountable to victims. We should not put victims on pedestals. Victims need help and support. Their victimization needs to end. MAP could serve victims better by being responsible rather than accountable.

The core principle of the statement is the agreement to be specifically accountable to those feminists who are actively accountable to victims of pornography and prostitution. This idea is problematic in several ways. First, it

poses as the keystone of a political stance a chain of accountability—accountability to feminists who are accountable to victims. Why must the accountability be secondhand? Why not be accountable directly to victims and leave out the middlewoman?

Second, there is a problem with the word "accountable" itself. If accountable means following orders, this may be part of the problem. There is no assurance that leaders of the antipornography movement such as Catharine MacKinnon or Andrea Dworkin know more about prostitution or pornography than anyone else. In fact, their practice of turning a deaf ear to those who disagree with their politics indicates that they may be lacking vital pieces of information. Marching to the beat of the antiprostitution feminists could lead profeminist men to hurt the very people they want to help.

Feminists, especially feminist men, must think carefully before rejecting certain aspects of feminism. It is silly to refer to feminists whose ideology we disagree with as "self-styled" feminists when, in reality, members of MAP are also self-styled feminists. When you call yourself something, you are self-styling. Thus, Buddhists are self-styled Buddhists, socialists are self-styled socialists, and so on.

It is inappropriate for feminist men to declare themselves the arbiters of "true" feminism. Rather, we are called on to listen to all feminist viewpoints, to understand the various ideas, and to try to discriminate between the true and false. To dismiss some feminists out of hand because they do not measure up to prefabricated standards is equivalent to flipping a coin to make a decision. To choose to affiliate with antipornography/antiprostitution feminists without ever hearing or rationally evaluating the other side increases one's chances of making a major mistake.

When MAP refers to antipornography feminists as "embattled," they are surely unaware of the irony. They may be struggling (with the culture and their own consciences), but they are hardly in the difficult position that the anticensorship feminists are in. Anticensorship feminists are generally denied a voice in the feminist media and in college women's studies departments. If MAP had its way, they would even be kept from calling themselves feminists.

Men in the antiviolence movement need to look at their own motivations in taking antipornography and antiprostitution positions. Some men that are now working against abuse and rape are, themselves, former abusers and rapists. In turning away from domestic violence, child abuse, and rape, they are doing a good thing, but some of them are still in denial. Instead of taking responsibility for their own actions, they blame their violence on pornography: "It's not my fault; the dirty pictures made me do it." The research on the effects of pornography on behavior is complex, and can be interpreted in a number of ways, but to say that pornography compels men to be violent is simplistic and denies human free will.

For some men in the antiviolence movement, opposition to prostitution and pornography may function as a sort of sublimated violence. These men are

now socially respectable; they no longer batter their wives, girlfriends, or children. Yet they can still express their terror of women and female sexuality through the antiprostitution movement. Men who no longer beat up their loved ones can still attack women by preventing prostitutes from plying their trade, by sanctioning expression of female sexuality in print or in pictures (usually most heavily enforced against lesbians), or by belittling sexual rights feminists and disrupting their events.

The antipornography movement is not without its good points. Antipornography/antiprostitution feminists have rightly pointed out that pornography is a form of prostitution in that it involves people having sex for money. Seeing the continuity of the sex industry from topless dancers to street walkers, from call girls to adult magazine models, and from massage parlor workers to actors in pornographic movies, is a key to understanding the sex industry as a whole.

However, the most important truth that the antiprostitution feminists bring to light is the pain that is present in the sex industry. It is true that many, or even most, prostitutes did not choose their profession as the best career option out of several. Often women and men turn to prostitution out of desperation. They may be forced into it by a pimp, spouse, or lover of any gender. They may take up prostitution to maintain a drug habit. They may have no other job skills to make a living. These are people who need help. They need shelter from domestic violence or drug rehabilitation or job training. What they don't need, however, is to be labeled a victim. The reason they got into these situations in the first place is that they felt powerless or as if they had no other choices. By branding struggling people "victims," we make them even more helpless. History is replete with practices and concepts that are supposed to be good for women, but actually hurt them—foot binding, genital mutilation. Maybe someday antisex movements will be on the list.

Not all prostitutes live lives of degradation. For many people, having sex for money is a less stressful way to make a living than waiting tables, digging ditches, pushing papers, or any of the "respectable" career paths. Some people find comfort in the sexuality or physicality of the work. Through prostitution or other forms of sex work, some find expression for their creativity, an opportunity to live out sexual fantasies, and a mode of showing and feeling physical love outside the bounds of conventional relationships. There is nothing inherently degrading about sex for money. Many other jobs are harder, more humiliating, and less rewarding.

It is true that in some ways sex workers are ground under the heel of the patriarchy. They live lives outside the protection of the law and the safety of socially acceptable modes of sexual behavior. Yet, though individuals may suffer greatly, many find freedom and fulfillment through sex work. A tradition stretches back to the beginning of civilization of sex workers being healers, artists, and priestesses. The archetype of the sacred prostitute is now being revitalized by some sex workers—not as a cynical ruse, but as a more realistic way

of envisioning themselves. In many societies of the past and present, sex workers have been the only women to live independent lives, free of the control of men. Sex workers were the first feminists.

MAP misunderstands the position of sex workers and their feminist supporters. Our intent is not to "advocate, obscure, or offer politicized apology for the abuse, subordination, and civil inferiority generated by the sex industry..." No feminist would make excuses for the wrongs that sex workers suffer. The aim of feminists within the sex industry and their allies is to end abuse, subordination, and civil inferiority. These abuses cannot be stopped or healed without listening to diverse sex workers and their varied perceptions. Those who are currently working in the industry should be heard and believed; they are most familiar with their own situations and have ideas about what could be done to make things better.

The MAP statement also fails to acknowledge any positive aspects of sex work. This lack of balance is not because an impartial investigation failed to discover any; in MAP's statement, generalizations imposed by ideology have replaced what can be borne out by facts. Many men in the antipornography movement have no direct experience of what sex work is like. They base their ideas on what they hear from antiprostitution feminists, or from their own guilt at the ways that they themselves have abused women, coupled with the fear of female sexuality that is prevalent in the patriarchy.

It is not fair to say that sex workers and their supporters are obscuring the problems in the sex industry. It is not obscurist to say that a complex situation is complex. And the sex industry is complex; it is a vast web of social, political, cultural, psychological, and economic interrelationships that percolate through every level of society and impact upon every developed culture on the planet.

Much remains to be learned about the sex industry and how it affects those involved in it and the rest of society (though sex workers know more than most of the "experts"). Antipornography/antiprostitution feminists (and conservatives) have overemphasized the negative side of the sex industry, while sex workers and their allies have often overemphasized the positive aspects. Everyone on every side of this issue needs to listen more and do more research.

Men especially need to listen to the voices of women sex workers. Men tend to have a one-sided and distorted view of sex work. This can be remedied by seeking out, reading, and listening to a variety of viewpoints. It is also worthwhile to study the role that sexually explicit literature and art, also known as pornography, has played in the development of the feminist, lesbian, and gay movements.

Compassion, study, and an open mind are powerful tools for transforming the self and society. Blind allegiance or "accountability" ideology leads to ignorance, fascism, and the destruction of human values. It would be tragic if feminism became another tool for the patriarchy to use in enslaving human beings. This does not have to happen; it's up to us and the choices we make.

A New Principle of Accountability: For Profeminist Men's Activism
Against Pornography and Prostitution

For profeminist men doing work to end rape and battery, a twofold accountability—to feminists and to victims—has become a guiding principle. In working to end men's violence, men who are unequivocally profeminist have agreed to follow feminist leadership in the anti-violence-against-women movement and not put any woman more at risk. But until now, there has been no self-evident understanding about how to play that crucial principle responsibly in doing work against pornography and prostitution.

When the Pornography Action Group met during the First National Ending Men's Violence Network Conference in Chicago on July 9, 1992, a new, clarifying principle of accountability was proposed for profeminist men doing antipornography and antiprostitution work. The need for this new principle was underscored by the fact that there may be no way for profeminist men to know directly the situation of those victimized by pornography and prostitution because of the silencing nature of the victimization. Moreover, men trying to end men's violence face a particular challenge selecting which feminists to be accountable to—because some self-styled feminists actively defend pornography and prostitution, promoting pornography as liberatory and prostitution as a viable career path through legalization and unionizing schemes.

This new principle therefore clarifies the choice we must make to be accountable—to those who are victimized by pornography and prostitution—at a time when the word "feminist" has become an insufficient guideline and when pornography and prostitution are often portrayed as "victimless."

We Ageee to be Specifically Accountable to Those Feminists Who are Actively Accountable to Victims Of Pornography and/or Prostitution.

This new accountability principle recognizes and affirms that there are brave and embattled feminist activists and writers whose work is explicitly grounded in politics that begins with the harm done to real human beings through systems of prostitution and the production, trafficking, and use of pornography. These feminists are devoted to stopping the harm, stopping the sexual violence and subordination, stopping the sexualized inferiority—not fronting for it.

We wish to dissociate our activism from any who, even in the name of feminism, would advocate, obscure, or offer a political apology for the abuse, subordination, and civil inferiority generated by the sex industry—a vast misogynist social institution of pimps and profiteers. For rapists and batterers, no such "feminist" defense exists—certainly not with the same significant links to legal and financial resources (through the American Civil Liberties Union, for instance), academia (including many women's studies departments), "progressive" publications with a sex industry advertiser base (such as

the Village Voice), organizations infiltrated with pro-prostitution and pro-pornography leadership (including the National Organization for Women), and pornography producers (such as Playboy, Penthouse, and On Our Backs).

We therefore publicly declare our political allegiance, in conscience, with feminists who are actively accountable to those who have been victimized by pornography and prostitution. These feminists are the freedom fighters whose inspiration and leadership we have determined must be our guide.

[27] A Prostitute Joins NOW

TERI GOODSON

WOMEN IN THIS CULTURE RECEIVE SUBTLE MESSAGES FROM CHILDHOOD onward to use their sexuality as a bargaining chip in exchange for economic security and protection from a man under the guise of "love" and family formation, but outright prostitution, while much more straightforward, is considered disreputable. This helps maintain the double standard that denies women the type of proactive freedom, pleasure, and agency accorded to men. Gender parity demands a thorough evaluation of erotic practices and politics, including an honest critique of how certain aspects of feminism reinforce rather than deconstruct the madonna/whore dichotomy.

Believing I could make a difference, I joined the San Francisco chapter of the National Organization for Women (NOW) in 1991. Working for over three years within NOW as an out prostitute and sex-worker advocate has been a trying but educational and rewarding experience. Originally, I had not joined with sex-worker advocacy in mind; the impetus was my outrage over Anita Hill's Senate hearing and Senator Kennedy's nephew's rape trial. The all-male Senate Hearing Committee questioned Ms. Hill's testimony with little if any sensitivity or understanding about sexual harassment. I had experienced similar unwanted advances since puberty and understood that it was an all-too-common phenomenon. During the televised Kennedy rape trial, the defense attorneys implied that the alleged victim was "asking for it," i.e., that she was a "bad" woman, a mother with her own sexual needs who dared go to bars alone to enjoy herself. These incidents lit a fire in me. I wanted women freed from the coercive social power of the sexual double standard; we couldn't allow men to retain their privileges at our expense.

When I first became a NOW member, I possessed scant knowledge about feminist sexual politics. I believed in the right to my own sexual choices without being unfairly stigmatized because my work branded me a "whore." Unaware of just how controversial commercial sex—or indeed, any "deviant" form of sexual expression, such as sadomasochism or pornography—is among feminists, I initially underestimated the commitment and resources required to educate other feminists about commercial sex and win them as allies.

NOW is a multi-issue, feminist organization whose politics are confined to gender issues affecting women; its activism does not necessarily cross over to include stigmatized forms of sexuality. Missing the overlap, NOW members often exhibit unexamined prejudices against sexual minorities common to the larger society. These prejudices can be traced to patriarchal religious and cultural traditions, rather than reason or feminism. If women refuse to question the sources of their assumptions about unconventional forms of sex, such traditions will continue to divide rather than unite women. I would like to see us create a broadly inclusive, woman-friendly sex ethos that embraces various types of erotic activities based on informed consent, mutual respect, responsibility, and the pursuit of pleasure. For many women, joyful, compassionate libertinism is a completely foreign concept. To traverse this territory, women must brave being labeled "whores."

Some non-sex-worker feminists seemed to understand that the stigma and oppression of female prostitutes is used to uphold the double standard and is limiting to all women's sexual freedom. Although NOW has been difficult to mobilize, partly because of the lack of sex-worker activists willing to work with them, I have witnessed victories, especially within San Francisco and California NOW, the two affiliates that have had the most exposure to commercial sex workers. Partly as a result of my work, during the 1994 California NOW State Conference, a resolution passed committing California NOW to work in solidarity with prostitutes' rights and advocacy groups. Prostitution bills were put on the 1995 legislation watch list, and the state PAC questionnaire continued asking candidates whether they favored the decriminalization of prostitution. During this time I was also able to establish a prostitution committee, an action liaison between California NOW and prostitutes' groups like COYOTE.

My efforts to build bridges have not been as successful as I had hoped. It has been difficult to find like-minded activists who are willing to work within NOW. Those who try often find themselves outnumbered by their opposition, or they experience hostile attitudes from sexual conservatives who want to label us victims or patriarchal pawns. More common are apathy or ambivalence and an unwillingness to prioritize our concerns. And it's also true that many commercial sex workers are politically inexperienced; they are encouraged by society to keep their work hidden, not to discuss it publicly.

Even though National NOW passed a resolution calling for the decriminalization of prostitution in 1972, attempts at membership mobilization around this issue have failed, especially as the conservative ideological rhetoric of prostitution abolitionists and antipornography forces has gained greater acceptance. These proponents advocate eradicating prostitution, despite the effect on prostitutes' lives, and "rescuing" the women whom they often reduce to being nothing but stereotypical helpless toys for men. But if they were to learn from history and the failed social-purity campaigns during the beginning of the century, they would understand that this approach translates into worse working conditions for prostitutes, especially the more visible ones.

It is presently unlikely that NOW or other women's groups will campaign for prostitution law reform without pressure from significant numbers of prostitutes. Prostitutes' work experience varies widely by socio-economic class and other factors. Those who are better equipped to participate in political discourse by virtue of education or social status often possess the least motivation for doing so. The more successful prostitutes may or may not benefit from change, depending on the tradeoffs involved. It is very likely that, given the present conservative political climate, state intervention would create a loss of privacy, autonomy, and the higher profits a prohibited market generates. For perhaps the vast majority, the personal risks faced by publicly exposing their illegal and highly stigmatized work seem to outweigh any advantage.

Meeting other commercial sex advocates who have worked within NOW, such as Miki Demarest, Bobby Lilly, and Priscilla Alexander, helped me become more familiar with pertinent NOW history and ideology. I soon realized that if cultivation of sex-worker allies was my goal, feminist discourse about sexuality needed to be lifted onto a more sophisticated plane.

Most NOW members are not sex workers, so they may easily dismiss sex-worker issues as being "merely about sex" when seemingly more pressing matters are at hand. Yet the connection between sex and economics is an important one for all women, not just sex workers, and should not be ignored. NOW strives toward a consensus about sexuality in general while marginalizing divisive issues like commercial sex, the inclusion of which would help highlight related and equally challenging economic issues. Socioeconomic class bias often becomes evident in feminist censure of commercial sex, and some women seem unaware of their own biases. Judgmental attitudes, particularly from middle- and upper-class women, usually trigger resentment from sex workers, many of whom are working-class or poor women trying to earn a living the best way they know how. They have already been stigmatized and/or criminalized as outcasts from society and wonder why feminists would add to these woes. Is it because sex workers expose public hypocrisy, myths about monogamy, and the possibilities for pleasurable sex outside a committed relationship? Again, what is the basis for judgments against them?

NOW resolutions dealing with sexual issues often reflect a shallow understanding of these topics. For example, a 1984 National resolution distinguishes between erotica, defined as that which is acceptable to women, from pornography, which is offensive to women and therefore condemned. In fact, any such distinction is subjective. Likewise, a 1980 position paper on lesbian rights mistakenly equates consensual sadomasochism with violence. Such resolutions reinforce narrow, traditional notions of women's desire as warm and fuzzy: nurturing, connected to intimacy, lacking in power dynamics, and unresponsive to explicit visual stimulus.

For centuries, madonnas provided legitimate children and social respectability; whores, illegitimate pleasure. Proper women are socialized to associate sex with intimacy and often have difficulty negotiating their desires

with men. Yet men are able to more easily distinguish between love and sex. They hold an advantage because they can enjoy erotic pleasure without the emotional restrictions so many women wrestle with. Our culture disproportionately discourages such behavior in women and will continue to do so until feminists claim such privileges for themselves. Why do women deny to each other the sexual freedom they allow men? What fears constrain them? Are we back to arguments that use biological determinism to justify behavior differences between the genders?

Some feminists want to know how sex work can be conducted in a manner that is not destructive or offensive to their dignity as women. They need to join with and listen to sexual service providers who are also interested in elevating themselves and their profession. This can be accomplished through both law reform and support of woman-friendly professional sex-worker organizations. Guilds and unions not forced underground because of legal constraints could promote ethical business practices, safer sex techniques, and responsible behavior.

Many women would like to know how to enhance their sex lives and relationships. They could benefit from associating with seasoned sex professionals, many of whom would gladly share their insights and expertise. Some examples of this can already be found in the San Francisco Bay Area, Los Angeles, and New York City, where current and former sex workers lead public forums, many designed specifically for women, sharing various erotic skills and challenging conventional ideas about sexuality and our bodies. These teachers are known as sacred prostitutes, mythologists, sex educators, or sensual masseuses. Their knowledge and expertise in the field of the erotic arts is sorely needed and should be highly valued. Instead, our culture uses sexual shame and ignorance for purposes of social control. The divisive sexual wounding of women— separating us into "madonnas" and "whores"—can heal. We must keep striving toward unity, working together for mutual benefit. What else can we do that makes any sense?

[28] Dancing Toward Freedom

SIOBHAN BROOKS

As with many strippers, I began dancing out of economic necessity. I started dancing to help pay my college expenses. I had applied for clerical work, telemarketing, retail . . . but no one called me back for an interview. I saw an ad for exotic dancers wanted at the Lusty Lady, saying it was clean, had friendly women managers who are former dancers themselves, and had ideal scheduling for students.

The next week I auditioned and was hired by a show director, Josephine, a beautiful woman with a caramel complexion, a professional air, and the body of a dancer. I felt comfortable with Josephine because she understood my concerns about my afro hairstyle and told me that my short black Josephine Baker wig was fine. The fact that she was Black made me feel good that a woman of color was in a position of power, because the women at the Lusty Lady were mostly white.

I was surprised at how comfortable I felt dancing nude in front of men and women that I did not know. I felt freedom, like I was dancing to the latest Beastie Boys tract in front of my bedroom mirror. I loved the mirrored stage, the bright lights, wearing different costumes, and the fact that dancers chose their own music. Dancers performed on stage before open windows; when a dancer approached an individual window, she raised one of her legs on a bar so that the customer could get a good view of her vulva, or turned around to give customers a butt show. Another feature of the Lusty Lady is the Private Pleasures booth. In the booth a dancer gives a private show for a customer (separated by glass) for a basic fee of five dollars for three minutes.

Most of the women at the Lusty Lady are students, artists, or both; they are very intelligent and creative, refuting the stereotype of strippers as brainless sex bunnies. I did not notice the race relations on stage at first because, as with many job settings, the racism is very covert. Now, I feel a sense of family and support from the dancers and support staff, while simultaneously being aware of the racism. The customers are mostly white and Asian, with few Blacks and Latinos. When I first began working there, I received good responses from cus-

tomers. But slowly, the compliments began to decrease. I noticed that I was almost always the only woman of color on stage with the white dancers. White customers often lost interest in my performance; I have even had customers wave me out of their view. I also noticed how some dancers reacted to customers of color; many were impatient with Asian and Latino customers who could not understand English well, and some dancers were hesitant about dancing for Black customers. The few Black women (about six out of seventy women) were hardly ever performing in the Private Pleasures booth, though we were all available to do it.

When I first noticed customers not paying attention to me and that I was not being scheduled for the booth—and therefore earning less money than my white counterparts—I internalized the notion that I was not as attractive as the other dancers. Like most Black women in this country, I had to fight insecurities about my appearance in the presence of white women, since they are perceived as the ideal beauty standard. I began to analyze the notion of sex work being exploitative to women. When I think of sex work as being exploitative, I think in terms of economics. Black women make less money in the business than other women, a fact reflective of the general economy.

I brought up the issues of Black dancers hardly being scheduled to perform in the Private Pleasures booth to Josephine. She informed me that customers did not want to pay the extra money to see Black dancers in Private Pleasures, and that even though all the Black women at the Lusty Lady were attractive, we just did not do as well economically as other dancers. I nodded my head and left the office. My wage climbed from ten to nineteen dollars an hour within a year, which was the top wage for a dancer who did not perform in the booth; if a dancer did perform in the booth, the top wage was twenty-four dollars an hour. Since I was hardly ever scheduled for the booth, even though I was available, my wages would always be lower than the white dancers, no matter how long I continued to work there. I continue to be disturbed by the dearth of Black women in the booth. After a year I have only been in the booth around eight times, while white dancers perform in the booth an average of three to four times per week.

Recently, a white coworker of mine wrote a petition to June, the general show director, requesting that women who perform in the booth should get paid more than thirty percent of what the booth takes in (the club keeps the rest). She circulated her petition, and got many dancers to sign. The petition made me angry, because Black dancers already were economically unequal to the other dancers. If her petition were successful, the wage gap would be even further widened.

I decided to write my own petition, also directed to June, stating that it was unfair that Black dancers did not perform in the booth as often as other dancers, and requesting that this inequity be redressed. A number of dancers of all races signed my petition, which made me happy. A few days later Josephine

called me in to discuss my petition. She wanted to know why I did not come directly to the show directors. I told her that my petition was in response to the first petition. Josephine then called a meeting of all the Black dancers to discuss our issues concerning the booth and our wages. I felt nervous because I knew that I was rocking the friendly, "raceless" boat of the Lusty Lady. The relationship of the white dancers and the dancers of color reflected the "melting pot" theory—we were all supposed to get along without any dialogue about racism, even though some of us were clearly being discriminated against because of our race. I felt as though we were expected to feel grateful simply because we were not being sexually harassed by managers.

A week before the meeting, I telephoned each of the Black dancers to get their views about my petition; I wanted to make sure they were aware of the larger patterns of racism that might otherwise be invisible to them. They all supported me, even the two dancers that already performed regularly in the booth, and we all agreed that it was good to unite and organize before the meeting. I had heard from other dancers that a few years ago the Black dancers had held a similar meeting with Josephine, only to be told that this is just the way the system works: white men did not want to pay extra to see Black dancers. Since I had heard white customers request Black dancers in the booth, I knew that was not completely true, though it was harder for Black dancers to make as much money in the booth.

When the Black dancers and show directors met, the directors interrogated me as to why I had the audacity to write a petition. After I explained how I felt about the whole situation, June asked me if I had ever asked to be scheduled in the booth. I responded that I did not know I had to ask, since other dancers were automatically scheduled. The outcome of the meeting was that even though we still would not perform in the booth as often, we could still reach up to twenty-four dollars an hour, the wage previously reserved for those who performed in the booth regularly. One dancer's suggestion, that we rotate Black dancers who perform in the booth so that we could do it at least once a month, was implemented.

A few days later a general dancer meeting was held. The show directors stated that because of my petition and the "misunderstandings" in it, one would have to ask permission to post flyers up in the dressing room; no political information would be allowed to circulate, especially concerning the job. Although I was satisfied with the changes that had come from the previous meeting, I knew that the Black dancers would have to constantly fight to keep our place on the booth schedule, lest it revert back to the more racist arrangement. I felt hurt that now a dancer would have to ask permission to put up a flyer and that no one could put up anything that inspired political thought. I was glad my petition brought the issue of the Black dancers out in the open, but having my First Amendment rights violated was a heavy price.

The meeting reminded me that as far as strip clubs go, the Lusty Lady was subversive in many ways. How many dancers at strip clubs are even allowed to

have meetings on the premises about their working conditions? But I am a Black woman, which means my freedom in the work place is always limited by white supremacy—even in a women-managed strip club.

Yet I do feel free dancing, exploring my erotic side, becoming more in tune with my body, receiving male and female attention—there are definitely not many jobs where women can experience these feelings. I just know that my freedom can go further than knowing how many licks of my fingers it takes to get a man off. I continue to fight racist policies, practices, and attitudes, and I know I am not alone.

Editor's Note

Since this writing, the Lusty Lady has joined the Service Employees International Union, Local 790, making it the second strip club to unionize in the United States, and the only U.S. strip club currently unionized.

[29] Feminists for Free Expression

JOAN KENNEDY TAYLOR

AS ERADICATING PORNOGRAPHY BECAME AN ISSUE for a faction within feminism in the 1980s, the large number of feminists concerned about freedom of speech began to mobilize opposition. Feminist anti-pornography efforts in the 1970s had focused on boycott and protest. When this emphasis shifted in the early 1980s to promoting laws to enable any woman to sue "traffickers in pornography" for monetary damages on the behalf of all women, a number of feminists were repelled by what they saw as substituting censorship for directly opposing violence against women. In the mid-1980s, the Feminist Anti-Censorship Task Force was formed and was very active for several years. It countered antipornography ordinances introduced by Catharine MacKinnon and Andrea Dworkin and presented a brief on the winning side to the Supreme Court when such an ordinance in Indianapolis was declared unconstitutional.

A suggested federal law that many people thought was a national version of the MacKinnon-Dworkin city ordinances was the catalyst that brought feminists from all parts of the spectrum together again in 1992 to form a new and vital national organization. I was there at 6:30 in the evening, on January 29, 1992, when a group of feminists met in a vacant classroom at the New York Law School to discuss protesting the perception that all feminists supported the censorship of pornography. The idea for the meeting had originated with Marcia Pally, who very specifically wanted to do something about the grotesquely named Pornography Victims Compensation Bill, then up for consideration by the Senate Judiciary Committee.

It was a very diverse group, brought together by a common concern for freedom of speech, even though we may have had widely differing views about contemporary pornography itself. Some of us considered pornography to be sexist and sleazy, but supported the rights of those who produced it; some loved it; some were actively involved in the sex industry. Some were active in other groups, including NOW; the National Coalition Against Censorship; the East End Gay Organization; the ACLU; the Rutgers Women's Rights Litigation Clinic; SIECUS; PONY; and the Association of Libertarian Feminists. There were also writers, filmmakers, professors, and businesswomen. Walking into the meeting and seeing the different styles of dressing was like going back to the

seventies, when women of entirely different interests, backgrounds, and life styles began to come together in the "women's movement."

We decided to call ourselves Feminists for Free Expression (FFE) and to begin by being an ad hoc committee whose sole purpose was to oppose the passage of the proposed Pornography Victims Compensation Act, Senate Bill S. 1521. We delegated members to draft a letter to the Senate Judiciary Committee, and assigned others to coordinate an effort to get other feminists to sign the final version and to publicize our activities. We soon persuaded the two largest chapters of NOW, in New York and California, to join us in sending letters opposing the bill. (Four other NOW chapters ultimately also protested S. 1521.)

This was a terrible bill. It assumed without citing any grounds for the assumption that "hardcore pornographic material" causes sexual abuse, rape, and murder, although even the Meese Commission had not been able to find evidence of such a causal connection. American tort law has not at the federal level generally recognized third-party liability, and therefore did not permit victims of sex crimes to sue booksellers and other purveyors or creators "of obscene material or child pornography" that they thought "caused" the crimes. The bill's purpose was to remedy this "deficiency" by alleging that any sexual offense "foreseeably caused, in substantial part," by such material and committed by a person who was exposed to the material calls for damages paid to the victim of the offense. The perpetrator of the sexual crime in question did not need to have been convicted—or even prosecuted.

The bill targeted obscenity and child pornography, which were both already illegal. "Child pornography" was defined not as involving actual children, but as "a *description* of a minor engaging in or participating in sexually explicit conduct" (emphasis added). Since a minor, according to the bill, is anyone under eighteen, this definition outlaws Nabokov's *Lolita*, Dostoevsky's *A Raw Youth*, Margaret Mitchell's *Gone with the Wind* (Scarlett was sixteen when she first got married), and William Shakespeare's *Romeo and Juliet*. Literary fiction (to say nothing of prime-time television) is full of descriptions of the sexual behavior of adolescents, and to sweepingly call it all "child pornography"—to call *any* fiction child pornography—would have subjected large portions of modern culture to civil suit. The bill died before going to the floor, before the end of 1992.

FFE, however, grew. In 1992 it fought S. 1521; set up a steering committee, a legal committee including Nadine Strossen and Wendy Kaminer, and a speakers' network including Karen DeCrow and Barbara Ehrenreich; submitted an amicus brief to the Supreme Court; and worked against censorship legislation in Congress—all with a volunteer staff and no office space. It acquired tax-exempt status and gradually began to get donations and grants. It called together a prestigious and diverse advisory board that now includes, among other feminists, authors Betty Friedan and Nancy Friday, Nadine Strossen of the ACLU, Judith Krug of the American Library Association, and performance artists Penny Arcade, Reno, and Holly Hughes.

In May 1993, FFE held a day-long workshop on feminism and pornography, which sparked a series of periodic educational seminars. Topics have included

sexual harassment, the work of antipornography activist Catharine MacKinnon, the controversy over rap lyrics, and censorship in cyberspace. One of the most effective was "Women and Sex: On Stage, On Film, On Our Own Terms" on November 23, 1993. It featured censored photographer Barbara Alper, feminist erotic filmmaker Candida Royalle, performance artist Annie Sprinkle, and sex-industry workers' rights activist Veronica Vera. Also in 1993, FFE issued a brochure on pornography, the first in an ongoing series. Since then, this series has presented free-speech analyses of sexual harassment, arts censorship, and censorship of the Internet. In all these areas, FFE argues against government intervention that curtails rights in the name of "protecting" women. Our position is that it is always disempowered groups (which include women and especially feminists) who have the most to fear from censorship, and therefore the right you suppress may turn out to be your own.

The organization has continued to grow and flourish. As of early 1996, the legal committee has submitted two amicus briefs to the Supreme Court (one was in the sexual harassment case, *Harris v. Forklift Systems, Inc.*) and a number of others in lower court cases. The Speakers' Network includes lawyers, authors, scholars, and some of the sex-industry feminists contributing to this book such as Carol Queen and Candida Royalle, who is also a member of FFE's board of directors.

Since FFE resists attempts at censorship, it has always supported women in the sex industry faced with the many government attempts to censor or zone them out of business. But more than that, FFE has from its inception spoken against the view that feminism is antisexual. Its letter against S. 1521 said:

> Women do not require "protection" from explicit sexual materials. It is no goal of feminism to restrict individual choices or stamp out sexual imagery ... there is no agreement or feminist code as to what images are distasteful or even sexist. It is the right and responsibility of each woman to read, view or produce the sexual material she chooses without the intervention of the state "for her own good."

Ellen Willis, in a review published on September 10, 1995 by the *New York Times Book Review* of *XXX: A Woman's Right to Pornography* by Wendy McElroy, called her part of a "mini-wave of dissident writers" who "reject the repressive, neo-Victorian moralism that has been strangling feminism for two decades." Many members of this mini-wave—I think of Marcia Pally, Sallie Tisdale, Rene Denfeld, Nadine Strossen, and McElroy herself, to name just those with books published in the last two years—are active members of FFE. FFE members, in or out of the sex industry, do not see women primarily as victims of a patriarchal society; we see them as powerful, outspoken, and able to control their own lives and make their own choices.

Appendix

Organizations for Sex Worker Support, Advocacy, Education, and Professional Advancement

United States

CAL-PEP (California Prostitutes Education Project)
630 20th Street, Suite 305
Oakland, CA 94612
Phone: (510) 874–7850
Director: Gloria Lockett

**Coalition on Prostitution (San Francisco)
and Prostitutes' Education Network**
PO Box 210256
San Francisco, CA 94121
Phone: (415) 435–7931
E-mail: penet@creative.net
Carol Leigh, Development Coordinator
Victoria Schneider, Outreach Director

COYOTE (Call Off Your Old Tired Ethics)/Los Angeles
1626 N. Wilcox Avenue, #580
Hollywood, CA 90028
Phone: (818) 892–1859
E-mail: 76370.3345@compuserve.com
Executive Director: Norma Jean Almodovar,

COYOTE /San Francisco
2269 Chestnut Street, #452
San Francisco, CA 94123
(415) 435–7950
Contact: Margo St. James

COYOTE/Seattle
16625 Redmond Way
Box M-237
Redmond, WA 98052
Phone-FAX-FAXBack: (206) 869–9245
COYOTE staff (coyote@coyotesea.org)
http://www.coyotesea.org

Cyprian Guild
A Trade Association and Social Network
for Entrepreneurial Sex Professionals
P.O. Box 423145
San Francisco, CA 94142–3145
(415) 522–2910
Director: Teri Goodson

Exotic Dancers Alliance
1442 A Walnut St, Suite 187,
Berkely, CA 94709
(415) 995–4745
Contacts: Johanna Breyer, Dawn Passar

Hooking is Real Employment (HIRE)
847 Monroe Drive
Atlanta, GA 30308
Phone: (404) 876–1212
E-mail: frenchdom@aol.com
Director: Dolores French

North American Task Force on Prostitution (NTFP)
Post Office Box 2113
New York, NY 10025–2113
Contact: Priscilla Alexander

P.O.N.Y. (Prostitutes Of New York)
271 Madison Avenue, #908
New York, NY 10016
Phone: (212) 713–5678

U.S. Prostitutes Collective
Post Office Box 14512
San Francisco, CA 94114
Phone: (415) 626–4114
Contact: Rachel West

Waikiki Health Center
277 Ohua Avenue
Honolulu, HI 96815–3695
Contact: Pam Vessel

Canada

Maggie's
298 Gerrard Street East
Post Office Box 1143, Station F
Toronto, Ontario M4Y 2T8
Phone: (416) 964–0150

Sex Workers Alliance of Toronto (SWAT)
Post Office Box 1143, Station F
Toronto, Ontario M4Y 2T8
Phone: (416) 360–8461
E-mail: maggie@intacc.web.net

Sex Workers' Alliance of Vancouver
Post Office Box 3075
Vancouver, British Columbia V6B 3X6

Bibliography

Abelove, Henry, Michele Barale, and David Halperin, eds. *The Lesbian and Gay Studies Reader,* New York and London: Routledge, 1993.

Abercrombie, Nicholas, Stephen Hill, and Bryan Turner. *The Dominant Ideology Thesis.* London: George Allen and Unwin Ltd. 1980.

Alexander, Priscilla. "Sex Workers Fight Against AIDS: An International Perspective," in Beth E. Schneider and Nancy Stoller (eds.), *Women Resisting AIDS: Strategies of Empowerment.* Philadelphia: Temple University Press, 1995.

Alexander, Priscilla, and Frédérique Delacoste. *Sex Work: Writings by Women in the Sex Industry.* Pittsburgh: Cleis Press, 1987.

Allison, Elizabeth, Joanne, Judy Ardito, Marcia Bronstein, and Mary Lou Shields. "Feminists on Prostitution: 'Guilty of Everything They Accuse Men Of.'" In the *Village Voice*, December 30, 1971, p. 3.

———. "Myths About Prostitution in a Sexist Society." In the *Village Voice*, January 6, 1972, p. 22.

Almodovar, Norma Jean. *Cop to Call Girl: Why I Left the LAPD to Make an Honest Living as a Beverly Hills Prostitute.* New York: Simon & Schuster, 1993.

Anderson, Peter. "Call Girl Turned Candidate Tells All." In *Marin Independent Journal*, Thursday, August 7, 1986, p. A–2.

Anonymous. *Pass It On: The Story of Bill Wilson and How the AA Message Reached the World.* New York: AA World Services, 1984.

Anthony, Jane. "Prostitution as 'Choice.'" In *Ms.* (January/February 1992).

Anzaldúa, Gloria. *Borderlands La Frontera: The New Mestiza.* San Francisco: aunt lute books, 1987.

Ardener, Shirley. "A Note on Gender Iconography: the Vagina." In *The Cultural Construction of Sexuality*, Pat Caplan, ed. New York: Tavistock, 1987.

———. "Sexual Insult and Female Militancy." In *Perceiving Women*, London: Dent, 1975.

Arobateau, Red Jordan. *Dirty Pictures.* New York: Masquerade Books, 1st Hard Candy Edition, 1995.

———. *Lucy & Mickey.* New York: Masquerade Books, 1st Hard Candy Edition, 1995.

Associated Press. "Prostitute: HIV Did Not Deter Her." In the Centers for

Disease Control and Prevention (CDC) National AIDS Clearinghouse, AIDS Daily Summary, April 25, 1994, p. B3.

Atkinson, Ti-Grace, ed. *Amazon Odyssey*. New York: Links Books, 1974.

B., Hima. *Straight for the Money: Interviews with Queer Sex Workers*. Distributed by Hima B., 1994.

Barry, Kathleen. *Female Sexual Slavery*. Englewood Cliffs, NJ: Prentice Hall, 1979.

———. *The Prostitution of Sexuality: The Global Exploitation of Women*. New York: New York University Press, 1995.

———.Charlotte Bunch, Shirley Castley, eds. *International Feminism: Networking Against Female Sexual Slavery*. New York: International Women's Tribune Centre, 1984.

Beers, Jinx. "Sometimes Shit Happens." In *The Lesbian Review of Books*, Vol II. No. 2/Winter 1995–96, p. 4.

Behar, Ruth. "The Body in the Woman, the Story in the Woman: A Book Review and Personal Essay." In *The Female Body: Figures, Styles and Speculations.*, Laurence Goldstein, ed. Ann Arbor, Michigan: University of Michigan Press, 1991.

Bell, David, and Gill Valentine. *Mapping Desire*. New York: Routledge, 1995.

Bell, Laurie, ed. *Good Girls/Bad Girls: Feminists and Sex Trade Workers Face to Face*. Seattle: Seal Press, 1987.

Bell, Shannon. *Reading, Writing and Rewriting the Prostitute Body*. Bloomington: Indiana University Press, 1994.

Bolen, Jean Shinoda. *Goddesses in Every Woman: A New Psychology of Women*. New York: Perennial Library, 1985.

Boston Women's Health Collective. *The New Our Bodies, Ourselves*. New York: Simon & Schuster, 1984.

Bourdieu, Pierre. "Sport and Social Class." In *Social Science Information*. 17: 1978. 819–840.

Brandt, Allan M. *No Magic Bullet: A Social History of Venereal Disease in the United States since 1880*. New York: Oxford University Press, 1985 (paperback, 1987).

Brown, Rita Mae. *Rubyfruit Jungle*. New York: Linda Grey Bantam Books, 1988.

Brownmiller, Susan. *Against Our Will: Men, Women and Rape*. New York: Simon & Schuster, 1975.

———. "What Price Whoring?" In the *Village Voice*, January 13, 1972, p. 13.

Butler, Judith. *Bodies That Matter*. New York and London: Routledge, 1993.

Califia, Pat. *Public Sex: The Culture of Radical Sex*. Pittsburgh: Cleis Press, 1994.

———. "Some Words About 'Some Women.'" In *Some Women*, Laura Antoniou, ed. New York: Masquerade Books, 1995.

Carter, Angela. *The Sadeian Woman and the Ideology of Pornography*. New York: Pantheon Books, 1978.

Castro, Kenneth G., Alan R. Lifson, Carol R. White, Timothy J. Bush, Mary E. Chamberland, Anastasia M. Lekatsas, Harold W. Jaffe, "Investigations of AIDS Patients with No Previously Identified Risk Factors." In the *Journal of the American Medical Association*, March 4, 1988, 259 (9) : 1338–42.

Centers for Disease Control and Prevention, HIV/AIDS Surveillance Report, October 1993 5(3):17.

Chesler, Phyllis. *Women and Madness*. San Diego: Harcourt, Brace Jovanovich, 1989.

Christ, Carol, and Charlene Spretnak. "Images of Spiritual Power in Women's Fiction." In Charlene Spretnak, ed., *The Politics of Women's Spirituality: Essays on the Rise of Spiritual Power Within the Feminist Movement*. Garden City, NY: Anchor Books, 1982.

Cohen, Judith B., and Priscilla Alexander. "Female Sex Workers: Scapegoats in the AIDS Epidemic." In Anne O'Leary and Loretta Jemmott Sweet, eds. *Women at Risk: Issues in the Primary Prevention of AIDS*. New York: Plenum, 1995.

Comfort, Alex, ed. *The Joy of Sex: A Cordon Bleu Guide to Lovemaking*. New York: Crown, 1972.

Committee of Fifteen, *The Social Evil*. Edwin R. A. Seligman, ed. New York: G.P. Putnam's Sons, 1902, 1912.

Connelly, Mark Thomas. *The Response to Prostitution in the Progressive Era*. Chapel Hill: University of North Carolina Press, 1980.

Corbin, Alain. *Women for Hire: Prostitution and Sexuality in France after 1850*. Translated by Alan Sheridan. Cambridge: Harvard University Press, 1990.

Darrow, William, and the Centers for Disease Control Collaborative Group for the Study of HIV-1 in Selected Women. "Prostitution, Intravenous Drug Use, and HIV-1 in the United States." In Martin Plant, ed., *AIDS, Drugs, & Prostitution*. London: Routledge, 1990.

Davenport-Hines, Richard. *Sex, Death and Punishment: Attitudes to Sex and Sexuality in Britain since the Renaissance*. London: Fontana Press/HarperCollins, 1990.

Delacoste, Frédérique, and Priscilla Alexander, eds. *Sex Work: Writings by Women in the Sex Industry*. Pittsburgh: PA: Cleis Press, 1987.

Dodson, Betty. *Liberating Masturbation: A Meditation on Self-Love Dedicated to the Women*. New York: Dodson, 1974.

Dorgan, Michael. "Oldest Profession Holds its Own SF Convention." In *San Jose Mercury News*, Friday, July 13, 1984, p. 17—A.

Dragu, Margaret, and A.S.A. Harrison. *Revelations: Essays on Striptease and Sexuality*. London: Nightwood Editions, 1988.

Duggan, Lisa. "Making it Perfectly Queer." In *Socialist Review*, vol. 22, no. 1 (January—March, 1992).

————, and Nan D. Hunter. *Sex Wars: Sexual Dissent and Political Culture*, New York: Routledge, 1995.

Dworkin, Andrea. *Pornography: Men Possessing Women*. New York: Perigee, 1981.

Echols, Alice. *Daring to Be Bad*. Minneapolis: University of Minnesota Press, 1989.

Eliade, Mircea, ed. *The Encyclopedia of Religion*, Vol. Six. New York: MacMillan, 1993.

Estebanez, P., and K. Fitch, et al. *Bulletin of the World Health Organization*. 1993. 71(3/4):397—412.

Federal Bureau of Investigation, *Uniform Crime Reports*. Washington, DC: U.S. GPO, 1995.

Feinberg, Leslie. *Stone Butch Blues.* Ithaca, NY: Firebrand Books, 1993.

Flexner, Abraham. *Prostitution in Europe*, Introduction by John D. Rockefeller, Jr. New York: Century Co., 1914.

Foucault, Michel. *A History of Sexuality, Vol. 1: An Introduction.* New York: Vintage, 1980.

Freed, Mimi =. "Nobody's Victim." In *10 Percent* (Summer 1993), p. 53.

French, Dolores, and Linda Lee. *Working: My Life as a Prostitute.* New York: E.P. Dutton, 1988.

Friedan, Betty. *The Feminine Mystique.* New York: Norton, 1963.

Fulbright, Catherine. "Morality has Nothing to Do With It." In the *Village Voice*, December 23, 1971, p. 26.

Fuss, Diana, ed. *Inside/Out.* New York and London: Routledge, 1991.

Gadon, Elinor. *The Once and Future Goddess.* San Francisco: Harper & Row, 1989.

Gaskin, Ina May. *Spiritual Midwifery.* Summertown, TN: Book Pub. Co., 1990.

Gibson, Mary. *Prostitution and the State in Italy, 1860–1915.* New Brunswick, NJ: Rutgers University Press, 1986.

Gilligan, Carol. *In A Different Voice: Psychological Theory and Women's Development.* Cambridge: Harvard University Press, 1982.

Gilligan, Carol and Lyn Mikel Brown. *Meeting at the Crossroads: Women's Psychology and Girls' Development.* Cambridge: Harvard University Press, 1992.

Gilroy, Sarah. "The EmBody-ment of Power: Gender and Physical Activity." *Leisure Studies.* 8 (1989): 163–71.

Giobbe, Evelina. "Prostitution: Buying the Right to Rape." In Ann Wolbert Burgess, ed., *Rape and Sexual Assault III: A Research Handbook.* New York: Garland Press, 1991.

Glueck, Grace. "A Zaftig Barbie? A Gay Ken? Mattel Guards Its Bosomy Icon." *New York Observer*, January 8, 1996.

Grahn, Judy. "They Say She Is Veiled." In *Queen of Wands.* Freedom, CA: The Crossing Press, 1982.

———. *Another Mother Tongue: Gay Words, Gay Worlds.* Boston: Beacon Press, 1984.

———. *Blood, Bread and Roses: How Menstruation Created the World.* Boston: Beacon Press, 1993.

———. *Queen of Wands.* Trumansburg, NY: The Crossing Press, 1982.

Greer, Germaine. *The Female Eunuch.* New York: McGraw-Hill, 1971.

Griffin, Susan "The Way of All Ideology." In *Signs, Journal of Women in Culture and Society*, 1982, Vol. 7, No. 3.

———. *Pornography and Silence: Culture's Revenge Against Nature.* New York: Harper & Row, 1981.

Harsin, Jill. *Policing Prostitution in Nineteenth Century Paris.* Princeton: Princeton University Press, 1985.

Hobson, Barbara Meil. *Uneasy Virtue: The Politics of Prostitution and the American Reform Tradition.* New York: Basic Books, 1987.

Hollibaugh, Amber, and Cherríe Moraga. "What We're Rollin Around in Bed

With." In *Heresies*. Volume 3, no. 4 (Issue 12: Sex Issue). New York: Faculty Press.

hooks, bell. "Choice Books: Tough Talk for Tough Times." An interview in *On the Issues: The Progressive Woman's Quarterly* (Winter, 1996).

—————. *Outlaw Culture: Resisting Representations*. New York: Routledge, 1994.

Hunt, Lynn. *The Invention of Pornography: Obscenity and the Origins of Modernity, 1500–1800*. New York: Zone Books, 1993.

Hyam, Ronald. *Empire and Sexuality: The British Experience*. Manchester: Manchester University Press, 1990, 1991, 1992.

Irigaray, Luce. *This Sex Which Is Not One*. Ithaca: Cornell University Press, 1985.

Jaggar, Alison M. "Prostitution." In *The Philosophy of Sex: Contemporary Readings*. Alan Soble, ed. Maryland: Rowman & Littlefield, 1991.

Johnson, D. "Security Versus Autonomy Motivation in Anthony Giddens' Concept of Agency." *Journal for the Theory of Social Behavior*. 20: 1990.

Kaplan, Rebecca. "Compulsory Heterosexuality and Bisexual Existence." In *Closer to Home: Bisexuality and Feminism*. Elizabeth Reba Weise, ed. Seattle: Seal Press, 1992.

Kearon, Pam. "The Politics of Pity: Mau-mauing the Feminists." In the *Village Voice*, January 13, 1972, p. 11.

Kelly, Christina. "Bonding With Our Topless Sisters." In *Sassy* (August, 1992).

Kennedy, Elizabeth, and Madeline Davis. *Boots of Leather, Slippers of Gold*. New York: Penguin Books, 1994.

Koltuv, Barbara Black. *The Book of Lilith*. York Beach, ME: Nicolas-Hays, 1987.

Lakoff, Robin Tolmach. *Language and Woman's Place*. New York Harper & Row, 1975.

Langum, David J. *Crossing over the Line: Legislating Morality and the Mann Act*. Chicago: University of Chicago Press, 1994.

Leboyer, Frederick. *Birth Without Violence*. New York: Knopf : distributed by Random House, 1975.

Leigh, Carol. "Cheap." In *Uncontrollable Bodies*. Rodney Sappington and Tyler Stallings, eds., Seattle: Bay Press, 1994.

—————, ed., *In Defense of Prostitution: Prostitutes Debate their 'Choice' of Profession*. Gauntlet, Vol. I, No. 7, 1994. A special issue devoted to sex work in the United States.

Lerner, Gerda. *The Creation of Patriarchy*. New York: Oxford University Press, 1986.

Lindsey, Karen. "Prostitution and the Law." In *the second wave: a magazine of the new feminism*. Volume One, Number 4, 1972.

Lord, M. G. *Forever Barbie: The Unauthorized Biography of a Real Doll*. New York: William Morrow, 1994.

—————. "The Question Is: What Would Ken Think?" *New York Times*, December 1, 1995, page C-1.

MacKinnon, Catharine. *Toward a Feminist Theory of the State*. Cambridge: Harvard University Press, 1989.

Maguire, Kathleen, and Ann L. Pastore, eds. *Sourcebook of Criminal Justice Statistics 1993.* U.S. Department of Justice, Bureau of Justice Statistics. Washington, DC: US GPO, 1994.

Mahood, Linda, "The Domestication of 'Fallen' Women." In *The Magdalenes: Prostitution in the Nineteenth Century.* London: Routledge, 1990.

Martin, Emily. *The Woman in the Body.* Boston: Beacon Press, 1987.

Masters, William, and Virginia Johnson. *The Joy of Sex.*

Meador, Betty De Shong. *Uncursing the Dark: Treasures from the Underworld.* Wilmette, IL: Chiron Publications, 1992.

McCall, Henrietta. *Mesopotamian Myths: The Legendary Past.* London: British Museum Publications, 1990.

McClintock, Anne, ed., *Social Text* (Special issue). 37 (Winter 1993).

McElroy, Wendy. *XXX: A Woman's Right to Pornography.* New York: St. Martin's Press, 1995.

McIntosh, Mary. "The Homosexual Role." In *Social Problems,* Vol. 16, No. 2 (Fall, 1968).

Miller, Ron. "The Working Women of the Streets." In *San Jose Mercury News.* July 17, 1995, p. 3 D.

Millett, Kate. *Sexual Politics.* New York: Ballantine Books, 1969.

————. *The Prostitution Papers.* New York: Avon Books, 1973. Quoted in Dworkin, Andrea. *Pornography: Men Possessing Women.* New York: Perigee, 1981, p. 199.

Morgan, Peggy. "Living on the Edge." In *Sex Work: Writings by Women in the Sex Industry,* Frédérique Delacoste and Priscilla Alexander, eds. Pittsburgh, PA: Cleis Press, 1987.

Morgan, Robin, ed. *Sisterhood Is Powerful.* New York: Vintage Books, 1970.

————. *Going Too Far: The Personal Chronicle of a Feminist.* New York: Vintage Books, 1978.

Nagle, Jill (writing as Vashti Zabatinsky). "Some Thoughts on Power, Gender, Body Image and Sex in the Life of One Bisexual Lesbian Feminist." In *Closer to Home: Bisexuality and Feminism.* Elizabeth Reba Weise, ed. Seattle: Seal Press, 1992.

————. "Interparadigmatics: Toward a Dynamic, Polyvisional Epistemology/Praxis of Queer Liberation." Unpublished paper presented at Queer Frontiers: The Fifth Annual National Lesbian, Gay and Bisexual Graduate Student Conference. Los Angeles, 1995.

————. "Framing Radical Bisexuality: Toward a Gender Agenda." In *Bisexual Politics: Theories, Queries and Visions.* Naomi Tucker, ed. San Francisco: Harrington Park Press, 1995.

Nestle, Joan. "Lesbians and Prostitutes: A Historical Sisterhood." In Delacoste and Alexander, *Sex Work,* op. cit.

————, ed. *The Persistent Desire: A Femme-Butch Reader.* Boston: Alyson Publications, 1992.

Nicholson, Linda J., ed. *Feminism/Postmodernism*. New York: Routledge, Chapman & Hall, Inc., 1990.

Nobile, Philip, and Eric Nadler. *United States of America vs. Sex: How the Meese Commission Lied About Pornography*. New York: Minotaur Press, Ltd., 1986.

No cited author, "HIV Prostitute," cited in the Centers for Disease Control and Prevention (CDC) National AIDS Clearinghouse, AIDS Daily Summary, March 14, 1994.

No cited author, *The Report of The Commission on Obscenity and Pornography*. Washington, DC: United States Government Printing Office. September, 1970.

No cited author, "Roundtable on Pornography." In *Ms.* (January/February 1994).

Otis, Leah Lydia. *Prostitution and Medieval Society: The History of an Urban Institution in Languedoc.* Chicago: University of Chicago Press, 1985.

Overall, Christine. "What's Wrong with Prostitution? Evaluating Sex Work." In *Signs* (Summer 1992).

Pateman, Carol. *The Sexual Contract*. Stanford, CA: Stanford University Press, 1988.

Peck, Charles. "The Implicit Employment Contract and Compensation," *Human Resources Briefing*, Special Issue. New York: The Conference Board, Inc. Winter 1994–1995.

Pedersen, Knud. "Prostitution or Sex Work in the Common Market?" In *International Journal of Health Services*, 1994, Vol. 24, No. 4, pp. 649–653.

Pheterson, Gail. Gail Pheterson, "The Whore Stigma: Crimes of Unchastity," in *The Prostitution Prism* (Amsterdam: Amsterdam University Press, 1996, pp. 65–89.

———. "The Social Consequences of Unchastity." In Frédérique Delacoste and Priscilla Alexander, eds., *Sex Work: Writings by Women in the Sex Industry*. Pittsburgh and San Francisco: Cleis Press, 1987.

———. *The Whore Stigma: Female Dishonor and Male Unworthiness.* Den Haag: Ministry of Social Affairs and Employment, 1986.

———, ed. *A Vindication of the Rights of Whores*. Seattle: Seal Press, 1989.

Reisig, Robin. "Sisterhood and Prostitution." *Village Voice*, Vol. December 16, 1971, p. 1.

———. "Prostitutes & Feminists: Are You Mary or Are You Eve?" In the *Village Voice*, December 23, 1971, p. 26.

———. "A Walk at Midnight: 'You're in a Den of Whores and Backs.'" In the *Village Voice*, December 30, 1971, p. 3.

———. "Myths About Prostitution: Reporter's Reply." In the *Village Voice*, January 13, 1972, p. 13.

Reuben, David R. *Everything You Always Wanted to Know About Sex but Were Afraid to Ask*. New York: D. McKay Co., 1969.

Rich, Adrienne. "Conditions for Work: The Common World of Women

(1976)." In *On Lies, Secrets, and Silence: Selected Prose 1966–1978*. New York: W.W. Norton & Company, 1979.

————. "Compulsory Heterosexuality and Lesbian Existence." In *Blood, Bread, and Poetry,* New York: Virago Press, 1986.

Roberts, Nickie. *Whores in History: Prostitution in Western Society*. London: Grafton (HarperCollins), 1992.

Rogue. "Ode to my Wig." *Playday '92: Tales from the Lusty Side.* 1992.

Rosen, Ruth. *The Lost Sisterhood: Prostitution in America, 1900–1918*. Baltimore: John Hopkins University Press, 1982.

Rubin, Gayle. "Misguided, Dangerous and Wrong: an Analysis of Anti-pornography Politics." In *Bad Girls & Dirty Pictures: The Challenge to Reclaim Feminism*, Alison Assiter and Avedon Carol, eds. London: Pluto Press, 1993.

————. "Thinking Sex: Notes for a Radical Theory of the Politics of Sexuality." In Carole Vance, ed., *Pleasure and Danger: Exploring Female Sexuality*. Boston: Routledge & Kegan Paul, 1984.

Russell, Diana E. H. *Against Pornography: The Evidence of Harm.* Berkeley: Russell Publications, 1993.

Sanday, Peggy Reeves. *Female Power and Male Dominance: On the Origins of Sexual Inequality.* Cambridge: Cambridge University Press, 1981.

Schneider, Beth E. and Nancy E. Stoller. *Women Resisting AIDS: Feminist Strategies of Empowerment*. Philadelphia: Temple University Press, 1995.

Seidman, Steven. *Embattled Eros: Sexual Politics and Ethics in Contemporary America*. New York: Routledge, 1992.

Shilling, Chris. "Educating the Body: Physical Capital and the Reproduction of Inequalities." In *Sociology*, 25:4, 1991.

Silverman, Jenny. "Topless Dancing: Why I Do It, Why I Like It." In *Glamour* (April, 1993).

Shuttle, Penelope, and Peter Redgrove. *The Wise Wound: Myths, Reality and Meanings of Menstruation*. New York: Bantam Books, 1978, 1986.

Smart, Carol. *Law, Crime and Sexuality*. London: Sage Publications, 1994.

Snitow, Ann, Christine Stansell, and Sharon Thompson, eds. *Powers of Desire: Politics of Sexuality*. New York: Monthly Review Press, 1983.

Sobol, Blair. "'Try it, You'll Like It.'" In the *Village Voice*, December 16, 1971, p. 1.

Spretnak, Charlene, ed. *The Politics of Women's Spirituality: Essays on the Rise of Spiritual Power Within the Feminist Movement*. New York: Doubleday, 1982.

Stan, Adele, ed. *Debating Sexual Correctness*. New York: Delta Press, 1995.

Steinem, Gloria. "Revaluing Economics." In *Moving Beyond Words*. New York: Simon & Schuster, 1994.

Stone, Merlin. *When God Was A Woman*. New York: Harcourt, Brace Jovanovich, 1976.

————. *Ancient Mirrors of Womanhood: A Treasury of Goddess and Heroine Lore from Around the World*. Boston: Beacon Press, 1984, c1979.

Strong, Ellen. "The Hooker." In Robin Morgan, ed. *Sisterhood is Powerful*. New York: Vintage Books, 1970.

Strossen, Nadine. *Defending Pornography: Free Speech, Sex and the Fight for Women's Rights*. New York: Scribner, 1995.

Stubbs, Kenneth Ray. *Women of the Light: The New Sacred Prostitute*. Larkspur: Secret Garden Press, 1995.

Tannahill, Reay. *Sex in History*. New York: Scarborough, 1982.

Tisdale, Sallie. *Talk Dirty to Me: An Intimate Philosophy of Sex*. New York: Doubleday, 1994.

Valverde, Mariana. *Sex, Power & Pleasure*. Philadelphia: New Society Publishers, 1987.

Vance, Carole, ed. *Pleasure and Danger: Exploring Female Sexuality*. Boston: Routledge & Kegan Paul, 1984.

Walker, Barbara. *The Woman's Encyclopedia of Myths and Secrets*. San Francisco: Harper and Row, 1983.

Walkowitz, Judith R. *Prostitution and Victorian Society: Women, Class, and the State*. Cambridge: Cambridge University Press, 1980.

Wallace, J. I., A. Weiner, A. Steinberg, and B. Hoffman. "Fellatio Is a Significant Risk Behavior for Acquiring AIDS among New York City Streetwalking Prostitutes."In International Conference on AIDS, Amsterdam, 1992 (abstract no. PoC 4196).

Warner, Michael, ed. *Fear of a Queer Planet*. Minneapolis: University of Minnesota Press, 1993.

Weeks, Jeffrey. *Coming Out*. New York: Quartet, 1977.

Wittig, Monique. "One Is Not Born a Woman." In *The Straight Mind and Other Essays*. Boston: Beacon Press, 1992.

Wolf, Naomi. *Fire With Fire: The New Female Power and How to Use It*. New York: Fawcett Columbine, 1993, 1994.

Wolkstein, Diane, and Samuel Noah Kramer. *Inanna, Queen of Heaven and Earth: Her Stories and Hymns from Sumer*. New York: Harper and Row, 1983.

Womongold, Marcia. *Pornography: License to Kill*. Somerville, MA: New England Free Press, 1979.

Woodhouse, Donald, Lovice Riffe, John B. Muth, and John J. Potterat. "Restriction of Personal Behavior: Case Studies on Legal Measures to Protect the Public Health." In International Conference on AIDS, 1992 (abstract PoD 5443).

Wynter, Sarah. "WHISPER: Women Hurt in Systems of Prostitution Engaged in Revolt." In Alexander, Priscilla and Frédérique Delacoste, eds. *Sex Work: Writings by Women in the Sex Industry*. Pittsburgh: Cleis Press, 1987.

Contributors

Blake Aarens is the great-granddaughter of Hattie and Esther, the granddaughter of Dicy, and the daughter of Cobia. She is a lesbian of African descent whose best friend on the planet is her blond, blue-eyed, Jewish ex-husband. She is a survivor of childhood sexual abuse who writes award-winning erotic fiction that has been published in *Herotica 2, 3,* and *5, Best American Erotica, 1993*; *Penthouse*; and the forthcoming anthology *Switch Hitters* (Cleis Press). Blake is a working artist in search of her tribe.

Priscilla Alexander is a member of the North American Task Force on Prostitution, a loose network of sex workers' rights organizations in the United States and Canada. From 1976 to 1989 her home was San Franciso's COYOTE, the first sex workers' rights organization, formed by Margo St. James in 1973. Along the way she coedited, with Frédérique Delacoste, *Sex Work: Writings by Women in the Sex Industry* (Cleis, 1987). In 1989, she moved to Geneva, Switzerland, to work for the World Health Organization's Global Programme on AIDS. She now lives in New York City where she works with an HIV/AIDS-prevention project that serves women who work in some of the poorest sections of the city. She is also working on a master's degree in public health at Columbia University.

Norma Jean Almodovar, author of *Cop to Call Girl*, spent ten years on the Los Angeles Police Department before deciding to pursue a more honest, ethical profession as a prostitute. She immediately became involved in the prostitute rights movement, and today is the director of the Los Angeles chapter of COYOTE. She spent eighteen months in state prison when her former comrades at the LAPD set her up on a bogus charge of pandering and confiscated her unfinished manuscript. In 1986, she ran for Lieutenant Governor of California on the Libertarian ticket and received over 100,000 votes. She is married to Victor Savant and lives in Panorama City, CA. They have no children.

Red Jordan Arobateau is the author of *Lucy & Micky, Dirty Pictures, Boys Night Out & Other Stories, Volume I, Rough Trade and Other Stories Volume II*, all published by

Masquerade Books and currently available at local lesbian and gay bookstores. She has also written a book of poetry entitled *Laughter of the Witch* from Women In The Moon Press. Send $3.00 for a catalogue of other writings to: Red Jordan Press, 484 Lake Park Ave., #228, Oakland, CA, 94610.

Hima B. is a queer South Asian filmmaker currently working as a stripper in a sleazy San Francisco lap and wall dancing club. She produced and directed *Straight for the Money: Interviews with Queer Sex Workers*, an explicit documentary that explores the complex lives of eight lesbian and bisexual sex workers who cater primarily to men. With her dominatrix comrade, Terry Morris, Hima B. is producing a documentary that analyzes the labor and legal movements of the sex industry in San Francisco. She is also collaborating with loanna de valencia, a San Francisco Latina dyke writer on an experimental phone sex project for and by dykes of color called DIELMO.

Siobhan Brooks lives in San Francisco, where she was born and raised. She has a Bachelor's degree in Women's Studies from San Francisco State University. Her two years of sex work experience include nude photos, phone sex, and stripping at the Lusty Lady. She has lectured publicly on stripping and feminism, including an appearance on the Mark Walburg show. She is on the Lusty Lady's bargaining committee, and is currently at work on a book about men and women of color and the sex industry.

Drew Campbell is a transgendered pervert writer and educator whose writing has appeared in several San Francisco Bay Area publications, including *Venus Infers, Roundup, Spectator, Girlfriends*, and the *SandM Utopian Guardian*. Drew is coediting with Pat Califia an anthology entitled *Bitch Goddess: The Spiritual Path of the Dominant Woman*, which focuses on breaking down the barriers between sexuality and spirituality.

Tawnya Dudash has lived on the West Coast and been a sex worker for over six years. Her article in this volume is drawn from her graduate thesis, entitled *Emerging Feminist Discourses Among Dancers at a San Francisco Peepshow*. Tawnya still dances whenever she gets a chance, though she has recently earned her elementary teaching credential, thus fulfilling her desire for a rewarding-yet-low-paying day job.

Cosi Fabian—mythologist, teacher, courtesan—embodies and expresses the archetypal "sacred prostitute." She is a published poet (*Return of the Great Goddess*, Shambala, 1994,) a popular storyteller, and a frequent guest lecturer at Bay Area colleges and conferences. Born on Malta and educated in England and the Far East, Cosi has now lived for twenty-five years in San Francisco, where she is a member of the Institute of Women's Arts, Mysteries and Sciences, and of the Cyprian Guild.

Vicky Funari is a film/videomaker. She also writes sometimes. Her recent videotape *skin • es • the • si • a* uses peepshow imagery to explore the codification of the female body. She is currently producing and directing a feature documentary on the life of a Mexican maid. She thanks Hannah Sim, Heidi Jane Rahlmann, Christina Sunley, Gretchen Stoeltje, and John Muse for insights and inspiration in writing this chapter.

Gina Gold worked as a stripper for five years before leaving the sex industry in 1994. She studied mass communications at Boston University and has recently completed her book entitled *Island of Misfit Toys: The Autobiography of a Stripper*.

Teri Goodson is a pleasure professional. She is also a civil libertarian and a COYOTE activist who served on the board of the San Francisco chapter of the National Organization for Women for over three years. During that time, she represented NOW on the city's Prostitution Task Force and lead a successful campaign to stop the district attorney from using condoms as court evidence against prostitutes.

Larry Grant is an East Bay, CA, writer and researcher. He hosts an interview and call-in talk show on community radio station KKUP.

Nina Hartley, one of the most widely recognized and respected adult video performers ever, has used her high visibility to promote sexual literacy and tolerance. A registered nurse and a firm believer in the value of sexual self-knowledge, she has begun producing, directing, and starring in a sex-education video series in addition to continuing her twelve-year career as actress, dancer, and "mother hen" to new talent in the adult industry. As a member of a longstanding triad, Ms. Hartley's professional life is a natural extension of her personal philosophy. For her, sexual liberation is a necessary and welcome component of feminist practice.

Liz Highleyman (aka Mistress Veronika Frost) is a professional dominant, writer, and public health educator. She is on the editorial staff of an AIDS treatment publication, editor of the monthly pansexual newspaper *Cuir Underground*, associate editor of the anthology *Bisexual Politics: Theories, Queries and Visions*, and is working on a book on anarchism and alternative sexuality. She is a member of COYOTE and San Francisco's HIV Prevention Planning Council, and is active in several online forums.

Jade Irie is a young performance artist guided by individualistic vision.

Madeleine A. Lawson, aka Diana, has been a professional dominatrix at FantasyMakers for one year. Known for trying anything once, she has also been "Terry," a phone-sex girl; an escort working for a madam; as well as a

partner and hostess "Kit" of the swing club, The Golden Rose in San Francisco. She is currently writing an article series for the *Spectator* on swinging, and has appeared on HBO's *Real Sex*. A volunteer for San Francisco Sex Information, Madeleine is a six-foot tall black Amazon who is slowly learning to heal from years of sexual abuse by using sexual understanding. A senior majoring in sociology at the University of California at Berkeley, she plans to study at the Institute for the Advanced Study of Human Sexuality to be a better therapist, advocate, and educator of sex.

Carol Leigh is an active member of COYOTE, a founding member of ACT UP (San Francisco), and long-time member of NOW. In 1994, she was facilitating chair of the San Francisco Board of Supervisor's Task Force on Prostitution, representing the Commission on the Status of Women. She coordinates the Coalition on Prostitution, a street outreach program that provides condoms and health and safety information to street workers. She teaches "Prostitution 101" at the Harvey Milk Institute, and video production for San Francisco's Community Access Television. Leigh has received numerous awards for her documentaries, and was nominated for a 1993 Rockefeller Fellowship. Censored at the University of Michigan Law School, her *OUTLAW POVERTY, NOT PROSTITUTES* won an American Film Institute award in 1992. Her website is http://www.creative.net/~penet/

Gloria Jean Lockett, native of San Francisco, cofounder and executive director of California Prostitutes Education Project (CAL-PEP) serves on national and international advisory boards as a health advocate for AIDS prevention, education, and research. A member of COYOTE since 1981, she has spoken at numerous conferences around the world. Ms. Lockett is coauthor of a widely published paper entitled "Black Women and AIDS," Black Women's Health, and is also published in *Sex Work* (Cleis, 1987) and *Women Resisting AIDS: Feminist Strategies of Empowerment* (Temple University Press).

Lyndall MacCowan has lived in San Francisco since the age of sixteen, where she came out through the auspices of the Daughters of Bilitis. She is a survivor of the lesbian-feminist '70s, and has degrees in anthropology and women's studies. At present, she chairs the Oral History Project of San Francisco's Gay and Lesbian Historical Society. An essayist and bibliographer, Lyndall's most recent writing appeared in Joan Nestle's *The Persistent Desire*. She is currently at work on a book of interviews with lesbians in the sex industry.

Julian Marlowe is a mild-mannered graduate student living in Vancouver. Introverted and antisocial to the extreme, Julian is an aspiring zillionaire who wishes to eventually relocate to an uncharted tropical island with two kittens named Dow and Jones, never to be heard from again.

Veronica Monét is a married (to a man) bisexual feminist sex worker who draws most of her spiritual inspiration from twelve-step groups and Native American stories. She has spent about a decade of her life in recovery from addiction, alcoholism, and a variety of abuses including rape, incest, and domestic violence. She believes that her firsthand experience with sex and men that harm women as well as her personal positive experiences as a prostitute and X-rated actress help her bridge the seemingly opposed positions of many feminists and sex workers. Veronica knows the pain of being denied choice, whether it is a woman's right to say "no" to sex or a woman's right to say "yes" to sex of any kind she chooses.

Jessica Patton graduated *cum laude* from Smith College and won first place (a blue plastic trophy of a woman with wings) at her first strip-club audition, an "Amateur Night" contest. She's shaken her ass for a living in San Francisco, New Orleans, and Hawaii and performed her monologues throughout San Francisco, at T.W.E.E.D. in New York City, and at Highways in LA. She retired at twenty-four from the sex industry. She currently resides in San Francisco with her wife and their four feline children. She is writing her first novel.

Eva Pendleton is a Ph.D. student in American studies at New York University. She is a member of the Dangerous Bedfellows Collective, which has just completed its first book, *Policing Public Sex: Queer Politics and the Future of AIDS Activism*, (South End Press, 1996.) She is also a professional sexual deviant and a member of PONY (Prostitutes of New York).

Tracy Quan, currently a member of Prostitutes of New York (PONY), professes to be this anthology's token postfeminist. Her articles have appeared in *Lingua Franca*, the *Village Voice, Puritan, Forum*, and on the World Wide Web in *Urban Desires* <http://desires.com/>. She has debated Evelina Giobbe (founder of the anti-prostitution group WHISPER) in the pages of *Congressional Quarterly*.

Carol Queen is a San Francisco writer and cultural sexologist completing her doctorate at the Institute for Advanced Study of Human Sexuality. She has also conducted private research into sexuality as a prostitute and peepshow worker, and in diverse sexual communities. Her erotic writing and essays have appeared in numerous 'zines and anthologies, including *Herotica 2, 3*, and *4, Best American Erotica 1993* and *1994, Women of the Light: The New Sacred Prostitute, Madonnarama, Bisexual Politics: Theories, Queries and Visions,* and *Dagger: On Butch Women*, among others. Her first book was *Exhibitionism for the Shy: Show Off, Dress Up and Talk Hot* (Down There Press, 1995). Her second, an erotic anthology coedited with Lawrence Schimel is *Switch Hitters: Lesbians Write Gay Male Erotica and Gay Men Write Lesbian Erotica* (Cleis, 1996). Her essay collection *Real Live Nude Girl: Chronicles of Sex-Positive Culture* is now available from Cleis.

Stacy Reed is a Houston writer and editor who studied psychology and philosophy in Austin, TX, before living in San Francisco for ten months. For six years she has been contributing articles and stories to various venues, including several city papers and national magazines as well as *Herotica 3, 4* and *5*. "All Stripped Off" is unique in that it has undergone a midterm, five mutations, and three publications since its inception in 1990.

Ann Renée is a writer, counselor, and mother. Her background as a teenage sex worker informs her work as an advocate for women's sexual rights. She is currently seeking an agent for her autobiography entitled *The Phoenix Wants Me*.

Candida Royalle is the creator and president of Femme Productions, Inc., which produces adult erotica from the woman's perspective for the male-female couples' market. Ms. Royalle performed in adult films in the 1970s, and now writes, produces, and directs the Femme line. She lectures widely at such venues as the World Congress of Sexology, the Smithsonian Institute, and the American Psychiatric Association National Annual Conference. Her films have received widespread acclaim, from the sex-therapy community for their "positive sexual role modeling," as well as from the press, both here and abroad, in frequent articles. She is a member of the American Association of Sex Educators, Counselors and Therapists (AASECT), and a founding board member of Feminists for Free Expression (FFE).

Marcy Sheiner writes fiction, poetry, essays, and journalism. She is the editor of *Herotica 4* (Plume, 1996). Her erotic stories have appeared in *Herotica 1, 2,* and *3, Virgin Territory, On Our Backs, Penthouse*, and *Cupido*. She has written for *Mother Jones*, the *San Francisco Chronicle*, and the *San Francisco Bay Guardian*. Her poetry has been published in many journals and anthologies. She is currently editing *Herotica 5* and writing a collection of autobiographical essays.

Annie Sprinkle spent eighteen years as a porn star, stripper, prostitute, and "queen of kink." With the advent of the AIDS crisis, she became interested in healing modalities and spirituality. She evolved into a high priestess of sacred sex magic rituals, a Tantrica, an internationally acclaimed avant garde artist, facilitator of sexual healing workshops, safe sex innovator, and feminist "pleasure activist." She lives by the sea with her lovely wife, Kimberley Silver.

Debi Sundahl is the founder of *On Our Backs* magazine. She owned Blush Entertainment Corporation with her partner Nan Kinney, producing twelve lesbian erotic videos for Fatale Video and serving as publisher of *On Our Backs* through its tenth anniversary issue. Debi is currently on sabbatical in Santa Fe, New Mexico, studying pottery and beading, exploring Native American ruins and the Great Plains, and beginning a novel. She owns Dasero, Inc., which

houses Fatale Video; she serves as its creative director and business executive. She is also a consultant for small businesses in the women's erotic industry.

Joan Kennedy Taylor is a writer who specializes in libertarian issues, primarily feminist ones since the 1992 publication of her book, *Reclaiming the Mainstream: Individualist Feminism Rediscovered* (Prometheus Books). She has worked as a book and magazine editor, a group therapist, and a paralegal, and is a founder and the current vice president of Feminists for Free Expression and the national coordinator of the Association of Libertarian Feminists.

Les von Zoticus is the working name ("Les" in honor of the writer's favorite butch author, Leslie Feinberg; "Zoticus," the word for "boy whore" in ancient Rome, and the closest historical reference available) of an Ivy League–educated, butch, queer, eccentric, rabble-rousing, semi-retired whore.

About the Editor

JILL NAGLE IS ENGAGED IN AN ONGOING SERIES of experiments with sex, gender, theory, social justice, and related topics. Some of her results to date, in the form of essays, book reviews, and titillatia, have been published in the books *Closer to Home: Bisexuality and Feminism* (Seal Press, 1992, under the pseudonym "Vashti Zabatinsky"), *Bisexual Politics: Theories, Queries and Visions* (Haworth, 1995), *First Person Sexual* (Down There Press, 1996) and the periodicals *Black Sheets*, *Girlfriends, Anything that Moves*, and *Spectator*.

A longtime radical queer Jewish activist, she believes all forms of oppression are connected, and seeks to elucidate and transform them through her writing, organizing, and performance. She has taught a course called "Theory and Practice for Activists" at the Harvey Milk Institute in San Francisco; and has spoken publicly, led workshops, and participated on panels on race, class, gender, Jewish and sexual orientation issues at conferences, in classrooms, and on television shows across the U.S.

Her topics of the hour include sex radicalism and white supremacy, inter-paradigmatics, the politics of queer liberation, mixed-gender queer sex spaces, sex industry consumers; "girl fags," Re-evaluation Counseling, bisexual theory, and strong Jewish women. Her interest in social justice is grounded in *tikkun olam*, the healing and repair of the planet, a cornerstone of Judaism. This is her first book.

Index